MANGA
MANIA
UNIVERSE

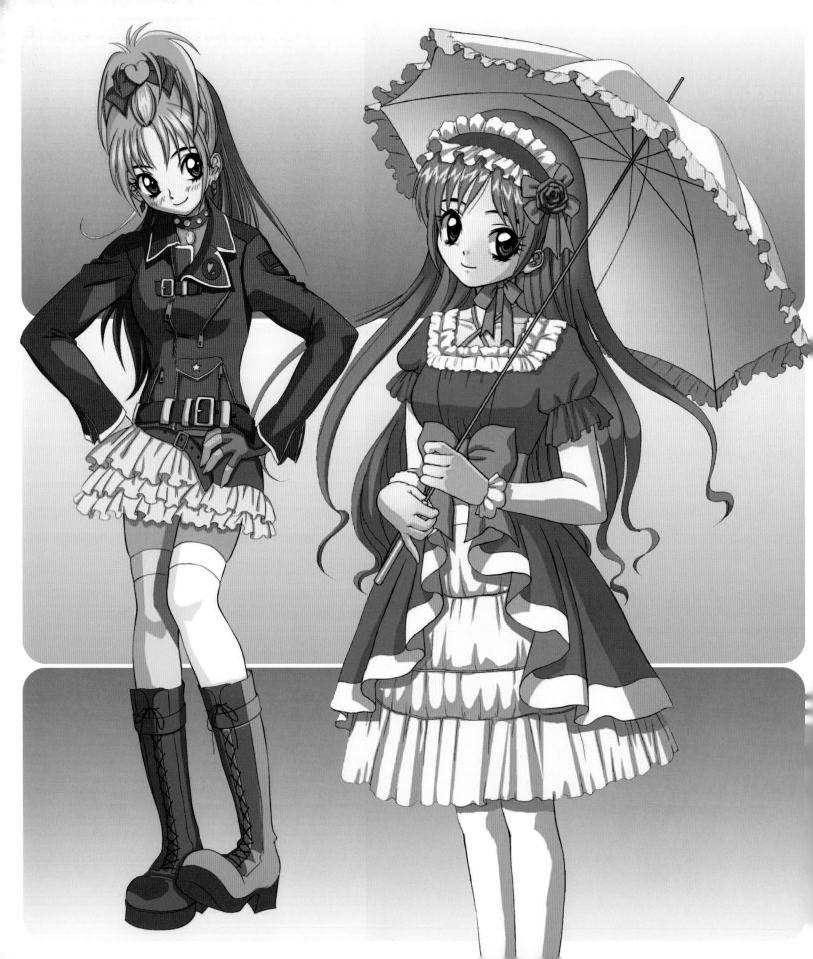

DRAWING WITH *Christopher Hart*

MANGA
MANIA
UNIVERSE

The Massive Book of Drawing Manga

Get Creative 6

DRAWING WITH Christopher Hart

An imprint of Get Creative 6
104 West 27th Street,
New York, NY 10001
sixthandspringbooks.com

Creative Director
DIANE LAMPHRON

Senior Editor
LAURA COOKE

Editorial Assistant
JACOB SEIFERT

Production
J. ARTHUR MEDIA

Contributing Artists
DENISE AKEMI
ANZU
DIANA DEOVRA
VANESSA DURAN
MAKIKO KANADA
IZUMI KIMURAYA
JIM JIMENEZ
CHIHIRO MILLEY
ROBERTA PARES
PH
JENNYSON ROSERO
DIOGO SAITO
JOSÉ CARLOS SILVA
KRISS SISON
AURORA TEJADO
NAO YAZAWA

Vice President
TRISHA MALCOLM

Chief Operating Officer
CAROLINE KILMER

President
ART JOINNIDES

Chairman
JAY STEIN

Get Creative 6

Library of Congress Cataloging-in-Publication Data
Names: Hart, Christopher, 1957-author
Title: Manga mania universe : the massive book of drawing
manga / Christopher Hart
Description: New York : Drawing with Christopher Hart, 2018 |
Series: Manga
 mania | Includes index.
Identifiers: LCCN 2018019469 | ISBN 9781640210158
(paperback)
Subjects: LCSH: Comic books, strips, etc.--Japan--Technique. |
 Cartooning--Technique. | Figure drawing--Technique. | BISAC:
ART /
 Techniques / Cartooning. | ART / Techniques / Drawing. |
DESIGN / Graphic
 Arts / General. | JUVENILE NONFICTION / Art / Drawing.
Classification: LCC NC1764.5.J3 H369395 2018 | DDC 741.5/952--
dc23
LC record available at https://lccn.loc.gov/2018019469

MANUFACTURED IN CHINA

5 7 9 10 8 6 4

www.christopherhartbooks.com
www.youtube.com/chrishartbooks
Facebook.com/CARTOONS.MANGA

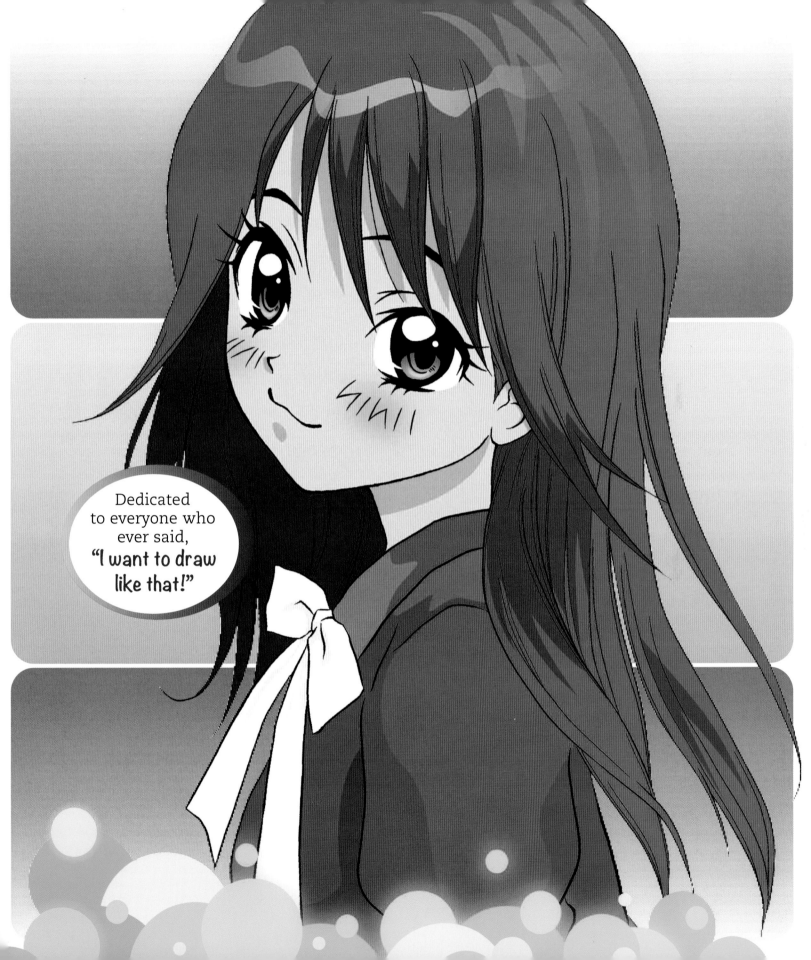

Table of Contents

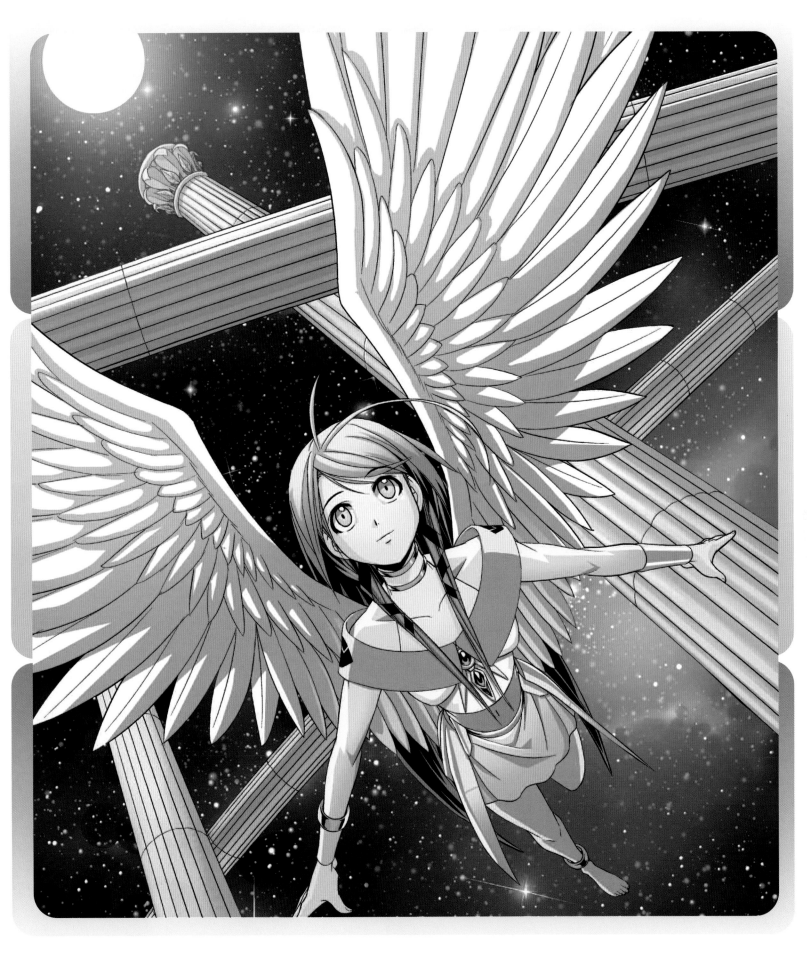

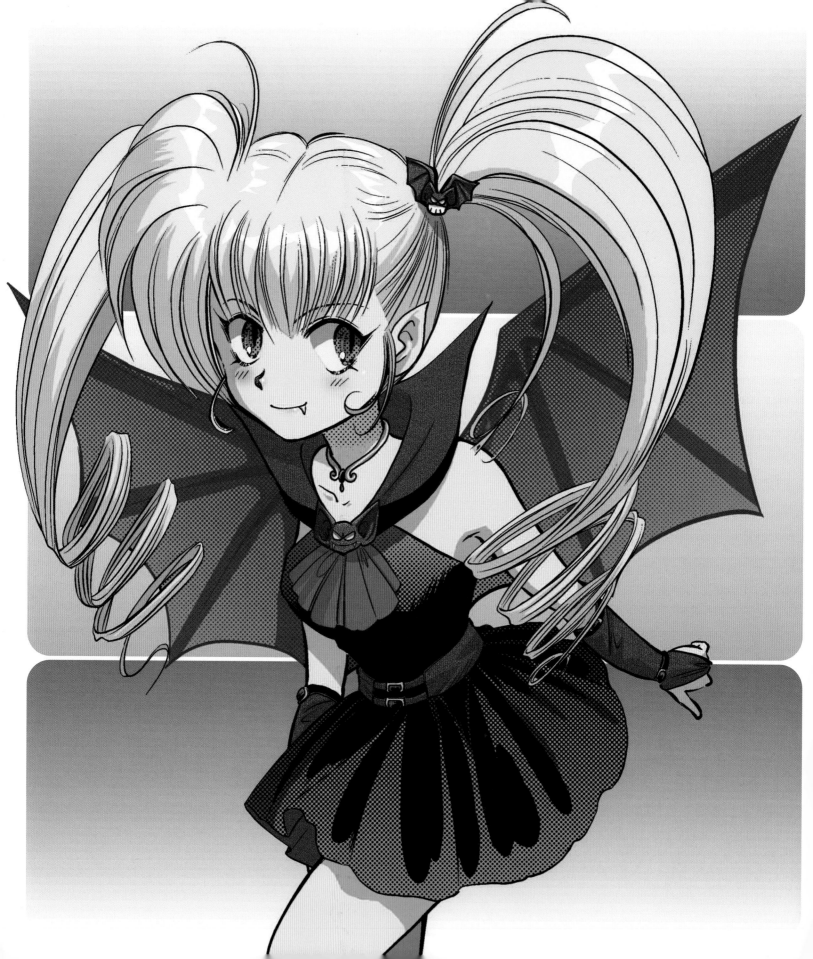

Manga has got to be one of the most popular styles of character art the world has ever come up with. Fans of manga find the graphic novels and characters so compelling that they not only devour series after series, they also draw them. This book will place the universe of manga art instruction at your fingertips. From the super-popular romance genre to the amazing action style and everything in between, this book will show you how to draw original characters accompanied by tons of clearly illustrated, step-by-step instructions and visual hints.

You'll learn how to draw the features of the male and female face and body, expressions, poses, and costumes. There is instruction on drawing cute characters, pretty characters, heroic characters, fantasy characters, comic characters, and even charming (and not so charming!) monsters. If you want the secrets to drawing manga, you've got it right here!

—Christopher Hart

www.christopherhartbooks.com

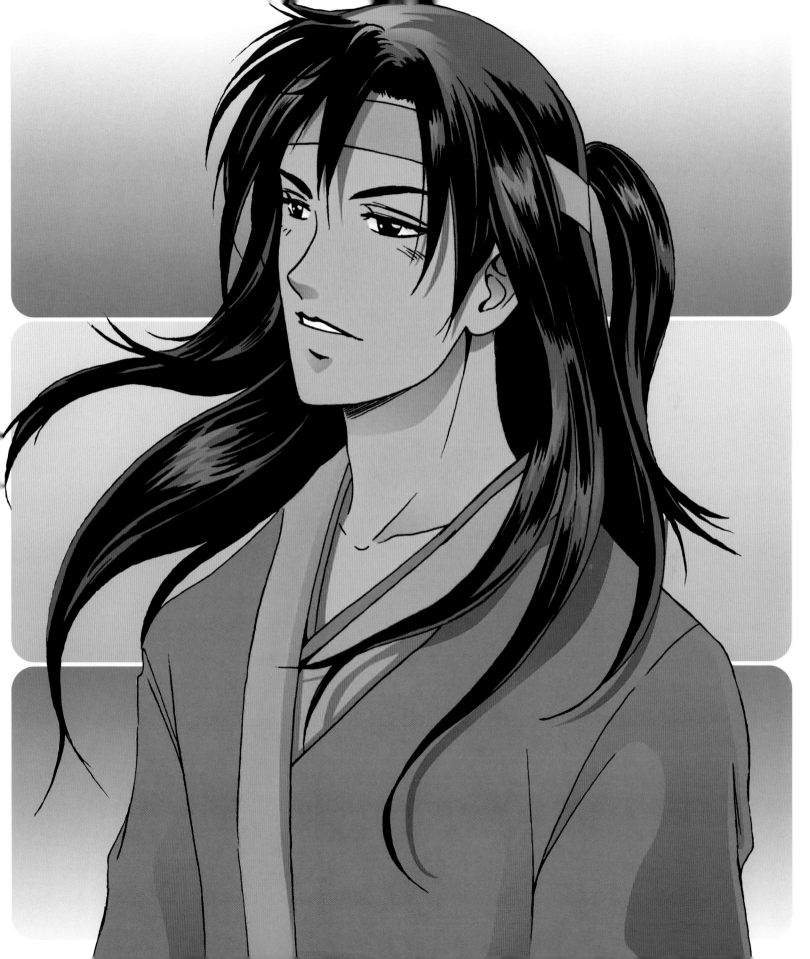

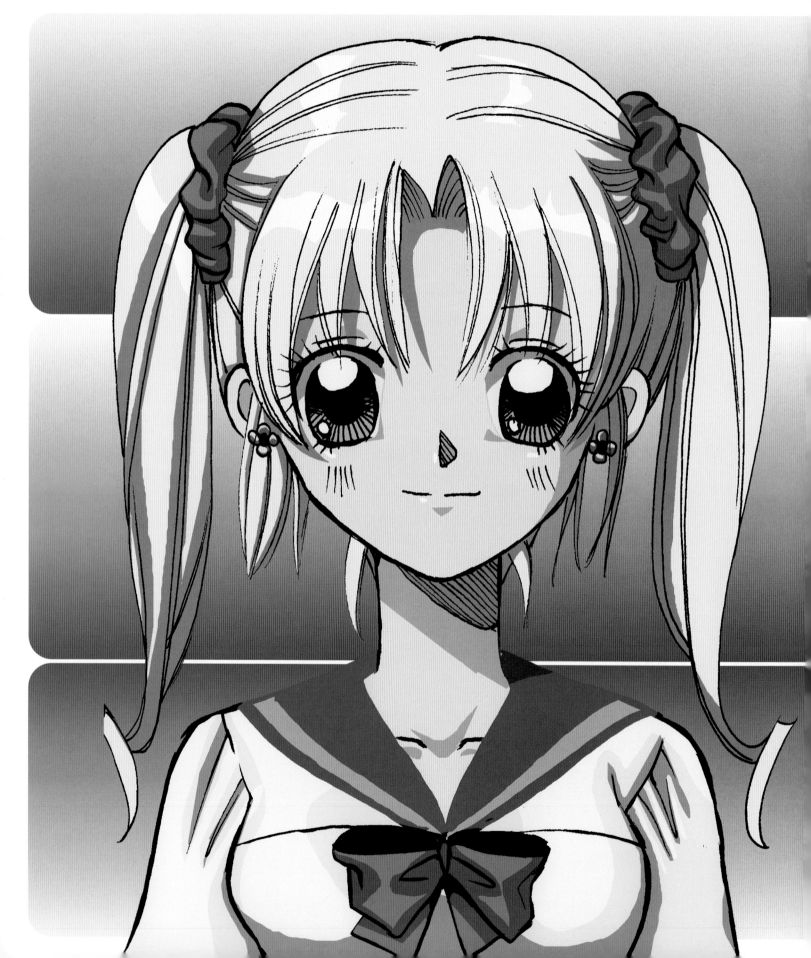

DRAWING MANGA GIRLS
The Basics

In manga, there are as many types of girls as there are stories, and no two manga girls are exactly alike. But there are certain techniques that are used in drawing most girl characters. In this chapter, we'll learn how to draw the manga head, including those fabulous eyes and intense expressions. Then we'll take a look at how to draw the body and put it into some interesting poses. Let's get started!

Drawing the Head

I know it's tempting to dive in and start drawing the features of the face right away. After all, drawing those great eyes and the nose and mouth is the quickest way to see the face come to life. But it's also the fastest way to veer off course.

 If we start by drawing the outline of the head and sketching in guidelines to help place the features accurately, when we do add the features, everything will line up correctly. It only takes an extra moment to do it in this order.

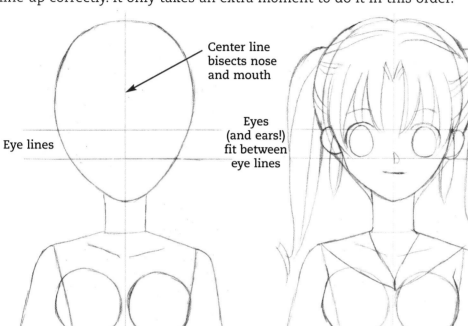

Center line bisects nose and mouth

Eye lines

Eyes (and ears!) fit between eye lines

Once you have the foundation in place, you can shade the eyes, fill in the hair, and add lots of details—all the fun stuff!

Front View

The front view is the simplest and most straightforward pose to start with. After you draw the basic head shape, add two horizontal eye lines and position the eyes and ears between them. Use a vertical center line to keep everything nice and symmetrical.

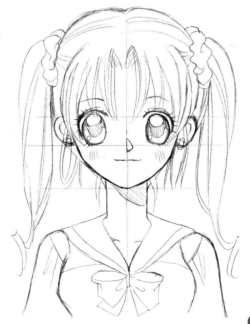

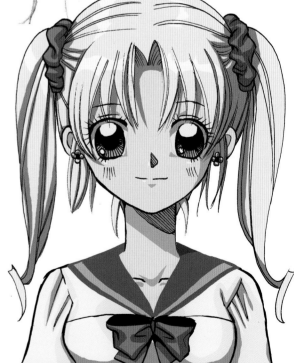

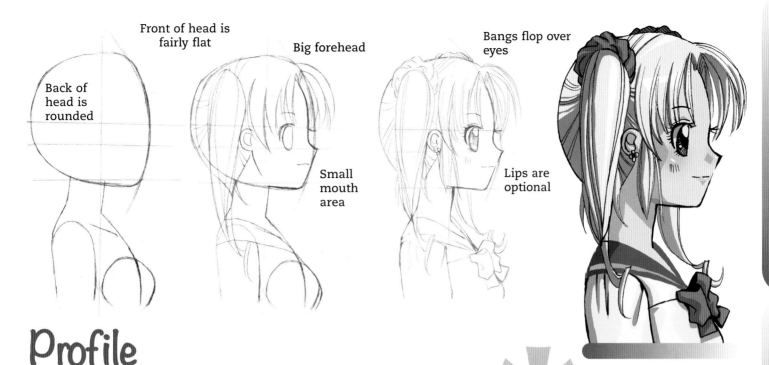

Back of head is rounded

Front of head is fairly flat

Big forehead

Small mouth area

Bangs flop over eyes

Lips are optional

Profile

In the side view, the front of the face flattens out considerably, but the forehead has a long, pleasing curve to it. The eye is deeply recessed in the head. The lips are usually not apparent in the side view, and the mouth is drawn as just a thin line.

Even in a profile or 3/4 view, the eyes and ears are still drawn within the eye lines.

Partial Profile

The center line is curved because it follows the contour of the head, which is round. The near eye is larger than the far eye, and the area of the face on the far side of the center line has less mass than the near side.

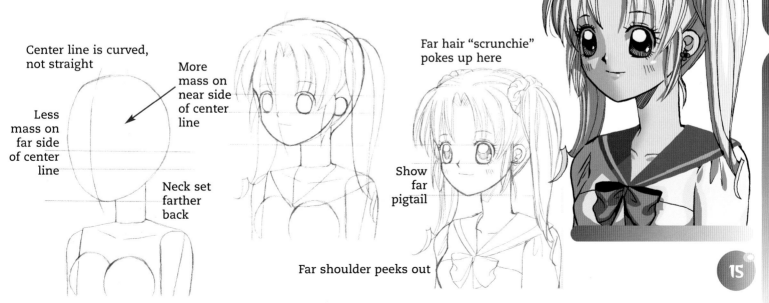

Center line is curved, not straight

More mass on near side of center line

Less mass on far side of center line

Neck set farther back

Far hair "scrunchie" pokes up here

Show far pigtail

Far shoulder peeks out

Beautiful Manga Hair

Manga girls are famous for their beautiful hair. It should always look plentiful, surrounding the head with generous amounts of waves, swirls, braids, pigtails and buns. Almost all manga girl hairstyles sport long bangs. Think of the hair as a beautiful frame for a canvas. Once you have drawn the face, don't place it in a cheap frame. Put it in the best frame possible. After all, it doesn't cost any extra. All it takes is a pencil!

Popular Hairdos

Here are a few trendy hairdos you can try on your characters to make sure they're in style.

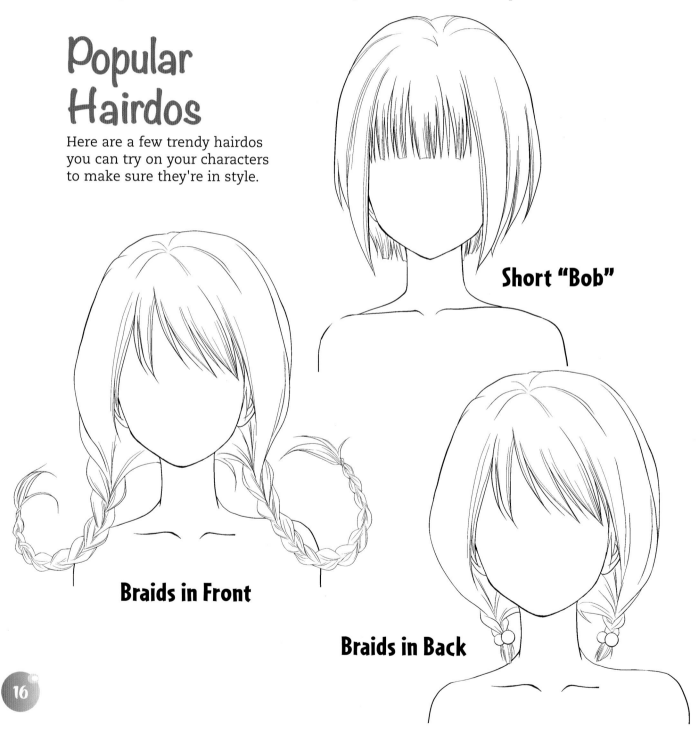

Short "Bob"

Braids in Front

Braids in Back

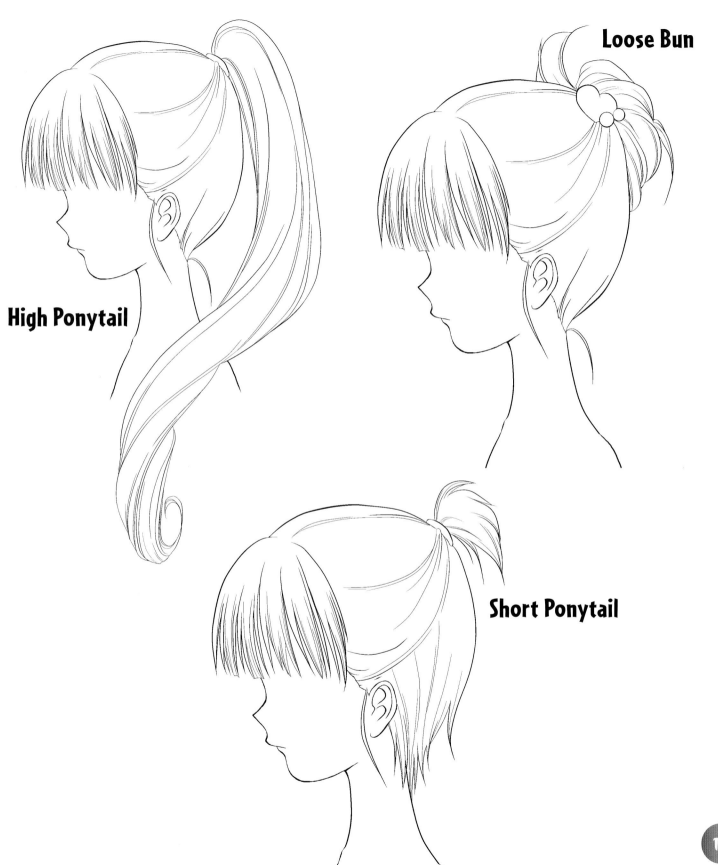

High Ponytail

Loose Bun

Short Ponytail

17

More Gorgeous Styles

Now let's add faces to the hair to get the full impact and glamour each style brings out. It's important to note that manga teens are drawn with more hair than actual people have—they have an idealized, fantasy version of perfect hair.

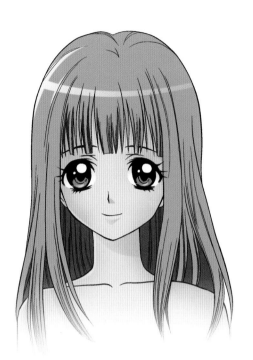

Long and Straight

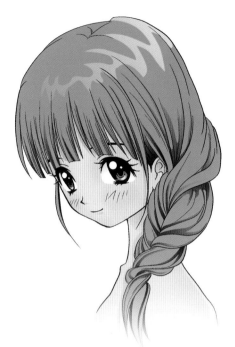

Single Thick Braid

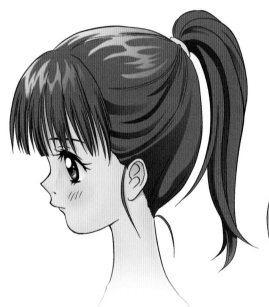

High, Unbraided Ponytail

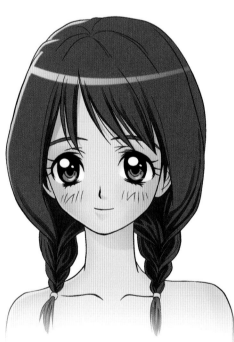

Short Braids

Face-framing Strands

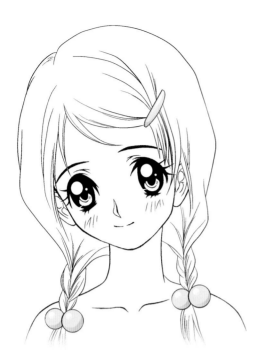

Clip and Beaded Hairbands

Flower Barrette

Accessorize!

When jewelry might be too showy, smaller hair accents like these ribbons, bows, and barrettes add sparkle to a character without going over the top. You can combine more than one accessory, like a barrette and a hairband, for some extra glamour.

Headband

Rose-and-Ribbon Barrette

Girls in Glasses

In manga, girls who wear glasses are never dorky. In fact, they're cool and stylish. Glasses are an accessory, just like jewelry. They make a statement. And you can create your own shapes of glasses to suit your character. Just don't skimp on the size of the lenses. Make them too small, and you'll give those gorgeous manga eyes a claustrophobic look.

Hint
When a character is turned in a profile, add lots of space between the lens and the eye.

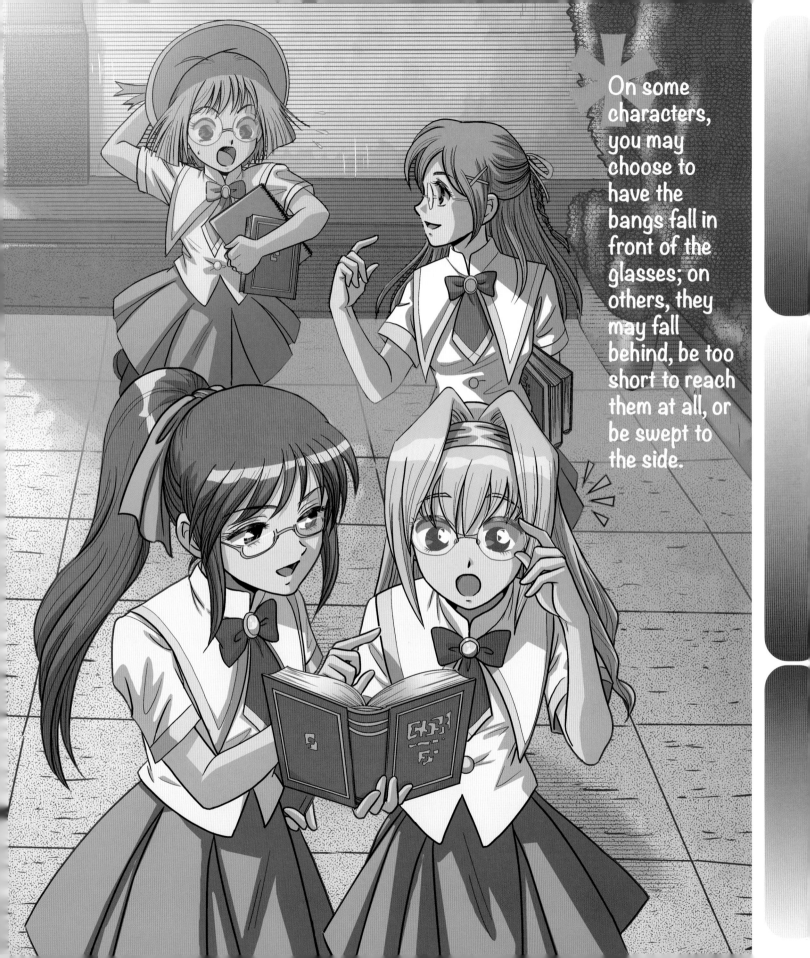

On some characters, you may choose to have the bangs fall in front of the glasses; on others, they may fall behind, be too short to reach them at all, or be swept to the side.

Drawing the Body

We're going to keep inventing new faces and heads of fabulous females, but now we're also going to draw bodies for them. Posing the same character at different angles is a great way to learn to draw the figure.

Front View

The key to drawing the front view is symmetry. Since everything can be seen clearly at this angle, both sides have to line up evenly. That's why it's a good idea to indicate guidelines for the body, as we did with the head. Draw horizontal sketch lines to line up the collarbone, waistline, and hips, and add a center line down the middle of the figure.

Torso Tricks

The torso is easiest to draw when you realize it's drawn in two sections (as in the first sketch at left): the upper half, where the rib cage is, and the lower half, which includes the hips.

Upper half of torso

Bottom half of torso

Legs start out wide at hips, then taper down toward feet

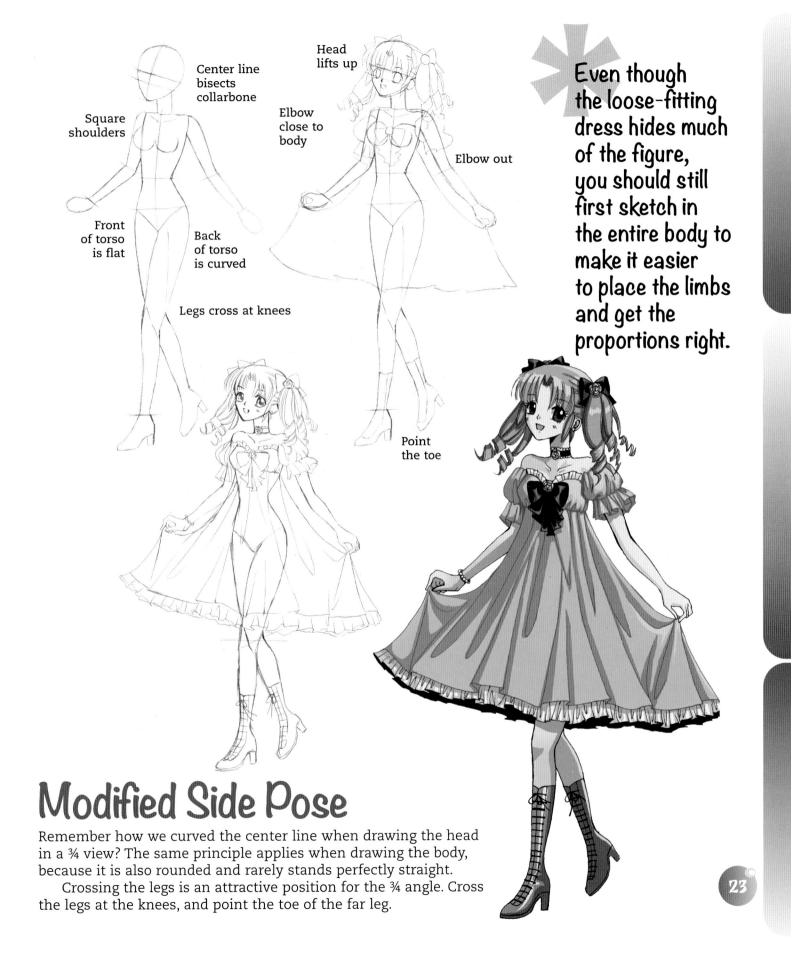

Center line
bisects
collarbone

Square
shoulders

Head
lifts up

Elbow
close to
body

Elbow out

Front
of torso
is flat

Back
of torso
is curved

Legs cross at knees

Point
the toe

Even though
the loose-fitting
dress hides much
of the figure,
you should still
first sketch in
the entire body to
make it easier
to place the limbs
and get the
proportions right.

Modified Side Pose

Remember how we curved the center line when drawing the head
in a ¾ view? The same principle applies when drawing the body,
because it is also rounded and rarely stands perfectly straight.

Crossing the legs is an attractive position for the ¾ angle. Cross
the legs at the knees, and point the toe of the far leg.

23

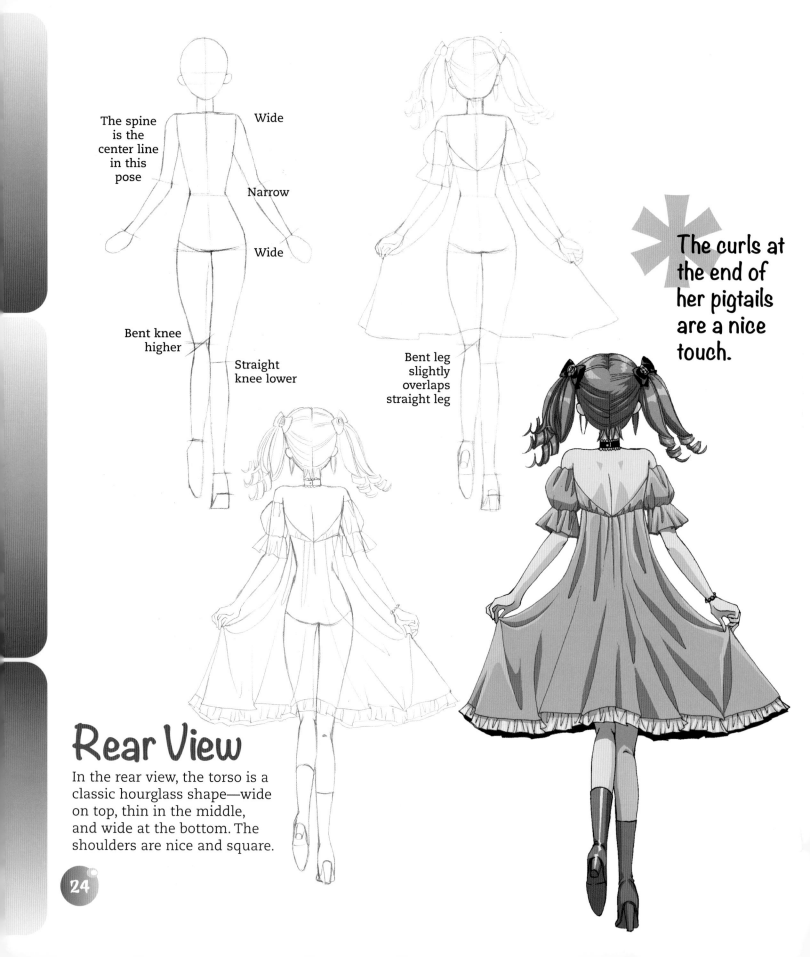

The spine is the center line in this pose

Wide

Narrow

Wide

Bent knee higher

Straight knee lower

Bent leg slightly overlaps straight leg

The curls at the end of her pigtails are a nice touch.

Rear View

In the rear view, the torso is a classic hourglass shape—wide on top, thin in the middle, and wide at the bottom. The shoulders are nice and square.

Figure Poses

Drawing your character in different poses may be challenging at first, but once you master these poses, drawing the standard ones will be a breeze. You don't have to copy these poses exactly the way you see them here. Experiment and personalize them. That way, you'll not only be learning from this book, but you'll also be developing your creativity.

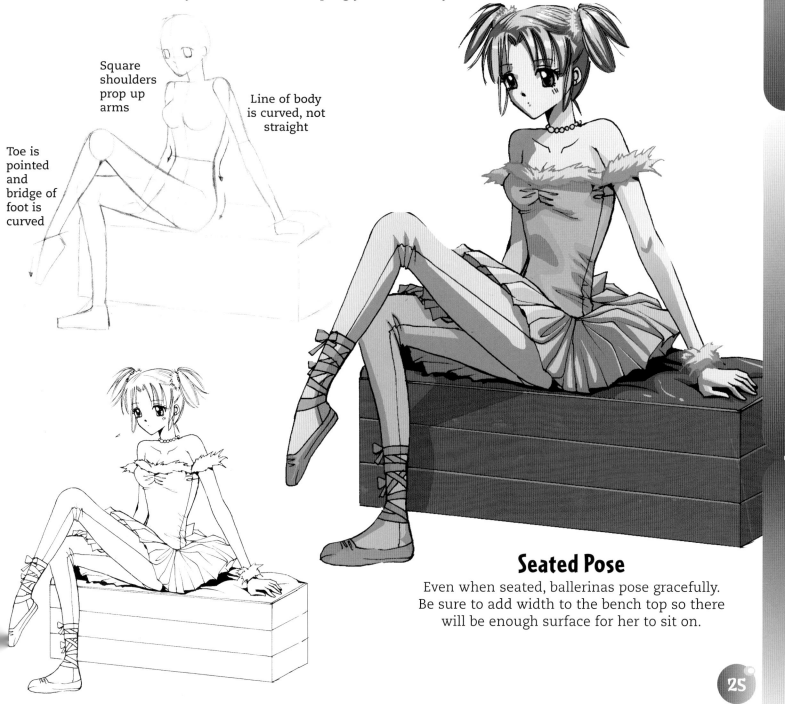

Square shoulders prop up arms

Line of body is curved, not straight

Toe is pointed and bridge of foot is curved

Seated Pose

Even when seated, ballerinas pose gracefully. Be sure to add width to the bench top so there will be enough surface for her to sit on.

Give Me an M—for Manga!

The cheerleader is the alpha girl, right at the top of the pack. Everyone wants to be her friend. This means that others are also plotting against her. Let's take a look at a classic cheerleading pose.

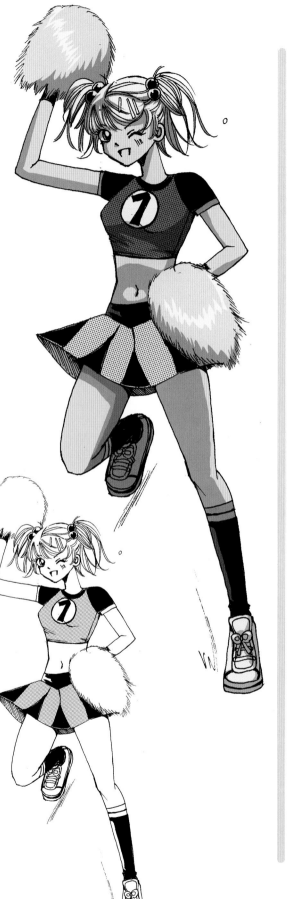

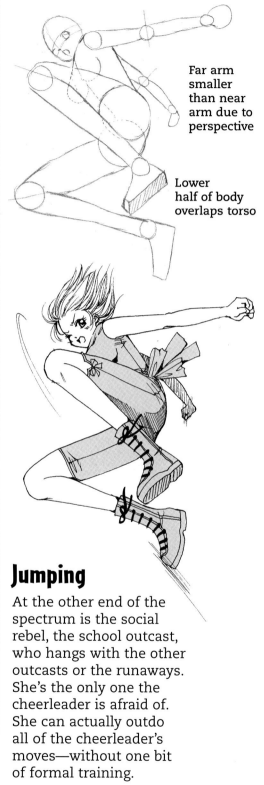

Far arm smaller than near arm due to perspective

Lower half of body overlaps torso

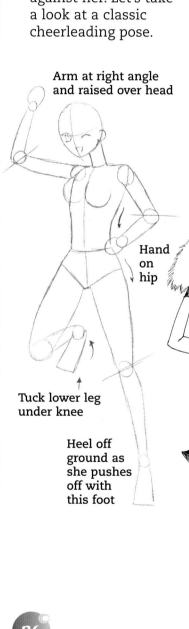

Arm at right angle and raised over head

Hand on hip

Tuck lower leg under knee

Heel off ground as she pushes off with this foot

Jumping

At the other end of the spectrum is the social rebel, the school outcast, who hangs with the other outcasts or the runaways. She's the only one the cheerleader is afraid of. She can actually outdo all of the cheerleader's moves—without one bit of formal training.

Knees up at chest level

Show far thigh

Show a bit of far arm

Hips curve in

Hands out far, to add stability

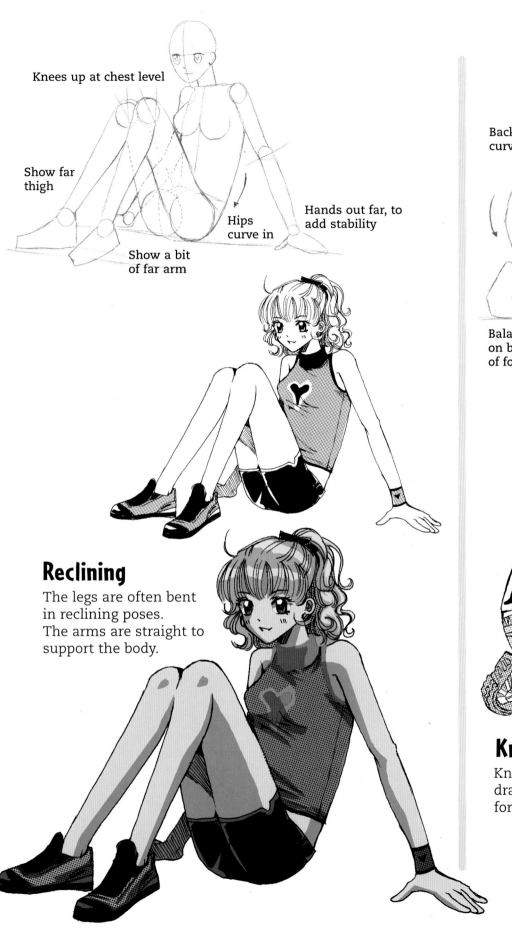

Reclining

The legs are often bent in reclining poses. The arms are straight to support the body.

Back is curved

Knee at chest level

Balances on ball of foot

Leave open space here

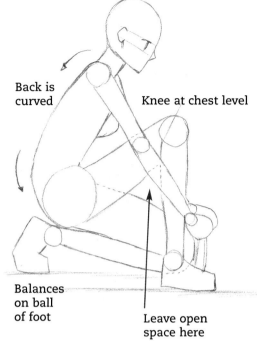

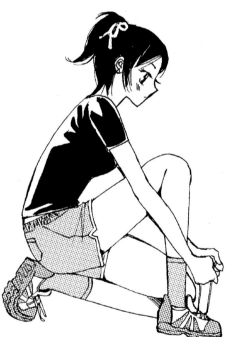

Kneeling

Kneeling poses are usually drawn with the body curved forward to maintain balance.

On the Move!

Now we'll take it a step further and go from drawing the body standing still to actual motion poses. The most useful motion poses to learn are those that occur most frequently in stories: walking and running. Running is much more than a fast version of walking. Each gait has its own dynamics.

Walking: Front View

The key to this pose is to place one foot directly in front of the other. We'll still be able to see the back leg, because the width of the hips pushes it outward.

Hint

In this pose, the front leg that is coming forward actually aligns with the neck!

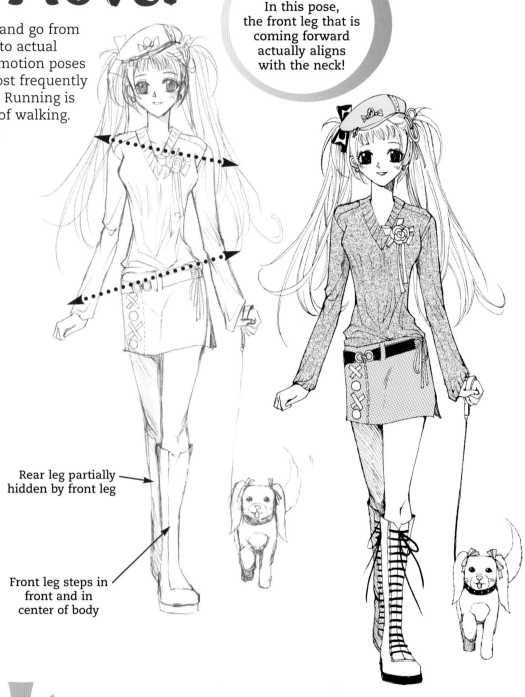

Rear leg partially hidden by front leg

Front leg steps in front and in center of body

The arrows show the direction in which the shoulders and hips must be tilted to give the illusion of motion.

Walking: Side View

When we walk, we swing our arms. However, we can cheat a little to create a feminine look for our characters. When they walk, their arms aren't going to swing very much at all. In fact, they are going to stay mainly at their sides, and even drag behind their torso a bit.

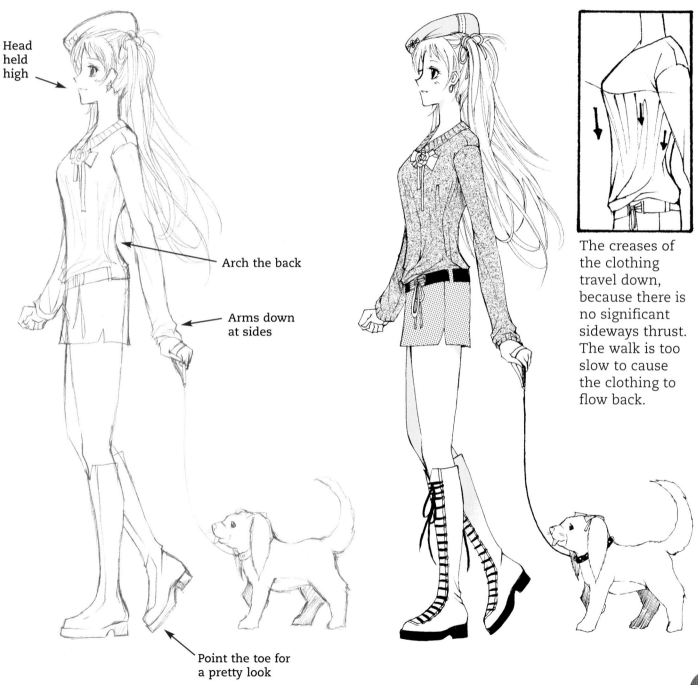

Head held high

Arch the back

Arms down at sides

Point the toe for a pretty look

The creases of the clothing travel down, because there is no significant sideways thrust. The walk is too slow to cause the clothing to flow back.

Drawing Hands and Feet

Now that we have the basics of drawing the head and body covered, let's zoom in and take a look at the hands and feet. Many artists find drawing hands and feet difficult, but with a few tips and tricks, you'll get a "hand"-le on them in no time! (Sorry, I couldn't resist.)

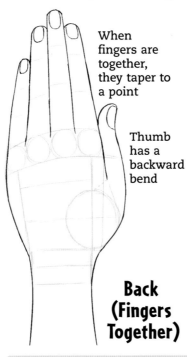

When fingers are together, they taper to a point

Thumb has a backward bend

Back (Fingers Together)

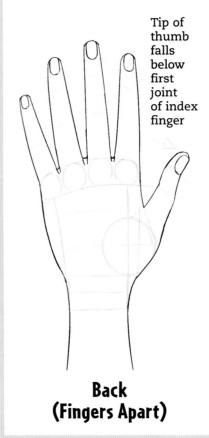

Tip of thumb falls below first joint of index finger

Back (Fingers Apart)

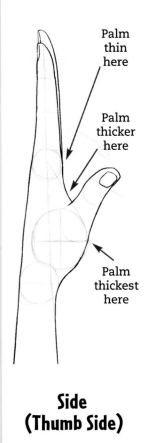

Palm thin here

Palm thicker here

Palm thickest here

Side (Thumb Side)

Hands: The Basics

Draw female hands so that they have a delicate quality. Tapered fingers, a wide palm, and a small wrist work best. Don't use big marks to indicate the knuckles, or you'll make the hands look too masculine. And just indicate where the joints occur with a light line—don't add wrinkles.

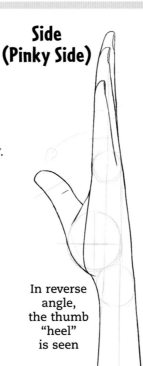

Side (Pinky Side)

In reverse angle, the thumb "heel" is seen

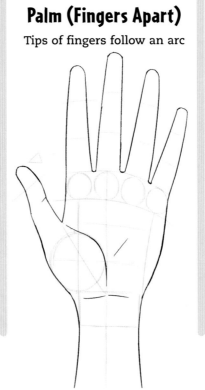

Palm (Fingers Apart)

Tips of fingers follow an arc

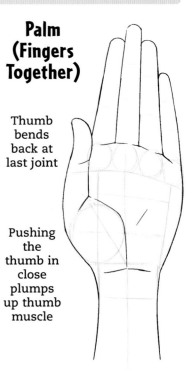

Palm (Fingers Together)

Thumb bends back at last joint

Pushing the thumb in close plumps up thumb muscle

Hand Gestures

The hands are very flexible. Even straight fingers aren't always perfectly straight, but can curve backward when pointing. Try to vary the finger placement for variety; don't draw them all in a perfect row. That would be too boring for manga!

Reaching (Up Angle)

Reaching (3/4 View)

Reaching (Down Angle)

Pointing

Victory Sign

Claw Hand (Angry)

Fist (Front View)

Fist (Side View–Thumb Side)

Fist (Side View–Pinky Side)

Pointing (Rear View)

Fingers Curled (Frightened)

Feet: The Basics

These are all the basic positions you'll ever need to know in order to draw the foot. Unlike the hand, the foot is not an expressive part of the body. We're more concerned with just making it look right. And to do that, there are a few specific areas of the foot we need to identify and be sure to include in our drawings.

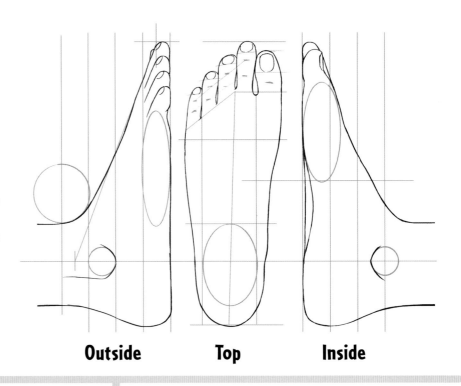

Outside **Top** **Inside**

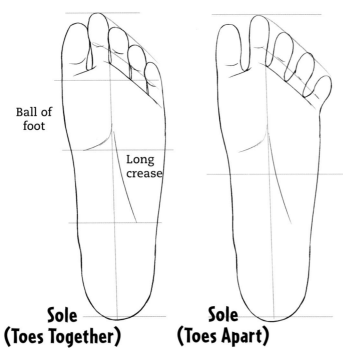

Ball of foot

Long crease

Sole (Toes Together) **Sole (Toes Apart)**

The toes can spread apart, but not that much. They have very little dexterity, unlike the fingers.

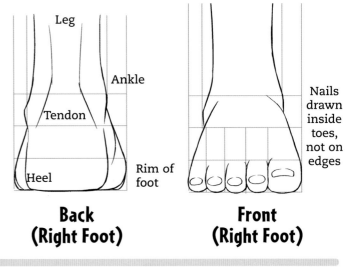

Leg

Ankle

Tendon

Heel

Rim of foot

Nails drawn inside toes, not on edges

Back (Right Foot) **Front (Right Foot)**

Toe Tips

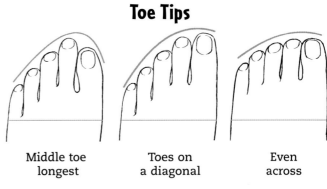

Middle toe longest Toes on a diagonal Even across

Foot Poses

Although the feet are not as expressive as the hands, you do need to be able to draw them at different angles.

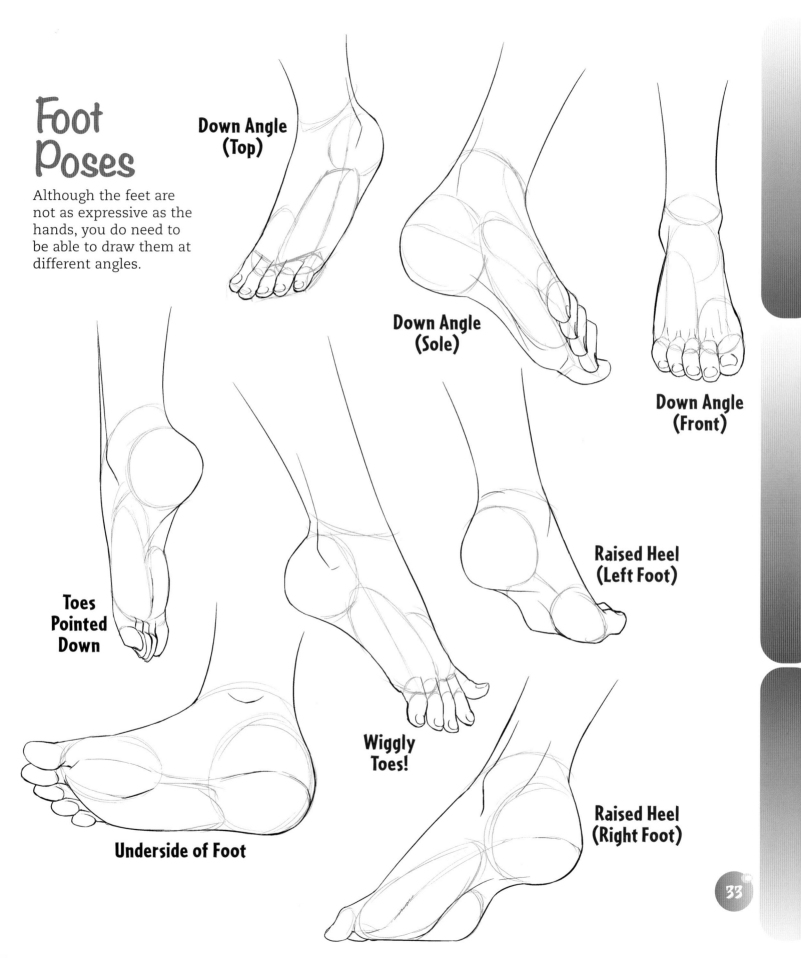

Down Angle (Top)

Down Angle (Sole)

Down Angle (Front)

Toes Pointed Down

Raised Heel (Left Foot)

Wiggly Toes!

Underside of Foot

Raised Heel (Right Foot)

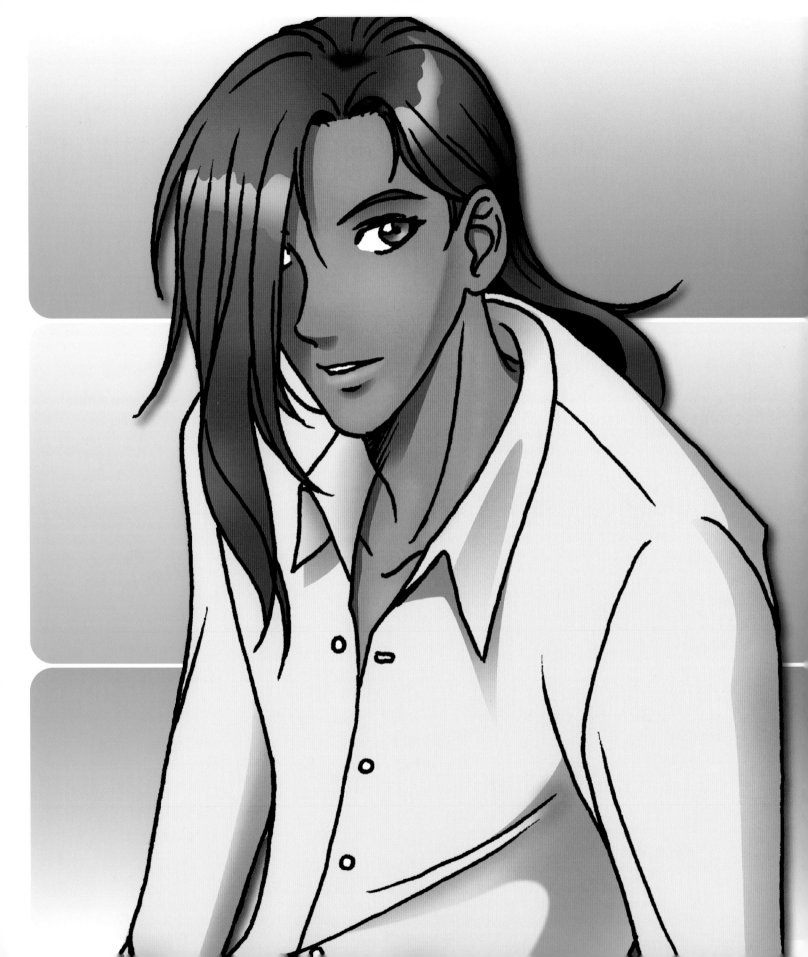

THE BASICS
Bishie Boys

Bishies are the teen boys of manga that are in all the romance graphic novels. These guys have caused more than their fair share of broken hearts. The bishie boy is self-confident but unable to commit. He's somewhat aloof, troubled, and mysterious—in other words, "Mr. Wrong," which is why he's a great dramatic character in teenage love stories.

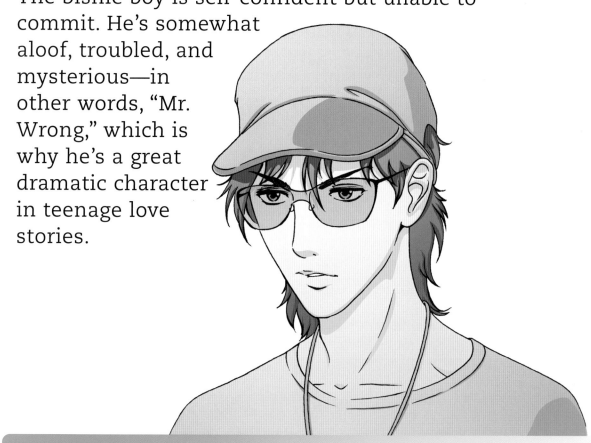

The Bishie's Head

In the romance genre of manga, the bishie is drawn with a very distinct look, and his head is more mature than the girl's. The proportions and the features are also different. Let's take a look at the individual differences that give him a more virile, and some would say slightly dangerous, persona.

Short-Haired Bishie

This bishie sports a short haircut, but the short sketch lines give it a soft look. This version of a bishie's face is drawn with an angular jaw line. However, since the features are all delicate (a must for bishies), the angularity doesn't make him look unduly rugged, which would ruin the effect.

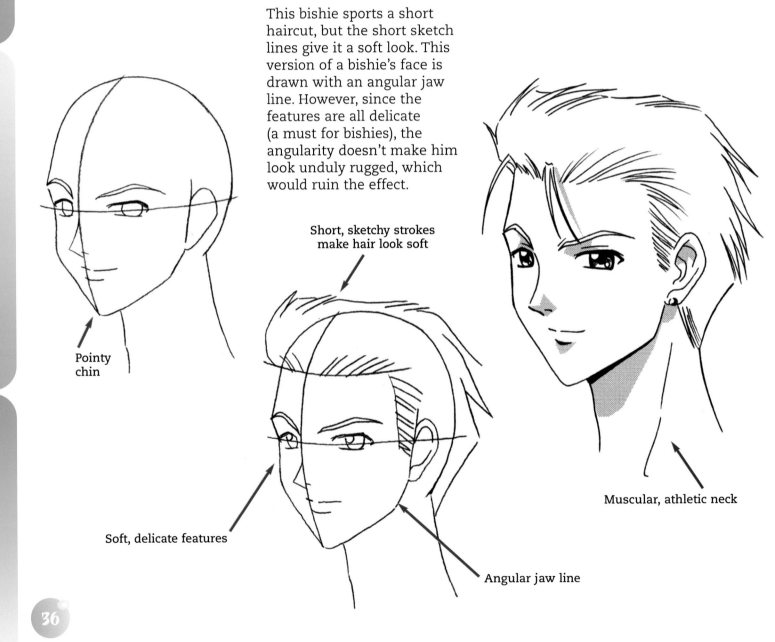

Pointy chin

Short, sketchy strokes make hair look soft

Soft, delicate features

Angular jaw line

Muscular, athletic neck

Classic Long-Haired Bishie

Another type of bishie has a face with a softer, less angular outline. He has a more androgynous look and is drawn with long hair.

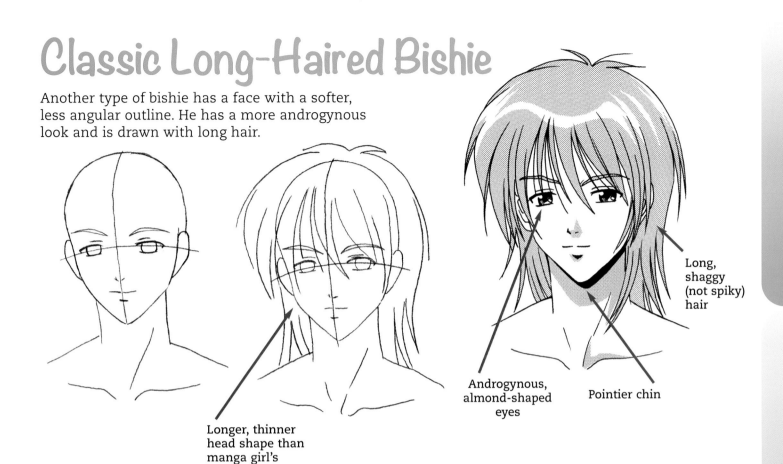

Longer, thinner head shape than manga girl's

Androgynous, almond-shaped eyes

Pointier chin

Long, shaggy (not spiky) hair

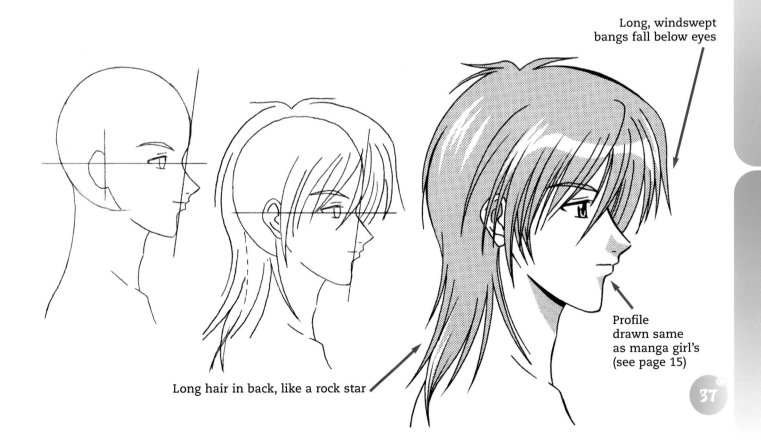

Long hair in back, like a rock star

Long, windswept bangs fall below eyes

Profile drawn same as manga girl's (see page 15)

Young Teen Bishie

While the romance genre tends to feature 12- to 17-year-old girls, most bishie boys appear to be older, even if they are meant to be their classmates. They usually look like they're 17 to 19 years old—even as old as 21. However, younger-looking bishies like this one are not uncommon.

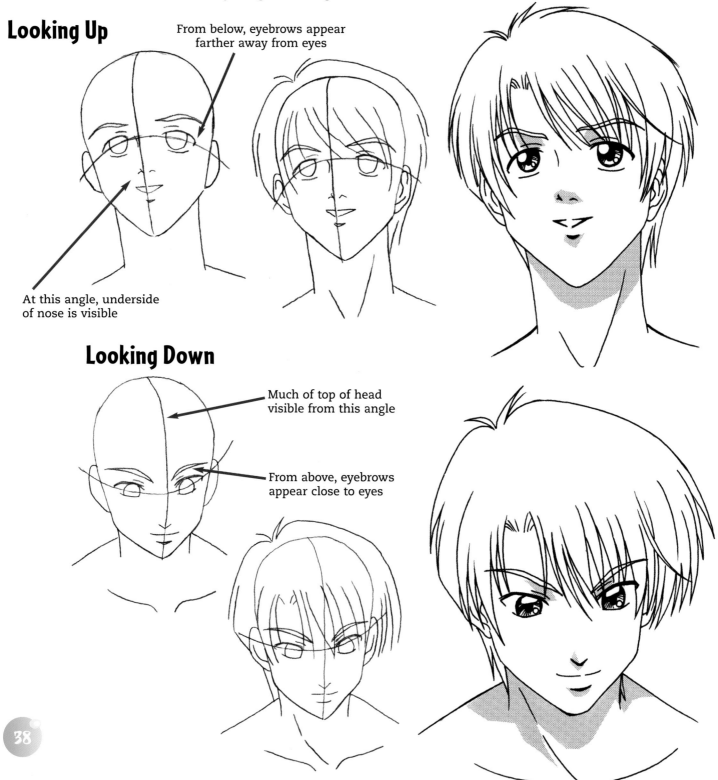

Looking Up

From below, eyebrows appear farther away from eyes

At this angle, underside of nose is visible

Looking Down

Much of top of head visible from this angle

From above, eyebrows appear close to eyes

Confident Bishie

For this bishie, we'll start with a generic head outline. Step by step we'll carve different angles from the outline until it takes on the recognizable shape of a bishie.

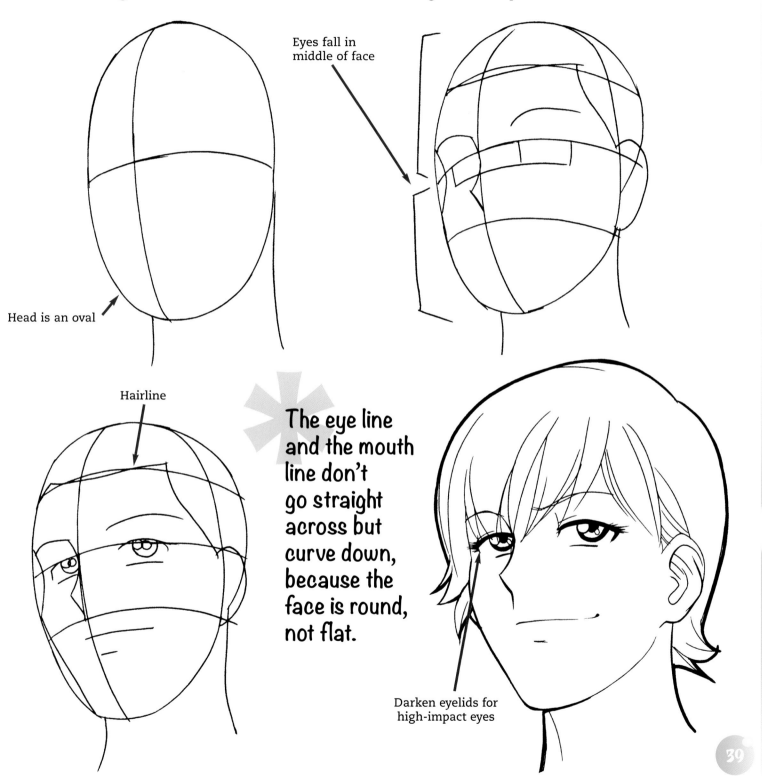

Head is an oval

Eyes fall in middle of face

Hairline

The eye line and the mouth line don't go straight across but curve down, because the face is round, not flat.

Darken eyelids for high-impact eyes

39

Intense Bishie

While bishies are usually reserved, they can display a full range of emotions if the situation calls for it. But you have to get them to the boiling point to see it!

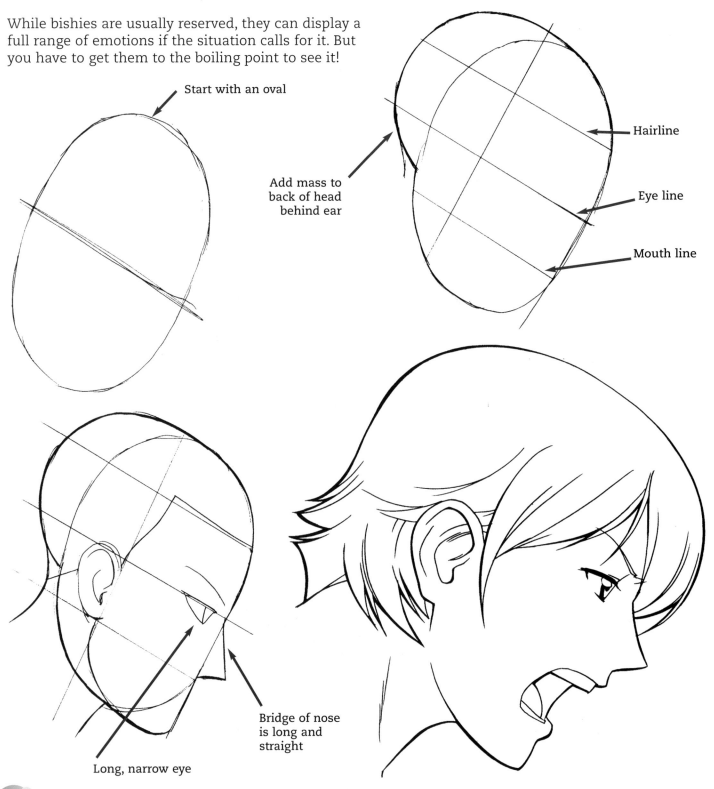

Start with an oval

Add mass to back of head behind ear

Hairline

Eye line

Mouth line

Long, narrow eye

Bridge of nose is long and straight

Bishie Character Designs

The bishie head has a signature look that needs to be locked into place before you draw the features. Here, I've highlighted the construction step in blue so you can see the commonalities in the character designs.

Classic Bishie: Front View

The classic bishie head is an egg shape that has been adjusted so the chin comes to a delicate point.

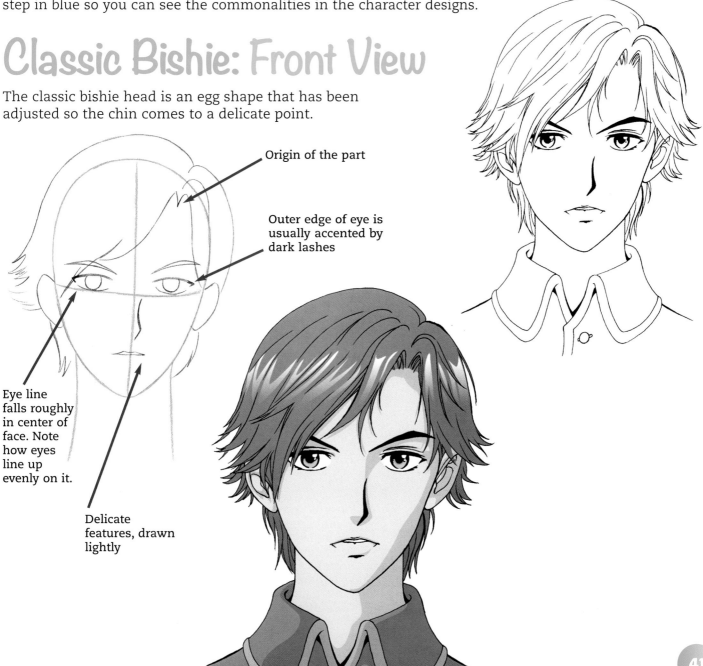

Origin of the part

Outer edge of eye is usually accented by dark lashes

Eye line falls roughly in center of face. Note how eyes line up evenly on it.

Delicate features, drawn lightly

Trendy Bishie: Side View

Here's a snapshot of a classic bishie look—quiet self-reflection. As shown by the unfocused gaze, this stylish bishie is an introspective character.

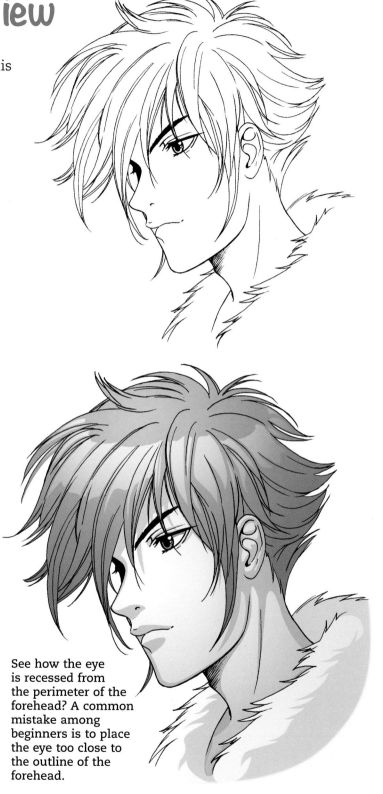

Huge hair in front and in back

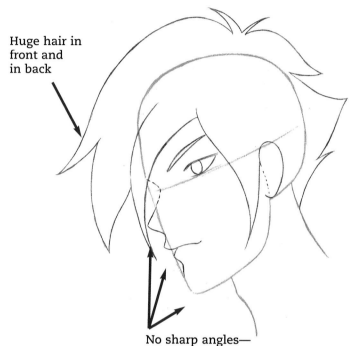

No sharp angles— all subtle contours

Back to Basics

If your drawing starts to go wrong, go back to the basic construction. Are the eyes aligned evenly? Is the eye line positioned roughly in the middle of the face? Try to take an objective look at your drawing rather than a disapproving one, and you'll see much more easily how to correct it. And besides, give yourself a break—we all make mistakes. If we didn't, it would mean we weren't taking any artistic risks, and therefore we would never grow.

See how the eye is recessed from the perimeter of the forehead? A common mistake among beginners is to place the eye too close to the outline of the forehead.

Adult Bishie: 3/4 View

This young adult represents roughly the upper age limit for bishies in the romance genre. There are plenty of adult-looking bishies in other genres, including action and the occult.

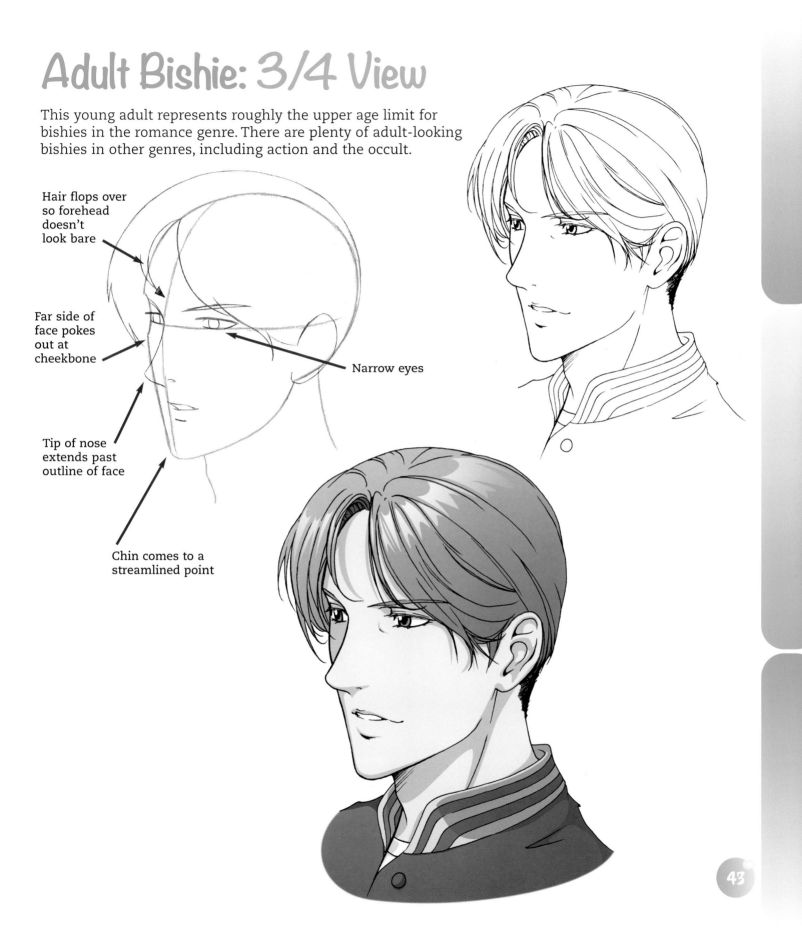

Hair flops over so forehead doesn't look bare

Far side of face pokes out at cheekbone

Narrow eyes

Tip of nose extends past outline of face

Chin comes to a streamlined point

Guys With Glasses

A popular subgenre of bishies, especially in Japan, is bishies with glasses. It's a fashion statement that lends a sophisticated air to the character—a trendy "Euro" look. While glasses give young manga teens a nerdy quality, these bishies are the epitome of cool.

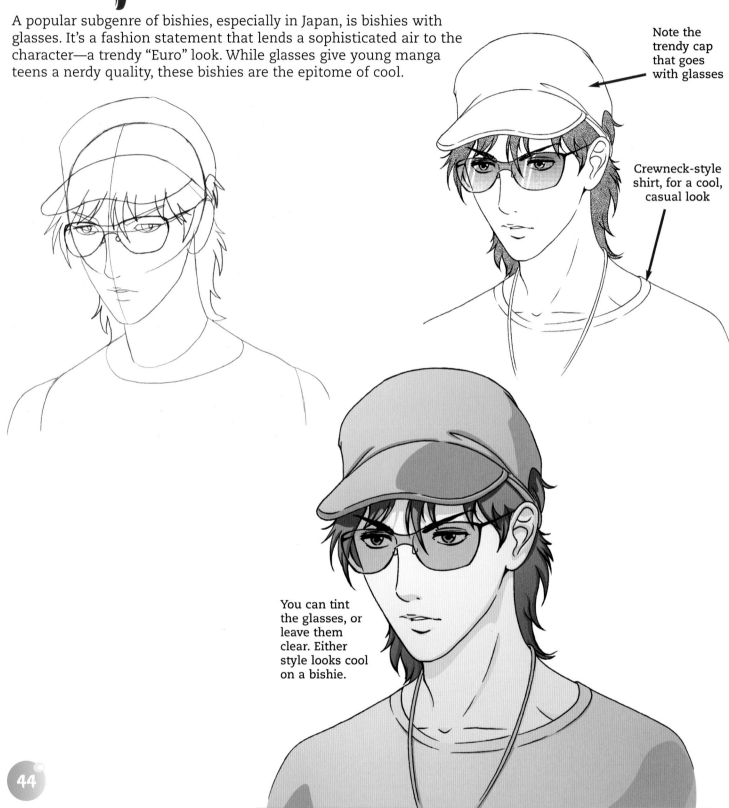

Note the trendy cap that goes with glasses

Crewneck-style shirt, for a cool, casual look

You can tint the glasses, or leave them clear. Either style looks cool on a bishie.

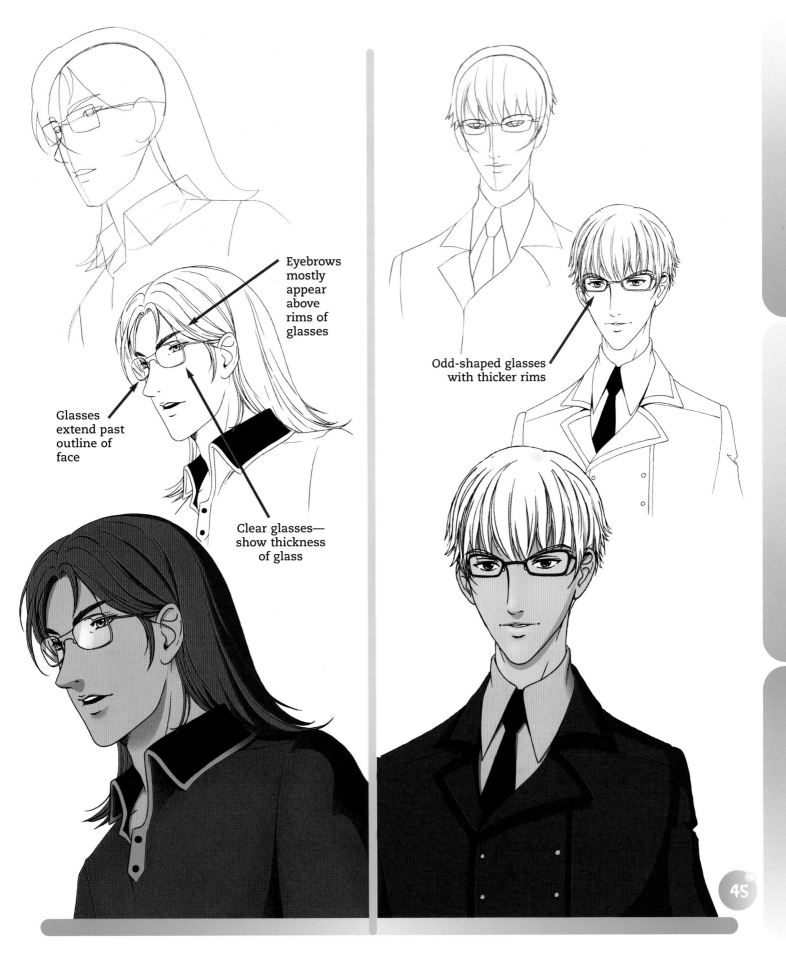

Eyebrows mostly appear above rims of glasses

Glasses extend past outline of face

Clear glasses— show thickness of glass

Odd-shaped glasses with thicker rims

Bishie Bodies

The typical bishie is long, lean and tall. His shoulders are broad, but the rest of his body is thin and lanky. He's got the classic "swimmer's" build.

Standing Poses

It's tempting when drawing a long-legged character to pose him stiffly. But it's the long-legged characters who need to be posed in a relaxed asymmetrical stance. These poses look natural because legs don't "mirror" each other.

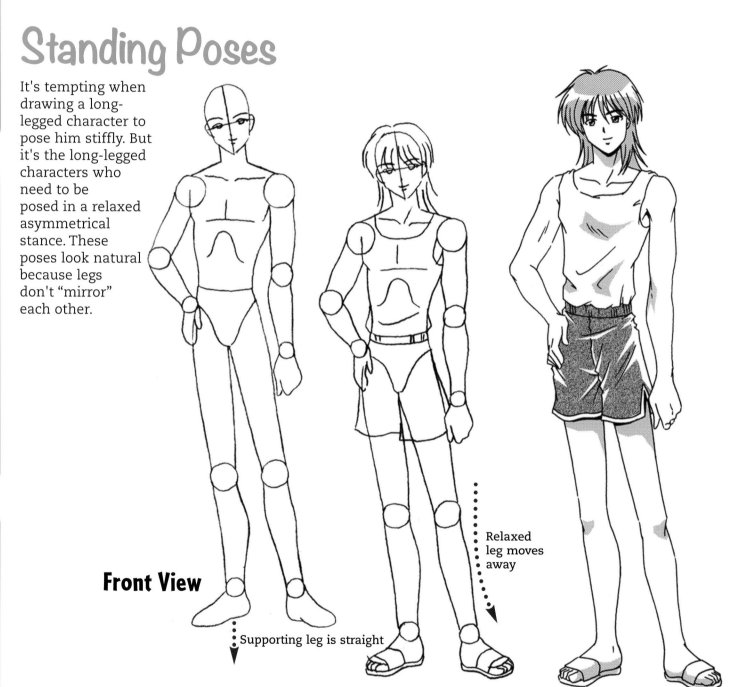

Front View

Supporting leg is straight

Relaxed leg moves away

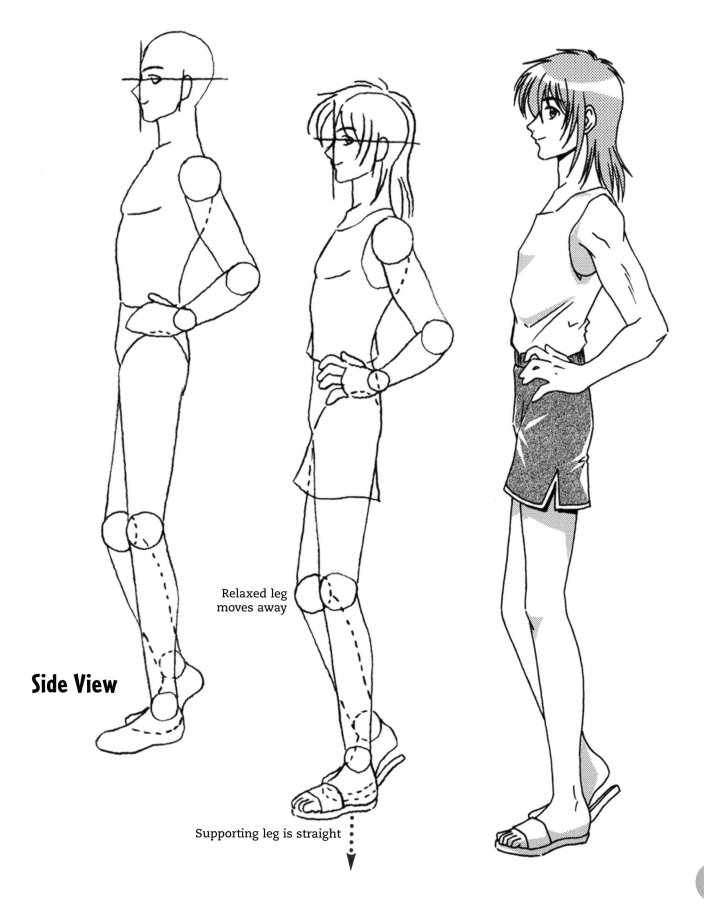

Side View

Relaxed leg moves away

Supporting leg is straight

Arm Positions

One of the questions that puzzle beginning artists when drawing a standing pose is "What am I going to do with the arms?" The arms often frustrate beginners who get too ambitious. They give the character a sandwich to hold, or a ball to toss in the air.

While that's okay, be careful not to make your character look conspicuously busy. It's often better to simply position the arms as if he were waiting for someone while standing in line. It's that simple. He doesn't have to be doing anything specific with his arms or hands.

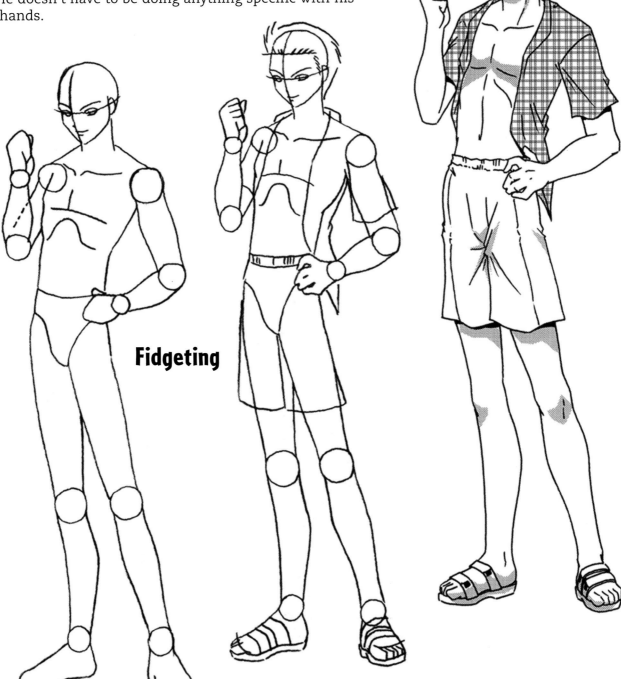

Fidgeting

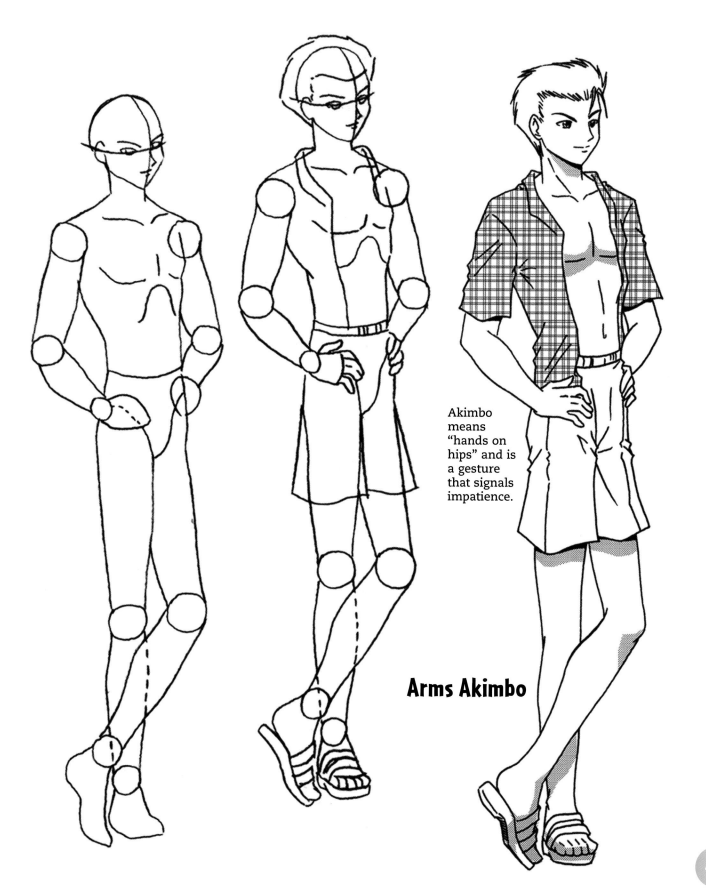

Akimbo means "hands on hips" and is a gesture that signals impatience.

Arms Akimbo

Body Angles

Just like the head, the body can be drawn at extreme angles, although this takes a little more concentration and is used less frequently. Using "up" and "down" angles creates a definite point of view on the reader's part and assists in the storytelling.

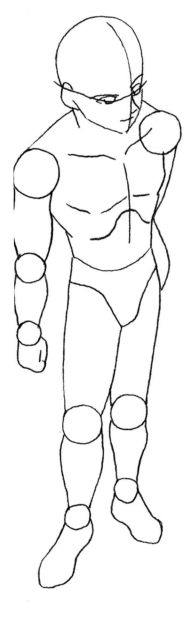

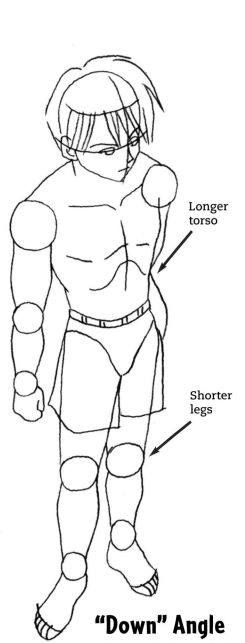

Longer torso

Shorter legs

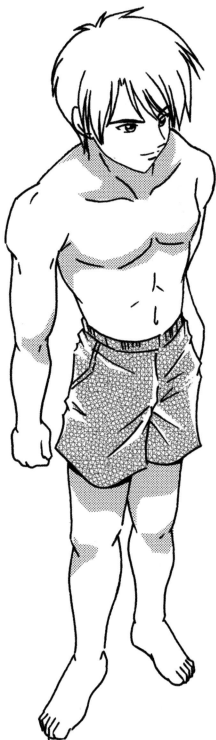

"Down" Angle

This angle is used when we are observing a person who is lonely, helpless, or isolated.

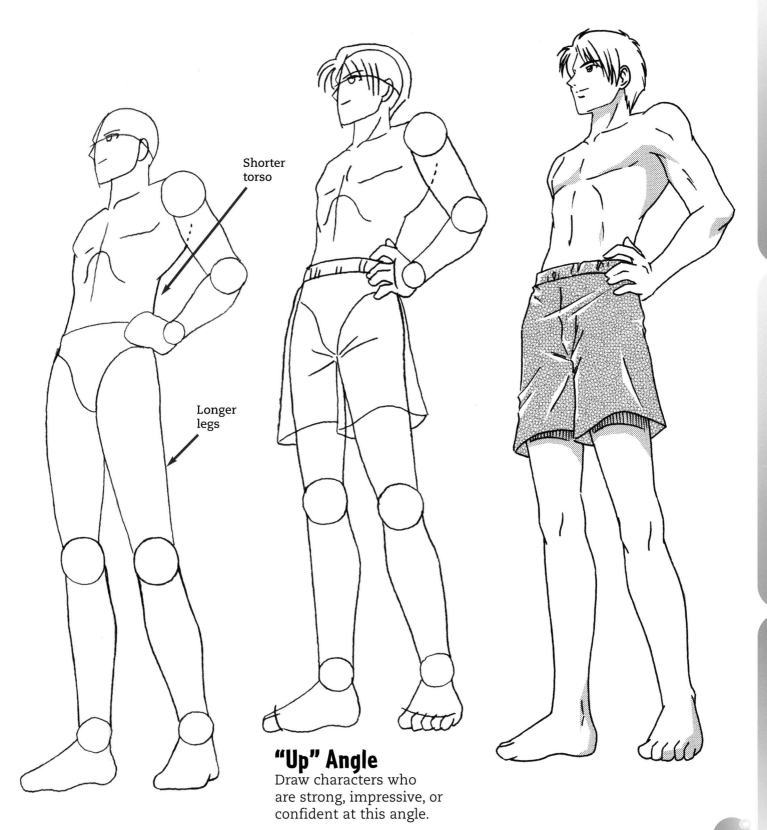

Shorter
torso

Longer
legs

"Up" Angle
Draw characters who
are strong, impressive, or
confident at this angle.

Bishies in Motion

The bishie always walks with an air of cool confidence. And as he goes past, the interested girls try to work up the courage to talk to him!

The Walk: Front View

When we draw a boy walking toward us, we keep the legs slightly apart at all times. Draw him with a relaxed posture bent slightly at the waist. No chest-out proud pose. He's not out to save the world, just to meet girls.

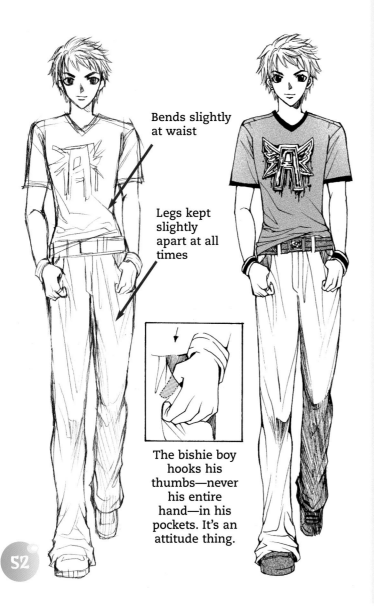

Bends slightly at waist

Legs kept slightly apart at all times

The bishie boy hooks his thumbs—never his entire hand—in his pockets. It's an attitude thing.

The Walk: Side View

It's especially easy to draw his side-view walk, because the arms remain in this same position no matter what the legs are doing.

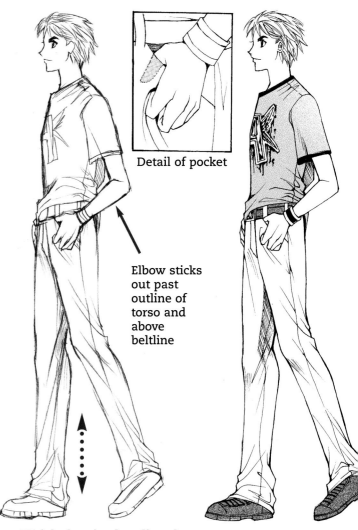

Detail of pocket

Elbow sticks out past outline of torso and above beltline

Weight-bearing leg aligned with center of body

Fast Run: Front View

The faster the run, the more the character will lean forward into the movement. There are two ways to make a running character look like he's leaning forward.

The first technique is obvious: Draw him bending at the waist. The second is subtler, but just as important. Position his head low on his shoulders, thereby eliminating his neck.

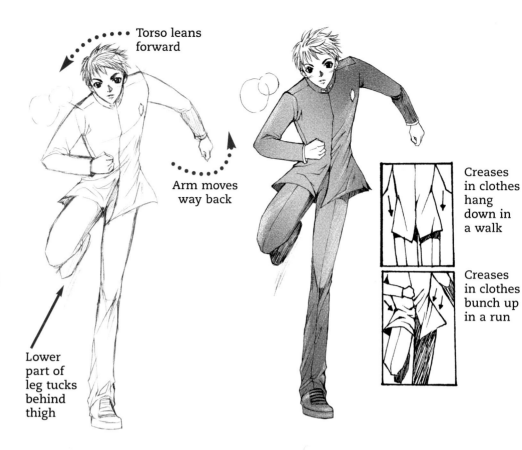

Torso leans forward

Arm moves way back

Lower part of leg tucks behind thigh

Creases in clothes hang down in a walk

Creases in clothes bunch up in a run

Fast Run: Side View

In order to avoid a flat look, twist the character's torso as he runs. It has the effect of turning him from a flat side view into a three-dimensional 3/4 view, and it makes him look like he's really digging into the action.

Torso "corkscrews" along center line

Entire body drawn on a diagonal

Folds in pant leg hang down in a walk

Folds in pant leg are drawn diagonally in a run

Bishie Poses

Here are a couple of bishie boy characters in full–body shots and in different poses. As you pose them, notice the attitude shared by almost all bishies: "restrained cool." No, they never get charged up about anything. They are introverts, and their body language contributes to their brooding, mysterious personae. There's always a distant look in their eyes that makes girls want to conquer them. But alas, it can't be done.

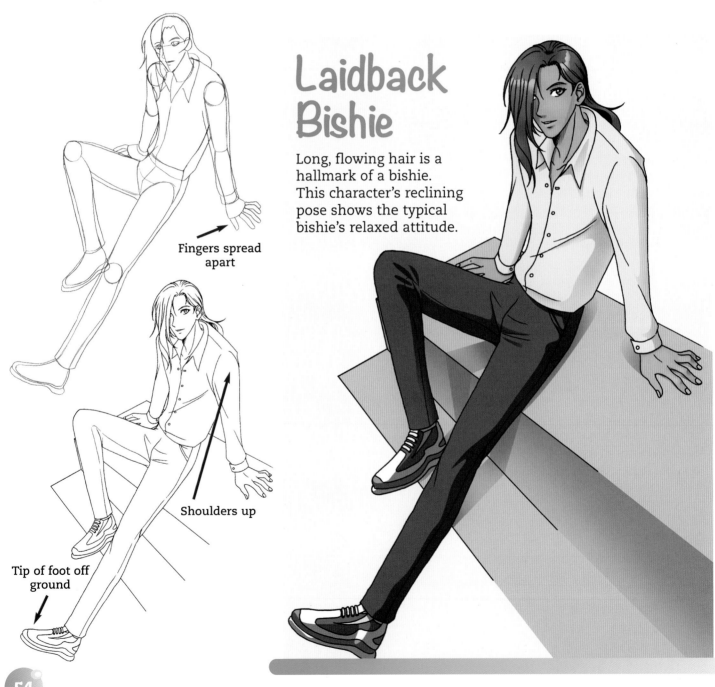

Fingers spread apart

Shoulders up

Tip of foot off ground

Laidback Bishie

Long, flowing hair is a hallmark of a bishie. This character's reclining pose shows the typical bishie's relaxed attitude.

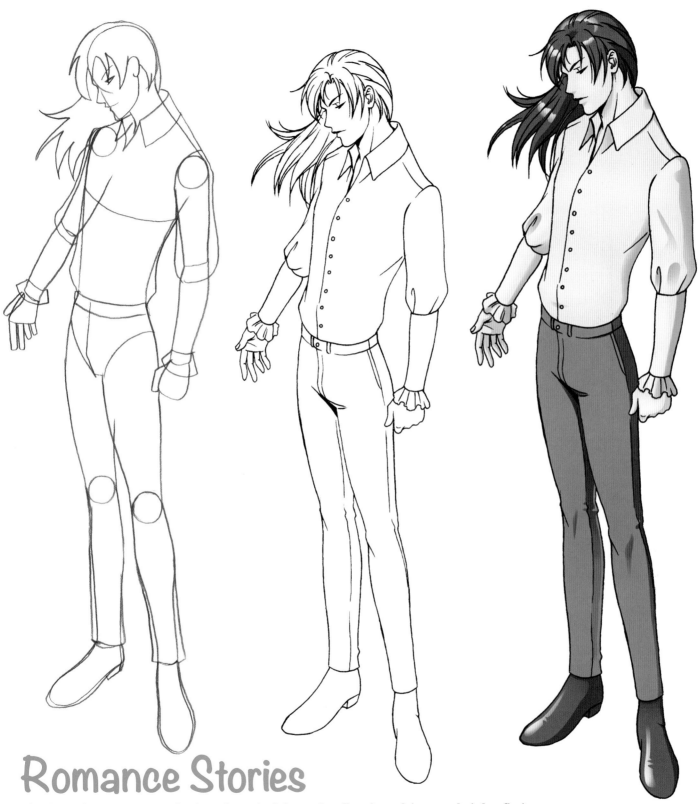

Romance Stories

Bishies often wear semi-Victorian clothing. The flowing shirts and tight-fitting pants, combined with the bishie's flowing hair make them popular in dramatic stories.

SHONEN BASICS
Drawing the Head & Body

Before we rush headlong into designing cool action characters, we need to take a step back and look at the basics of the shonen style. In this chapter, we'll draw, step by step, the heads of the most popular shonen characters, including the good guys we like to root for and the not-so-nice characters we love to hate. We'll also learn how to draw eyes that express the excitement and urgency of this action-packed style.

Action Boy

This young hero is a star of shonen manga. He fights every type of bad guy, and even monsters. He is often surprisingly young for a character with so much riding on his victory, but making him look slightly underpowered is a surefire way to get the readers' attention, because it leads them to ask, "How in the world is he going to survive the match?!" But of course he will. He'll get knocked down a few times, then gather all the strength he can muster and attack with blinding fury.

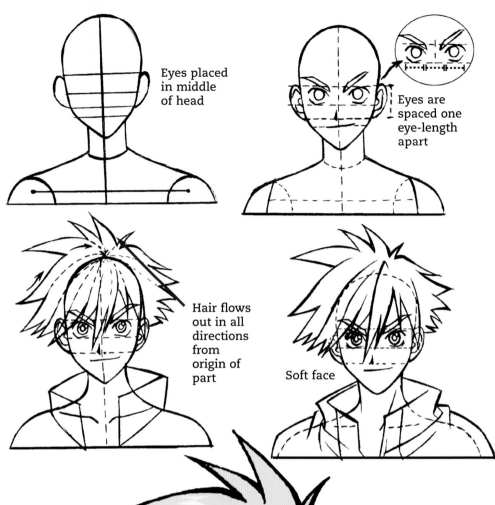

Eyes placed in middle of head

Eyes are spaced one eye-length apart

Hair flows out in all directions from origin of part

Soft face

From Rough Sketch to Finished Art

Throughout this book, you'll see several different styles of artwork: rough pencils, final pencils, inks, gray tones and color art. Generally, a manga artist first blocks out a scene in pencil, then refines it to create a final pencil drawing. The inking is done by hand, right over the pencil lines. Most manga graphic novels are printed in gray tones, which can be created on a computer or shaded by hand. Anime (animated manga) is usually in color.

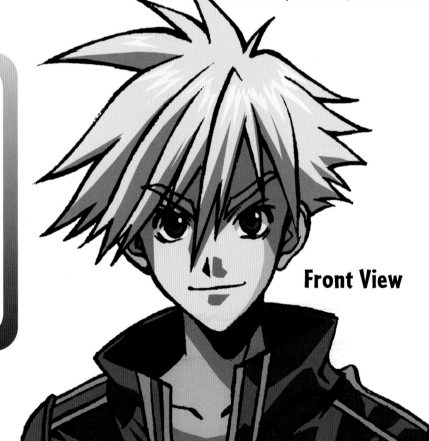

Front View

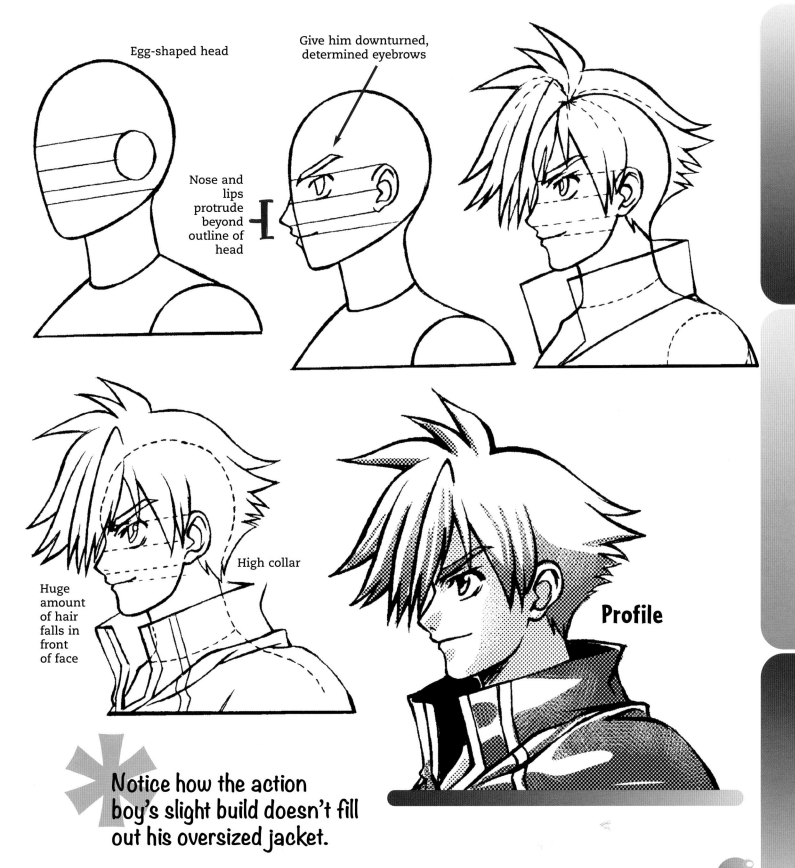

Egg-shaped head

Give him downturned, determined eyebrows

Nose and lips protrude beyond outline of head

Huge amount of hair falls in front of face

High collar

Profile

Notice how the action boy's slight build doesn't fill out his oversized jacket.

Teen Enemy

He's somewhat older and more mature than the action boy. His face is longer and thinner, with a chin that comes to a point. His eyes are not as round and are more of an almond shape—a sign of evil. And he wears that scar on his face like a badge of honor. Of course you can't trust his smile, but you have to admit he's got a roguish charisma.

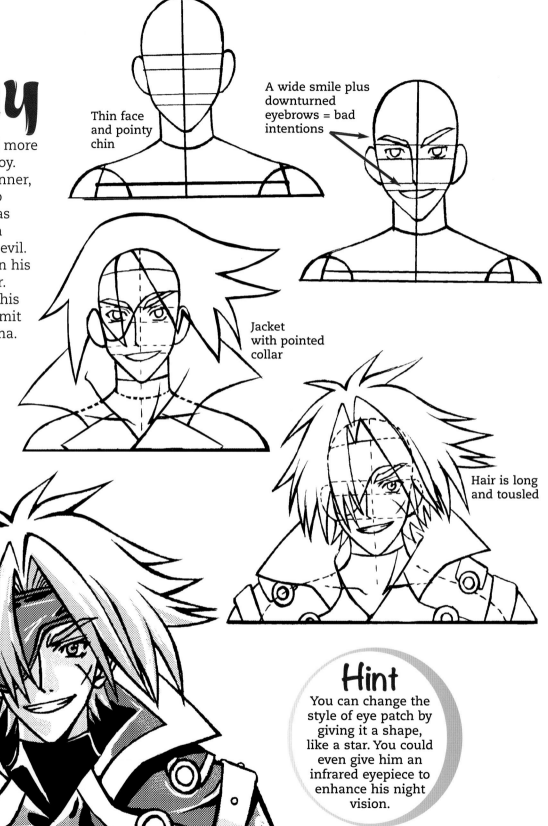

Thin face and pointy chin

A wide smile plus downturned eyebrows = bad intentions

Jacket with pointed collar

Front View

Hair is long and tousled

Hint
You can change the style of eye patch by giving it a shape, like a star. You could even give him an infrared eyepiece to enhance his night vision.

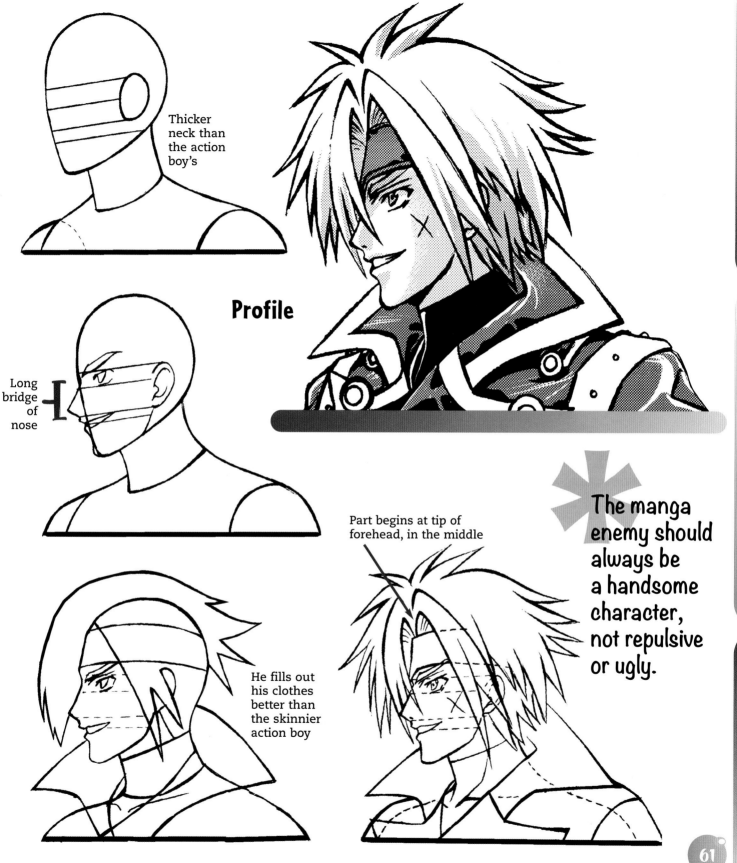

Thicker neck than the action boy's

Profile

Long bridge of nose

Part begins at tip of forehead, in the middle

He fills out his clothes better than the skinnier action boy

The manga enemy should always be a handsome character, not repulsive or ugly.

Action Girl

This youthful character can fight alongside the young action hero or take on a few enemies of her own. Her slight build, wide eyes, and perky attitude may cause some evildoers to underestimate her. That would be a mistake. What she may lack in size, she makes up for in spunk, ingenuity, and fighting skill.

Front View

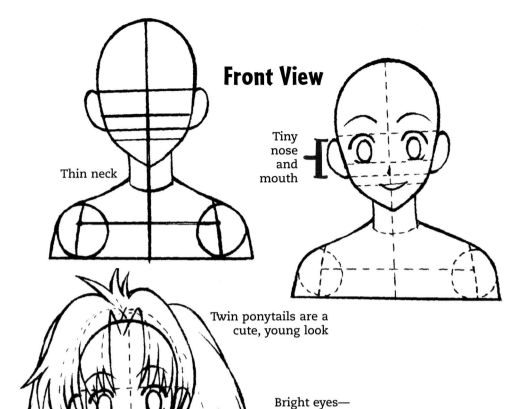

Thin neck

Tiny nose and mouth

Twin ponytails are a cute, young look

Bright eyes— eyebrows placed far above eyes in a high arch...

...and upper eyelids don't cover irises

Ribbons in hair

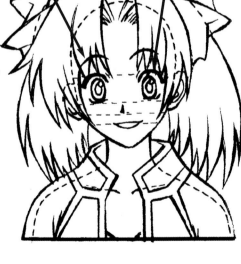

Young characters like this girl usually have lots of hair surrounding the head.

Profile

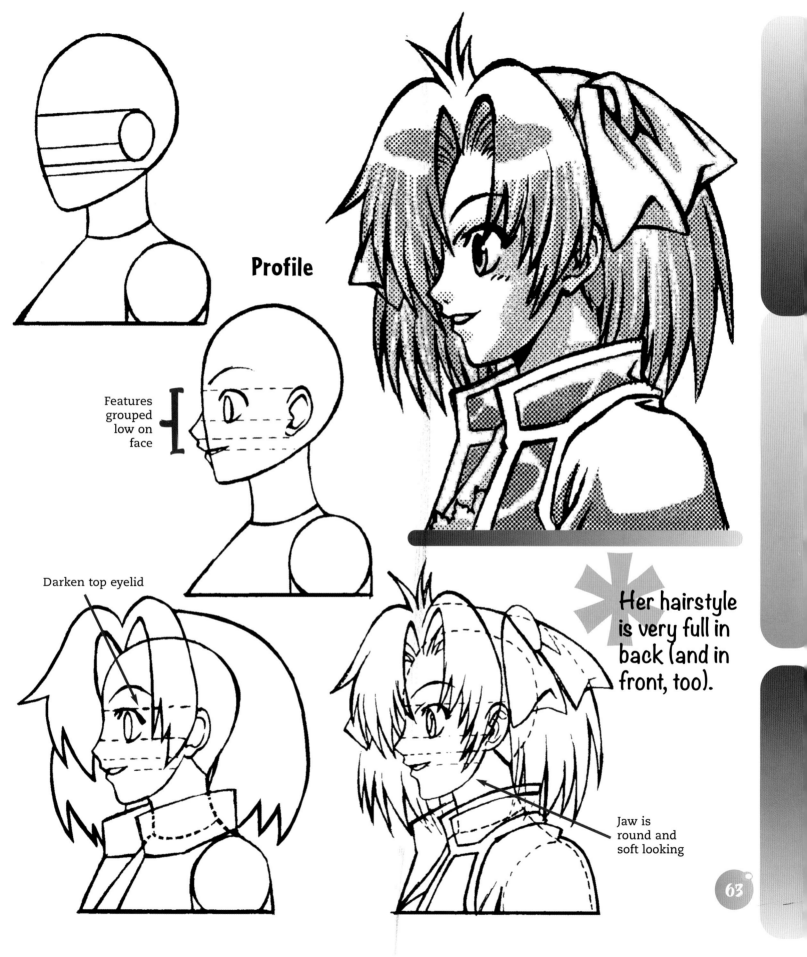

Features grouped low on face

Darken top eyelid

Her hairstyle is very full in back (and in front, too).

Jaw is round and soft looking

Dark Beauty

Evil is glamorous in shonen manga. And nowhere is it as glamorous as on the dark beauty. There's always the danger that the good guy will be seduced by her charms. She is a totally untrustworthy character, a deceiver and a manipulator. But she's so good at it that she's irresistible to watch.

Front View

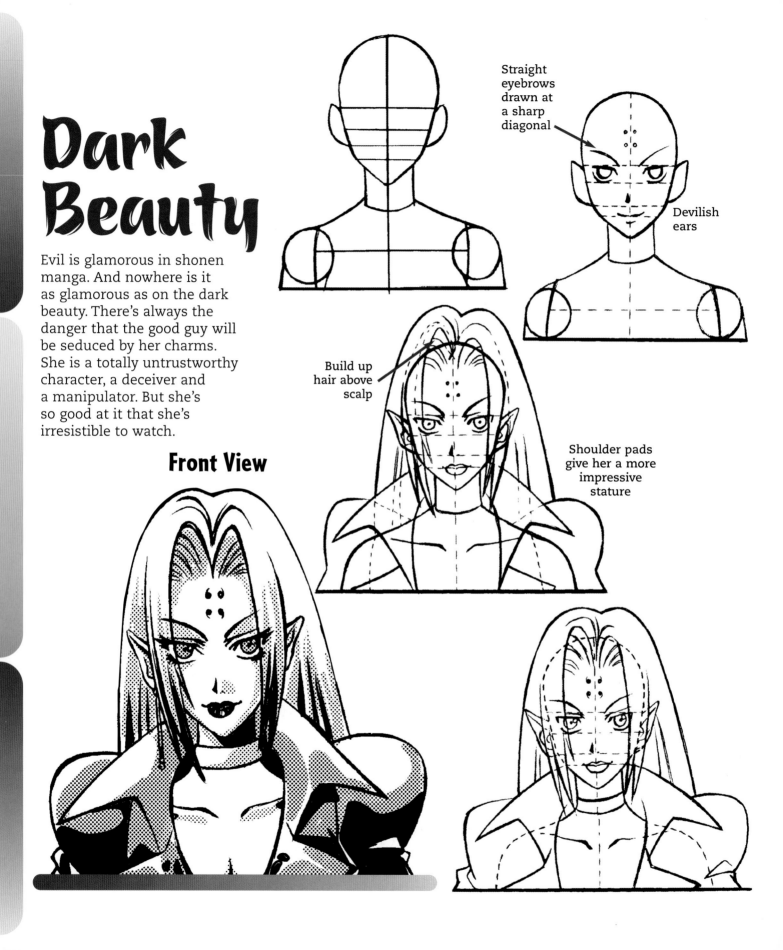

Straight eyebrows drawn at a sharp diagonal

Devilish ears

Build up hair above scalp

Shoulder pads give her a more impressive stature

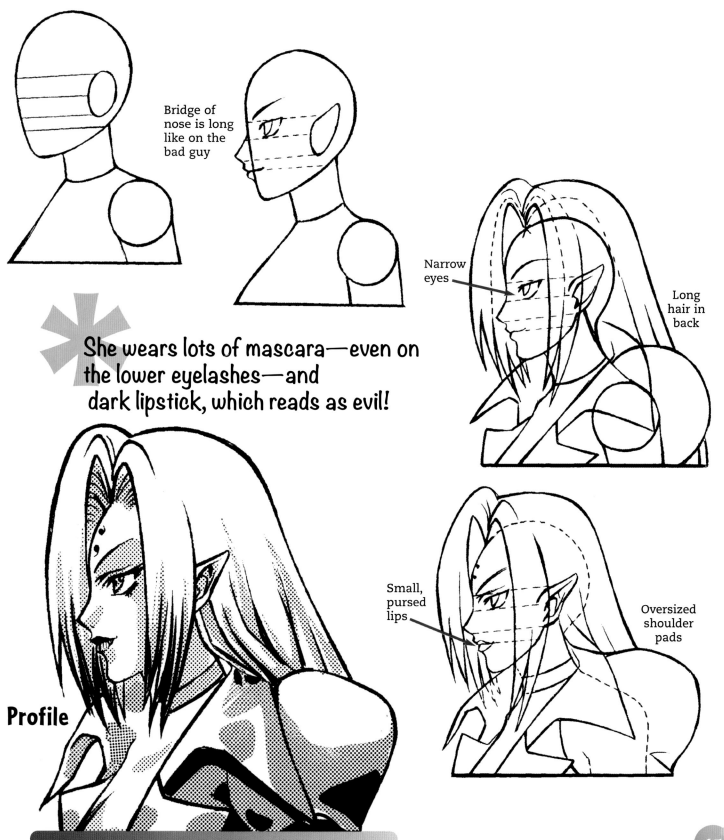

Bridge of nose is long like on the bad guy

She wears lots of mascara—even on the lower eyelashes—and dark lipstick, which reads as evil!

Narrow eyes

Long hair in back

Small, pursed lips

Oversized shoulder pads

Profile

Body is 2 "heads" across:
½ per shoulder and
1 for the head

Body slightly stocky—
he's no pushover

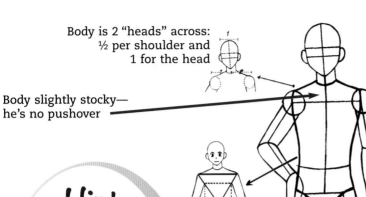

The boy hero is 7¼ heads tall.

Hint

An easy way to build the correct proportions of the body is to start with an equilateral triangle and then superimpose a square onto it.

Brave Fighter Kid

The fighter kid has a medium build. He's not overly muscular, but he's not skinny either. He's completely average—and that's the point of manga. Instead of superpowered heroes, regular guys and gals save the day. They're ordinary people doing extraordinary things, making it easy for us to relate to them. In manga, we're the heroes. And we don't need capes or superpowers, just guts and a fighting spirit.

Rough-and-tumble fighting clothes

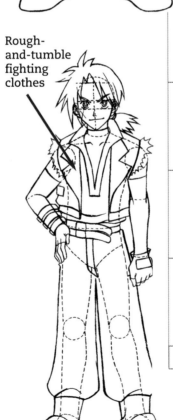

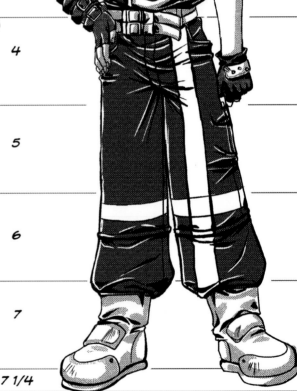

1

2

3

4

5

6

7

7 1/4

Front View

Numbers on side-view figure (top to bottom): 1, 2, 3, 4, 5, 6, 7

7 1/4

Side View

* Straps, gloves, boots and loose clothes for punching and kicking—he's ready to fight!

Heads Up!

The method artists use to measure a character's height is to count heads. Simply measure the size of the head and count how many "heads" tall the figure is. Drawing horizontal lines behind the figure, as shown on these pages, makes it easy to do the math.

Normal people measure about 6 heads tall, but our fighter boy is over 7 heads tall! Older teens and characters in their twenties can be taller still. And note that except for kids and young teens, most shonen characters are drawn with relatively small heads, compared to their bodies. It's the thing that differentiates shonen characters from shojo characters, who have big heads and huge eyes.

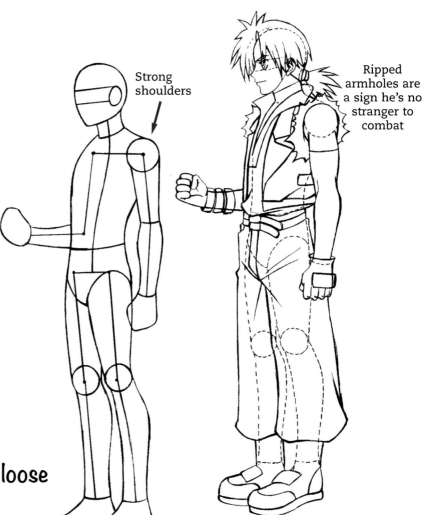

Strong shoulders

Ripped armholes are a sign he's no stranger to combat

The bad guy is 8¾ heads tall.

Powerful Foe

Bad guys are almost always older and more mature physically than the young hero. The villain should look significantly more powerful than our good guy, too. Notice the bad guy's arms and shoulders—they're rock solid and popping with muscles, making him look broad. He's also considerably taller. This should intimidate the young hero, but of course it won't!

Front View

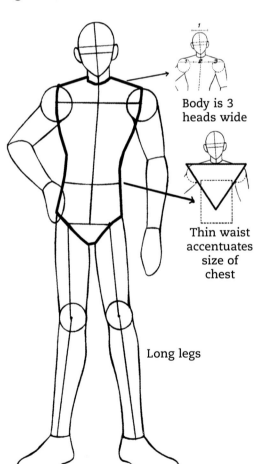

Body is 3 heads wide

Thin waist accentuates size of chest

Long legs

Big shoulders

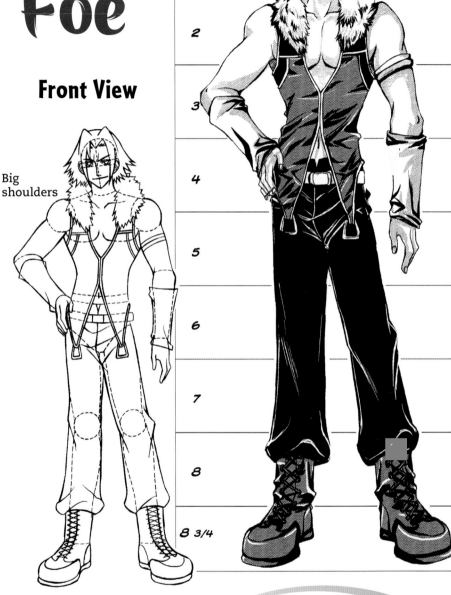

1
2
3
4
5
6
7
8
8 3/4

Hint

Give the villain body-builder-style shoulders and arms, but keep the rest of him skinny to create an overall lanky appearance.

68

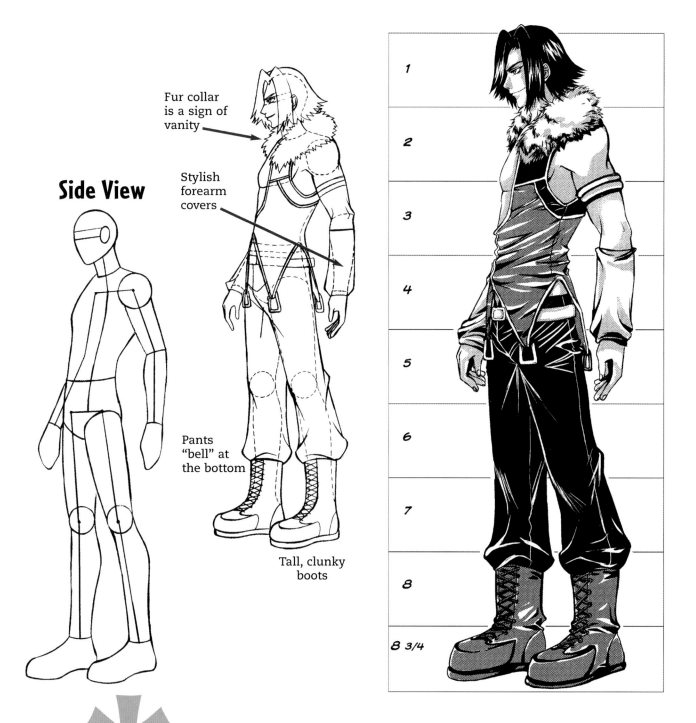

Side View

Fur collar is a sign of vanity

Stylish forearm covers

Pants "bell" at the bottom

Tall, clunky boots

1
2
3
4
5
6
7
8
8 3/4

The evil guy's costume is darkly glamorous. Yep, on top of everything else, he's vain, too!

Fighter Girl

This perky character wears her heart on her sleeve. You always know where she stands on any matter, because she lets you know in no uncertain terms. Think of her as the girl next door who just happens to have amazing fighting skills. She has an athletic figure.

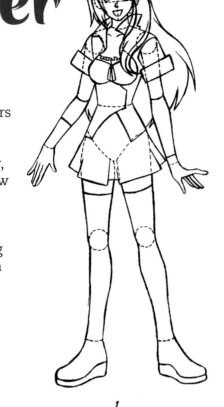

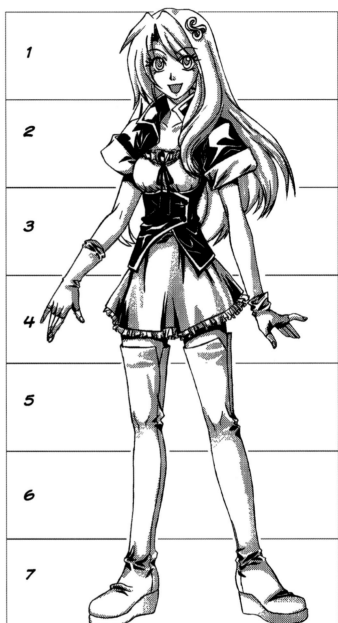

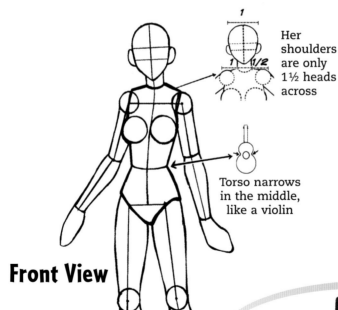

Front View

Her shoulders are only 1½ heads across

Torso narrows in the middle, like a violin

1

1 1/2

1
2
3
4
5
6
7

Hint
Tall boots or leggings combined with a short skirt is a popular look for teen girls in manga.

70

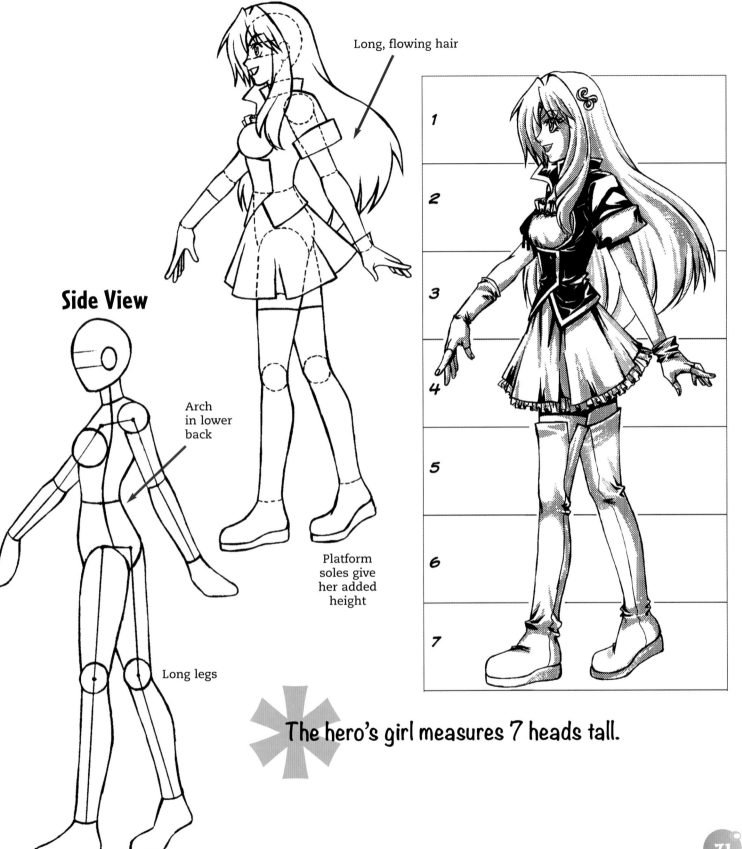

Long, flowing hair

Side View

Arch
in lower
back

Long legs

Platform
soles give
her added
height

1

2

3

4

5

6

7

The hero's girl measures 7 heads tall.

Drawing Fabulous Manga Eyes

Manga characters, especially in the romance genre, are known for their sparkling eyes. You can draw any type of eyes for your character that you want, but these are tried-and-true designs that you can use as springboards for your creations. After a detailed look at eyes in this chapter, we'll combine them with the other features to show how to create expressions that pop off the page.

Girls' Eyes

In manga, teen girls get to have the most glamorous eyes of any characters. The eyes shown here have been taken to the max—with bright "shines" and lots of shading and sparkles. If you want to simplify them, just eliminate the gray areas by turning them solid black. But remember to leave the shines!

Bubbly

Bubbly eyes have round pupils. The eyelids rise up, off the eyes, and the eyebrows are placed high.

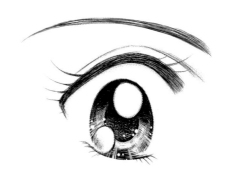
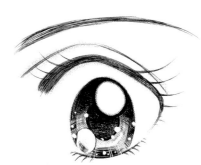

Introspective

Introspective eyes are huge, with very little white around the irises. The eyelids droop at a diagonal.

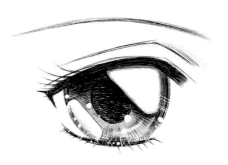
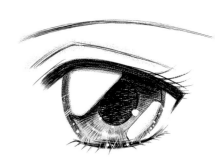

Hint

Most often, and as a good general rule of thumb, two eye shines should be drawn in opposite corners of the eye, diagonal to each other. This placement is very effective.

Wild

These eyes have tiny pupils and eyelashes that tilt up sharply at the ends!

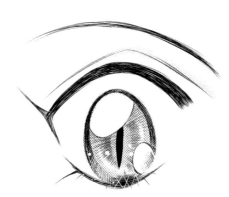
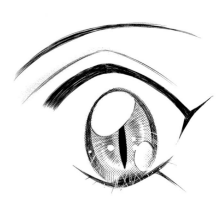

Concerned

When you droop the upper eyelids severely, the character will look concerned.

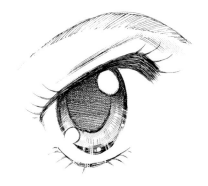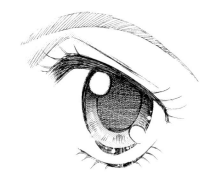

Seductive

The upper eyelids drop down over the pupils for an alluring expression.

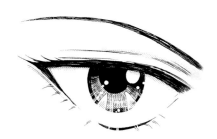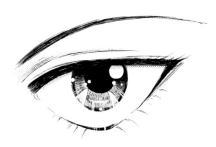

Thoughtful

Lower the bottom eyelid and leave a good amount of white around the iris.

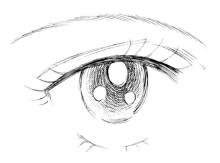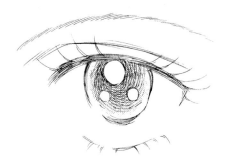

Eyelid Creases

Note that the upper eyelid is always drawn the thickest and darkest. But most important, just above the eyelid there is a light crease. Without that, the eye would appear flat and have no depth.

Boys' Eyes

It may seem surprising, but most manga teenage boys do not have thick eyebrows. A few do, but they are in the minority. For the most part, boys' eyebrows are drawn much closer to the eyes than females', which are usually drawn in a high, arching curve.

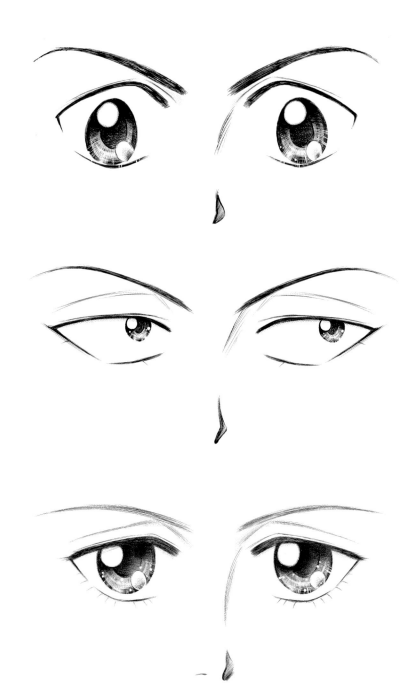

Classic

This is the standard look for boys' eyes: big and dark without a lot of variation. You can't go wrong with this style.

Sarcastic or Cynical

Beady eyes always connote a negative thought or a negative character.

Sensitive

The more sensitive a character, the larger the eyes.

The Eye in Profile

When drawing the eye in profile, you've got to completely change the shape of the pupil/iris. It's no longer a circle at all—or even close to it. Instead, it becomes the slenderest of ovals.

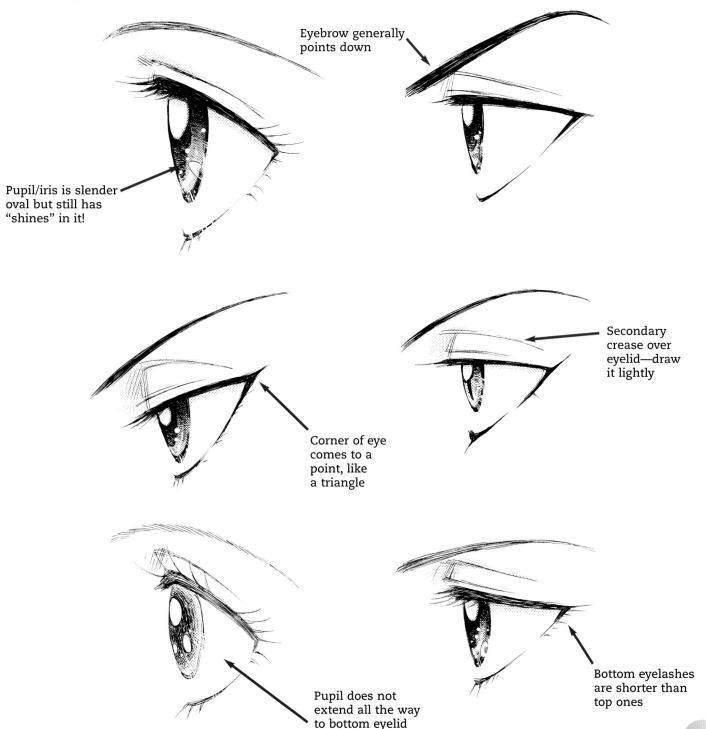

Eyebrow generally points down

Pupil/iris is slender oval but still has "shines" in it!

Corner of eye comes to a point, like a triangle

Secondary crease over eyelid—draw it lightly

Pupil does not extend all the way to bottom eyelid

Bottom eyelashes are shorter than top ones

And Don't Forget Eyebrows!

The eyebrows are the workhorses of the eyes. They do the heavy lifting, using their muscles (yes, the eyebrows really have muscles!) to form a shape that will convey a strong expression. The eyebrows can mirror the shape of the eye or move in the opposite direction. Manga characters are famous for their emotionalism, so it's no coincidence that they have the longest eyebrows in all genres of comics.

Angry

The eyebrows crunch down over the eyes to create an angry look.

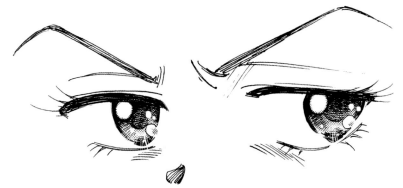

Happy

Arched eyebrows frame bright, wide-open, happy eyes.

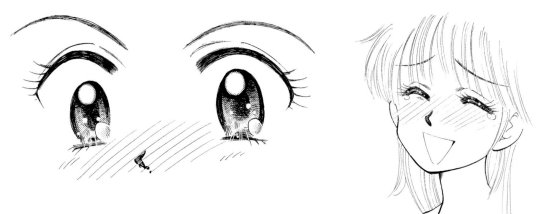

Upset

Squeezing the eyebrows together and pushing them up conveys worry. The funny little loop in one eyebrow adds to the look of concern.

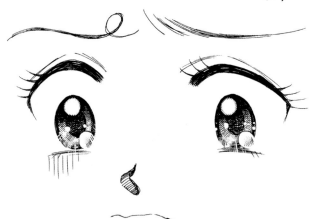

Furious

Eyebrows drawn at an extreme angle add to this character's look of fury. Compare these eyes to the merely angry ones on the previous page.

Disbelief

Combining classic arched eyebrows with very small pupils shows the character's disbelief.

Melancholy

Horizontal eyebrows with almost no arch create a melancholy look.

Drawing Eyes for Action Characters

How do you get good at drawing eyes? By drawing eyes! And this section provides lots of examples to give you plenty of practice. We'll focus on the most popular characters in the shonen style: teens and adult villains.

Be sure to vary the thickness of your line. Upper eyelids are always darker than lower eyelids. Remember to get the eyebrows into the act, too!

Young Teen Boy

This very popular character type ranges in age from about 12 to 15. He's usually portrayed as earnest, sincere and fiercely determined. But he lacks guile and is vulnerable to the double-dealing ways of villains. His pupils are normally large and round—a sign of honesty. But even he can have a bad thought flash across his eyes, which will result in beady pupils.

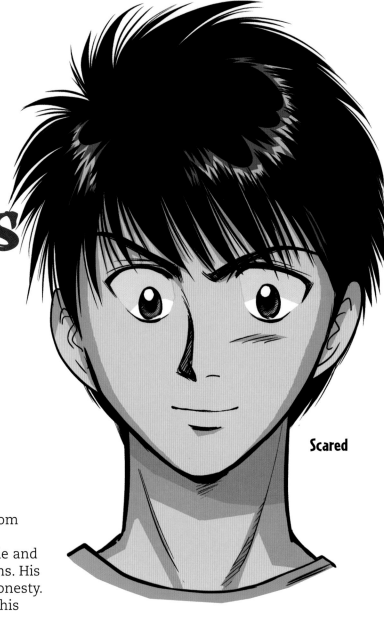

Scared

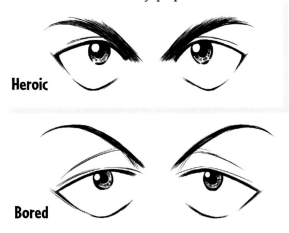

Heroic

Bored

Sincere

Plotting

80

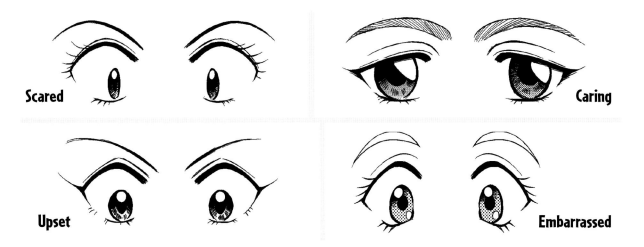

Scared

Caring

Upset

Embarrassed

Young Teen Girl

When you draw girls' eyes, think of dark eyelids and thick eyelashes that flare up at the ends. That's where the emphasis needs to be.

Calm

These Eyes Are True Blue

This character is often used to give the reader an "emotional cue." What do I mean by that? Here's an example: Suppose a powerful bad guy challenges our teen boy to a fight. When he naturally accepts, the girl is concerned. Why? Because she knows that the enemy is too powerful. The girl is giving the reader a cue that the fight is going to be extremely dangerous for our young hero. In this way, she helps build anticipation and heighten suspense. (But the boy may surprise her yet!)

Peeved

Cynical

Ironic

Mildly Concerned

Bishojo Girl

Bishojo (pronounced "bee-show-joe") is the counterpart to the male bishie and means "pretty girl" in Japanese comics. She's a mature teen or young adult—never a very young girl. Her eyes are almond shaped (sleeker and narrower than the young teen girl's), with glamorous long lashes and darkened upper eyelids.

The famous "eye-shine" overlaps both the pupil and the iris.

Hint

The bishie's elegant eyebrows angle downward, but be sure to give them just a slight downward turn, or you'll risk making him look angry. Instead, the thin eyebrows should make him look like a cynic.

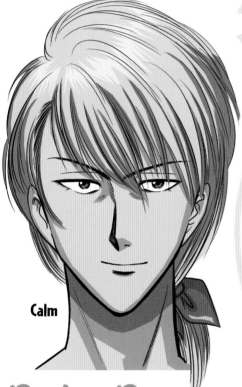

Calm

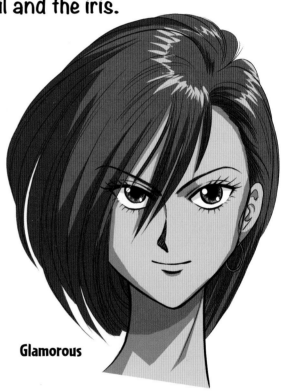

Glamorous

Bishie Boy

Bishies also appear in the shojo style as well as the occult, samurai, and historical genres. In shonen manga, they're usually depicted as amazing fighters. As the teen boy ages, he becomes more mysterious and brooding. His eyes are narrow and lack the roundness of younger fighters' eyes. That's because he doesn't need to look so earnest and pure. He's streetwise.

Satisfied

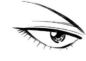

Confident

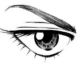

Annoyed

Suspicious

Sideways Glance

Scar Across Eye

Slightly Cross-eyed

Squeezed Eyeballs

Female Villain

These are the eyes of a woman with wicked intentions. Classic evil eyes are always drawn in a narrow shape. They also have tiny little irises surrounded by the whites of the eyes. The eyebrows are not only thin, but are drawn in an ultra-high arch. It's an extreme look that is completed by short, sharp bottom eyelashes.

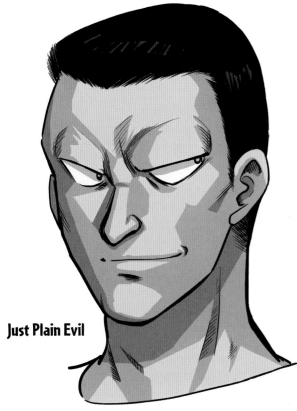

Just Plain Evil

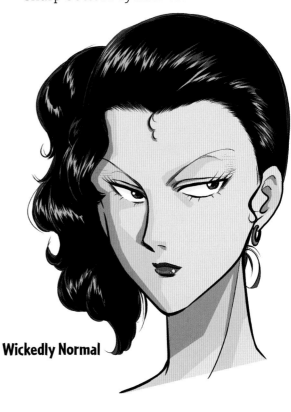

Wickedly Normal

Male Villain

The evil guy gets the beady-eye treatment. Notice how he peers out of the corners of his eyes. This shows that a character is thinking bad thoughts. The eyebrows crush together at the bridge of the nose, creating creases around the eyes. And if you like, you can also add a slashing scar across one eye, making him look even more dangerous.

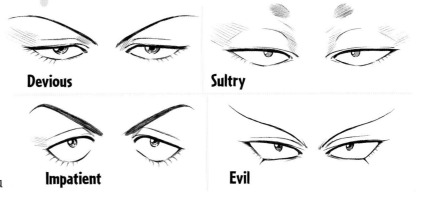

Devious

Sultry

Impatient

Evil

Expression Models

Now, we could just show you a bunch of cool-looking expressions, but you should be able to draw the character that will be making those expressions first. Therefore, we're going to introduce Miyoko—our cartoon model—and show you how to draw her in a step-by-step manner first. Then Miyoko and her friends will go through a series of expressions for us. Notice how the eyes work in tandem with the rest of the body.

Front View

Our model Miyoko is a classic, manga character. Here she is in a simple front view with a small smile that gives her a pleased, content look.

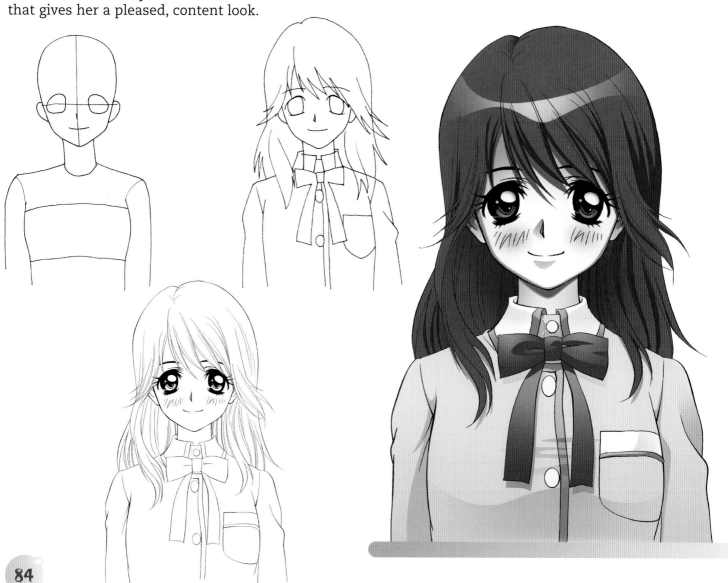

3/4 View

Here is Miyoko again with the same expression as in the front view, but turned slightly to the left. Notice how the shapes of the eyes change as she turns.

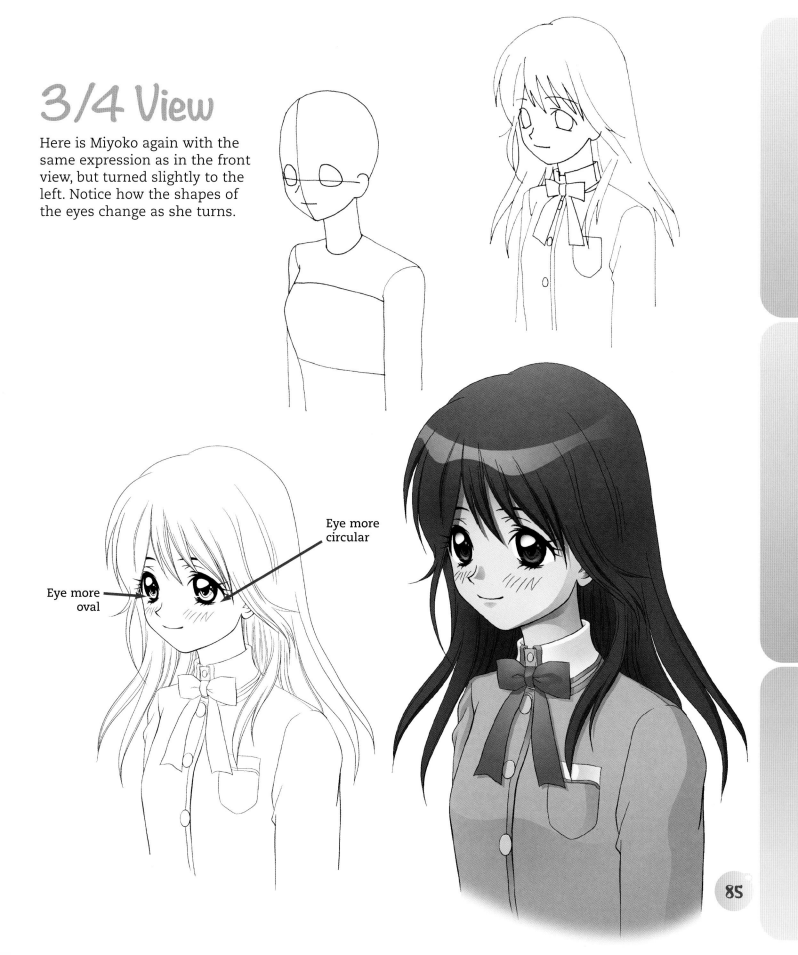

Eye more circular

Eye more oval

Changing the Angles

Here's a good exercise: When you reach a comfort level in drawing a particular character you like, whether you've invented her or gotten her from this book, try drawing her in a variety of poses using the same expression. Once you can do that successfully and consistently, you have moved past the beginner and intermediate levels and are headed toward the advanced levels of comic art.

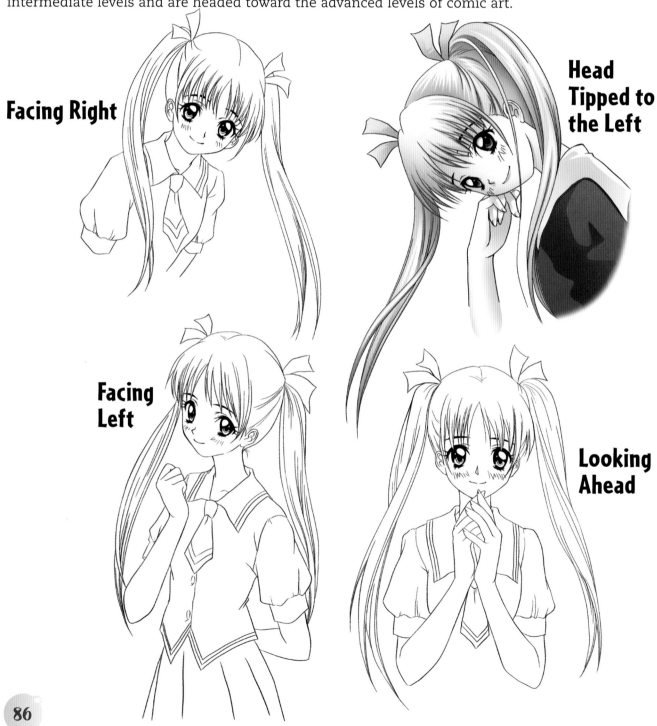

Facing Right

Head Tipped to the Left

Facing Left

Looking Ahead

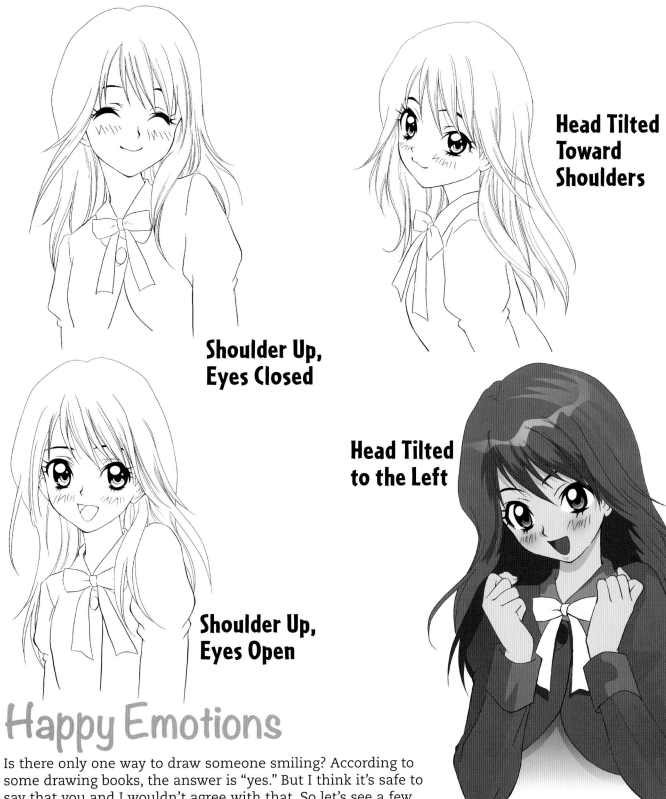

Head Tilted Toward Shoulders

Shoulder Up, Eyes Closed

Head Tilted to the Left

Shoulder Up, Eyes Open

Happy Emotions

Is there only one way to draw someone smiling? According to some drawing books, the answer is "yes." But I think it's safe to say that you and I wouldn't agree with that. So let's see a few different poses for a happy girl.

Do you notice anything interesting going on here? OK, I'll give you a hint: The tilt of the head and shoulders conveys as much emotion as the expression on the face. Take a look!

Boo-Hoo!

Readers love to see their favorite characters in the grip of deep emotions. It allows them to empathize with them.

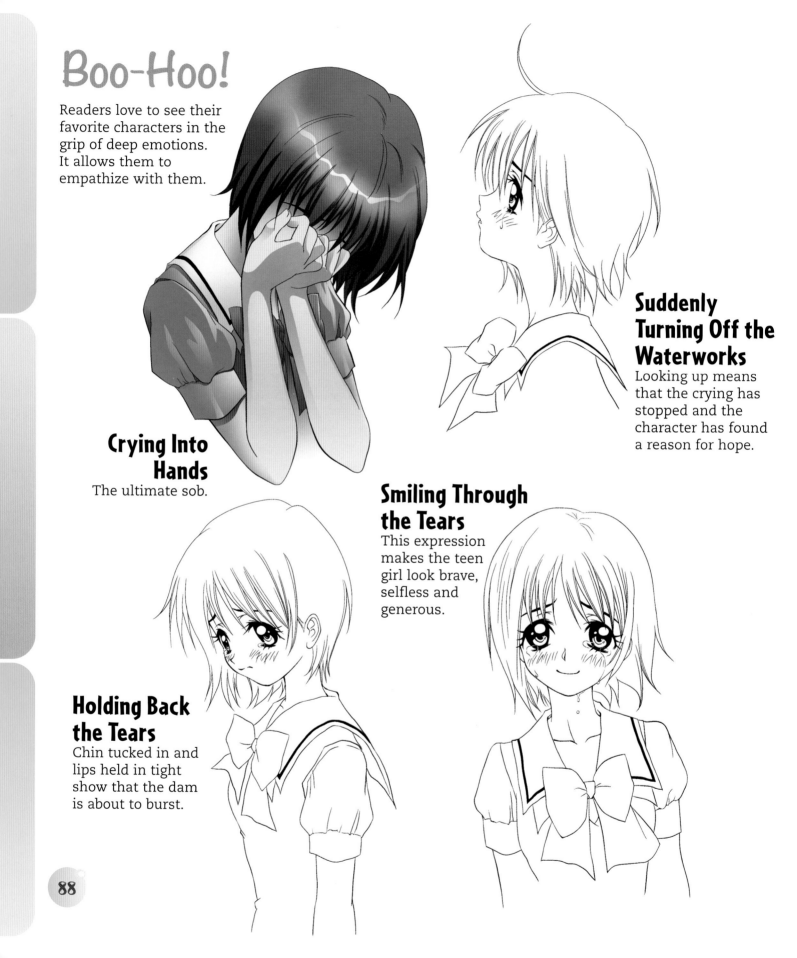

Crying Into Hands
The ultimate sob.

Suddenly Turning Off the Waterworks
Looking up means that the crying has stopped and the character has found a reason for hope.

Smiling Through the Tears
This expression makes the teen girl look brave, selfless and generous.

Holding Back the Tears
Chin tucked in and lips held in tight show that the dam is about to burst.

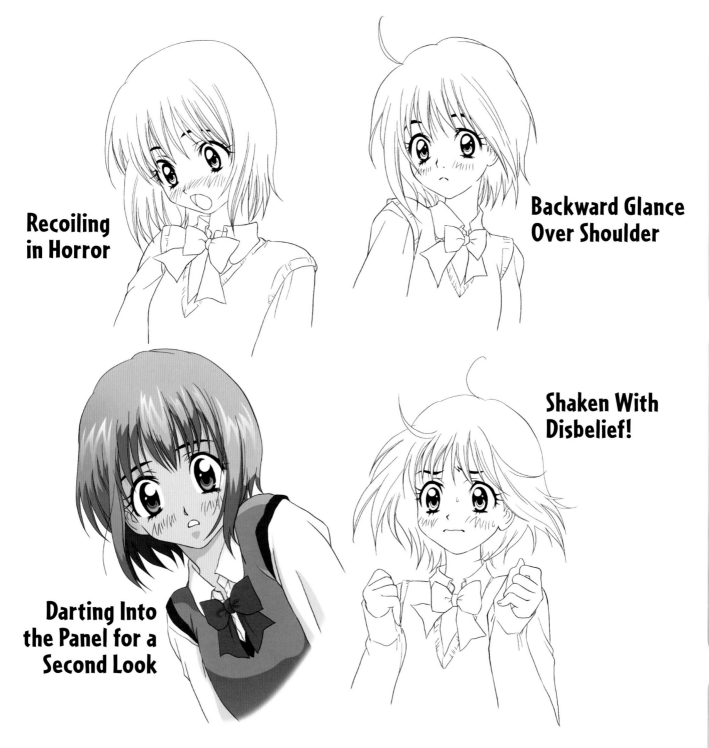

Recoiling in Horror

Backward Glance Over Shoulder

Shaken With Disbelief!

Darting Into the Panel for a Second Look

What in the World?!

Astonished eyes share a common trait, no matter what the rest of the face is doing: The pupils swim in the middle of the whites of the eyes. And don't forget to draw those great blush lines across the cheeks. Stunned expressions lend themselves naturally to comedic interpretations.

Expressions

Famous for their expressive faces, shojo characters react visibly to many situations. And even when they try to hold their feelings inside, we can usually tell what they're thinking!

Isn't He Wonderful?

Half-closed eyes combined with a small smile create a dreamy expression.

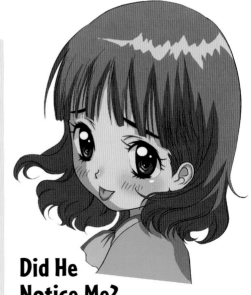

Did He Notice Me?

A typical playful manga expression. She has a tiny smile with her tongue poking out halfway—not all the way. The eyebrows curve up in a hopeful expression.

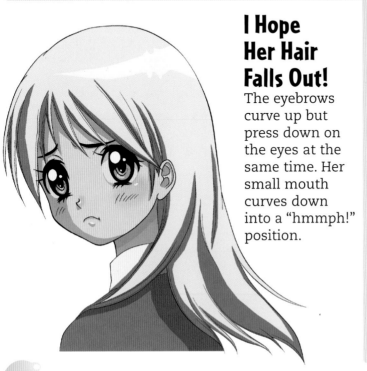

I Hope Her Hair Falls Out!

The eyebrows curve up but press down on the eyes at the same time. Her small mouth curves down into a "hmmph!" position.

Maybe He Loves... Her!

She looks down, while her eyebrows push up and together. Her mouth forms a small O.

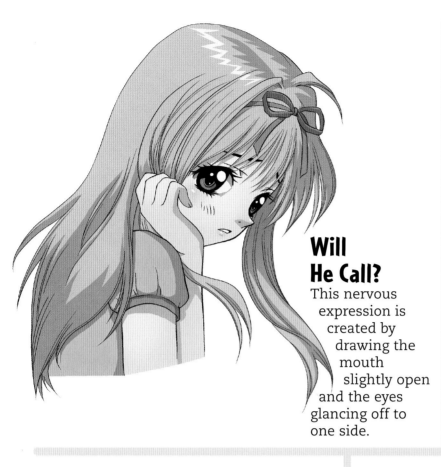

Will He Call?

This nervous expression is created by drawing the mouth slightly open and the eyes glancing off to one side.

I Forgot My Own Phone Number!

Don't even try to reason with this one—at least not while she's in her silly spell. Her eyes are closed and her tongue sticks out.

Yes, I Like Movies!

The eyes curve down when a person smiles widely. Keep the mouth small, or it will look as if she is laughing.

Maybe I Shouldn't Have Sent Him That Text...

A pouty lower lip, big, glistening eyes and blush marks on her cheek—you can't get more expressive than that!

Coy, Shy, and Modest

This playful look requires a narrowing or closing of the eyes and often a slight tilt of the head. Notice how she gestures with her hands. They cover the mouth slightly as if to hide the embarrassment of a smile. Can you tell what is being exaggerated in this charming expression? It's the eyelashes. Yes, you can actually make them longer to suit a particular emotion.

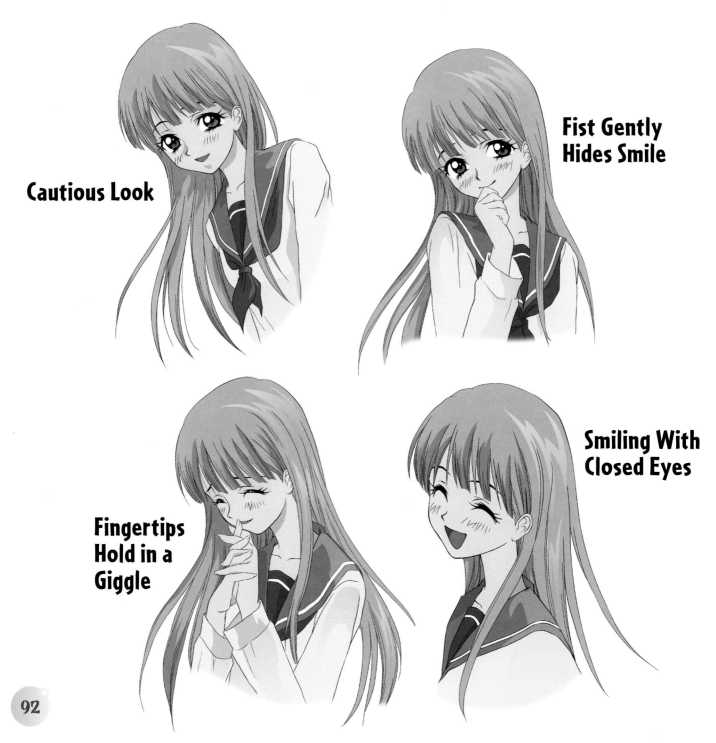

Cautious Look

Fist Gently Hides Smile

Fingertips Hold in a Giggle

Smiling With Closed Eyes

Bishie Expressions

Here's a condensed spectrum of bishie expressions from angry to happy. Most bishie attitudes are slightly restrained—even the emotionally charged ones. It's consistent with the style of character.

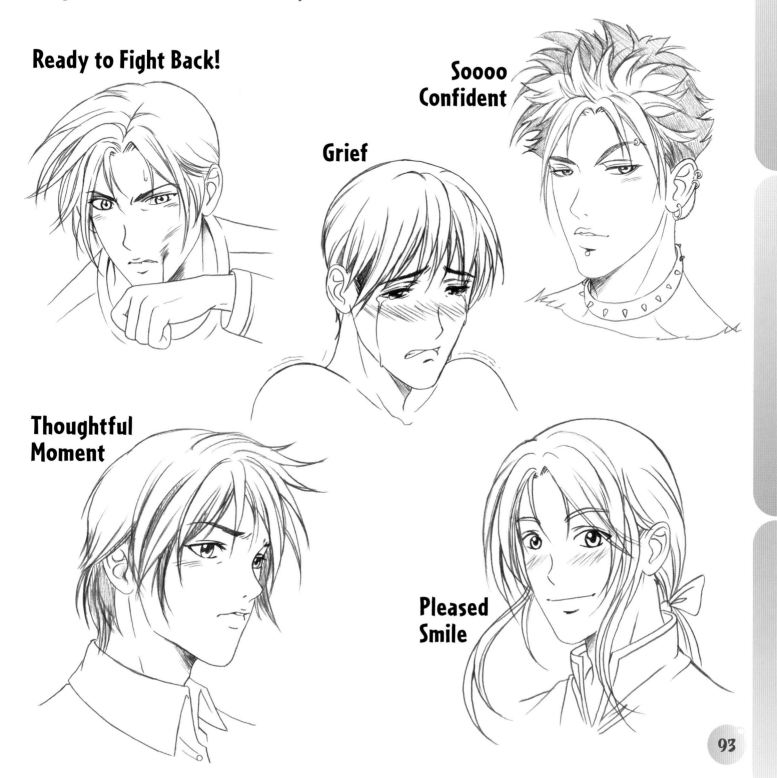

Ready to Fight Back!

Grief

Soooo Confident

Thoughtful Moment

Pleased Smile

Funny Faces—Chibi Style!

Have you ever had a really embarrassing moment where you said something or did something so stupid that all your friends burst out in laughter? Me neither.

But for those characters who have, any extreme emotion can be turned into a humorous moment. And chibies are at their funniest when their emotions are extreme. Manga is a sturdy genre, and it is able to poke fun at its own characters and bounce back without disrupting the general flow of the scene, while American-style comics cannot.

In-Your-Face Disappointment

Chibi-Powered Eagerness

Mischievous Chibi

Faucets of Tears

The Sneaky Thought

Evil glint in the eye

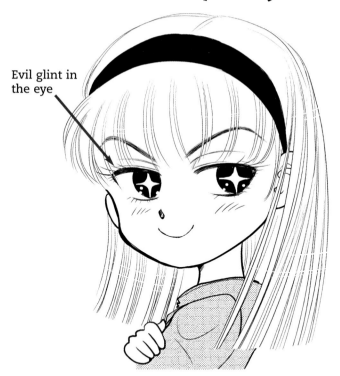

Stunned Into Silence

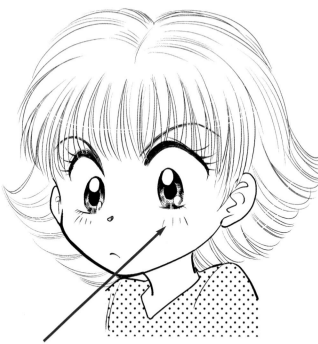

Surprise streaks—keep them short and spread 'em apart!

Very, Very Bad Indeed

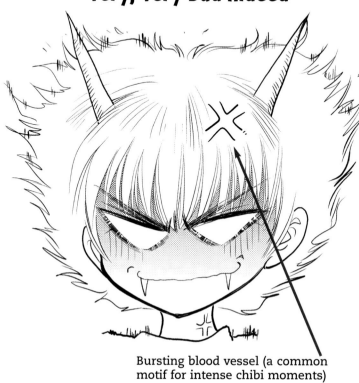

Bursting blood vessel (a common motif for intense chibi moments)

Determination

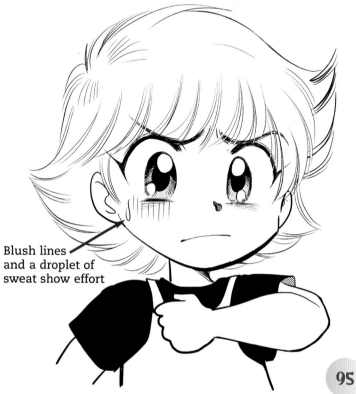

Blush lines and a droplet of sweat show effort

95

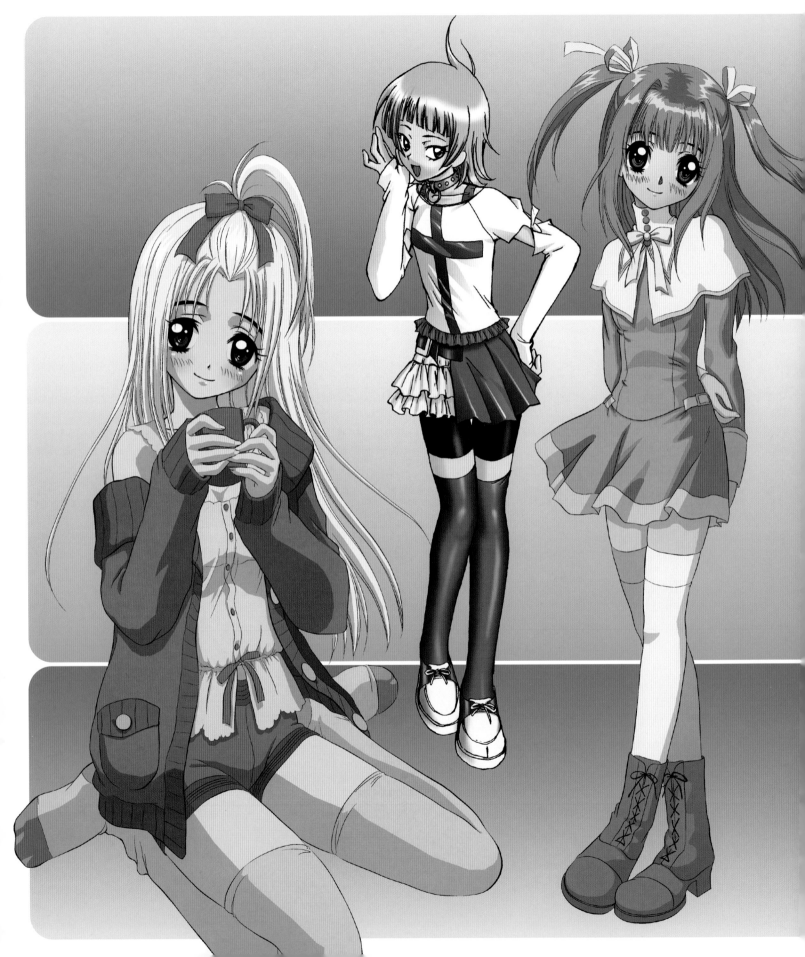

Costume Design

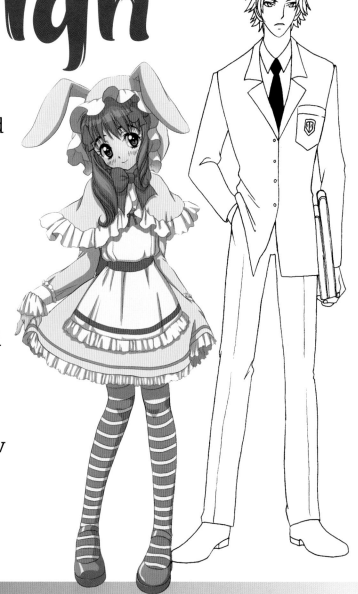

Now we're going to put our characters in popular schoolgirl and bishie costumes. The outfits in this chapter have been drawn exclusively for this book by a Japanese manga artist working in Japan, so you know they're authentic. And as you've probably come to expect by now, we're going to show you how to draw them step by step so you'll have no trouble designing your own fabulous costumes.

GIRLS' COSTUMES
Classic Sailor Suit

The most popular Japanese public-school uniform is a loose interpretation of a sailor suit. It's a cute, endearing outfit. You can personalize it by adding more frills or buttons, or by designing different types of trims or patterns. Perhaps your collar will be wider and rounder, or triangular instead. None of these changes will sacrifice the authenticity of the look. And it's a good way to make the character your own.

Sailor Outfit: Version I

In order to glamorize the outfit, everything is lightly exaggerated: boots a little taller, ribbons a little longer, flounces a little frillier. This step-by-step demonstration shows you the common traits of almost every sailor suit. After you make sure your design has these in place, you can work on creatively customizing them.

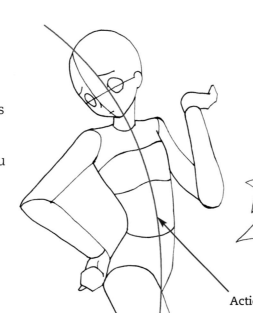

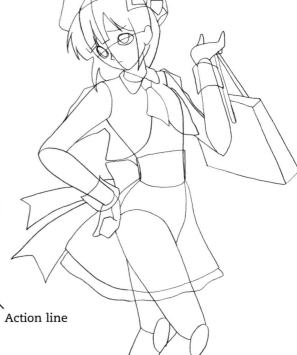

Action line

The "line of action" or "action line" is a sketch line that helps the artist plot the basic thrust of the pose.

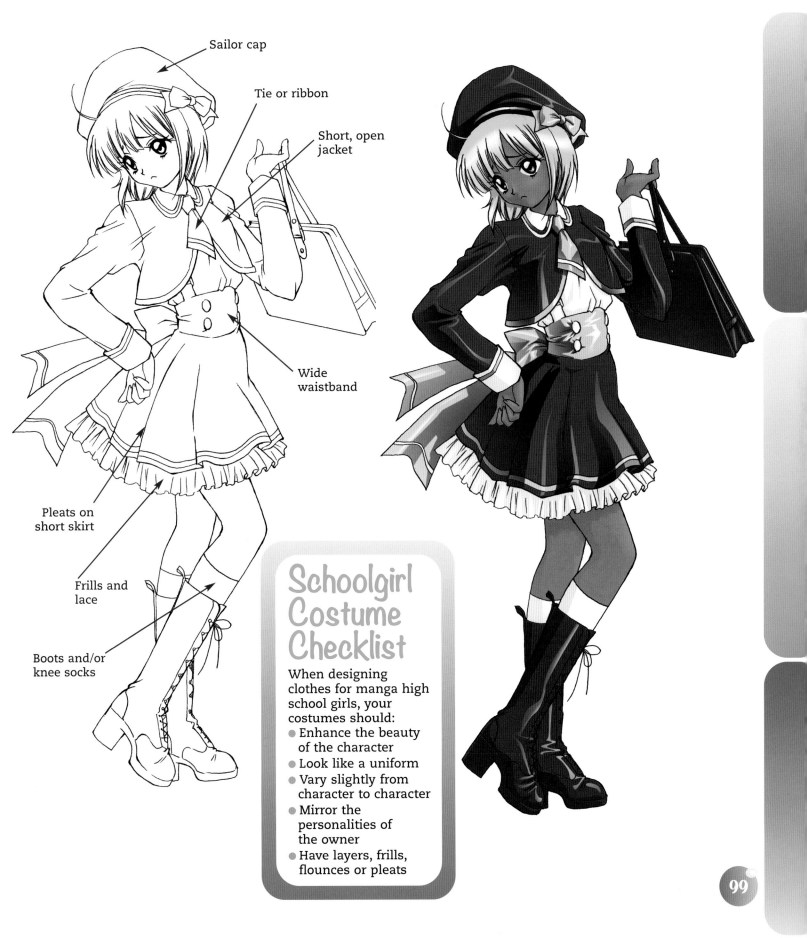

Sailor cap

Tie or ribbon

Short, open jacket

Wide waistband

Pleats on short skirt

Frills and lace

Boots and/or knee socks

Schoolgirl Costume Checklist

When designing clothes for manga high school girls, your costumes should:

- Enhance the beauty of the character
- Look like a uniform
- Vary slightly from character to character
- Mirror the personalities of the owner
- Have layers, frills, flounces or pleats

Sailor Outfit: Version 2

The sailor-suit outfit is a great costume for high school characters because only schoolgirls wear them. It immediately says to your reader that the story is set amongst students.

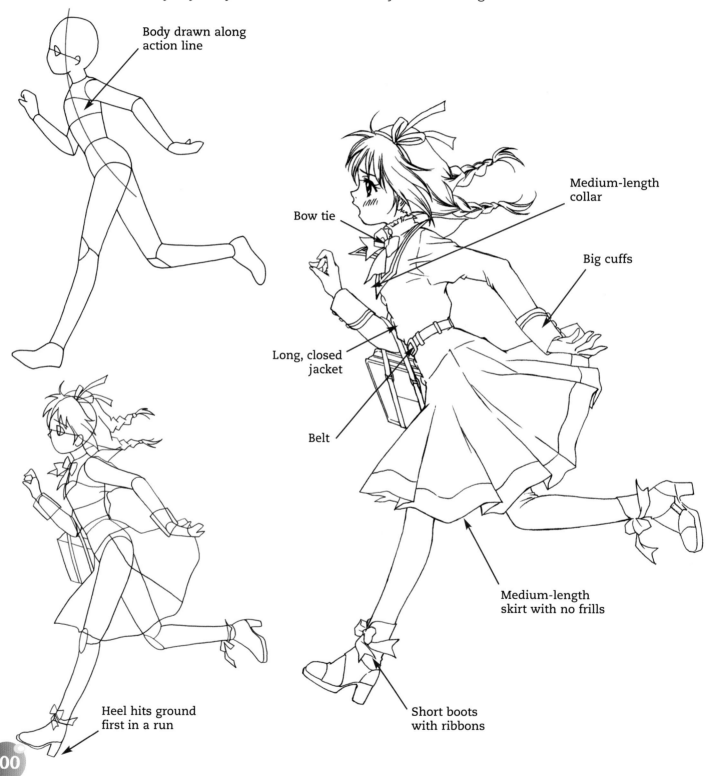

Body drawn along action line

Bow tie

Medium-length collar

Big cuffs

Long, closed jacket

Belt

Medium-length skirt with no frills

Heel hits ground first in a run

Short boots with ribbons

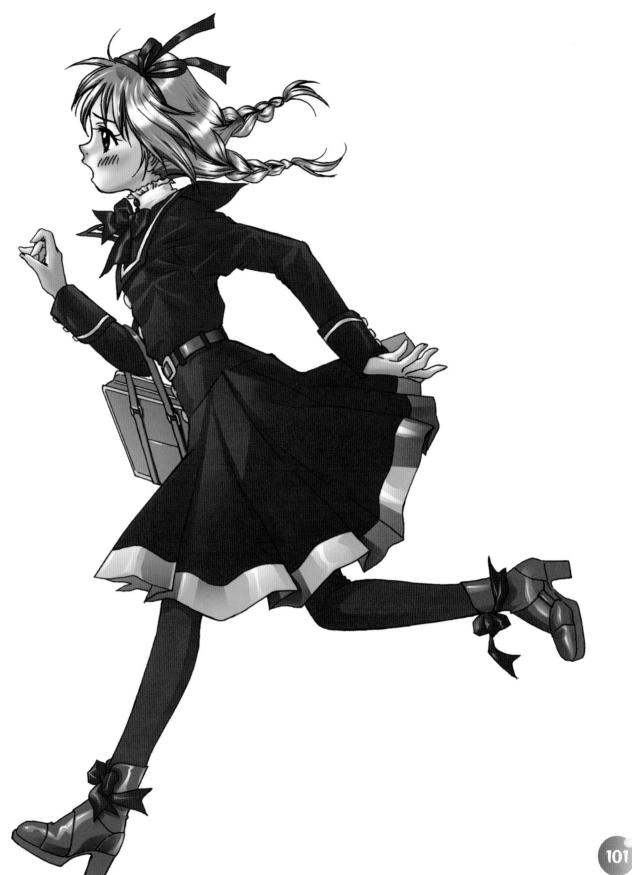

Girls' Private-School Outfits

In private schools, students are freer to wear what they want. They can be trendy and upscale or slightly gothic and intense. It depends on the character.

Upscale Outfit

Remember that we talked about tilting the head and employing the shoulders in the section about expressions? See how that comes in handy when we want to give this character a coy look?

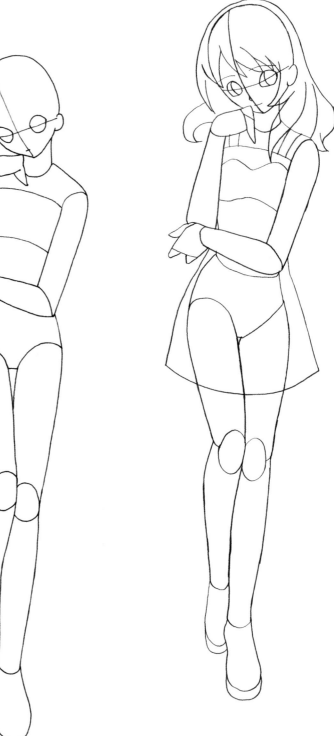

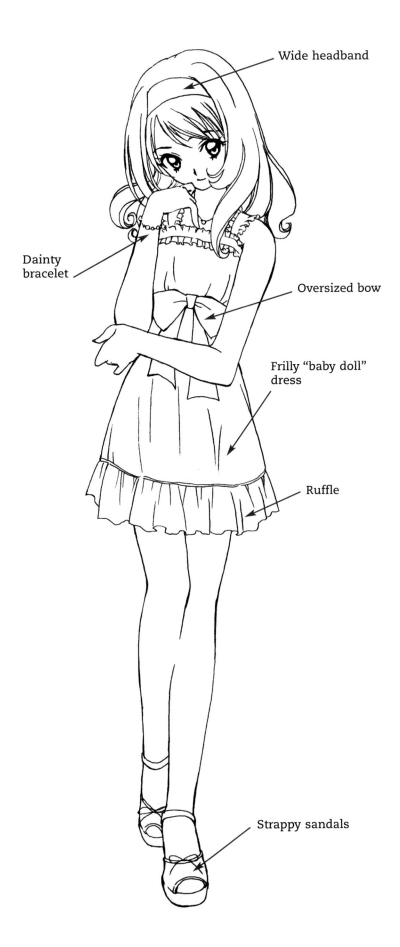

Wide headband

Dainty
bracelet

Oversized bow

Frilly "baby doll"
dress

Ruffle

Strappy sandals

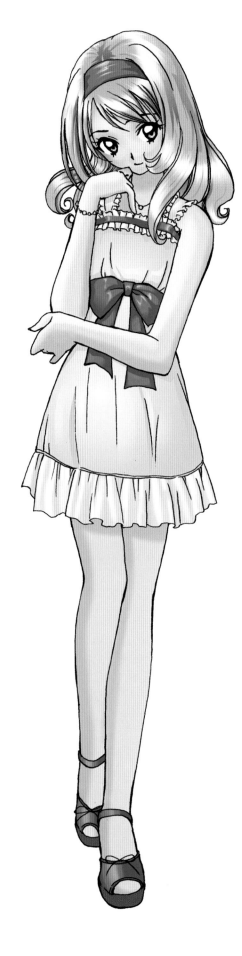

Rebel Teen Outfit

There's always one in the crowd who doesn't go along with the clique—and not because she's uncool or not pretty enough. Maybe it's because she's too cool. She doesn't need to be part of a group of pretentious teens to feel good about herself. Maybe she's a singer in a garage rock band or a gifted graphic artist. Whatever her story is, she's definitely artsy.

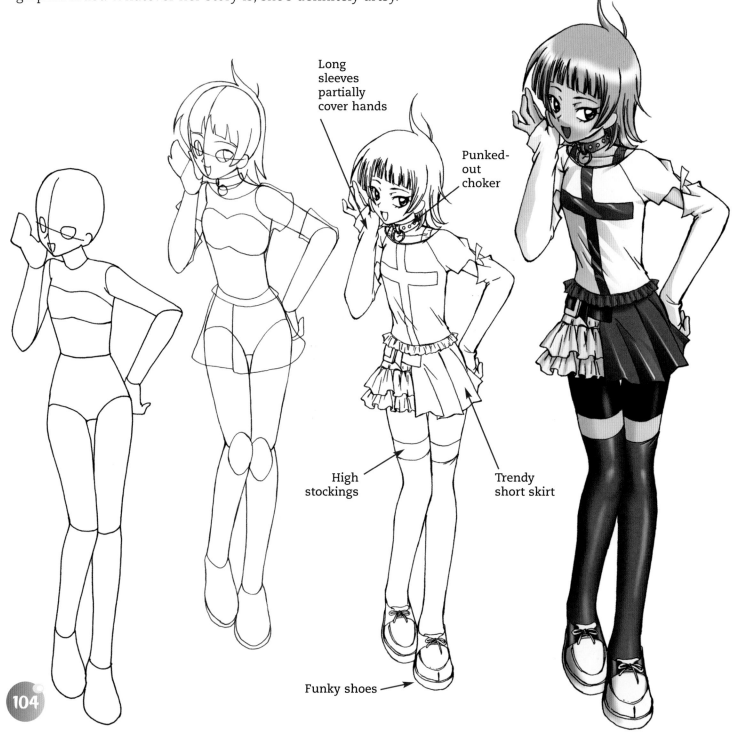

Long sleeves partially cover hands

Punked-out choker

High stockings

Trendy short skirt

Funky shoes

Magical Girls

Magical girls are extremely popular shojo characters. They are regular schoolgirls who can transform into super-glamorous versions of themselves. Their magical costumes are all tricked out with bells and whistles. Many of the magical girls have wands and fantasy pets—strange little plump creatures from other universes with whom they pal around.

Finger points playfully

Deep angle in small of back

Hand hides most of arm in foreshortened pose

Big shines in big eyes

Baubles in hair

Fighting Magical Girl

This magical girl has to manage having two identities—one as a typical schoolgirl and a secret one as a glamorous intergalactic heroine who travels between universes to save the earth from evil invaders. Her parents and everyone but her best friends are unaware of her secret identity.

The magical fighter girl always wears boots

Foreshortening

Foreshortening is a drawing technique in which objects that are coming toward you are compressed and enlarged to create depth in the image. See how the hand holding the wand is much larger than the other? That's foreshortening!

More Manga Girls!

Here are a variety of girls for you to practice drawing. These are the ebullient types of manga girls that you want to bring into your own manga drawings and, eventually, into your own graphic novels. Classic manga girls are typically self-composed, but at the same time vulnerable and sweet.

Standing in the Wind

This is a perfect summer outfit for walking along the boardwalk. She might "accidentally" let go of the hat when her crush walks by. Then he'll have to chase it down for her, and she can act ever so grateful!

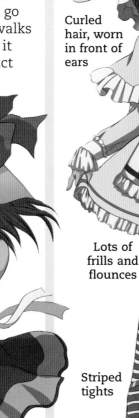

Curled hair, worn in front of ears

Big bow

Lots of frills and flounces

Striped tights

Her hat, hair, dress and ribbons on the hat and dress all blow back in the wind.

Cosplay Girl

"Cosplay" is short for "costume play." Devotees of manga and anime dress up like their favorite characters and attend manga and anime conventions. The costumes range from sweet schoolgirls to fantasy fighters. This cosplayer wears a frilly rabbit outfit.

Sipping Coffee and Steamed Milk

Time for a coffee break! Her clothing is all soft and oversized, as if she had wrapped herself in a cozy old sweater and curled up in front of a fire. Note the relaxed sitting position. The sweater falls off her shoulders as she cups the mug with two hands, savoring the moment.

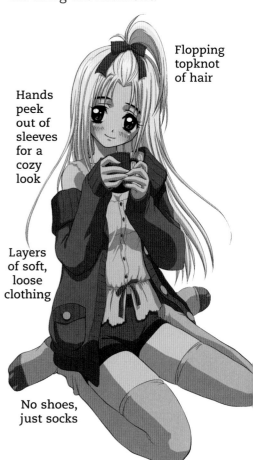

Flopping topknot of hair

Hands peek out of sleeves for a cozy look

Layers of soft, loose clothing

No shoes, just socks

Manga girls have lots of hair!

Bring elbows forward

Slip has plenty of ruffles

Toes pointed inward to show awkwardness

Oh No—My Hair!

Two hours at the salon and a single gust of wind threatens to undo the entire thing. Draw her holding her hair in place as it blows wildly in the wind. The wind also blows her ribbon, sash, and dress. Her knees knock together as she buckles under the force of the breeze.

Urban Teen

She's more streetwise than a suburban daddy's girl who rarely ventures into the city. While the daddy's girl wears her mother's designer shoes, the city teen wears funky boots she bought at a vintage store.

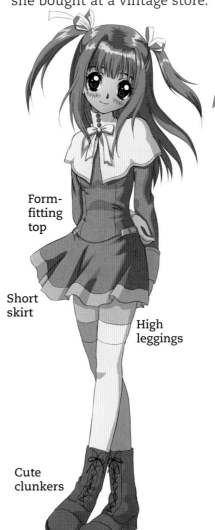

Form-fitting top

Short skirt

High leggings

Cute clunkers

Beautiful, long, flowing hair

Figure bends forward at waist

Hands hold feet near ankles

Point the toes for a feminine look

Nighttime Musings

In manga, characters feel just what every teen feels: the angst and growing pains of trying to fit in. Will things work out for them? What will their future hold? These introspective moments in a story communicate the character's fears and frustrations to the reader.

Story Time When you're writing a story about a group of friends, it's easy to lose track of one or more of them and concentrate mainly on your favorite character(s). But what you may not realize is that your reader may have a different favorite—one that you might have ignored. So be sure to keep all of the characters involved throughout the story.

Upscale Bishie Boys

There are two main styles of bishie costume used in the romance genre: casual sports attire and sports jackets, or sometimes Nehru jackets. Either way, the clothes should be stylish and fashionable.

Upscale clothing brings out the mature side of the character and also puts him at a distinct advantage over younger-looking teenage boys.

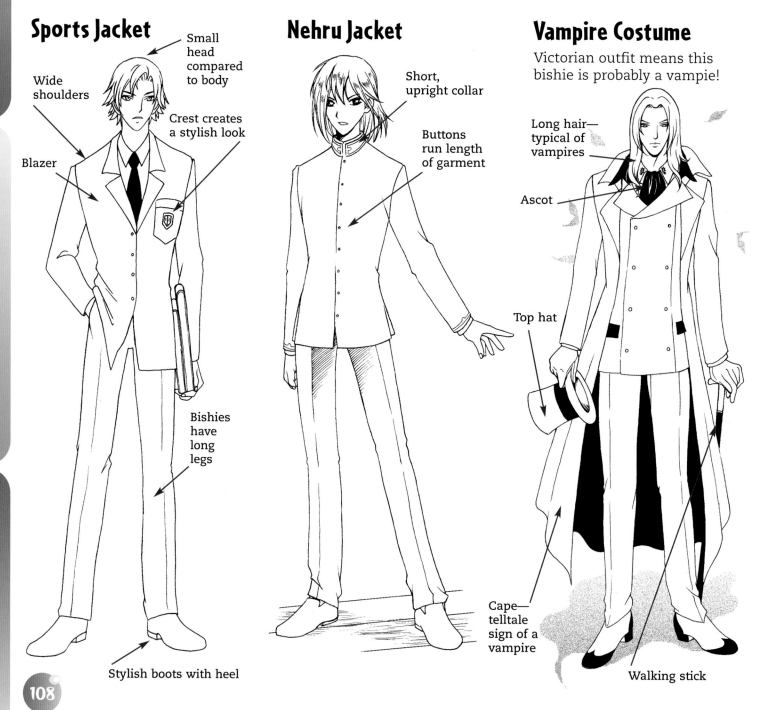

Sports Jacket

Small head compared to body

Wide shoulders

Crest creates a stylish look

Blazer

Bishies have long legs

Stylish boots with heel

Nehru Jacket

Short, upright collar

Buttons run length of garment

Vampire Costume

Victorian outfit means this bishie is probably a vampie!

Long hair— typical of vampires

Ascot

Top hat

Cape— telltale sign of a vampire

Walking stick

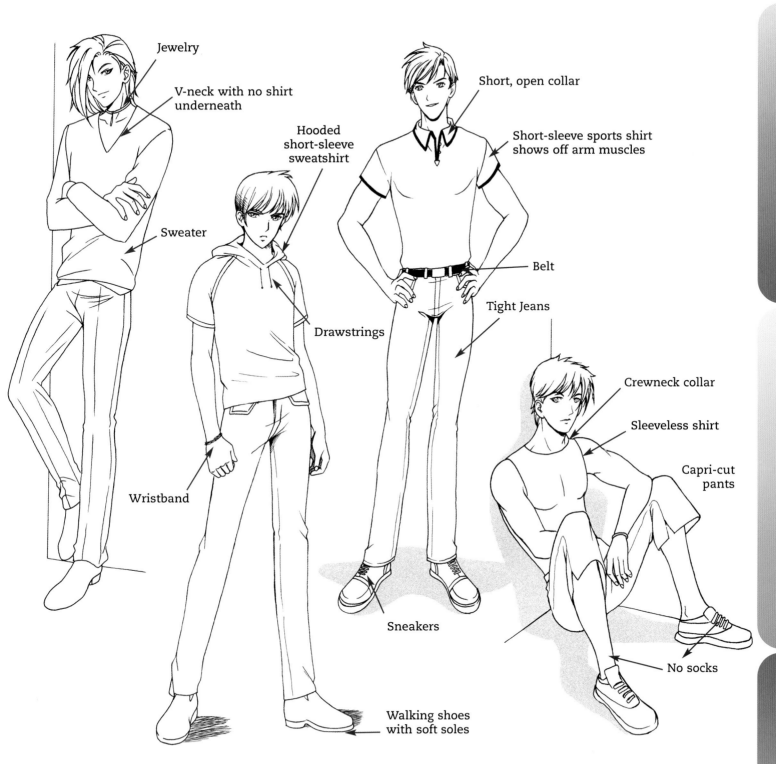

Jewelry

V-neck with no shirt underneath

Sweater

Hooded short-sleeve sweatshirt

Drawstrings

Wristband

Short, open collar

Short-sleeve sports shirt shows off arm muscles

Belt

Tight Jeans

Crewneck collar

Sleeveless shirt

Capri-cut pants

No socks

Sneakers

Walking shoes with soft soles

Casual Bishie Outfits

Bishies, by nature, are quasi-rebels. Even in school they sport a casual look that tells the world that they're individuals.

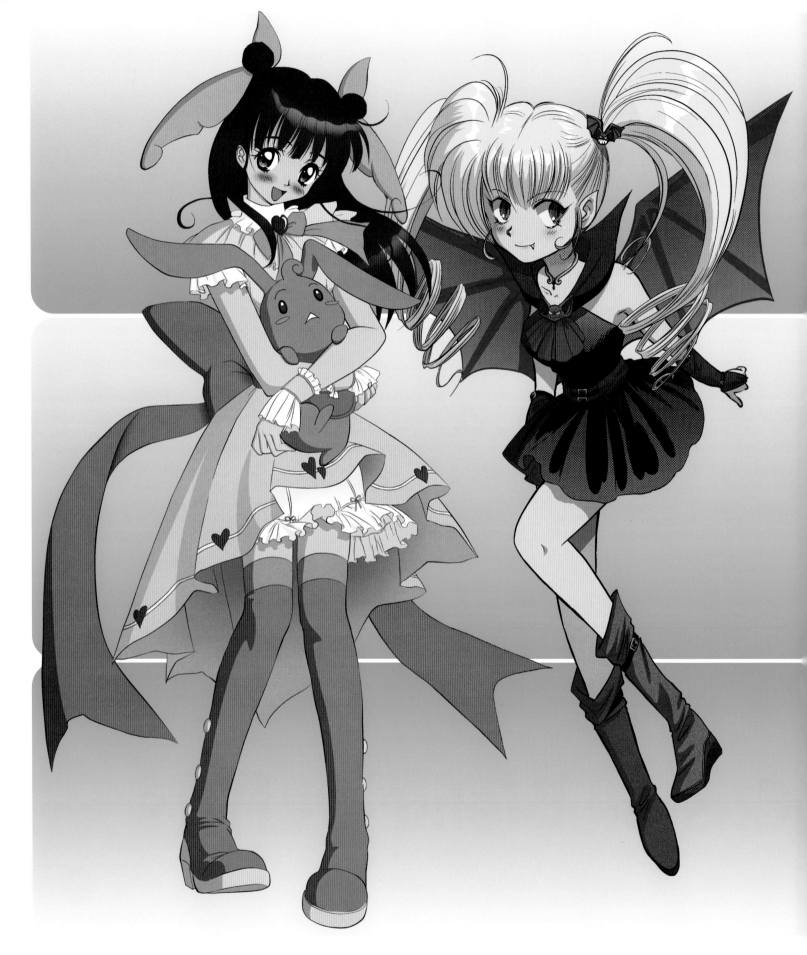

Magical Girls

Magical girls are high school girls who discover they have special powers that transform them into super-glamorous versions of themselves. They can be the supermodel who gets the unattainable guy, a rock star, a beautiful anthro, or anything else a girl might want to be. It's all about wish fulfillment—on a spectacular level. We've already drawn schoolgirls in earlier chapters. Those are the pre-magical girls. This chapter shows them post-transformation.

Classic Magical Girl

Magical girls wear a festival of frills, lace, and ribbons. The classic look includes a short dress with long sleeves and lots of layers. Poofy shoulders and fantasy-style hair are almost always checked off on the list.

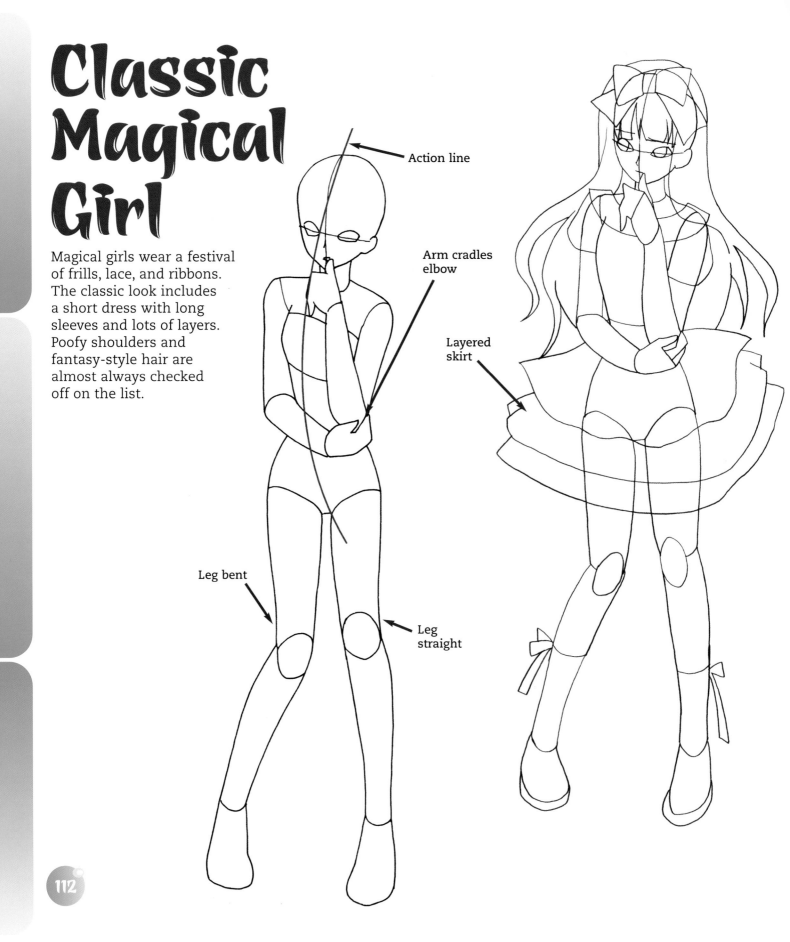

Action line

Arm cradles elbow

Layered skirt

Leg bent

Leg straight

112

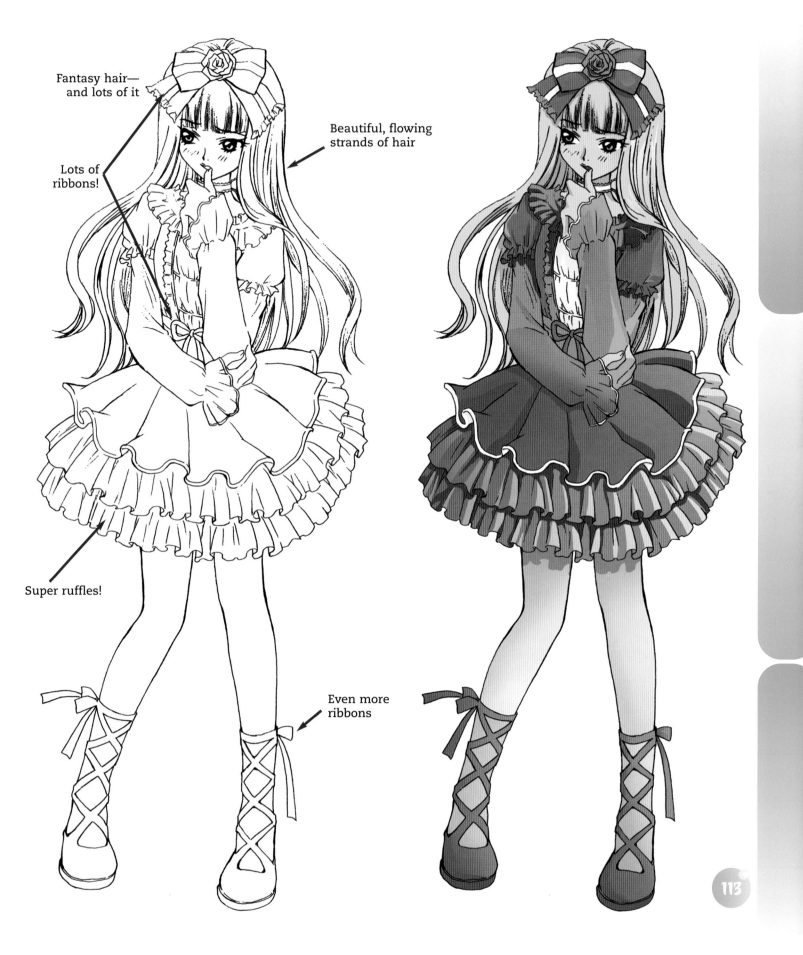

Fantasy hair— and lots of it

Lots of ribbons!

Beautiful, flowing strands of hair

Super ruffles!

Even more ribbons

113

Magical Girl Princess

In this transformation, the girl has become a young princess with a magical locket, perhaps bearing the picture of the boy she loves. Lockets, crystals, rings, bracelets, and other trinkets can add some personality and depth to a character.

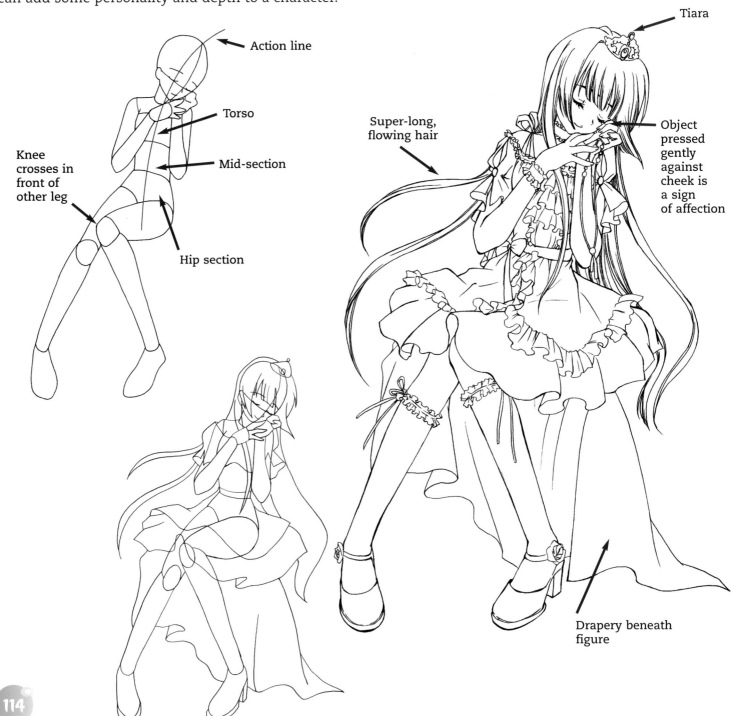

Action line

Torso

Mid-section

Knee crosses in front of other leg

Hip section

Tiara

Super-long, flowing hair

Object pressed gently against cheek is a sign of affection

Drapery beneath figure

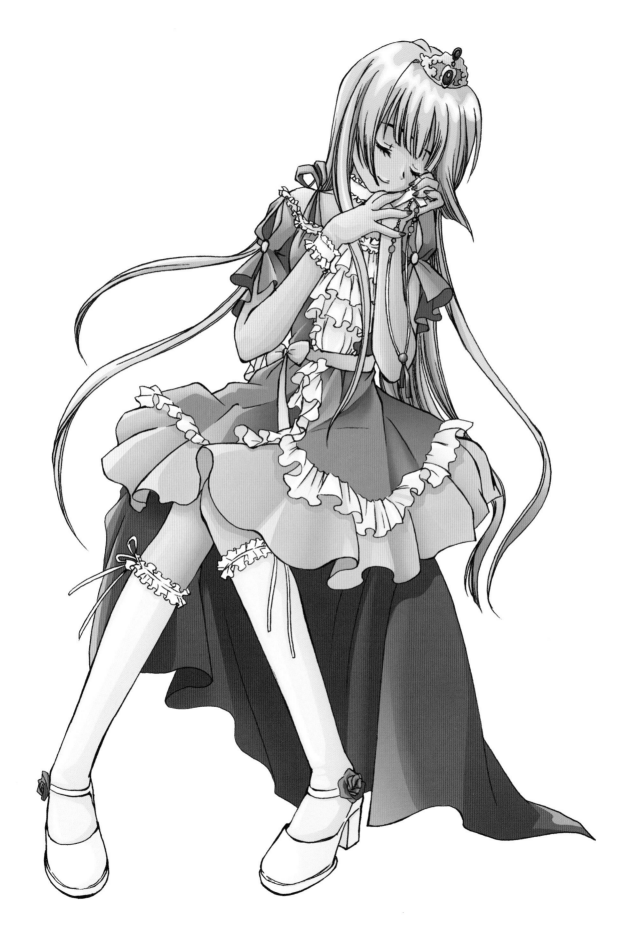

Cat Girls

Magical girls can also be funny, especially if they are silly
"anthros"—animal-human combos. This girl's over-the-top outfit
and exuberance make her a sweet, humorous character.

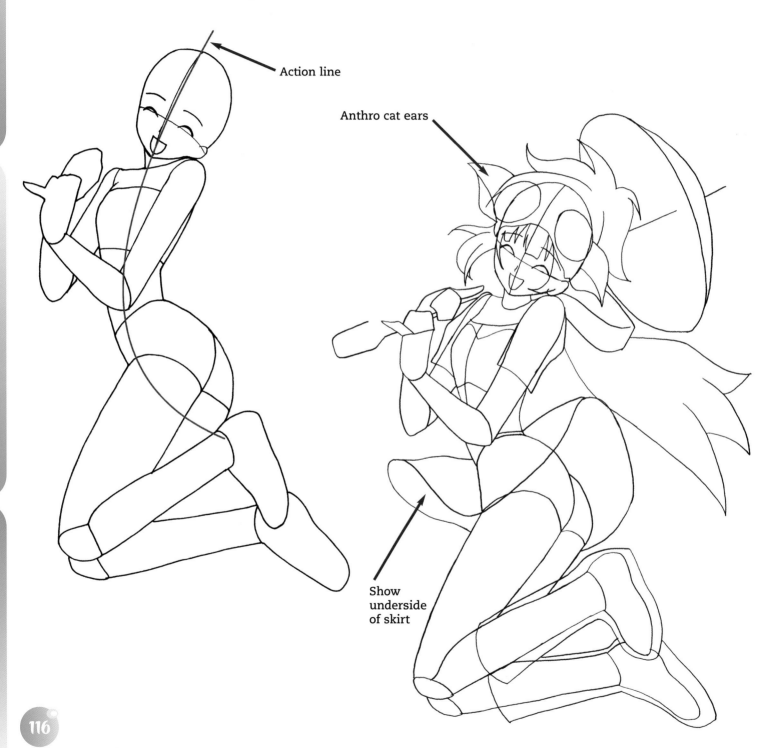

Action line

Anthro cat ears

Show
underside
of skirt

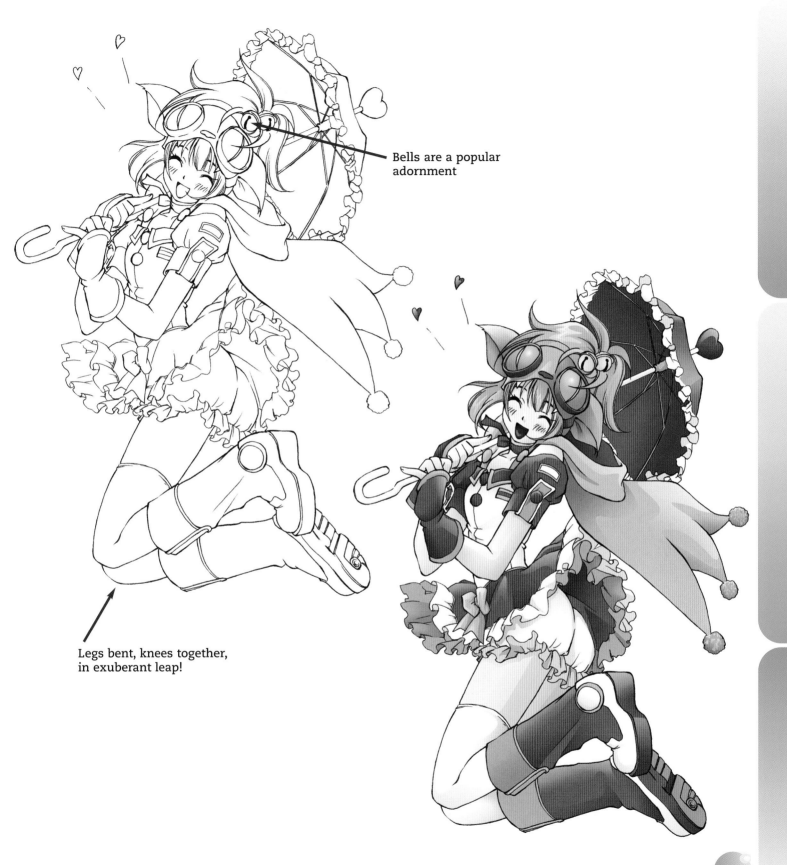

Bells are a popular adornment

Legs bent, knees together, in exuberant leap!

Spotted Cat Girl

Cat girls don't have to be based on housecats. They can be any cat: leopards, tigers, even lions!

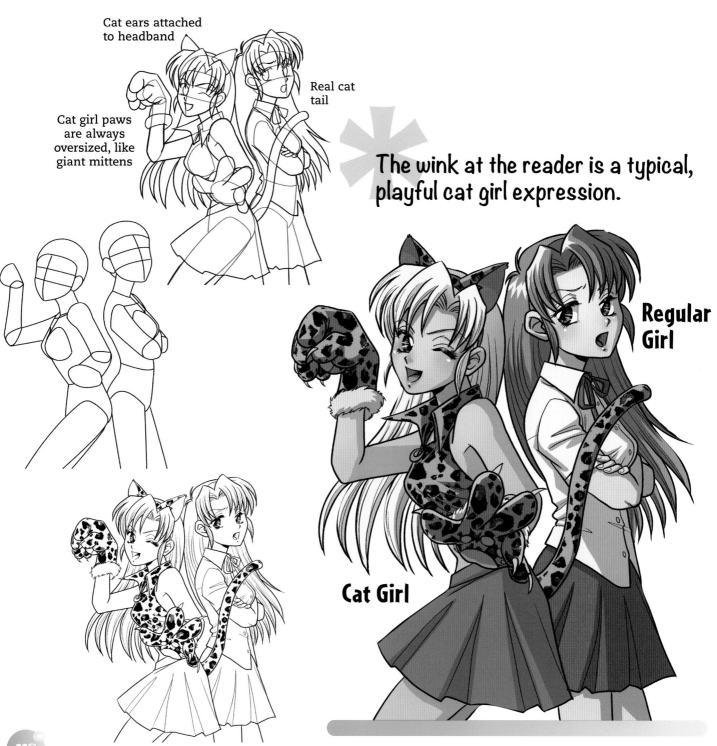

Cat ears attached to headband

Cat girl paws are always oversized, like giant mittens

Real cat tail

The wink at the reader is a typical, playful cat girl expression.

Regular Girl

Cat Girl

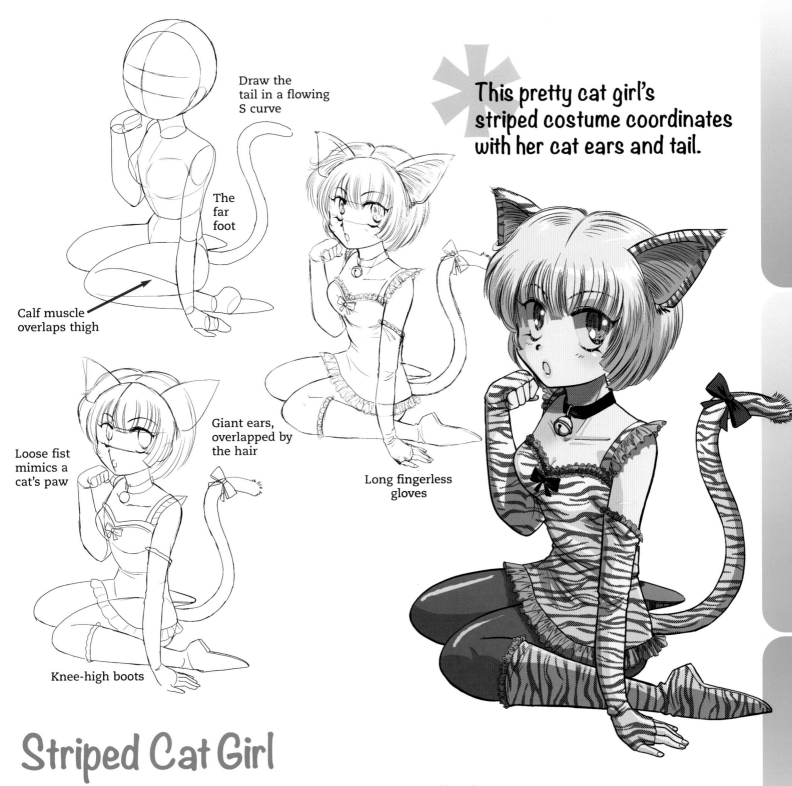

Draw the
tail in a flowing
S curve

The
far
foot

Calf muscle
overlaps thigh

This pretty cat girl's
striped costume coordinates
with her cat ears and tail.

Giant ears,
overlapped by
the hair

Loose fist
mimics a
cat's paw

Long fingerless
gloves

Knee-high boots

Striped Cat Girl

This cute kitty has real cat ears, as well as a tail, but the rest of her is
human. You can go with any combo in creating cat girls. There are no rules,
other than that they have to look cute. The bell hanging from her collar and
one hand curled up like a paw are both reminiscent of a true cat.

Girl Witches

Witches really stand out. Besides their irresistible character designs, they wear striking costumes that pop off the page. And you don't have to slow down the plot to explain how your character got her power. The audience just accepts it, because she's a witch!

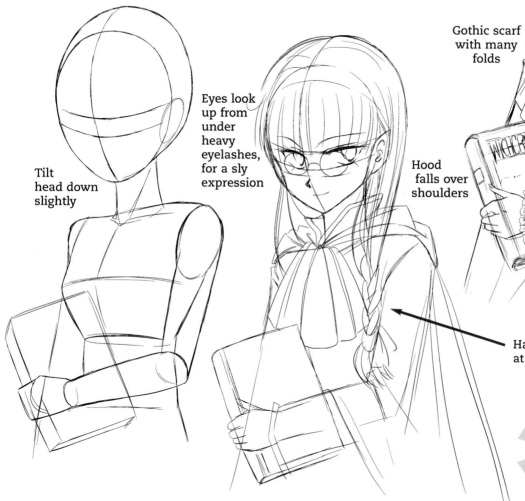

Gothic scarf with many folds

Tilt head down slightly

Eyes look up from under heavy eyelashes, for a sly expression

Hood falls over shoulders

Hair braided just at the ends

Witches can work alone or as part of a coven of witches.

Master of Spells

This is a studious witch who diligently commits all of her spells to memory. How can you tell she's a bookworm? By the heavy tome she's holding and by her glasses, which indicate intelligence when combined with the book.

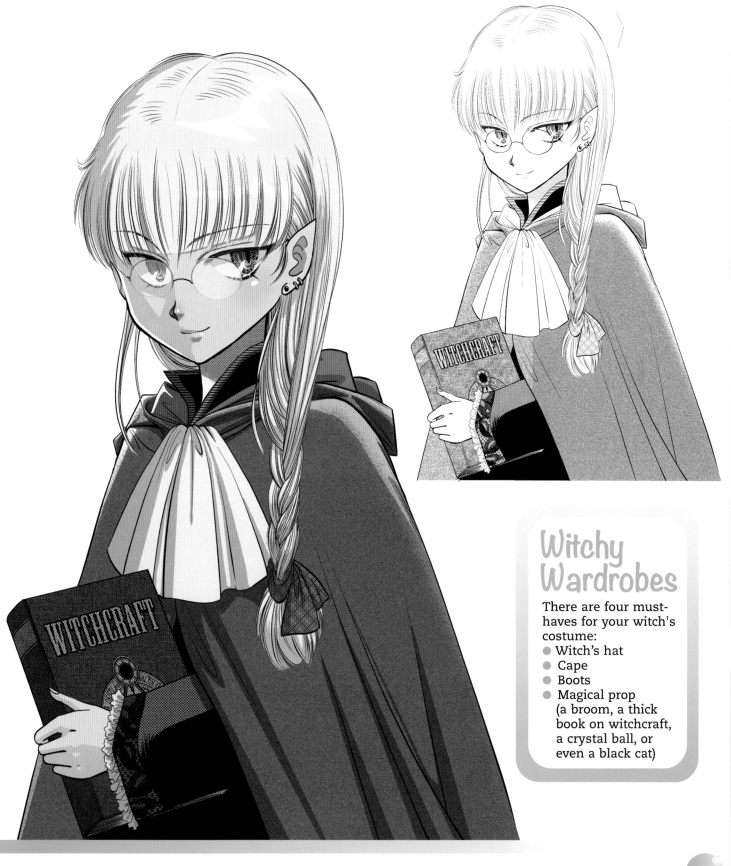

Witchy Wardrobes

There are four must-haves for your witch's costume:
- Witch's hat
- Cape
- Boots
- Magical prop (a broom, a thick book on witchcraft, a crystal ball, or even a black cat)

First-Time Flyer

Afraid of flying? So is she! She can't even find the turn signal on this broom. And forget about parallel parking. Not all witches are good at "witching." She's only just grown into her magical powers, and she's having a difficult time learning to direct them.

Hold on tight to that hat!

Slanted broomstick shows instability

Doggy is all head, with very little body

Legs in chaotic position

By facing in the opposite direction of his mistress, the pup appears to be saying, "No, no! Wrong way!!"

Indicate several folds of the skirt

Big eyes and even bigger ears!!

Show dimension at end of broom

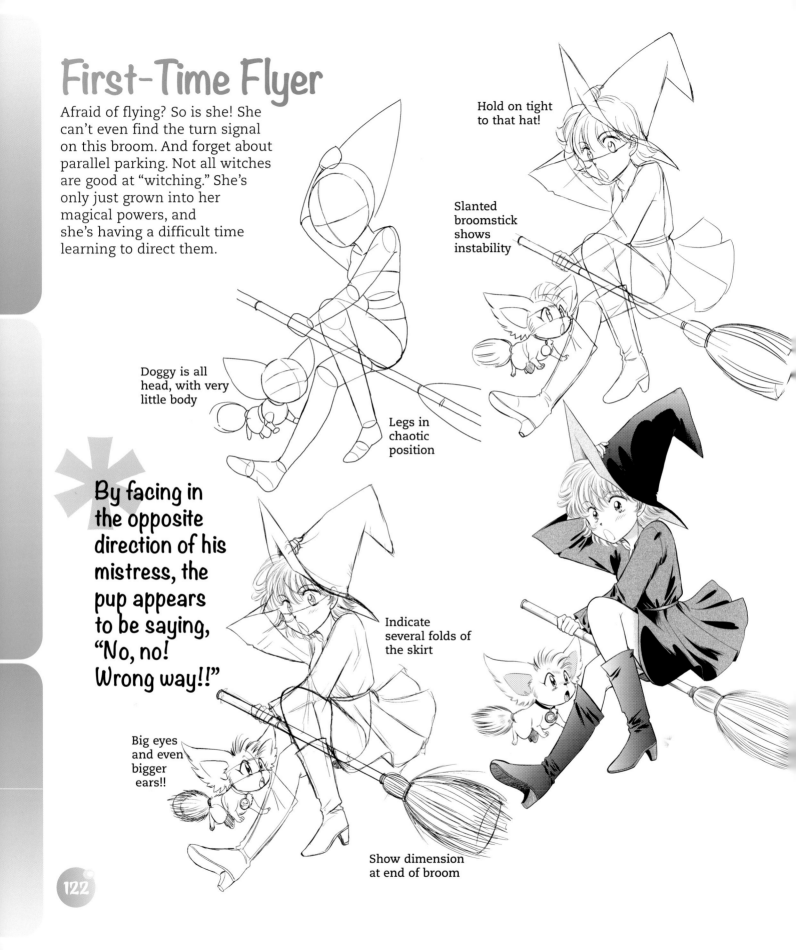

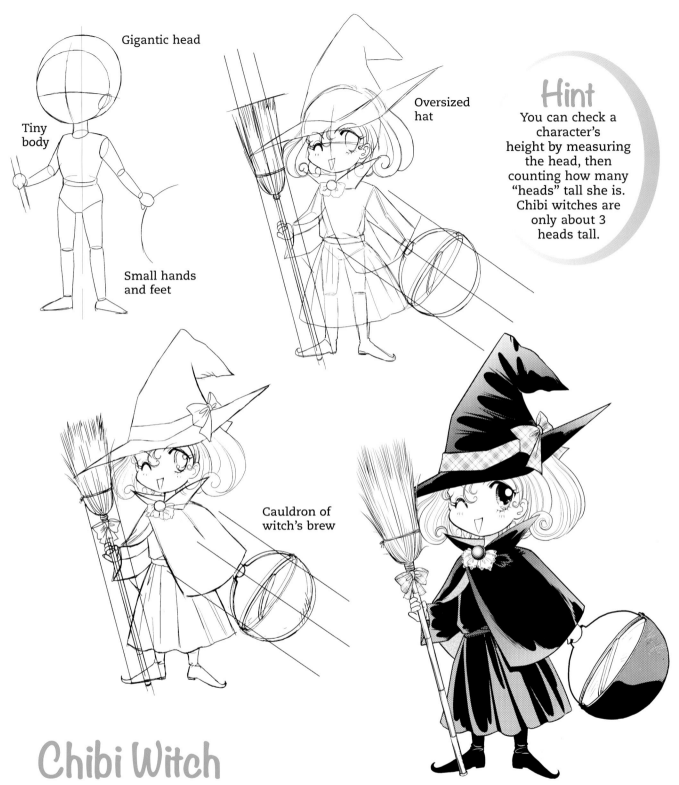

Gigantic head

Tiny body

Small hands and feet

Oversized hat

Hint
You can check a character's height by measuring the head, then counting how many "heads" tall she is. Chibi witches are only about 3 heads tall.

Cauldron of witch's brew

Chibi Witch

Chibis are amazingly adorable, super-small people of the cutest proportions. Short and a little plump, these mischief-makers nonetheless have outsized special powers. Their costumes are usually drawn a bit too big, to emphasize their small stature. This petite witch has tiny hands and feet—and no nose at all! But chibi eyes are always gigantic.

Teen Vampires

These creatures of the night may look pretty, but they harbor evil intent: to sink their teeth into your neck—their version of fast food. They're often drawn with pointed ears and fangs, although you need only show the fangs when an attack is imminent. Bat-like wings are a good look for vampires, but vampires don't walk around with their wings in plain view. Remember, they have to pass themselves off as human. Once the humans have let down their guard, the vampire can strike.

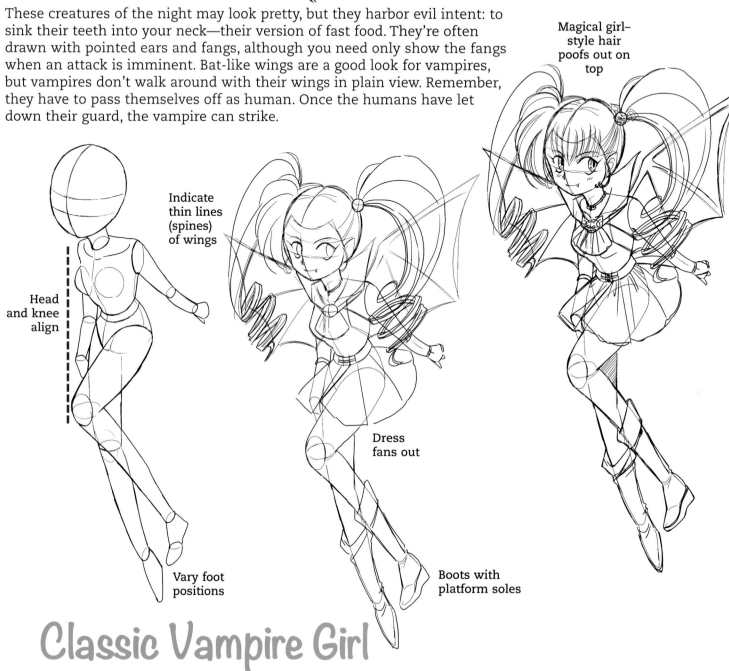

Magical girl–style hair poofs out on top

Indicate thin lines (spines) of wings

Head and knee align

Dress fans out

Vary foot positions

Boots with platform soles

Classic Vampire Girl

She's got everything, from bat wings to fangs and pointed ears. Even her hair ties and her scarf pin are shaped like bats! The magical girl–style hair gives her a fantasy look, which prevents her from looking too evil. Very long hair is more sinister looking than short to mid-length hair or pigtails and ponytails.

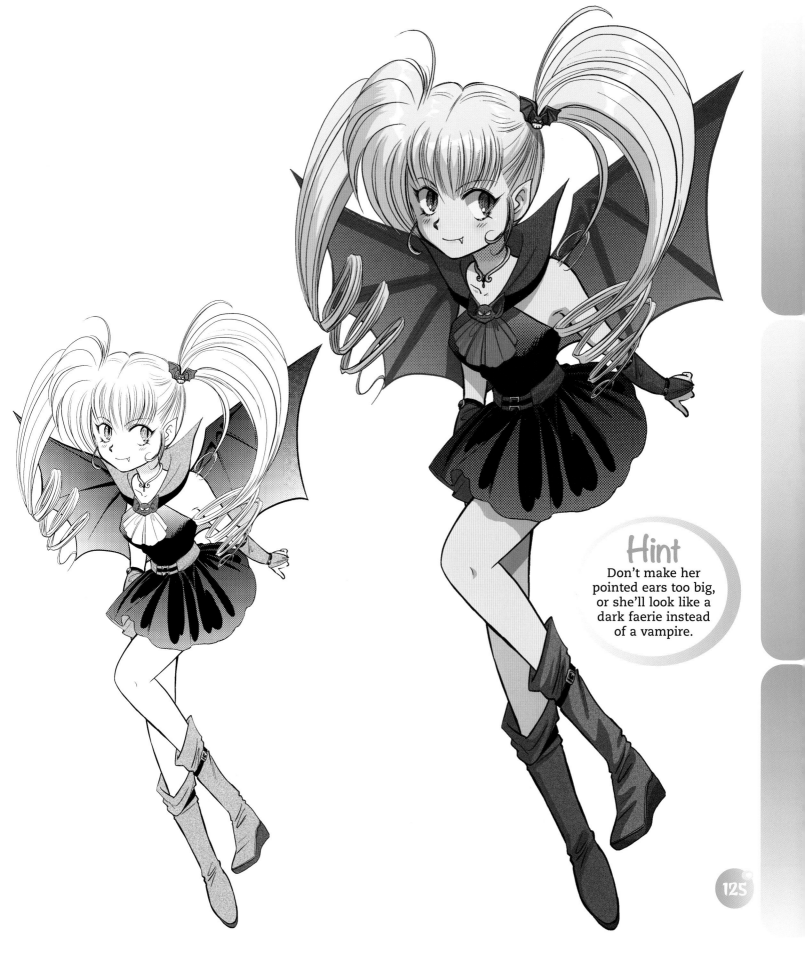

Hint

Don't make her pointed ears too big, or she'll look like a dark faerie instead of a vampire.

125

Schoolgirl Vampire

No one at school wants to be her friend just because she's a vampire. Even her best friends abandon her. What about her boyfriend? What will he say? You, as the story creator, have some decisions to make: Does her boyfriend fight for her or run like a coward? Or is he secretly a vampire, too?

With the school uniform, simple hairdo, and big, teary eyes, we're playing up the human aspect of the girl and trying for sympathy.

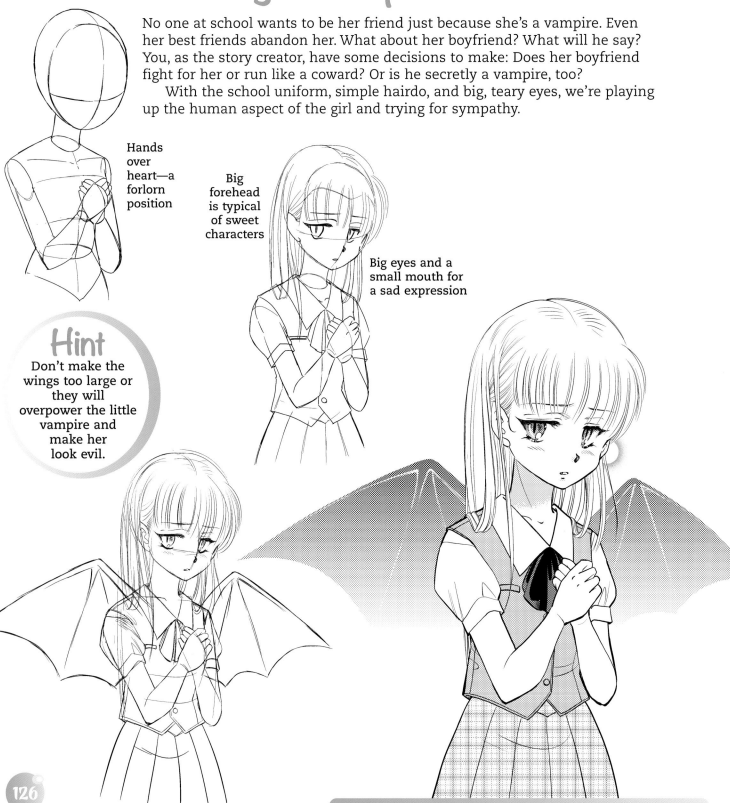

Hands over heart—a forlorn position

Big forehead is typical of sweet characters

Big eyes and a small mouth for a sad expression

Hint

Don't make the wings too large or they will overpower the little vampire and make her look evil.

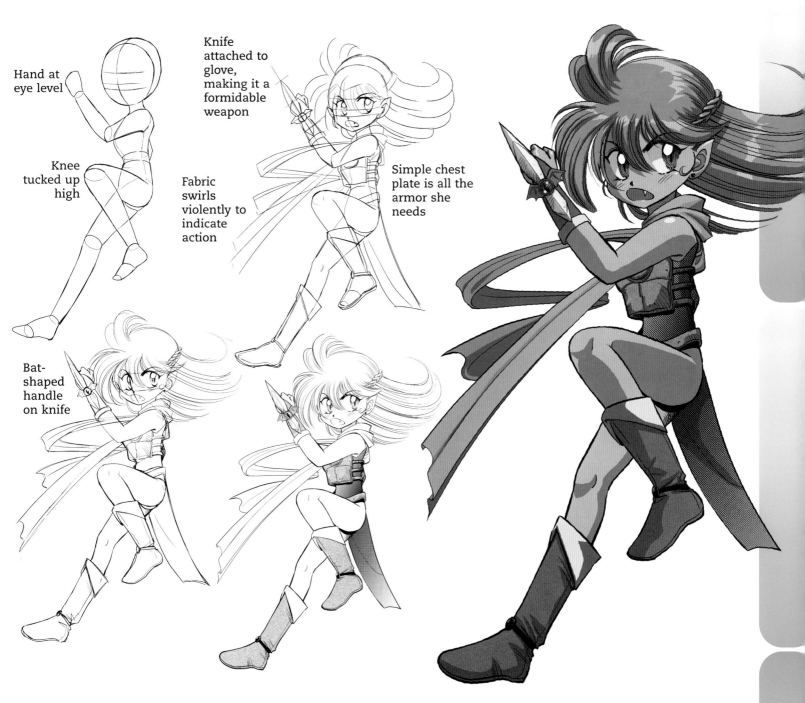

Hand at eye level

Knee tucked up high

Knife attached to glove, making it a formidable weapon

Fabric swirls violently to indicate action

Simple chest plate is all the armor she needs

Bat-shaped handle on knife

Fighting Vampire

She may be small, but she packs a big bite. With just a hint of armor and weaponry, you can turn an ordinary vampire into a fantasy fighting vampire. The sleeveless and legless bodysuit she wears is typical of the fantasy fighter genre. But unlike the usual fantasy fighter, who has long legs and sports a graceful, heroic stance, the vampire girl fighter is shorter and cuter—sort of a cross between a chibi and a fighter.

127

Magical Girls & Their Magical Buddies!

Magical girls often have ultra-adorable little sidekicks. These funny, tiny creatures make irresistible pets. But oh boy, do they cause trouble! They're so cute, though, that you can't stay mad at them for long.

 These critters should be drawn with huge heads and round, pudgy bodies—the kind you just want to squeeze and hug. Spread their eyes far apart to maximize their cuteness.

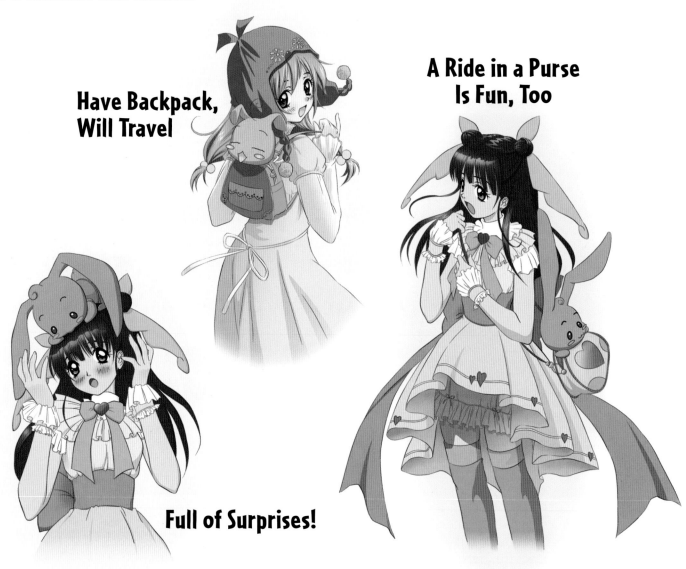

Have Backpack, Will Travel

A Ride in a Purse Is Fun, Too

Full of Surprises!

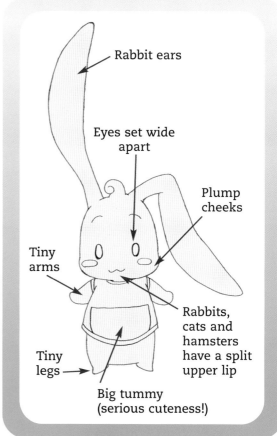

Rabbit ears

Eyes set wide apart

Plump cheeks

Tiny arms

Tiny legs

Rabbits, cats and hamsters have a split upper lip

Big tummy (serious cuteness!)

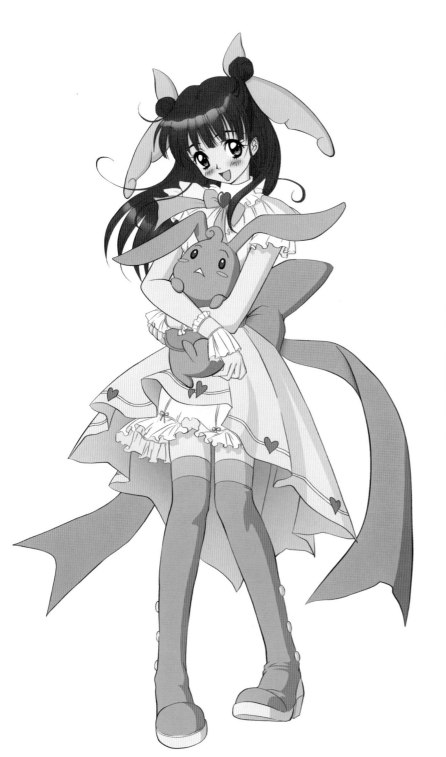

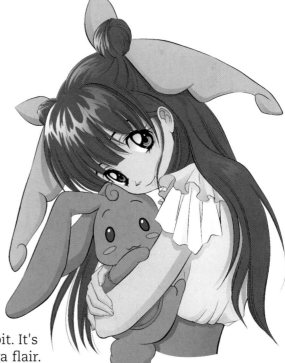

Rabbit-Type Magical Pets

Of course, the magical pet rabbit doesn't look much like a real rabbit. It's a pudgy, cartoon version that has been "tweaked" to give it a manga flair. It has big eyes, a small mouth and a tiny nose (if it has a nose at all).

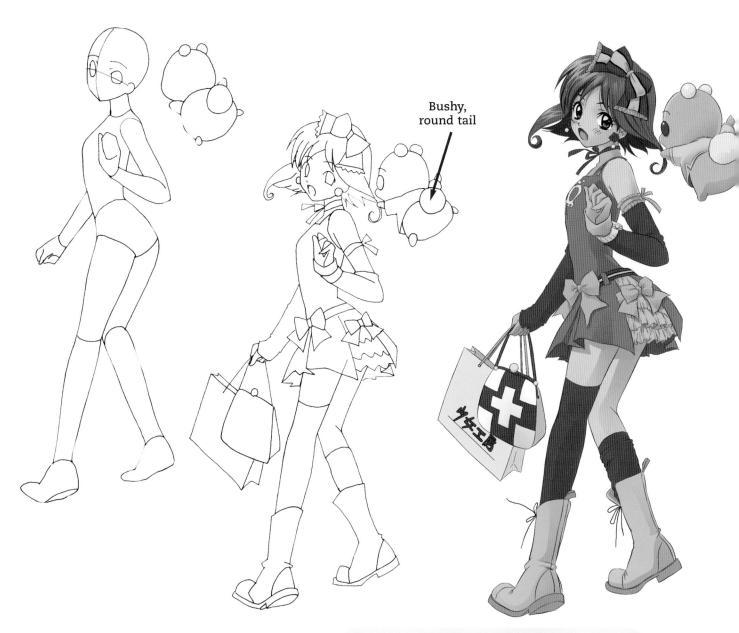

Bushy,
round tail

Hamster-Type
Magical Pets

Any small, woodland creature—
chipmunks, gophers, mice,
hedgehogs—can be turned into
a cute fantasy pet.

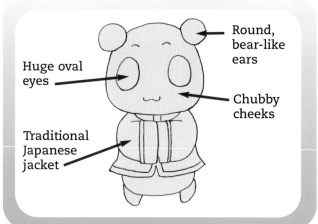

Round,
bear-like
ears

Huge oval
eyes

Chubby
cheeks

Traditional
Japanese
jacket

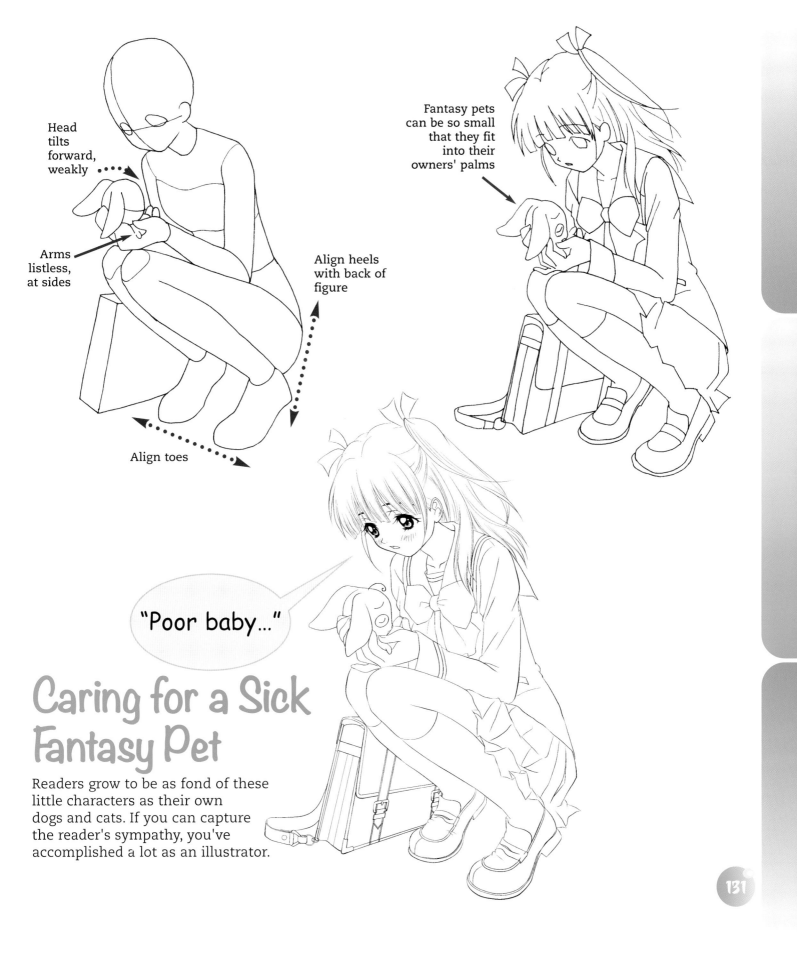

Head tilts forward, weakly

Arms listless, at sides

Align heels with back of figure

Align toes

Fantasy pets can be so small that they fit into their owners' palms

"Poor baby..."

Caring for a Sick Fantasy Pet

Readers grow to be as fond of these little characters as their own dogs and cats. If you can capture the reader's sympathy, you've accomplished a lot as an illustrator.

131

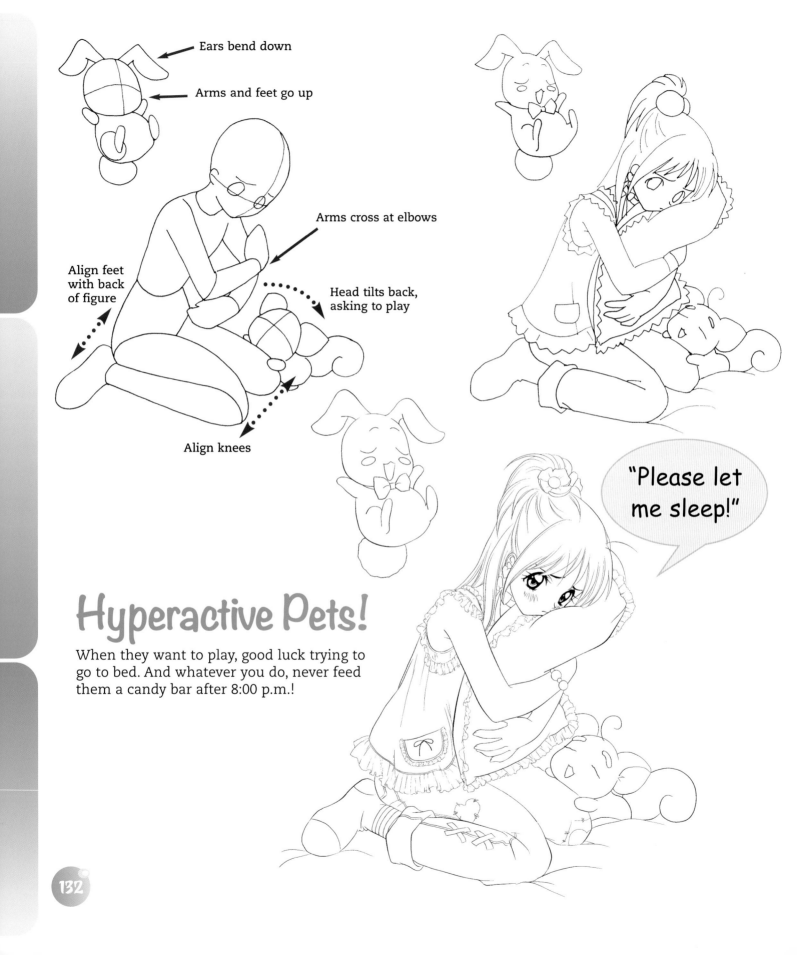

Ears bend down

Arms and feet go up

Arms cross at elbows

Align feet with back of figure

Head tilts back, asking to play

Align knees

Hyperactive Pets!

When they want to play, good luck trying to go to bed. And whatever you do, never feed them a candy bar after 8:00 p.m.!

"Please let me sleep!"

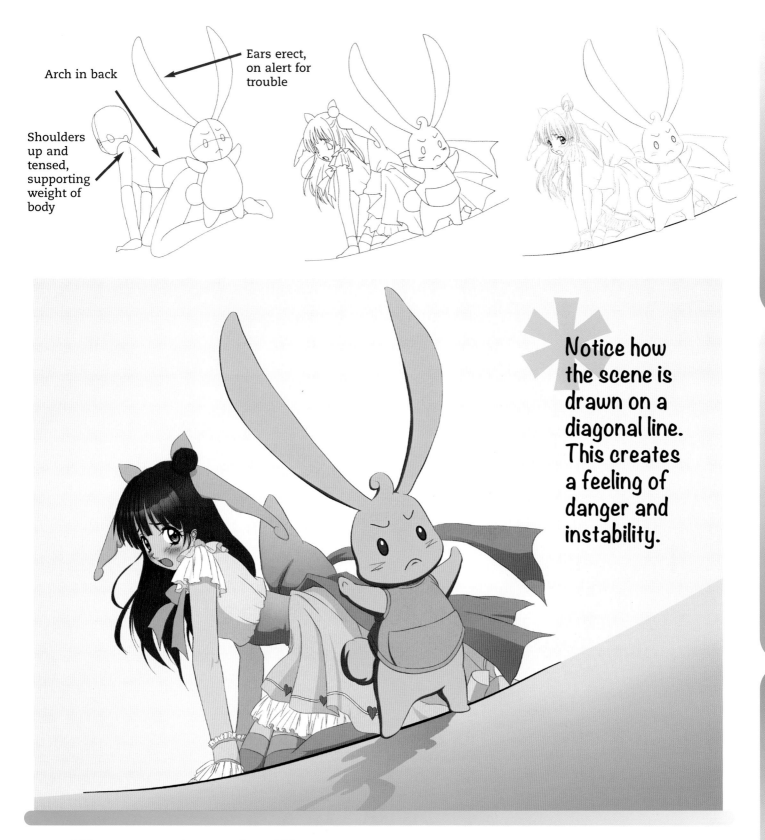

Arch in back

Ears erect, on alert for trouble

Shoulders up and tensed, supporting weight of body

* Notice how the scene is drawn on a diagonal line. This creates a feeling of danger and instability.

Brave Little Pet

If you're ever in trouble and your friends all run for cover, there's one pal who will never abandon you!

More Cool Bishies

Earlier in this book we took an in-depth look at bishies, focusing on characters that typically appear in the romance genre. But there are many more types of bishies that you can call on to appear in your graphic novel. Some of these characters cross over from other genres, like fantasy. In this chapter, we draw some of these guys and also cover in detail the very popular Mysterious Boy, putting him in some common romance scenarios.

Bishie Fantasy Fighter

Bishies are extremely popular characters, and although they are most commonly seen in the romance genre, they also cross over into other popular categories of manga. For example, these dashing characters are often featured in the world of fantasy manga alongside warriors, faeries, and knights. They are also well represented in the occult genre where they appear as seductive vampires.

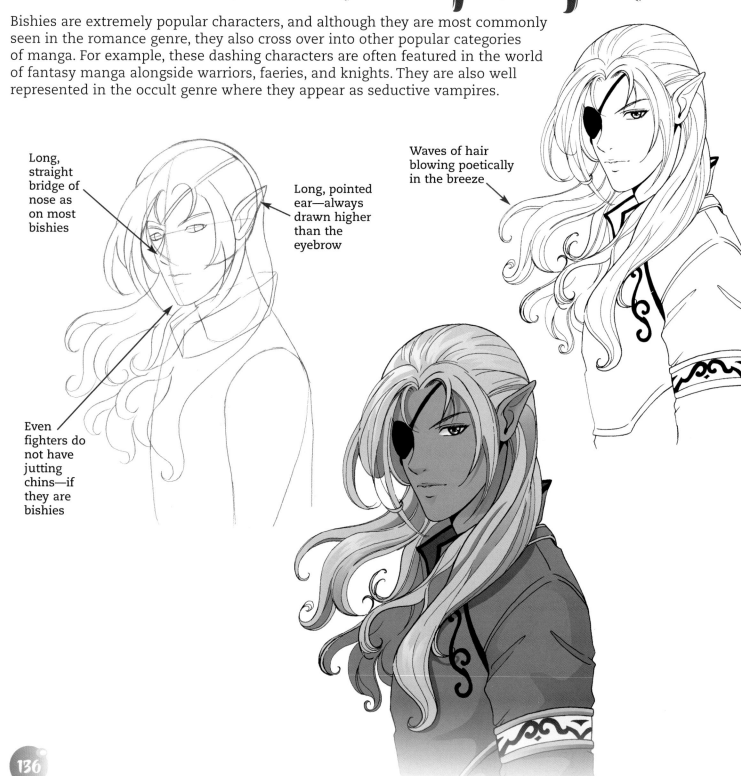

Long, straight bridge of nose as on most bishies

Long, pointed ear—always drawn higher than the eyebrow

Waves of hair blowing poetically in the breeze

Even fighters do not have jutting chins—if they are bishies

Samurai Bishie

Usually you'll see a character like this as a samurai in a dramatic story or a period piece. He's a popular and noble bishie who also crosses genres. There are futuristic and even teen adventure genre samurai bishies.

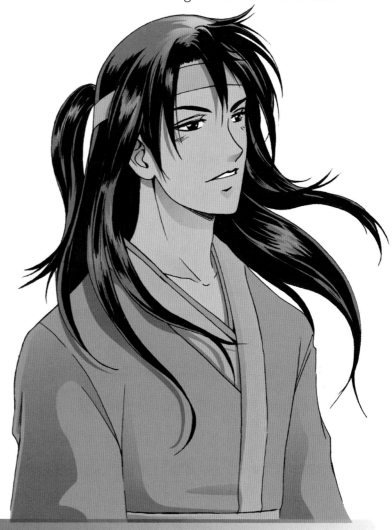

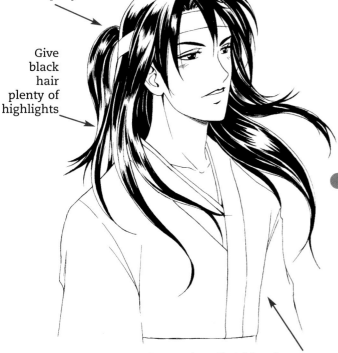

Samurai ponytail

Give black hair plenty of highlights

Samurai outfit (either heavy canvas or silk, depending on rank)

For elegantly drawn bishies only, show an indentation, also called a "cupid's bow," in the middle of the upper lip.

Emos

For some, the teen years are a time of angst and personal rebellion. Emos are emotional characters, somewhere between punks and goths. They come across like the "minor notes" on a piano. But unlike punks and goths, they're not antisocial or devoid of fashion sense. Their outfits should be strategically put together, even if they are extreme. They're more like characters on the fringe. They're not part of the in-crowd, but pride themselves on being loners—who hang out with other emos!

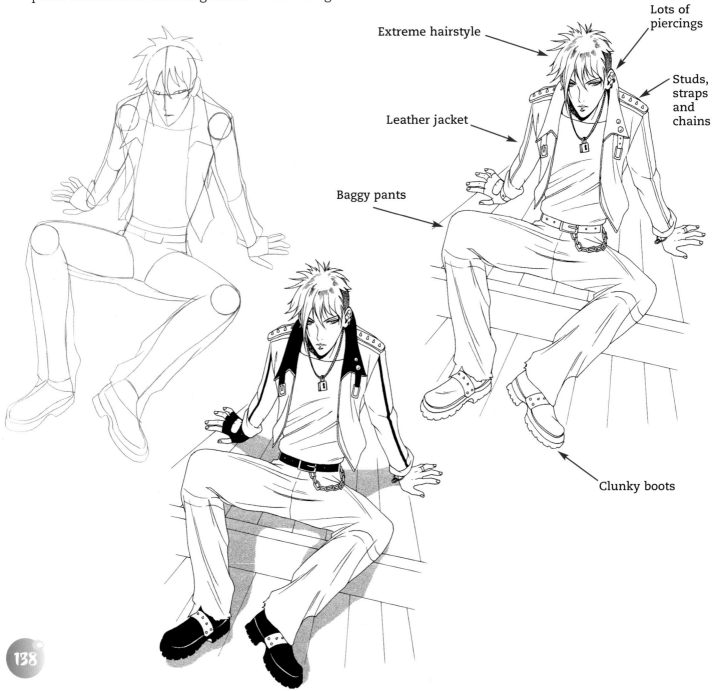

Extreme hairstyle

Lots of piercings

Studs, straps and chains

Leather jacket

Baggy pants

Clunky boots

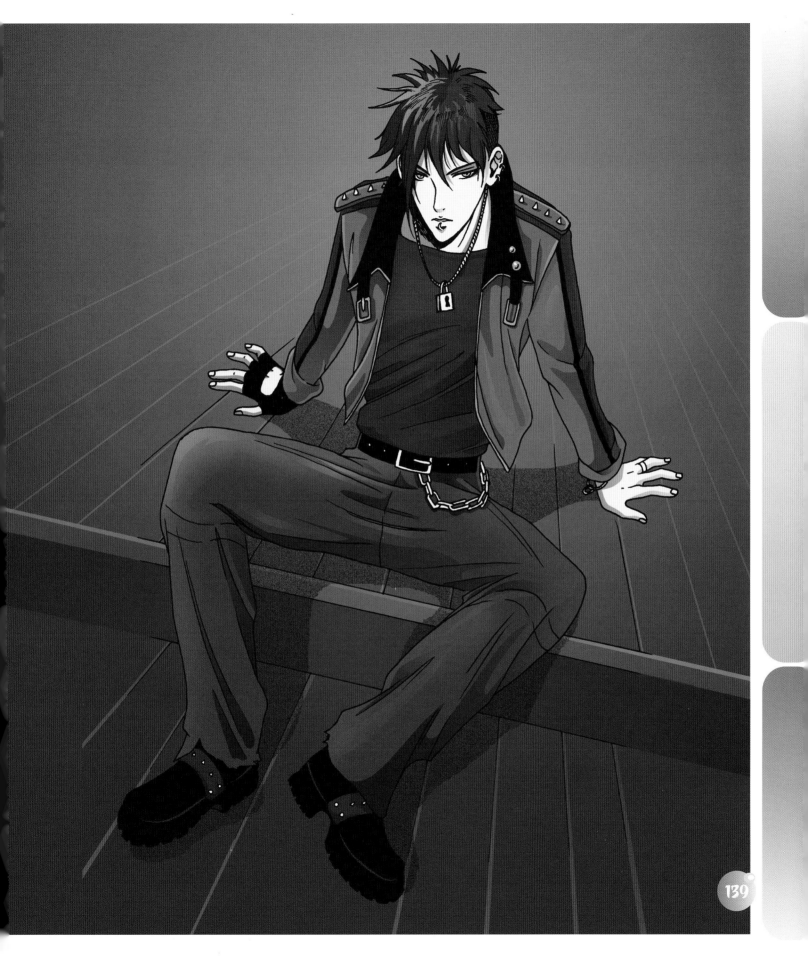

Spirit of Light

This type of character is more popular in the fantasy genre than the romance genre. However, it's common in manga to blend genres, and fantasy-romance stories are common. Maybe you can come up with an idea for a romance story that uses a guiding angel as a plot device!

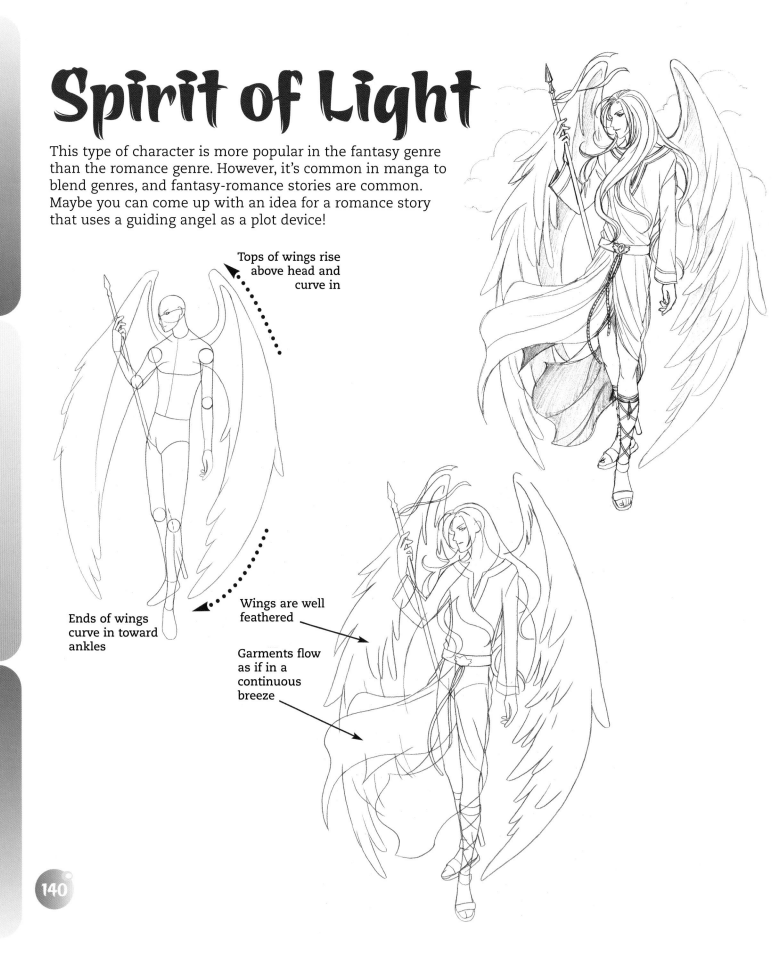

Tops of wings rise above head and curve in

Ends of wings curve in toward ankles

Wings are well feathered

Garments flow as if in a continuous breeze

He's No Angel!

It may seem counterintuitive that such a peaceful, serene-looking chap should also be such a capable fighter. But to my way of thinking, the Japanese writers who invented this type are really on to something that the comic book writers in the West have overlooked. If you have a huge lug of a guy who loves to fight and wins lots of battles, well, there's no great surprise there. However, if you have a tranquil spirit who shows up only when disturbed by injustice and won't back down from a challenge, then you're going to wonder if this spirit guy is crazy. Or is he really more formidable than he appears? Readers will certainly want to stick around and find out!

These angel-types are typically aggressive, vicious fighters when provoked and are tough to defeat!

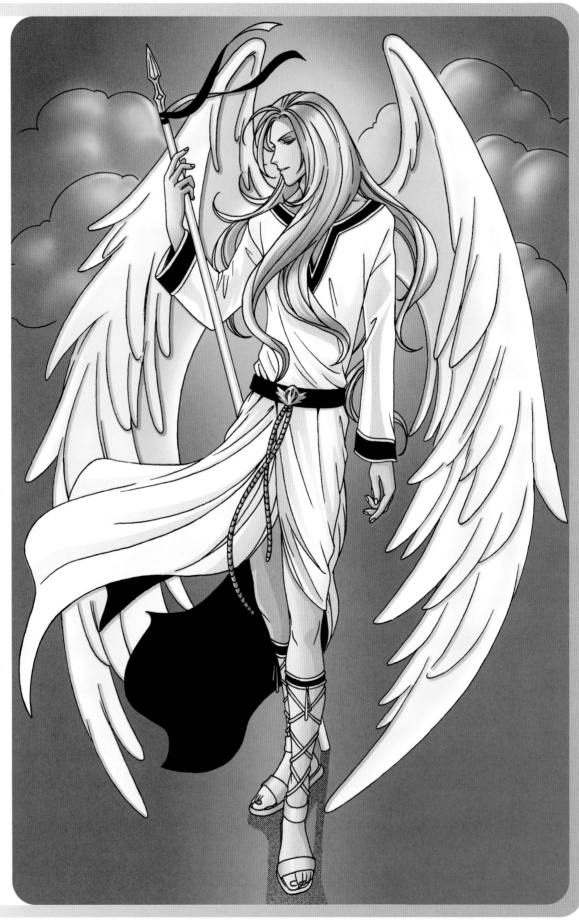

The Mysterious Boy

He's from out of town. We don't know where. What's his deal? No one knows. There's a dark charisma about him and a vague sense of danger. He's not looking for trouble, but if you start something with him, he can back it up with his expert martial arts skills. All of this makes him an irresistible character to readers. Whenever he's on the page, you've just got to keep reading to see what's going to happen next, because the fuse has been lit, and eventually he'll explode into action, breaking a few hearts along the way.

Mysterious Boy's Eyes

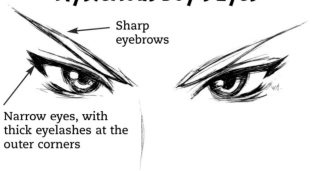

Sharp eyebrows

Narrow eyes, with thick eyelashes at the outer corners

More About Eyes

Here's how to draw the eyes of the unfortunate girl who has fallen for the Mysterious Boy.

Caring Eyes

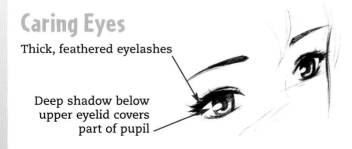

Thick, feathered eyelashes

Deep shadow below upper eyelid covers part of pupil

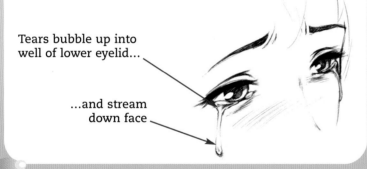

Tears bubble up into well of lower eyelid...

...and stream down face

The Heartbreaker
Some girls will try, but they can never possess him.

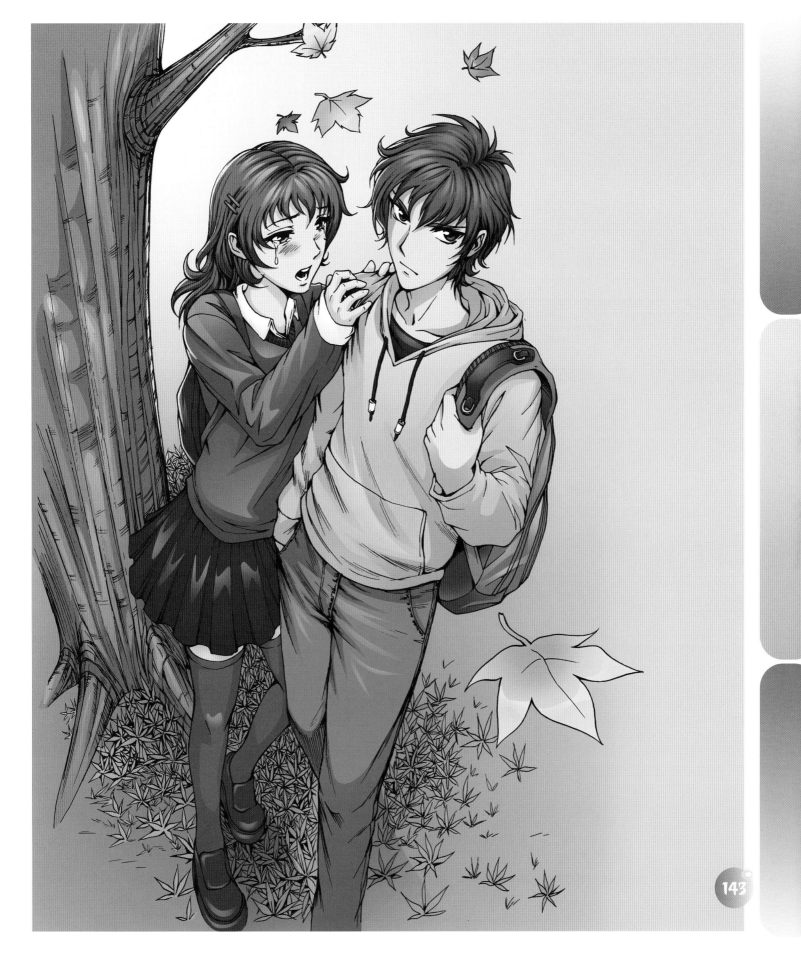

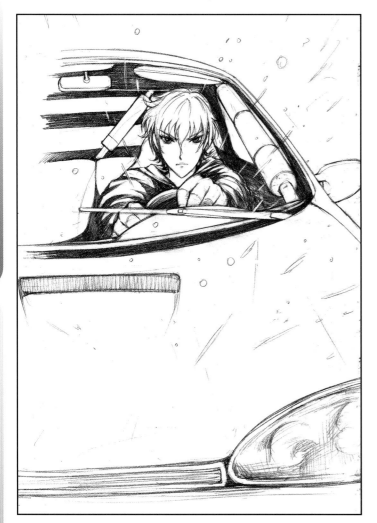

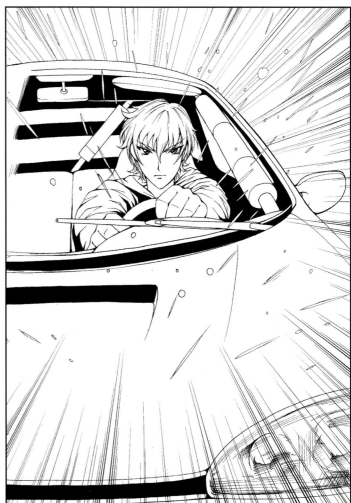

The Bad Boy

The Bad Boy is a version of the Mysterious Boy, just ratcheted up a notch. This is the guy your mother warned you to stay away from. But she didn't say you couldn't read about bad boys in graphic novels, did she?

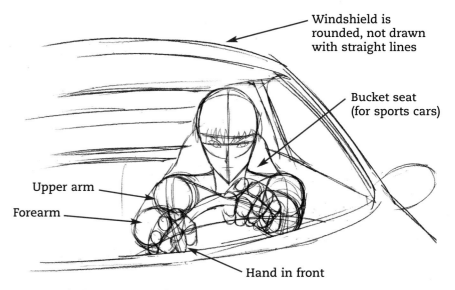

Windshield is rounded, not drawn with straight lines

Bucket seat (for sports cars)

Upper arm

Forearm

Hand in front

***** "Layer" the sections of the arm when drawing it in perspective (foreshortened).

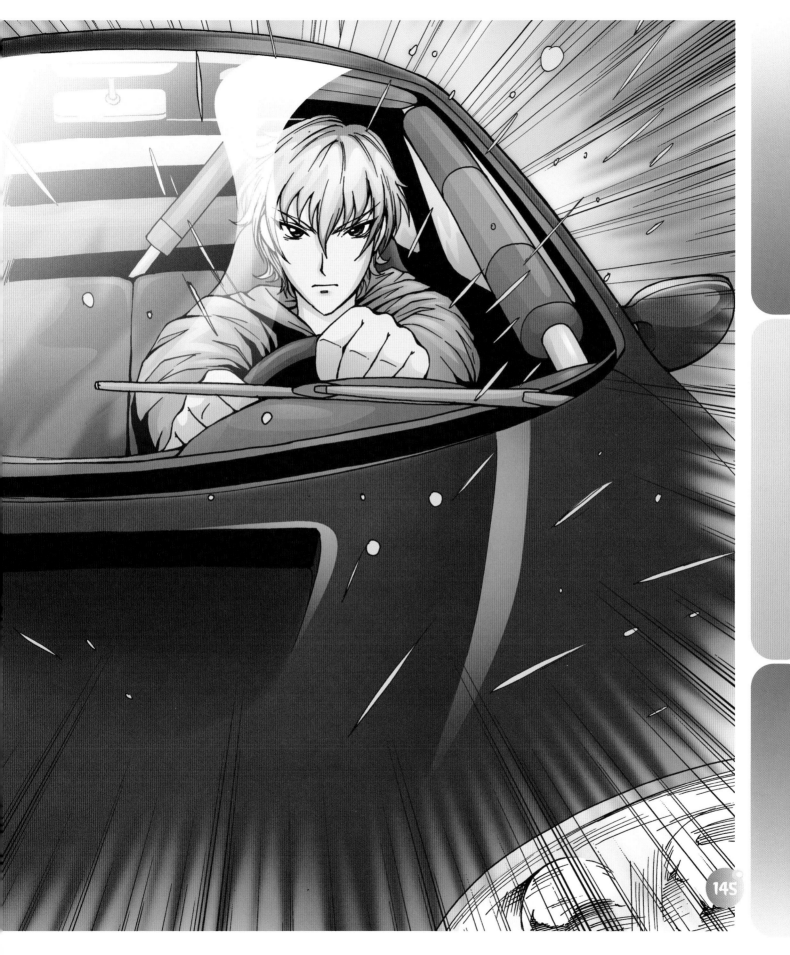

Attention Magnet

The mysterious boy may be the new guy on campus, but he is usually the focus of attention. Among the girls, that is. The boys can't stand him!

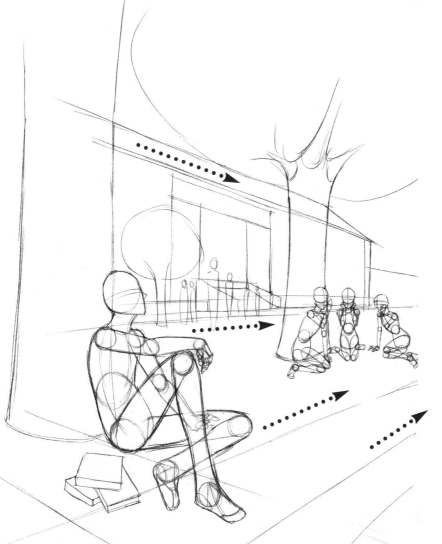

Dynamic Compositions

Professional manga artists, like all cartoonists, try to create depth in their scenes by layering the foreground, middle ground, and background. They also "weigh" both the left- and right-hand sides of the page. Sometimes it looks better if both sides have the same weight—the same amount of "stuff" (symmetry); at other times, it looks better if one side weighs more than the other (asymmetry). Third, drawing a scene along diagonals creates a more dynamic look. Here, in the rough sketch for this scene, you can see the diagonal sketch guidelines (also called vanishing lines) that have been used as the basis of the scene. That is why the group of girls appears higher on the page than the bishie boy.

When drawing multiple characters, each expression must differ from the others. Remember the rule: "Repeating is cheating!"

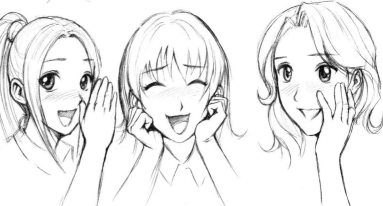

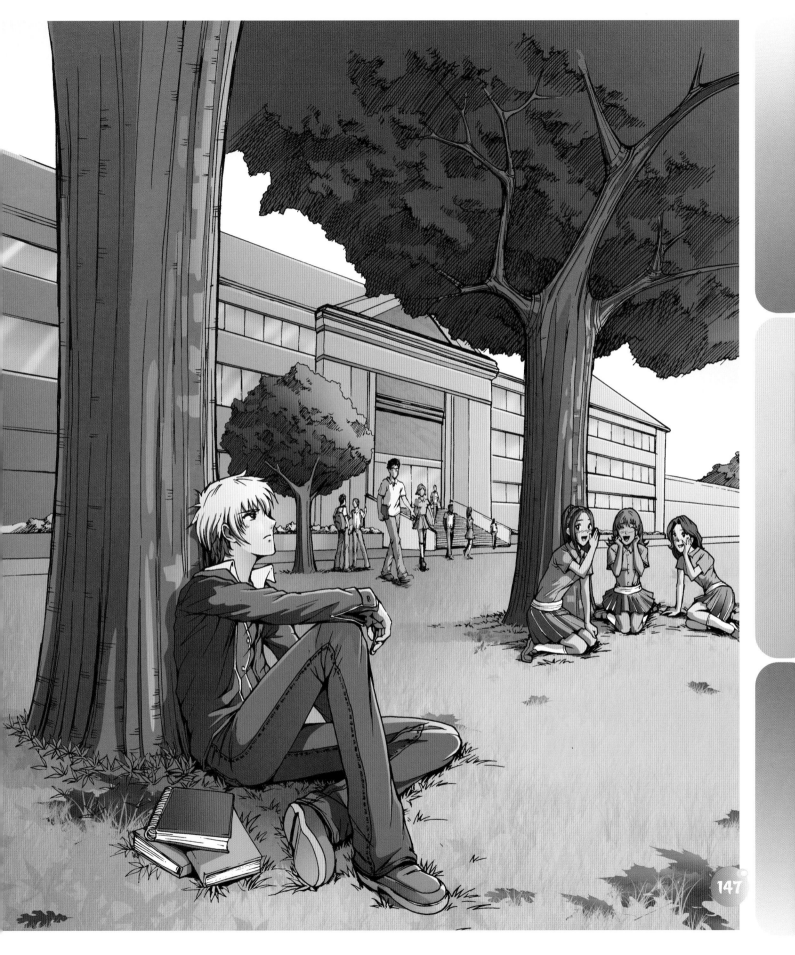

New Kid in Town

Wherever the New Kid goes, he makes waves. He doesn't move over for anyone—you make room for him. If you're the captain of the baseball team, it doesn't mean anything to him. The boys resent him. The girls are strangely intrigued. Here he is walking down the school hallway, bumping right past the surprised school jock, who is used to intimidating everyone else.

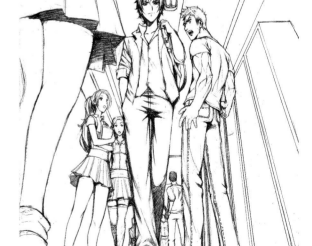

Up & Down Composition

Sometimes the sketch lines in a drawing will converge in two different points, called vanishing points. Vanishing point A is a point chosen at any randomly selected height over the character, but directly in the center of the page. All of the characters' bodies are drawn so that they converge along these lines toward this vanishing point. The lines of the walls and the ceiling of the school hallway converge, like sets of railroad tracks, into the distance, and finally disappear at vanishing point B.

Vanishing point A

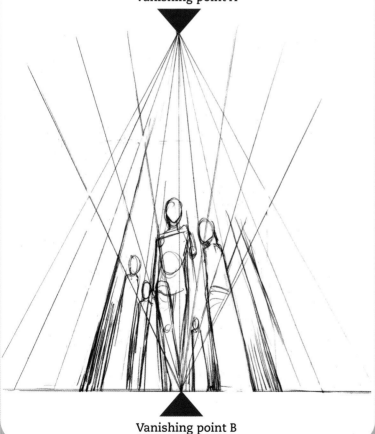

Vanishing point B

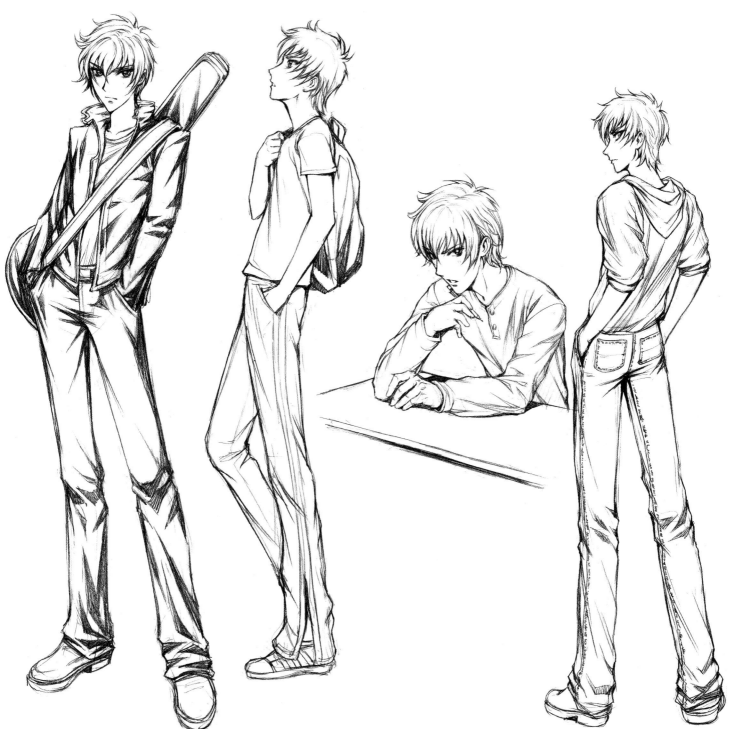

Mysterious Boy Outfits

The mysterious boy is always from "the wrong side of the tracks." Therefore, he doesn't wear the school uniform, but instead wears casual clothes, perhaps a bit too casual. He can appear to have a lack of respect for school, but he is never sloppy or a goth. He's got to always look good enough to maintain that "cool" factor. Here are some examples.

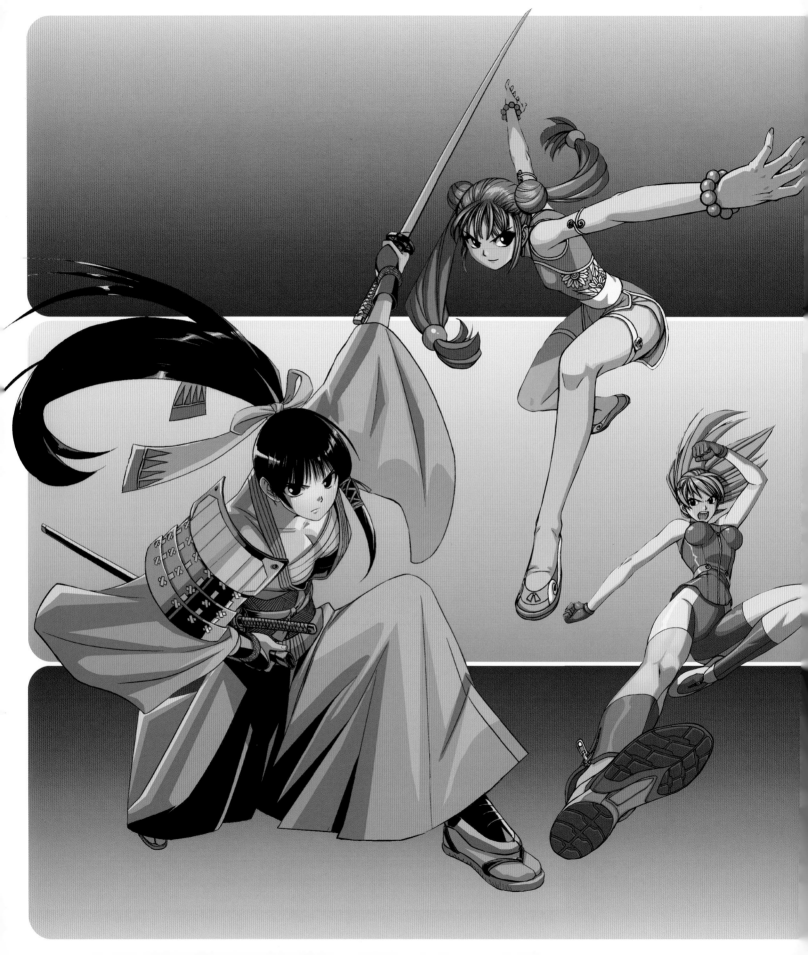

Adventure Girls

Now we move on to adventure characters—the ones who appear in all sorts of action manga. These fearless fighters run the gamut from primitive gals of the jungle to sci-fi fighters to dark angels. Some use their fighting skills on the side of justice and all that is right and good, while others have more nefarious motives. Whether battling beasts or swordfighting evil samurai, they give the guys in manga a run for their money.

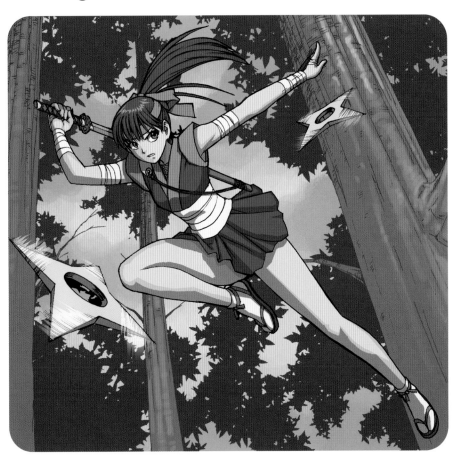

Girl of the Jungle

Lots of manga adventure stories feature brave fighter girls. This girl is an expert with primitive weapons. With that boomerang, she can take on any adversary. She also has a special ability to communicate with animals. She can hear their thoughts, and they understand hers.

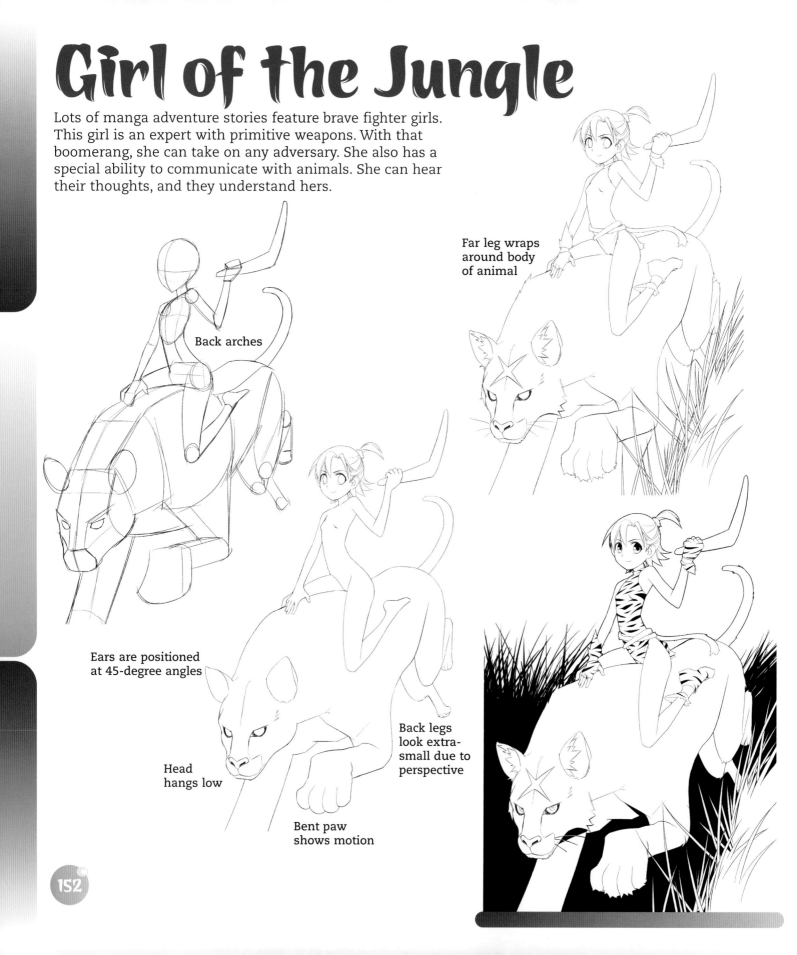

Back arches

Far leg wraps around body of animal

Ears are positioned at 45-degree angles

Head hangs low

Bent paw shows motion

Back legs look extra-small due to perspective

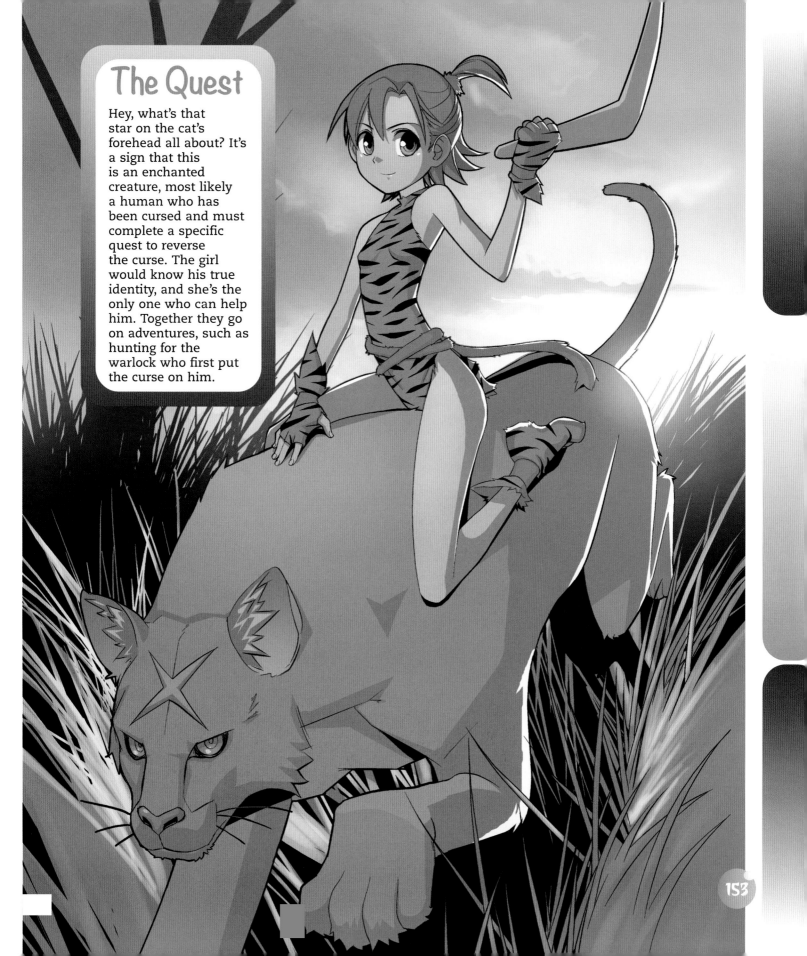

The Quest

Hey, what's that star on the cat's forehead all about? It's a sign that this is an enchanted creature, most likely a human who has been cursed and must complete a specific quest to reverse the curse. The girl would know his true identity, and she's the only one who can help him. Together they go on adventures, such as hunting for the warlock who first put the curse on him.

Beast Slayer

Her weapon of choice is a flamethrower with a multidirectional stream. She used to hate hearing the screams of those ugly, flying things when the flames would fry 'em. Did she stop hunting them? Nah. She got some earplugs.

Hint

Notice how the bad guys are evenly spaced out across the image, but for variety, each one is placed at a different distance from the slayer.

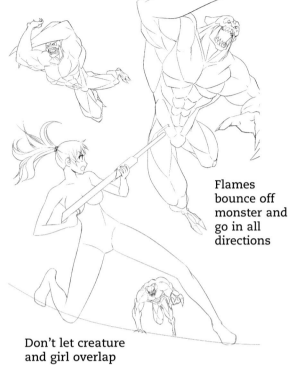

Flames bounce off monster and go in all directions

Don't let creature and girl overlap

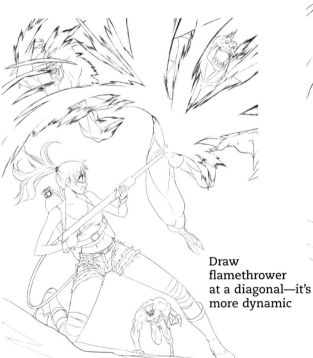

Draw flamethrower at a diagonal—it's more dynamic

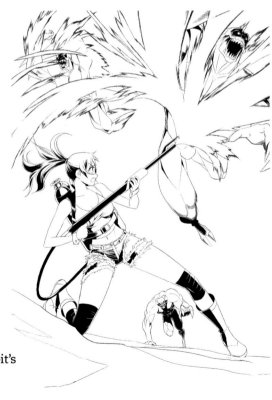

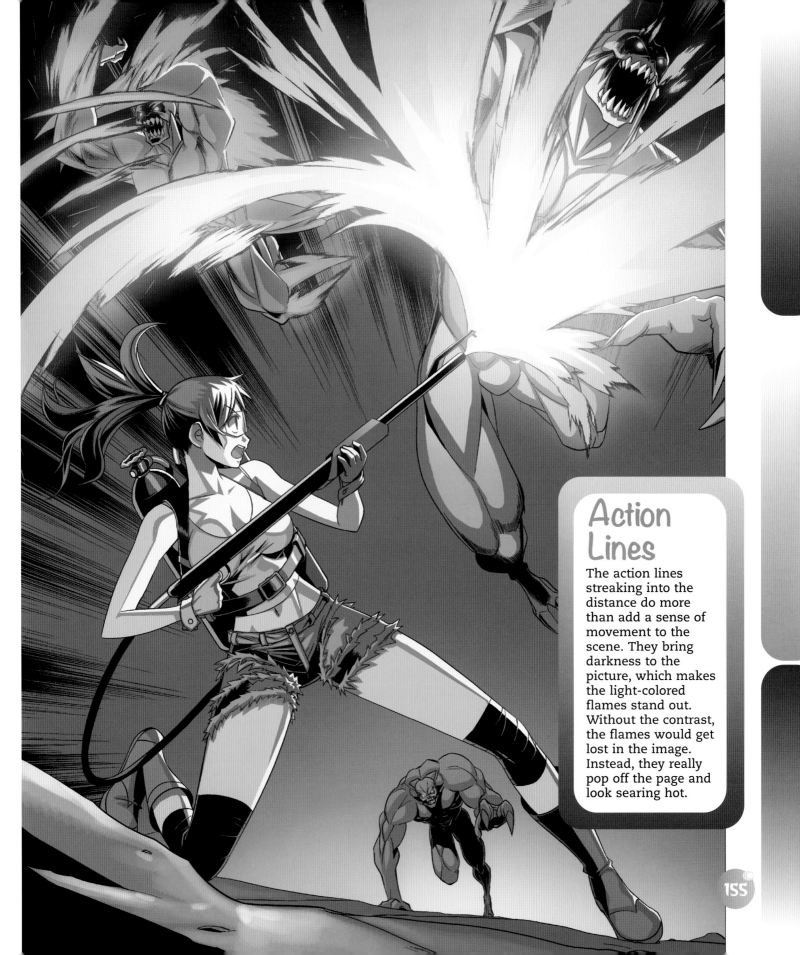

Action Lines

The action lines streaking into the distance do more than add a sense of movement to the scene. They bring darkness to the picture, which makes the light-colored flames stand out. Without the contrast, the flames would get lost in the image. Instead, they really pop off the page and look searing hot.

Sci-Fi Spy

Sci-fi characters usually wear formfitting bodysuits, often with stripes running down the sides for a sharp look. This gal sports turbo rollerblades. With them, she can roll up and down the sides of any building. This action pose is actually a simple walking pose, but with more arm movement. And, as in a walking pose, the arms and legs move in opposite directions. In other words, the right arm is back while the left leg is in front, and vice versa.

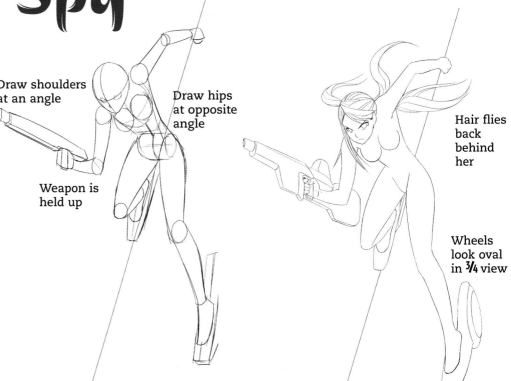

Draw shoulders at an angle

Draw hips at opposite angle

Weapon is held up

Hair flies back behind her

Wheels look oval in ¾ view

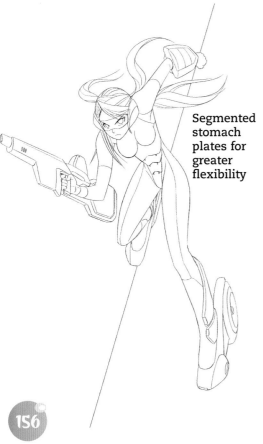

Segmented stomach plates for greater flexibility

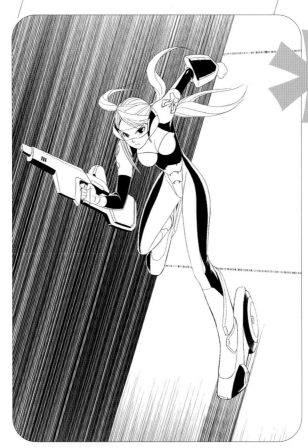

The black areas of the uniform add contrast and make the figure much more interesting than if it were left all white or totally black.

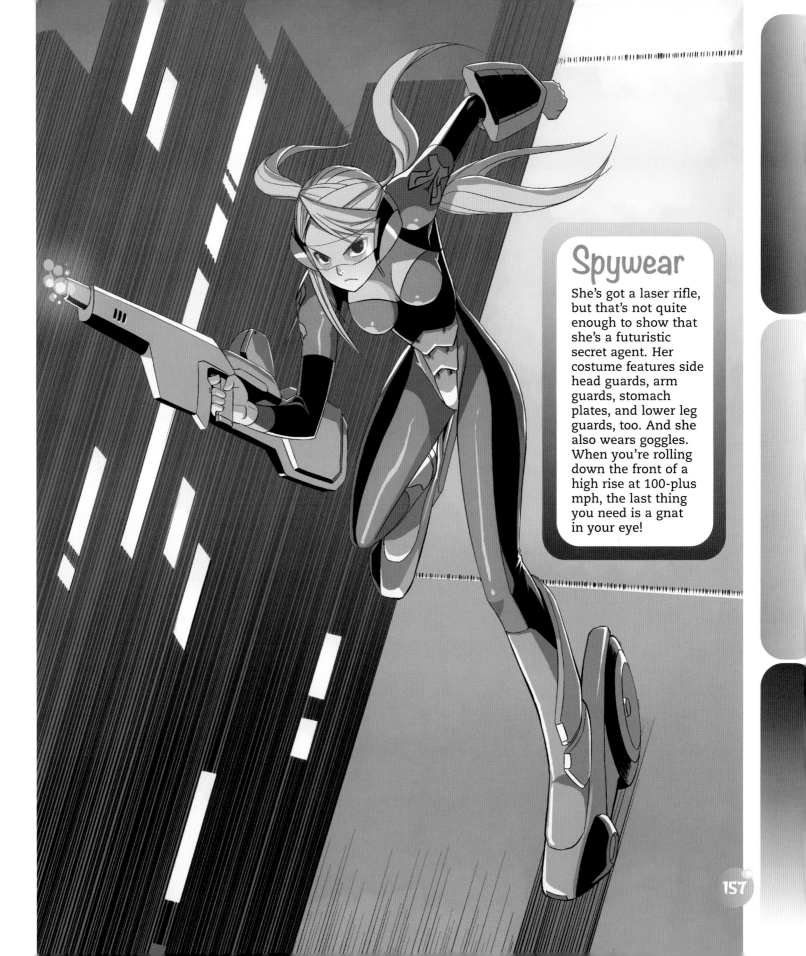

Spywear

She's got a laser rifle, but that's not quite enough to show that she's a futuristic secret agent. Her costume features side head guards, arm guards, stomach plates, and lower leg guards, too. And she also wears goggles. When you're rolling down the front of a high rise at 100-plus mph, the last thing you need is a gnat in your eye!

Amazing Samurai

She's a master with a blade, so don't get her mad, or you'll be sorry—very, very sorry. Notice the way she swings the sword—with a straight arm held far away from the body. Not tight, bent or cramped. That just wouldn't be graceful enough. She wears the traditional samurai outfit—a flowing robe with armor and sandals.

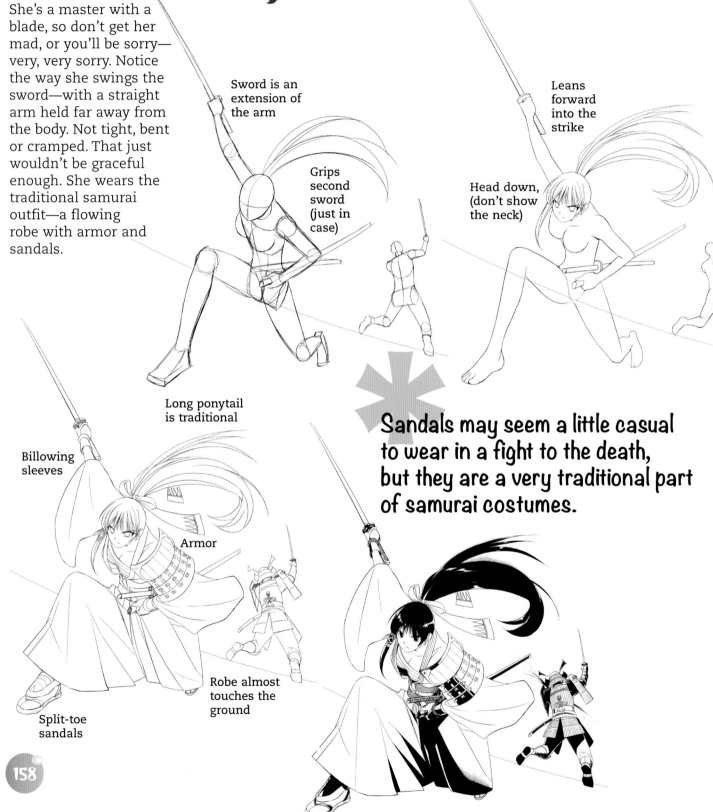

Sword is an extension of the arm

Grips second sword (just in case)

Leans forward into the strike

Head down, (don't show the neck)

Long ponytail is traditional

Billowing sleeves

Armor

Split-toe sandals

Robe almost touches the ground

Sandals may seem a little casual to wear in a fight to the death, but they are a very traditional part of samurai costumes.

158

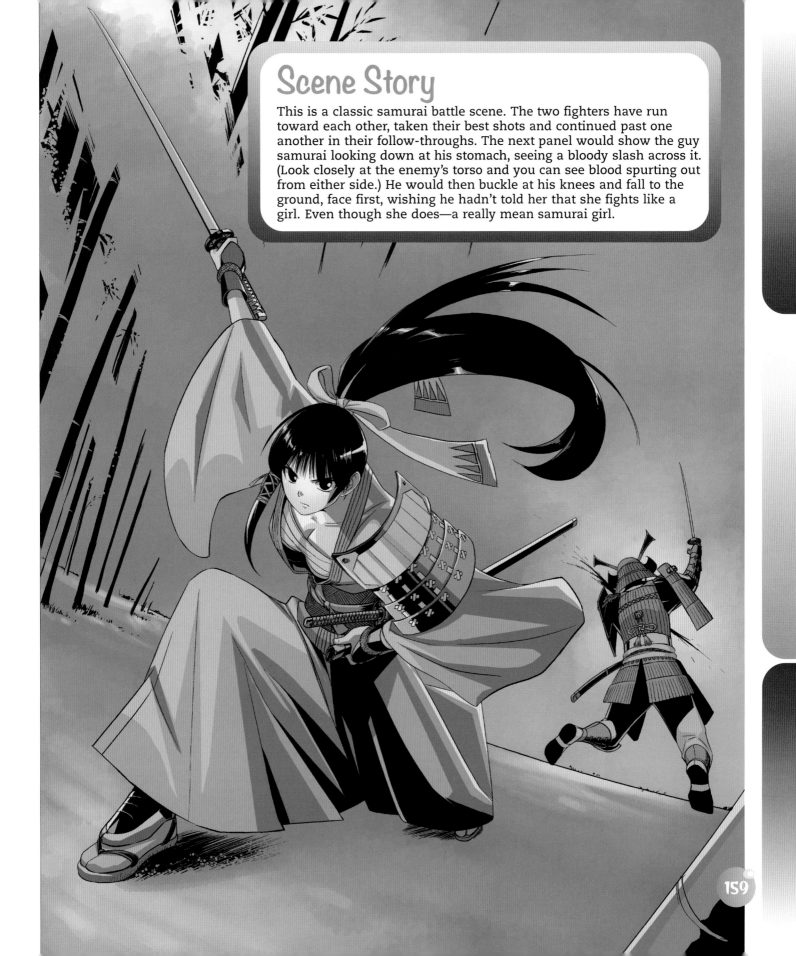

Scene Story

This is a classic samurai battle scene. The two fighters have run toward each other, taken their best shots and continued past one another in their follow-throughs. The next panel would show the guy samurai looking down at his stomach, seeing a bloody slash across it. (Look closely at the enemy's torso and you can see blood spurting out from either side.) He would then buckle at his knees and fall to the ground, face first, wishing he hadn't told her that she fights like a girl. Even though she does—a really mean samurai girl.

Flying Ninja

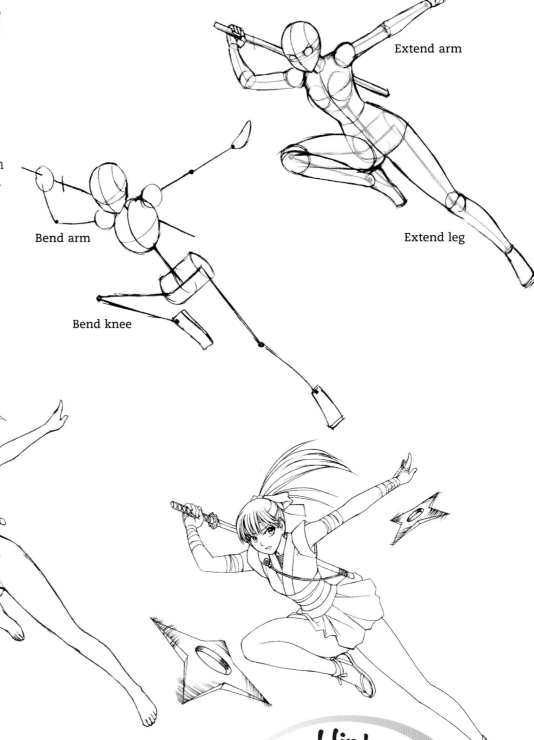

She's throwing four-pointed stars, called shurikens, which she keeps hidden in a pouch. These deadly weapons are tossed backhand like disks. They rotate as they spin toward the opponent. As she tosses the shurikens with one hand, the other is already on the handle of the blade, ready to follow up the attack.

Extend arm

Bend arm

Extend leg

Bend knee

Hair is part of action

Hint

Be sure to show the thickness of the shurikens, so they don't look two-dimensional.

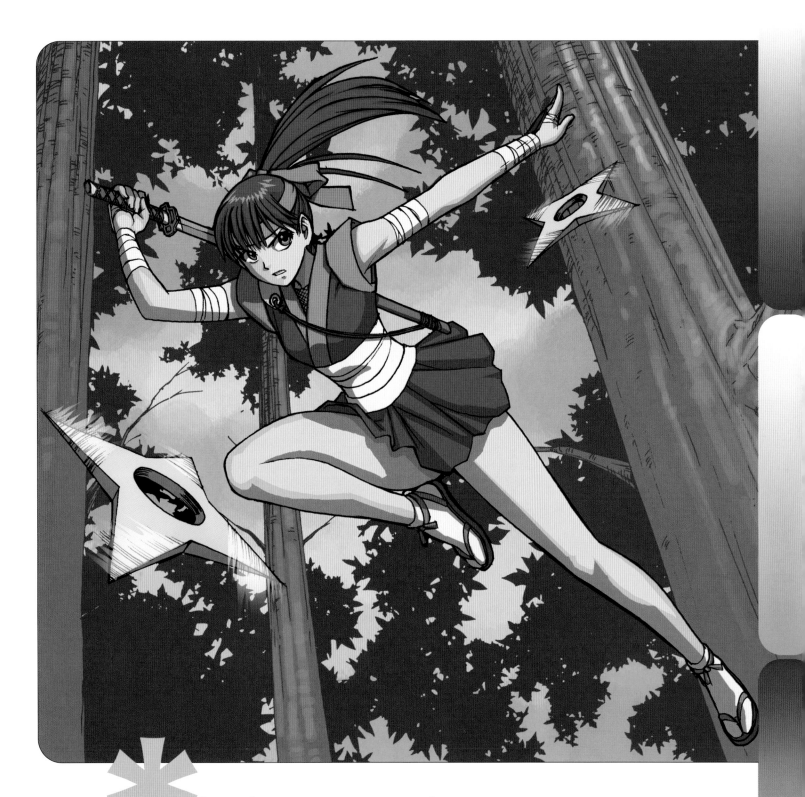

Notice how the trees narrow and converge as we look up at them, thanks to perspective.

Dark Angel

Not all angels are good. Some are very, very bad. But they can also be alluring and beautiful. To make her awe-inspiring, give her gigantic wings and curve them so that they surround her in a luxurious manner. Note the leather straps, which are de rigueur for bad girls.

Light and Dark

For a powerful contrast between light and dark, blacken out the interior of the wings and of her skirt. Leave a few long, light-colored individual feathers on the exterior of the wings to contrast with the interior. For even more contrasting black, add the reflections of her skirt—drawn precisely in the opposite direction of the real skirt—and of the tips of the wings.

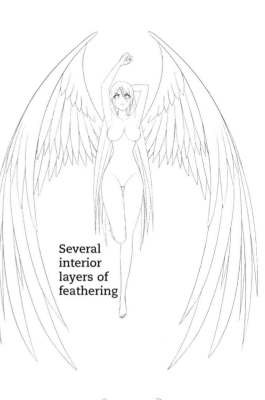

Several interior layers of feathering

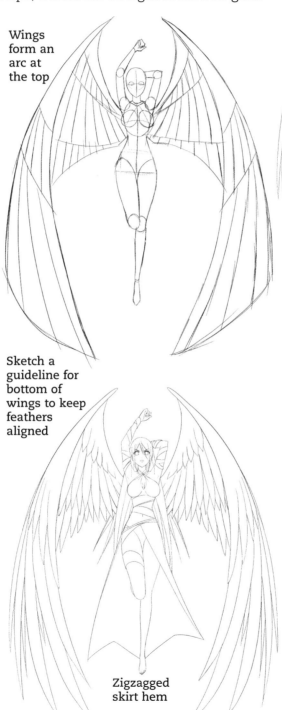

Wings form an arc at the top

Sketch a guideline for bottom of wings to keep feathers aligned

Zigzagged skirt hem

Leave some white sections to represent the shiny parts

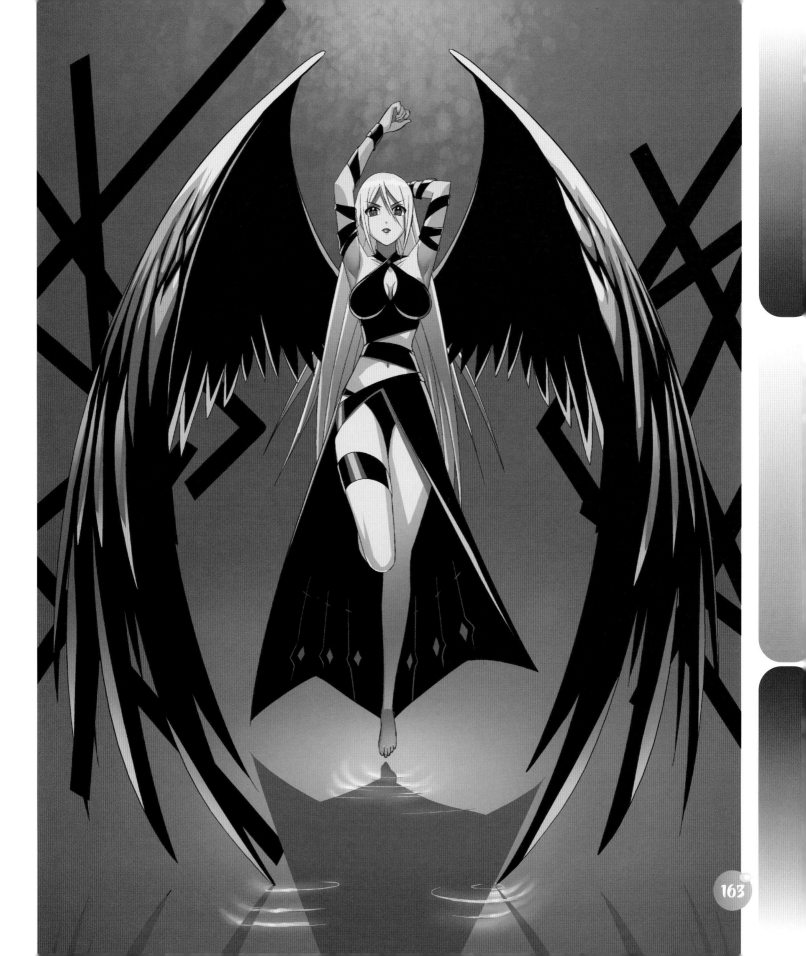

Angel of Light

Now let's take a look at a "good" angel. She wears a looser garment than the dark angel, and with her jewelry, she looks like she could be a primitive princess. This pose calls for some serious foreshortening. Don't be shy about it. Make the foreshortening effect obvious.

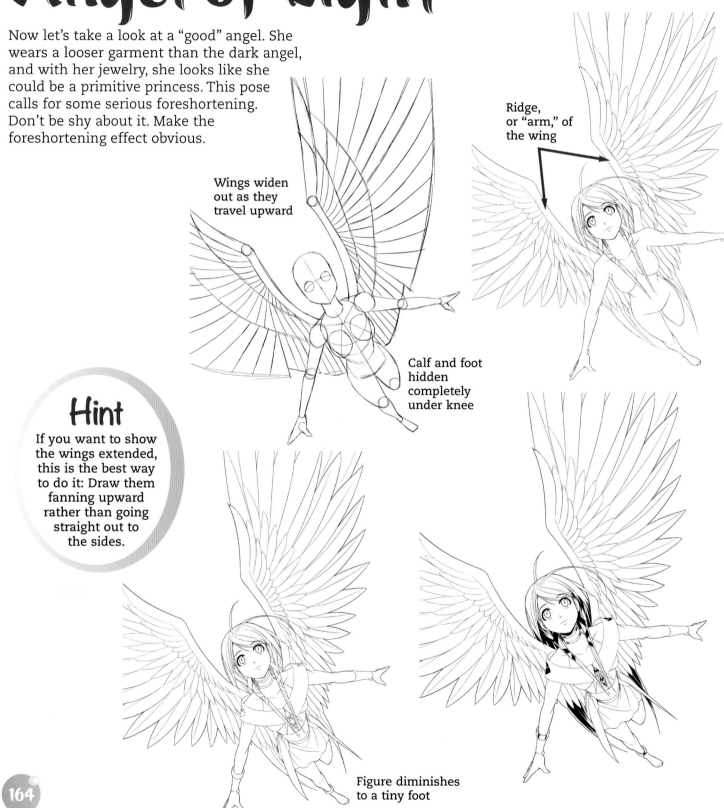

Wings widen out as they travel upward

Calf and foot hidden completely under knee

Ridge, or "arm," of the wing

Hint

If you want to show the wings extended, this is the best way to do it: Draw them fanning upward rather than going straight out to the sides.

Figure diminishes to a tiny foot

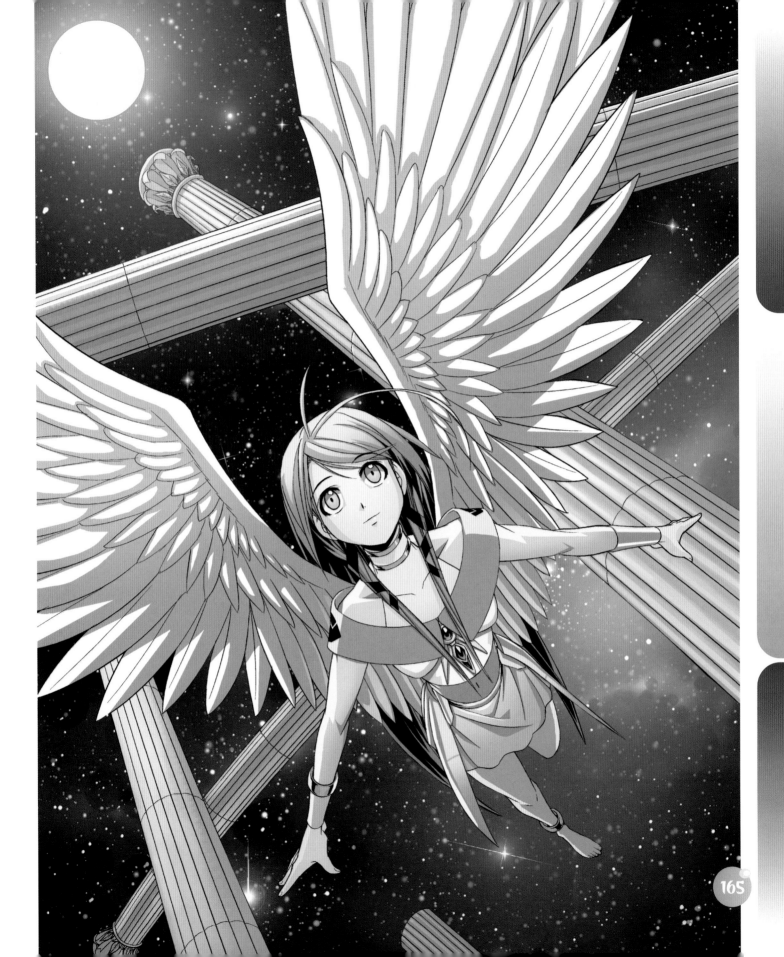

Evil Enchantress

The badder they come, the more exotically beautiful they're drawn. This is how artists create a push-pull tug of emotions in the audience. She's beautiful and alluring, yet we know we should be rooting against her. We have conflicting feelings. It gets complicated—and not just for us, but for the good guy, too. That makes for a good story.

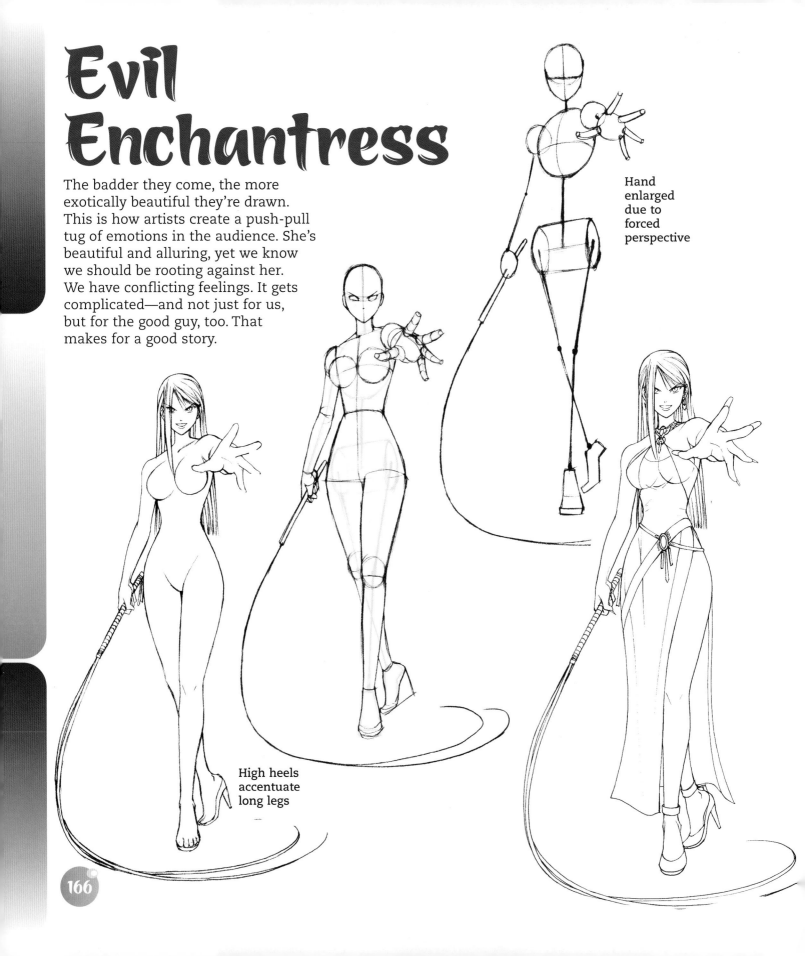

Hand enlarged due to forced perspective

High heels accentuate long legs

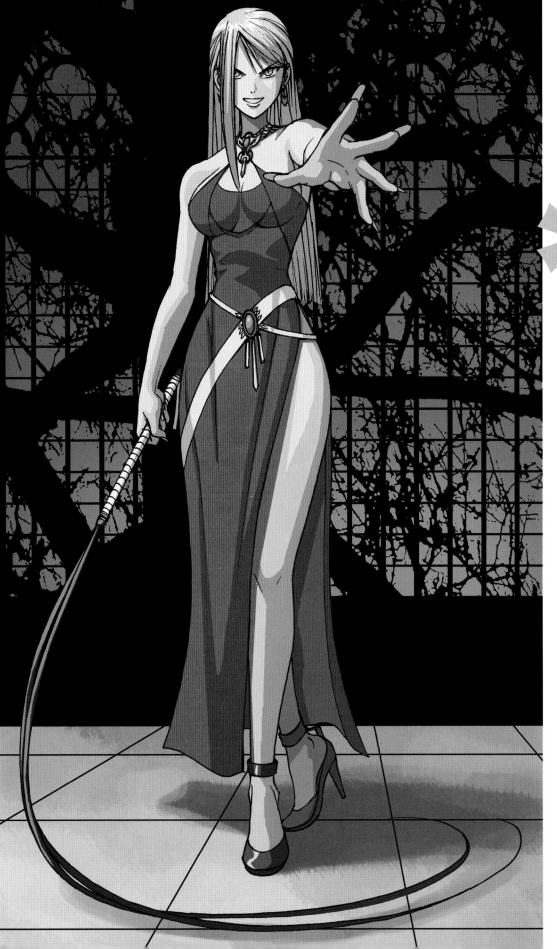

Wide shoulders and hips create the classic look of a seductive beauty.

Fantasy Fighter

The fantasy fighter girl may be a magical girl with superpowers or, like the archer shown here, a regular human who possesses great fighting skill. Although this pose may look advanced, it's actually fairly simple to draw.

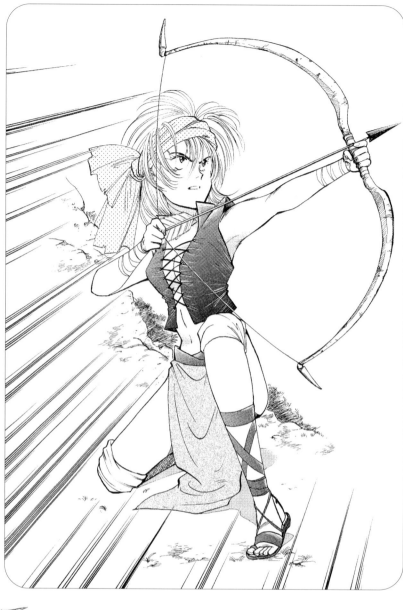

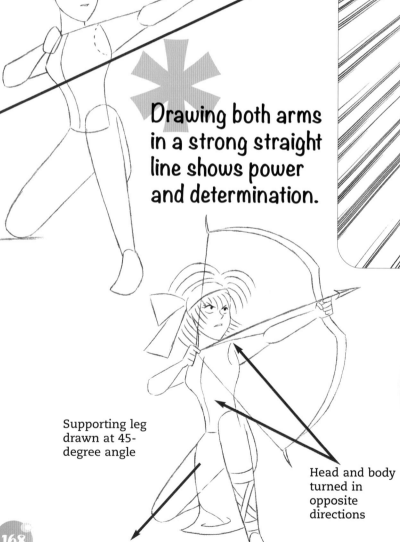

Drawing both arms in a strong straight line shows power and determination.

Supporting leg drawn at 45-degree angle

Head and body turned in opposite directions

Hint

Draw the arrow pointed up at an angle to signify that she is shooting at something larger, and therefore stronger, than she is. That makes her the underdog, which is the essence of drama.

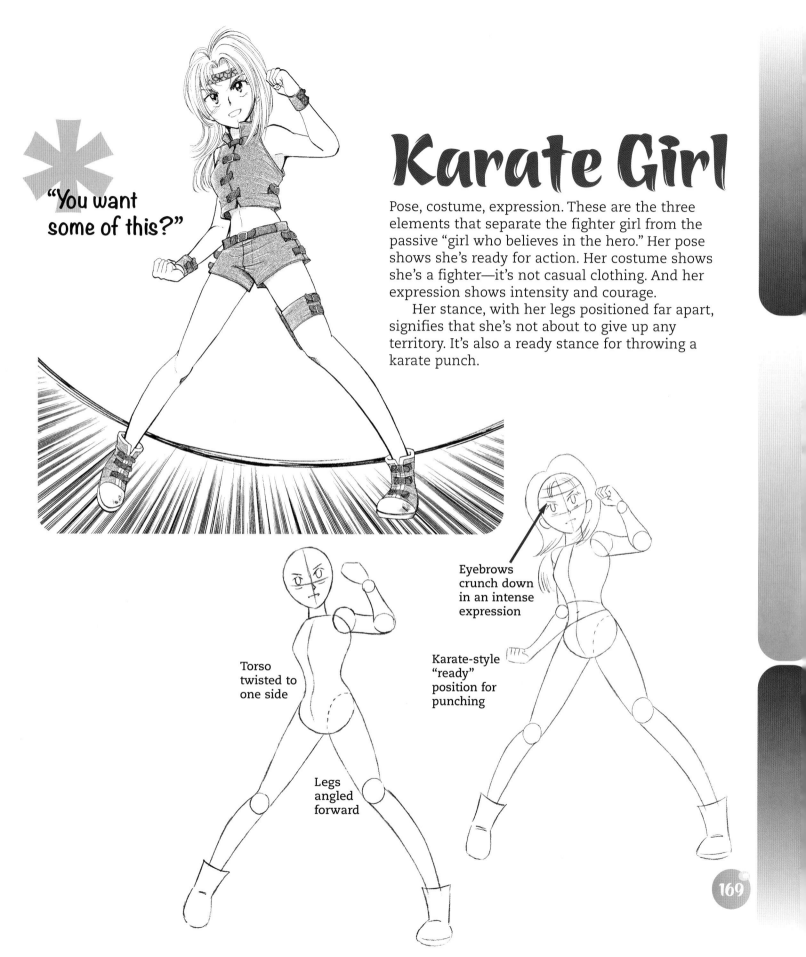

"You want some of this?"

Karate Girl

Pose, costume, expression. These are the three elements that separate the fighter girl from the passive "girl who believes in the hero." Her pose shows she's ready for action. Her costume shows she's a fighter—it's not casual clothing. And her expression shows intensity and courage.

Her stance, with her legs positioned far apart, signifies that she's not about to give up any territory. It's also a ready stance for throwing a karate punch.

Eyebrows crunch down in an intense expression

Karate-style "ready" position for punching

Torso twisted to one side

Legs angled forward

Forced Perspective

If you want to take your action poses to the next level, you've gotta start thinking about perspective. But not perspective in the ordinary sense, with vanishing lines that are used to create houses and buildings. We're talking about body-warping, extreme forced perspective. This is actually easier to do, and you don't need a ruler. The effect is very powerful.

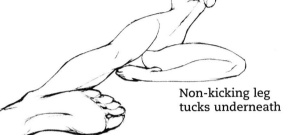

Non-kicking leg tucks underneath

Foot greatly exaggerated

Arm moves away from body to allow room for kick

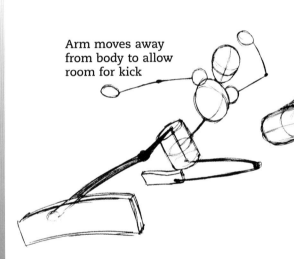

Leg gets longer and wider as it comes toward us

Flying Kick

Can you see how dramatic this pose is simply because she's kicking at us rather than being shown in a side view? You can feel the kick, because of the forced perspective. We've greatly exaggerated her kicking foot and leg while reducing the size of her torso, arms, and head. This is the type of high-impact pose you can get only with forced perspective.

Hint

These poses are the extreme moments in an action sequence, so use them sparingly to create maximum impact. If you were watching a clip of a sports event on TV, these would be the highlights.

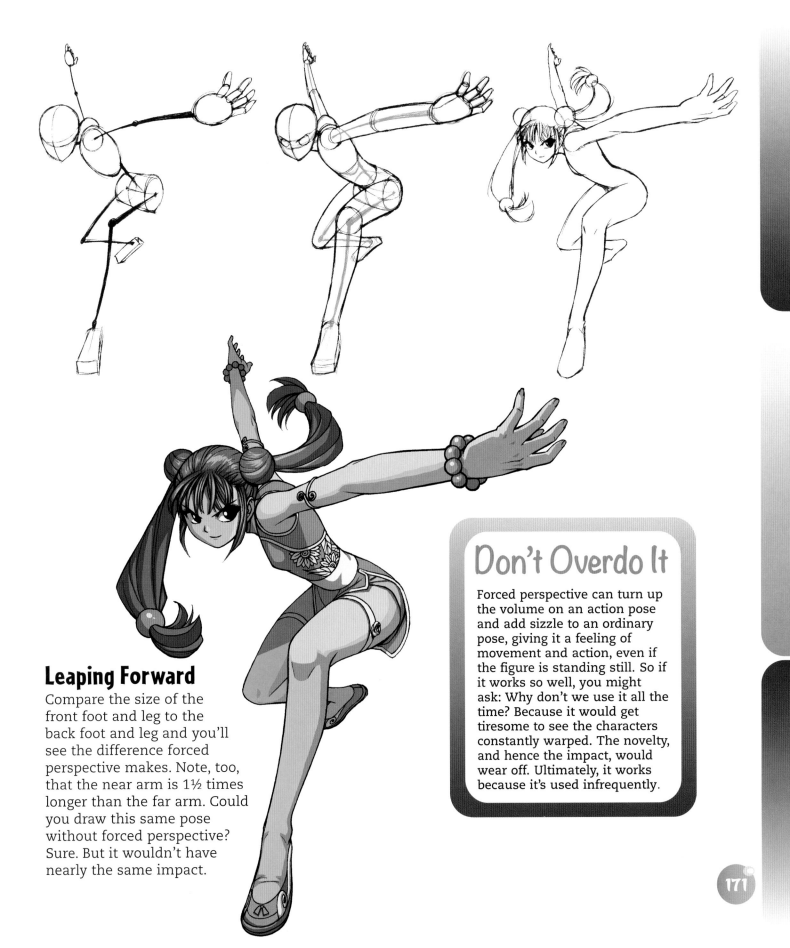

Leaping Forward

Compare the size of the front foot and leg to the back foot and leg and you'll see the difference forced perspective makes. Note, too, that the near arm is 1½ times longer than the far arm. Could you draw this same pose without forced perspective? Sure. But it wouldn't have nearly the same impact.

Don't Overdo It

Forced perspective can turn up the volume on an action pose and add sizzle to an ordinary pose, giving it a feeling of movement and action, even if the figure is standing still. So if it works so well, you might ask: Why don't we use it all the time? Because it would get tiresome to see the characters constantly warped. The novelty, and hence the impact, would wear off. Ultimately, it works because it's used infrequently.

171

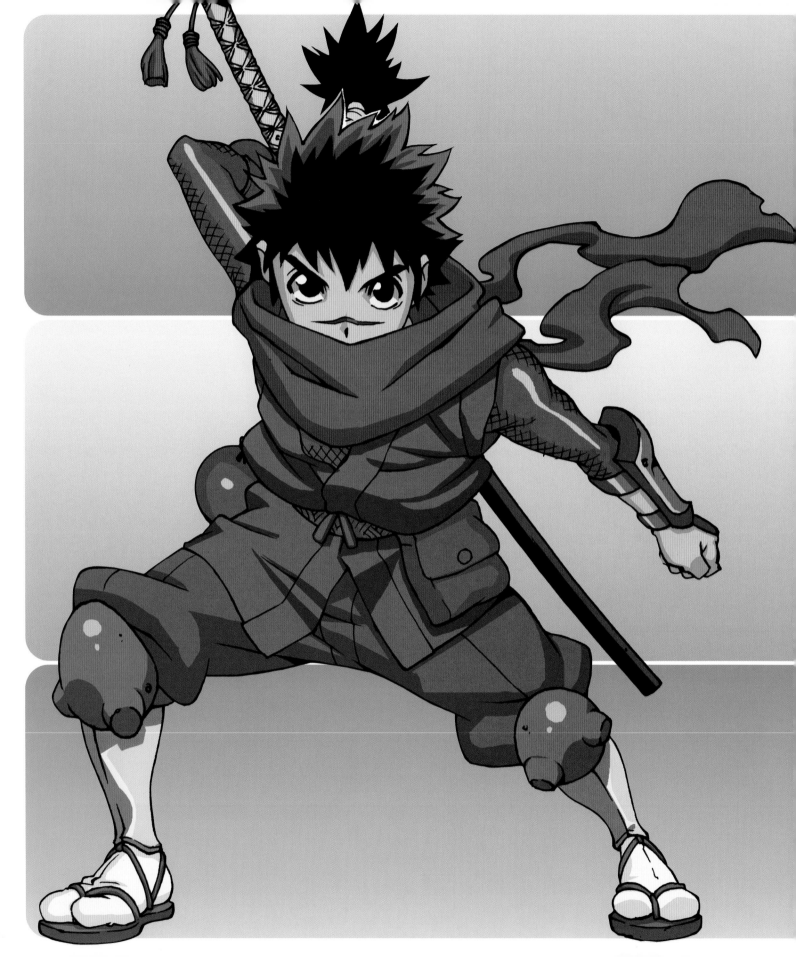

Samurai Characters

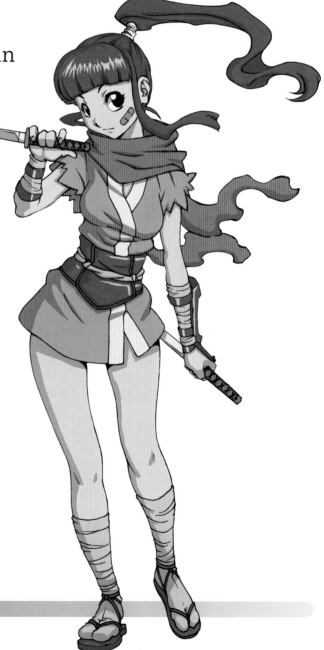

Samurai stories are exploding in popularity in manga, and they bring plenty of action to shonen-style graphic novels. Whereas samurai used to be portrayed as adult men, today's samurai include teens—sometimes even young boy and girl fighters as well. All you need to be a samurai is the right equipment, a cause beyond your own personal ambitions, and an indomitable fighting spirit. This chapter will show you all you need to know to draw shonen-style samurai.

Samurai Boy Turnarounds

One of the questions I'm often asked is: How do I make my character look the same when I draw him at different angles? Here's what I, and many artists, do, and you can try, too: "turnarounds." Turn the character around 180 degrees and draw him in all the stages in between. Nothing will help you get to know a character like doing turnarounds. It's time well spent. Let's draw some turnarounds of a young samurai.

Never let a samurai's size or youth fool you. It's not how tall he is that counts in a fight, it's the size of his heart! Younger samurai are often dressed in bunchy garments, which make them look more serious about fighting. Remember, they're actually pretty skinny under all that fabric!

Eyes set wide apart on youthful characters

The mouth and nose are placed low on the face for young teens, including girls.

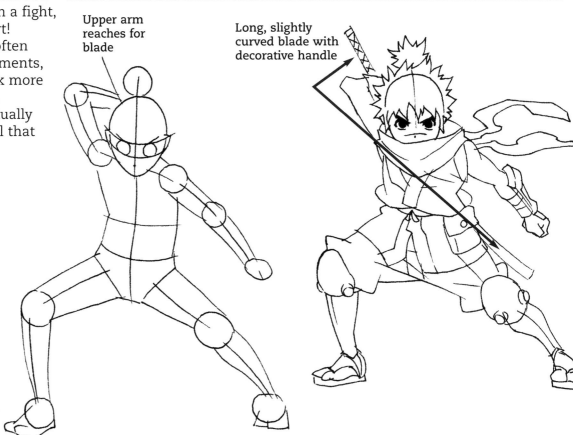

Upper arm reaches for blade

Long, slightly curved blade with decorative handle

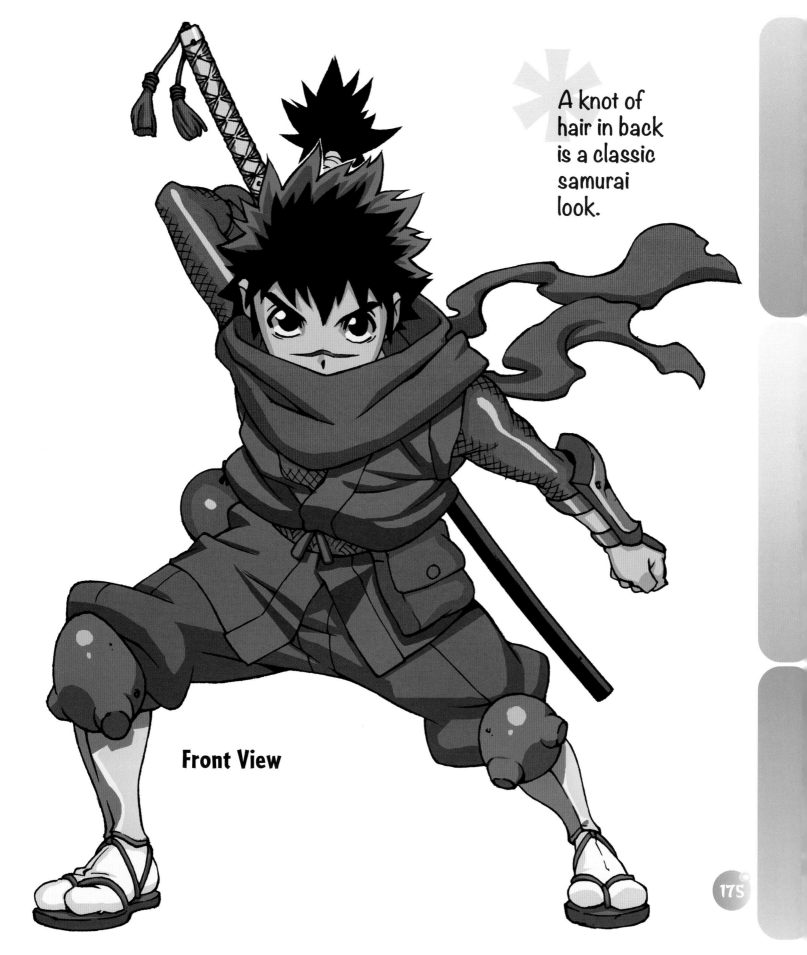

A knot of hair in back is a classic samurai look.

Front View

Knot of hair

Spikey hair

Hint

For a modern look, give your samurai spiky hair; traditional samurai wore their hair slicked back and tied in a knot.

3/4 Front View

Cross-hatching makes material look heavy, like canvas

Arm guards

Scarf blows in wind

Pouch

Knee guards

He wears a pouch to hold emergency "last-ditch" weapons. If all else fails, try poison darts or a smoke bomb!

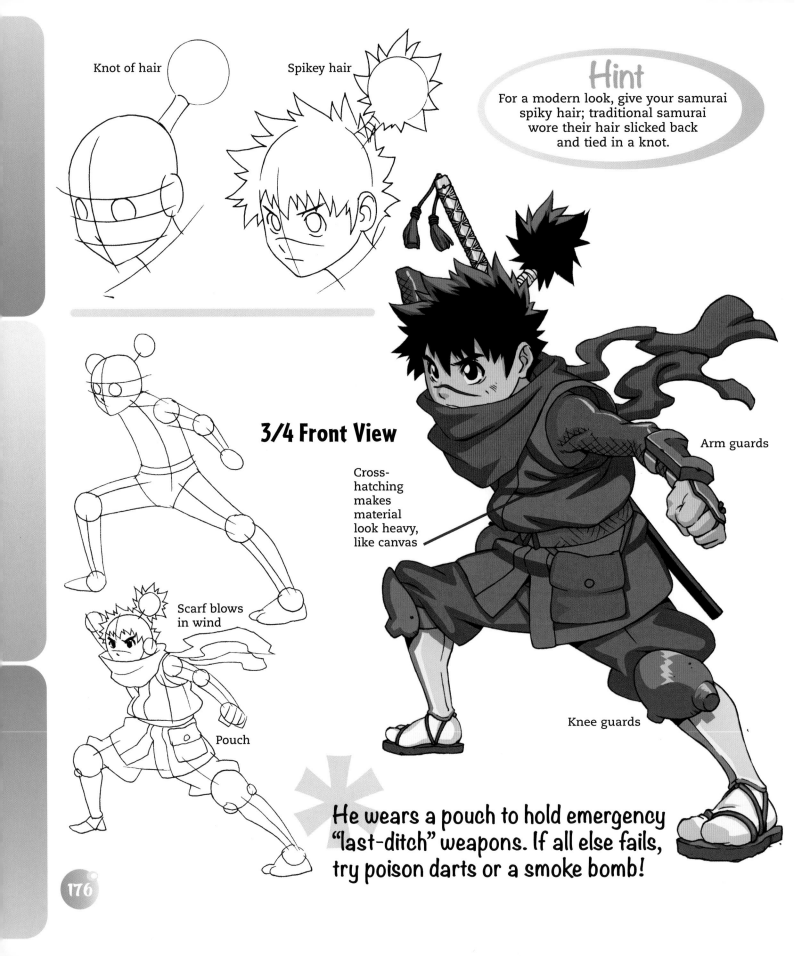

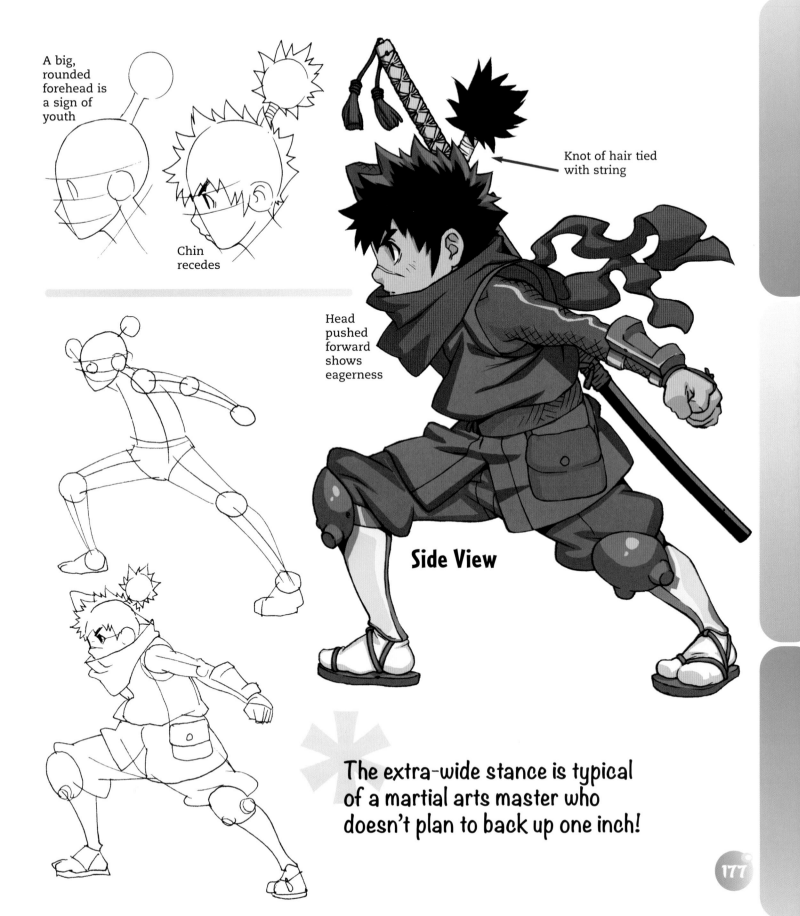

A big, rounded forehead is a sign of youth

Chin recedes

Knot of hair tied with string

Head pushed forward shows eagerness

Side View

The extra-wide stance is typical of a martial arts master who doesn't plan to back up one inch!

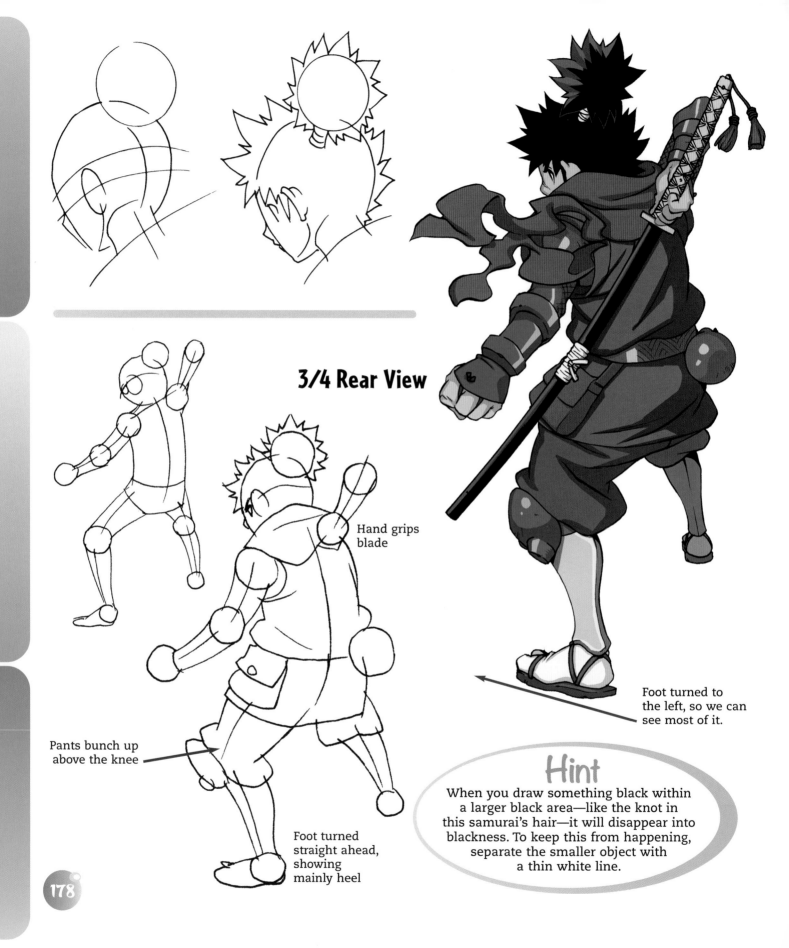

3/4 Rear View

Hand grips blade

Pants bunch up above the knee

Foot turned straight ahead, showing mainly heel

Foot turned to the left, so we can see most of it.

Hint
When you draw something black within a larger black area—like the knot in this samurai's hair—it will disappear into blackness. To keep this from happening, separate the smaller object with a thin white line.

The New Samurai

The strength of manga is its ability to relate the characters to the reader. Teens don't necessarily want to read story after story about 30-year-old samurai men, even if they are great stories. In order to capture the imagination of younger readers, the samurai heroes had to change as well. And the Japanese creators of samurai stories were forward-looking in breaking their own conventions, so that today we think nothing of it when introduced to a 14-year-old samurai warrior. But it's taken some growing pains to get here!

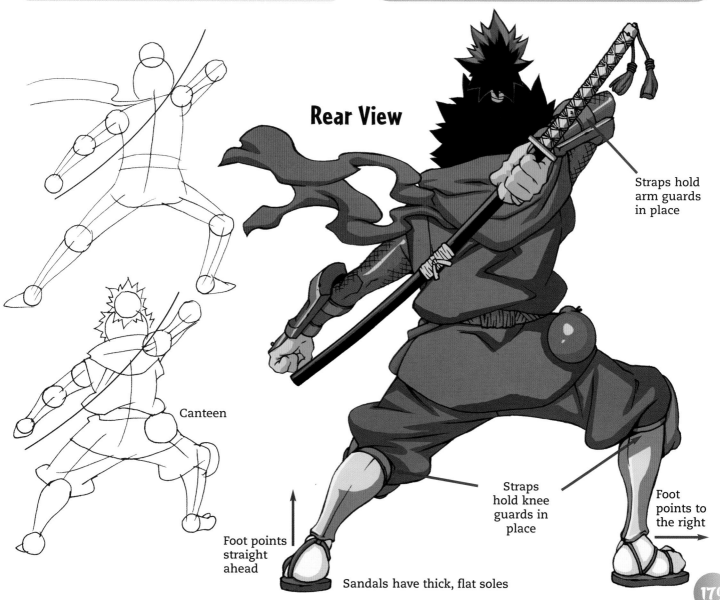

Rear View

Straps hold arm guards in place

Canteen

Straps hold knee guards in place

Foot points straight ahead

Foot points to the right

Sandals have thick, flat soles

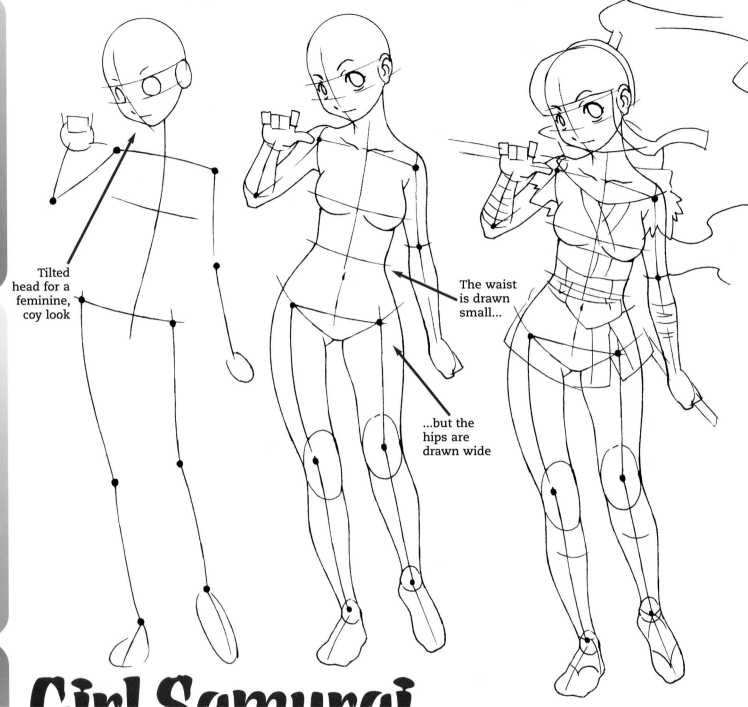

Tilted head for a feminine, coy look

The waist is drawn small...

...but the hips are drawn wide

Girl Samurai

She looks like a combination of homecoming queen and professional hit man all rolled into one. She's a skilled fighter, but her wide, innocent eyes and round face signal to the reader that she's one of the good guys. Angular faces and beady eyes are reserved for bad types.

Hint
Her arm guards and wraps and the bandage on her face let you know she's a fighter. It's little details like these that really make the character.

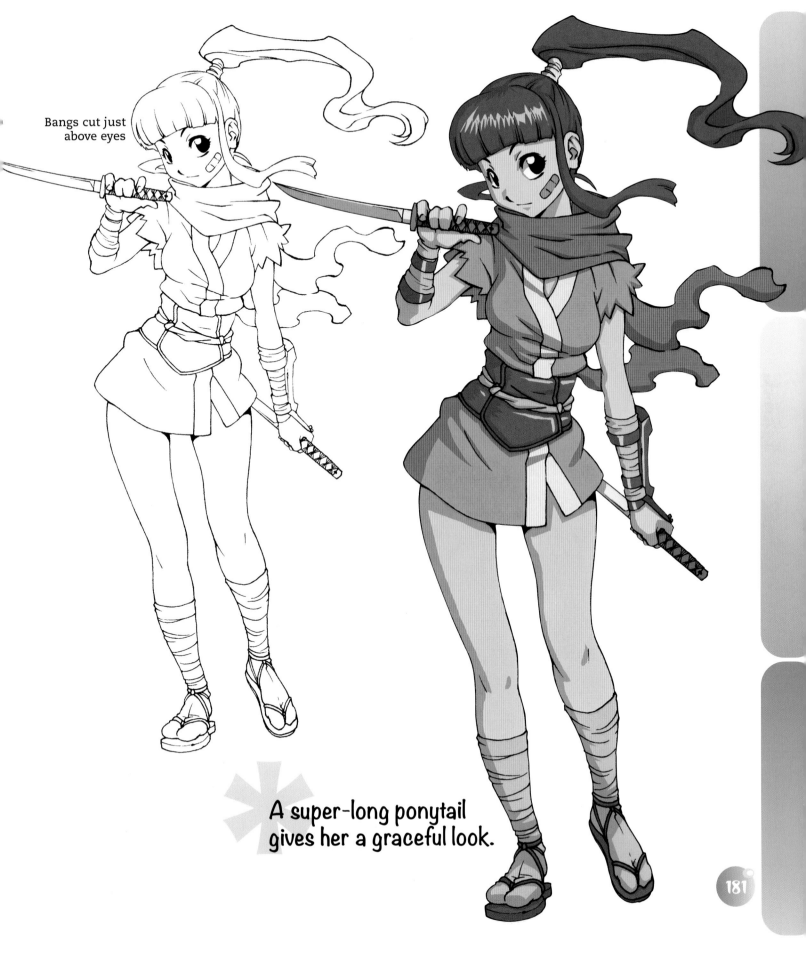

Bangs cut just
above eyes

A super-long ponytail
gives her a graceful look.

Bad Samurai!

How long did you think it would take most manga artists to get bored with drawing only samurai heroes and start drawing ruthless, vicious samurai as well? Yep, about five minutes. Bad guys are fun to draw!

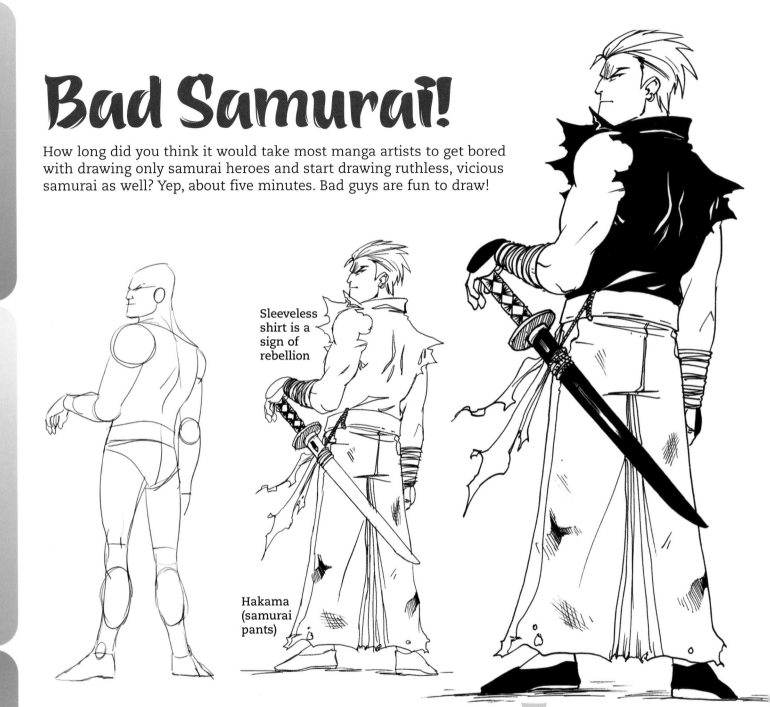

Sleeveless shirt is a sign of rebellion

Hakama (samurai pants)

Street Warrior

He's less of a martial arts devotee and more of the muscle behind a gang of thugs. Hey, no thugs, no story. Gotta have the thugs. But first, he's going to create a little mayhem among the peasants and the common folk. Like making sure they "pay him for "protection"—against himself!

Samurai are humble : Pretentious, showy muscles mean he's not a true samurai.

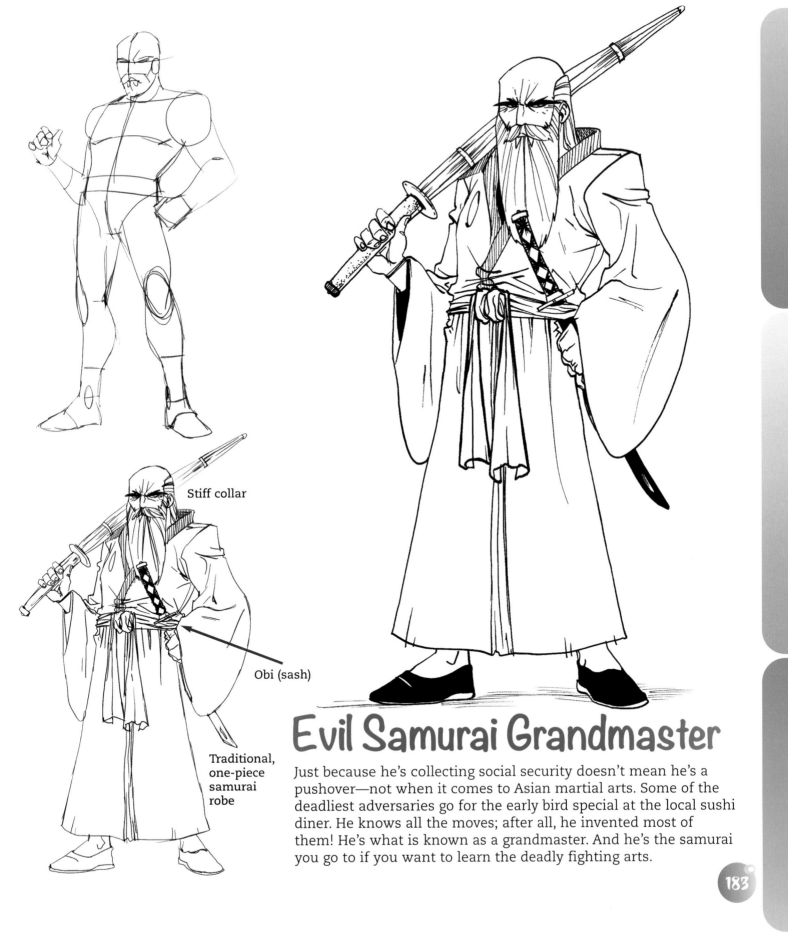

Stiff collar

Obi (sash)

Traditional,
one-piece
samurai
robe

Evil Samurai Grandmaster

Just because he's collecting social security doesn't mean he's a pushover—not when it comes to Asian martial arts. Some of the deadliest adversaries go for the early bird special at the local sushi diner. He knows all the moves; after all, he invented most of them! He's what is known as a grandmaster. And he's the samurai you go to if you want to learn the deadly fighting arts.

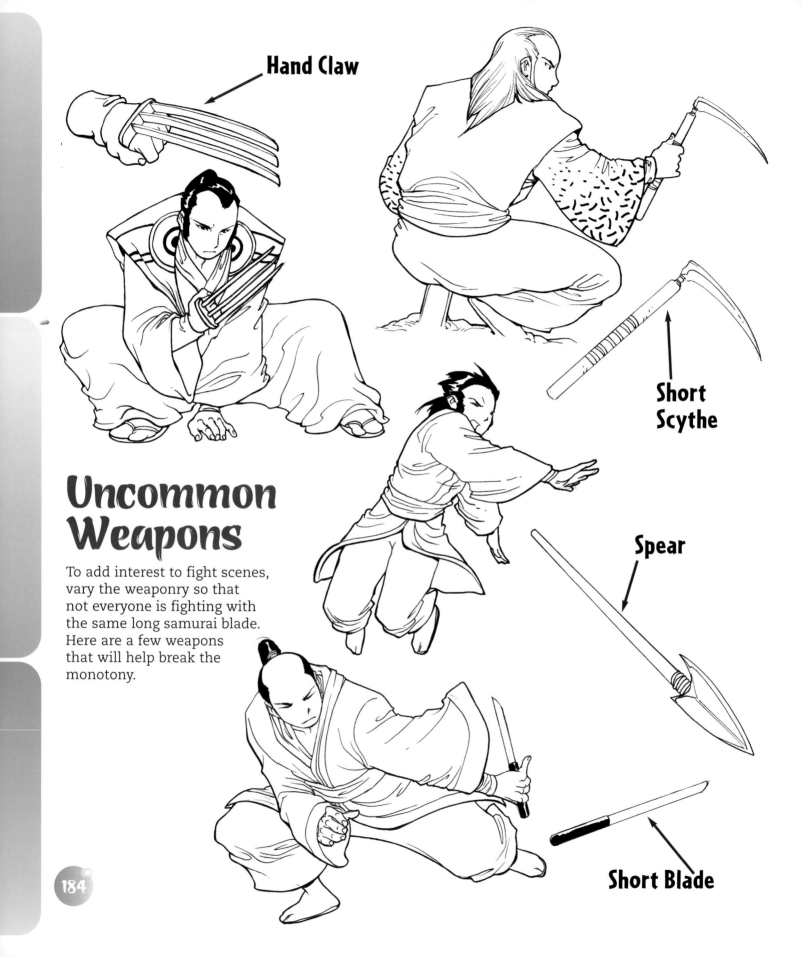

Hand Claw

Short Scythe

Spear

Short Blade

Uncommon Weapons

To add interest to fight scenes, vary the weaponry so that not everyone is fighting with the same long samurai blade. Here are a few weapons that will help break the monotony.

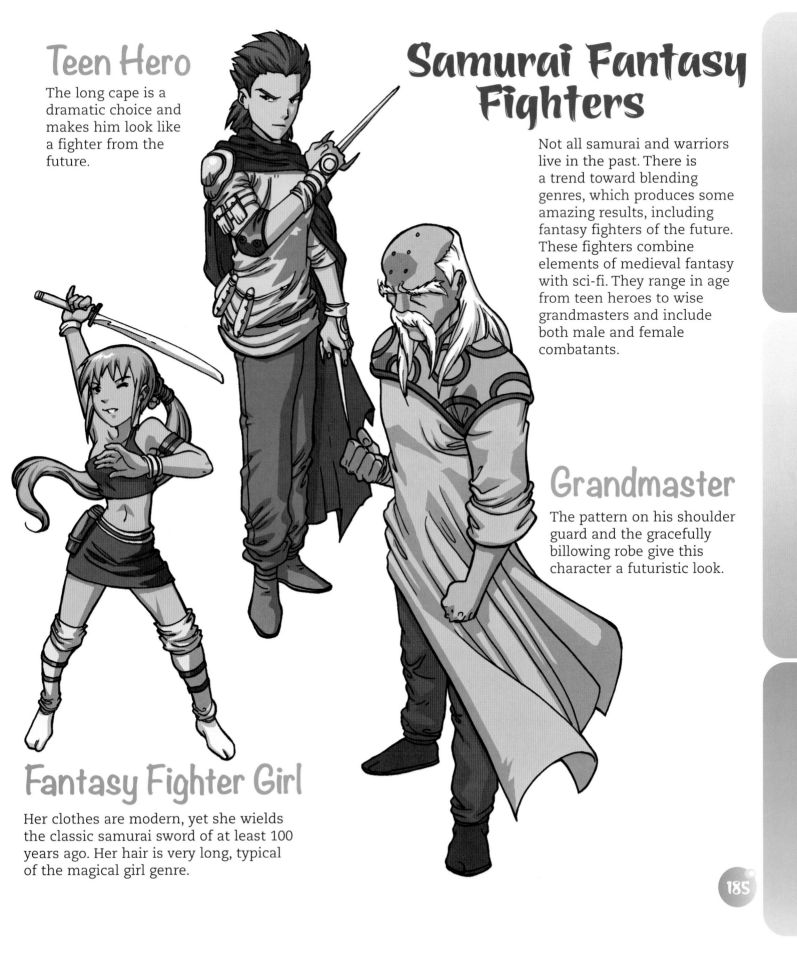

Teen Hero

The long cape is a dramatic choice and makes him look like a fighter from the future.

Samurai Fantasy Fighters

Not all samurai and warriors live in the past. There is a trend toward blending genres, which produces some amazing results, including fantasy fighters of the future. These fighters combine elements of medieval fantasy with sci-fi. They range in age from teen heroes to wise grandmasters and include both male and female combatants.

Grandmaster

The pattern on his shoulder guard and the gracefully billowing robe give this character a futuristic look.

Fantasy Fighter Girl

Her clothes are modern, yet she wields the classic samurai sword of at least 100 years ago. Her hair is very long, typical of the magical girl genre.

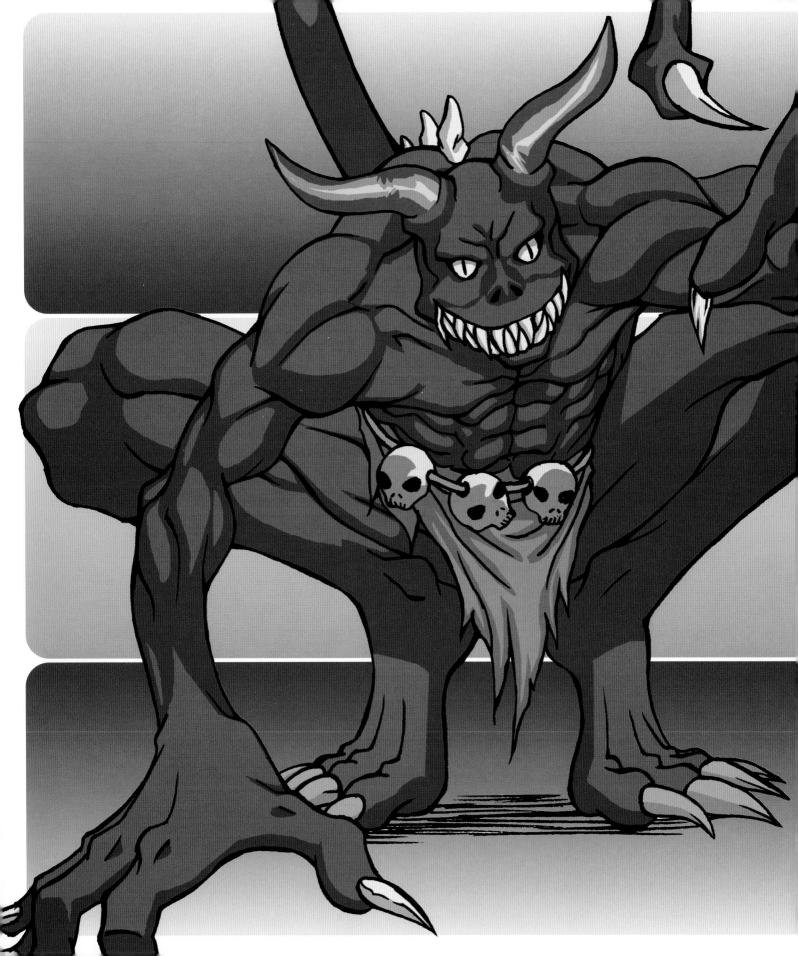

Monsters and Creepy Creatures

The monsters of shonen-style manga are a strange and fearsome crew of creatures. With instincts directed toward maximum destruction, they cause the faint of heart to turn tail and run. Only the brave or foolish remain to do battle. The character designs of the beastly villains are deviously inventive, setting the scene for an epic fight. Luckily for you, we're just going to draw these fiends. Are you ready?

Rock Monster

Jagged spikes shoot up from his shoulders, back, and head, and the rippling definition lines of his muscles look craggy, like the edges of a rock. But beneath the exterior shell, the body outline (see the first drawing) is the same as that of any brute-like character, with two notable exceptions: the immense, oversized fists and the lower legs that widen into solid feet.

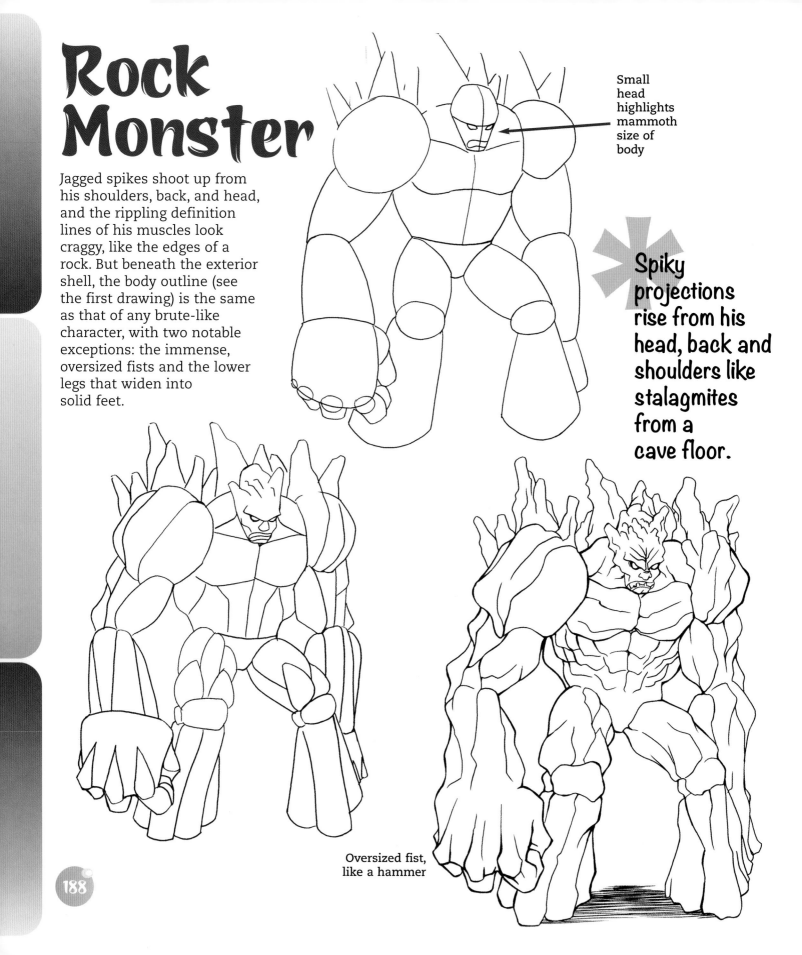

Small head highlights mammoth size of body

Spiky projections rise from his head, back and shoulders like stalagmites from a cave floor.

Oversized fist, like a hammer

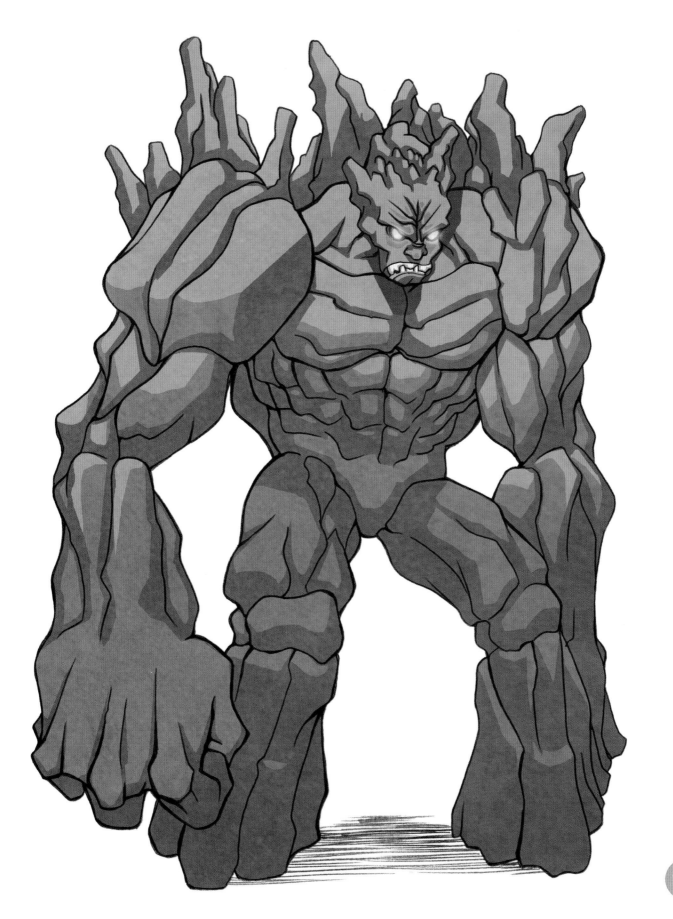

Devil Creature

Horns, claws, sharp teeth, and skull accessories are the things that distinguish demon-style monsters. Visual clues like extra-large feet signal to the reader that this character is a beast. Note the slit-like, predatory pupils.

The spike in the tail is not for scratching its back!

Hands enlarged due to forced perspective

Bovine-type horns point out instead of straight up

Rests on balls of feet, with heels pointed toward sky

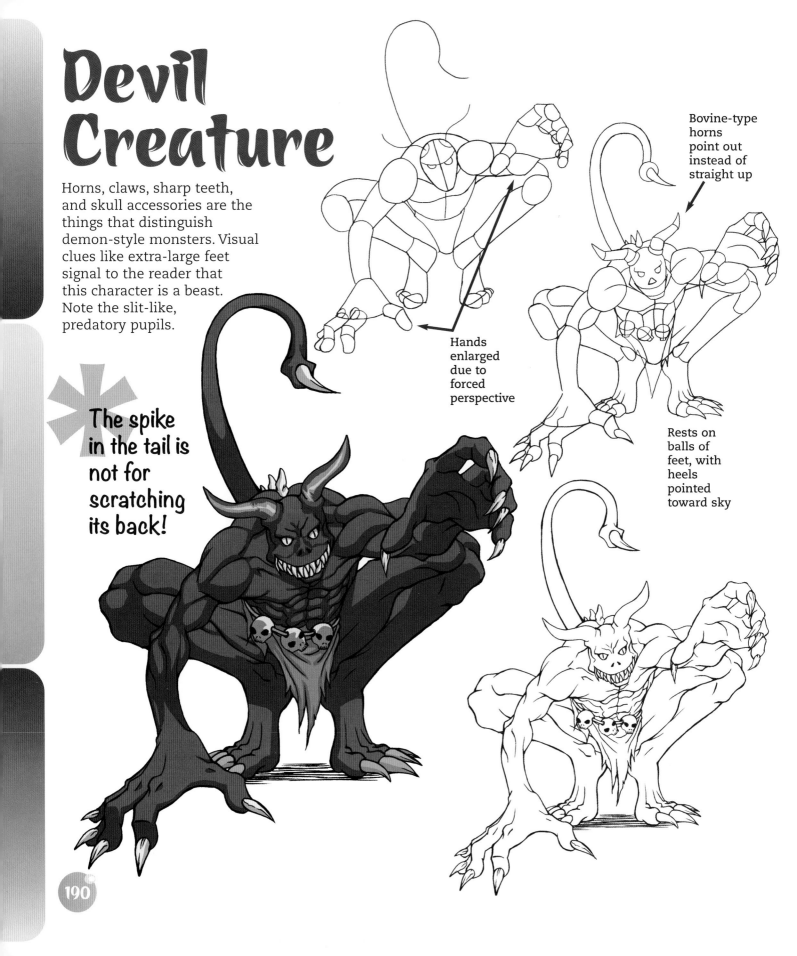

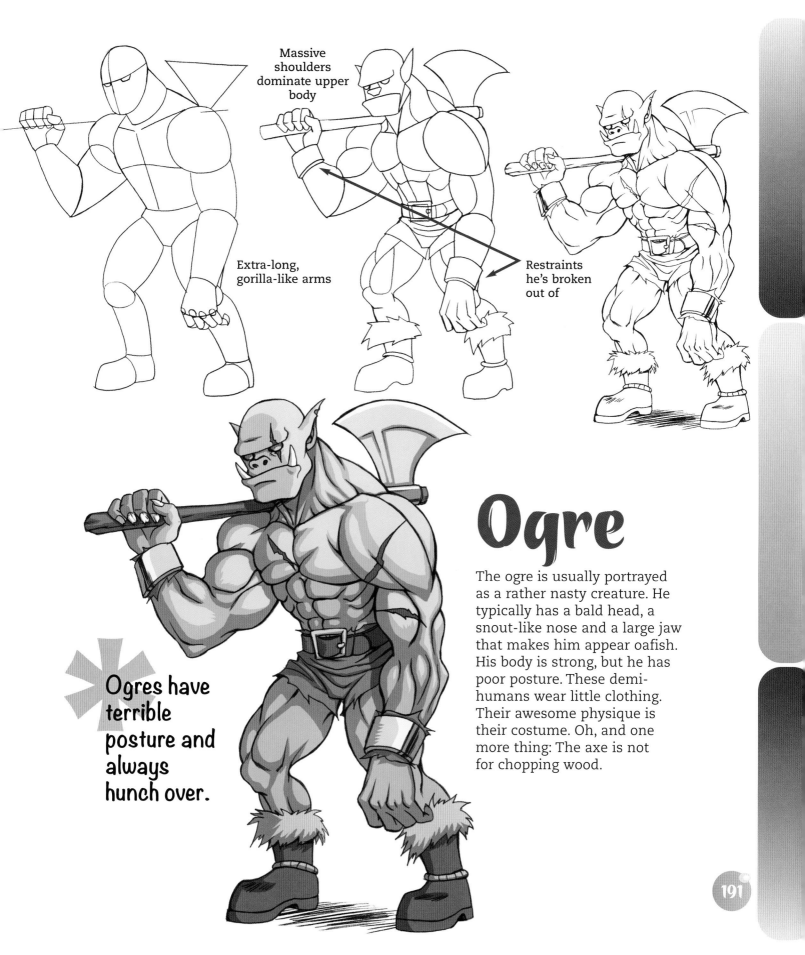

Massive shoulders dominate upper body

Extra-long, gorilla-like arms

Restraints he's broken out of

Ogres have terrible posture and always hunch over.

Ogre

The ogre is usually portrayed as a rather nasty creature. He typically has a bald head, a snout-like nose and a large jaw that makes him appear oafish. His body is strong, but he has poor posture. These demi-humans wear little clothing. Their awesome physique is their costume. Oh, and one more thing: The axe is not for chopping wood.

Summoning Demons

He uses his powers to conjure shadowy demons that do his dark bidding.

Generating Force Fields

This evil being wields a magical staff that harnesses electrical energy he uses to strike down his enemies.

Monsters With Special Powers

We've got some pretty compelling heroes and heroines in this book, and if our evil characters are going to go toe to toe with them, they'll have to do more than stand around looking wicked. Special powers make evil characters seem more threatening. And they're fun to draw, too.

Super Speed and Bounce

This strange creature bounds from perch to perch leaving speed lines in its wake.

Capturing Prey

Multiple tongues make it easy to ensnare unsuspecting prey.

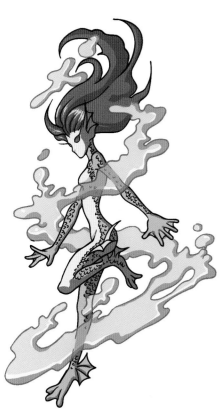

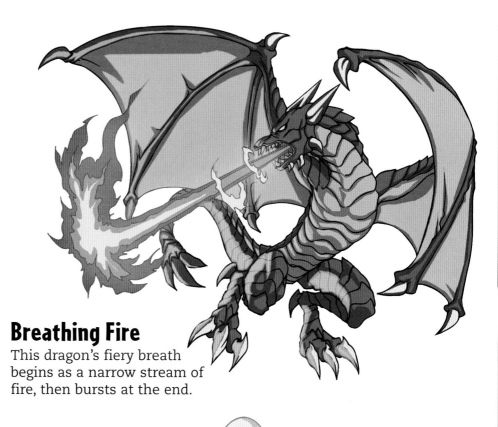

Breathing Fire

This dragon's fiery breath begins as a narrow stream of fire, then bursts at the end.

Underwater Abilities

Some mutants can swim and breathe underwater as well as on land.

Shape Shifting

This pint-sized villain morphs from a ghost into a boy.

Super Strength

This guy's huge mechanical arm is programmed to deliver maximum power.

Monster Fighter!

This is the ultimate showdown—a battle between boy and beast. Summoning the spirits of his ancestors, who were great fighters, the boy is imbued with powers far beyond his normal abilities. His razor-sharp karate punch pulverizes the rock with such an explosive force that the monster evaporates.

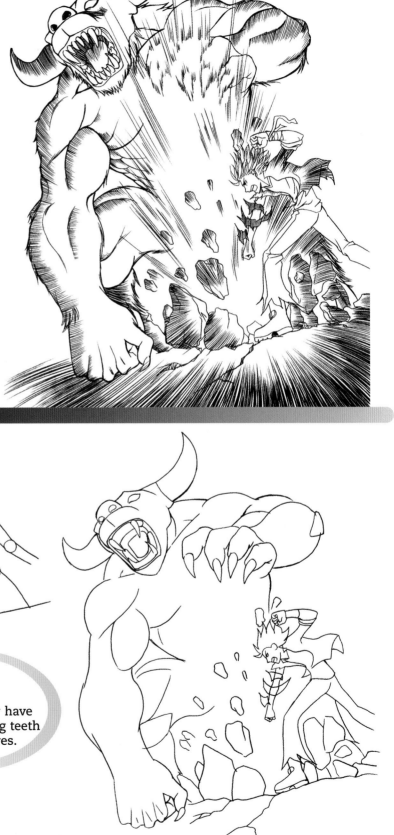

Hint
Demons usually have large, intimidating teeth and empty eyes.

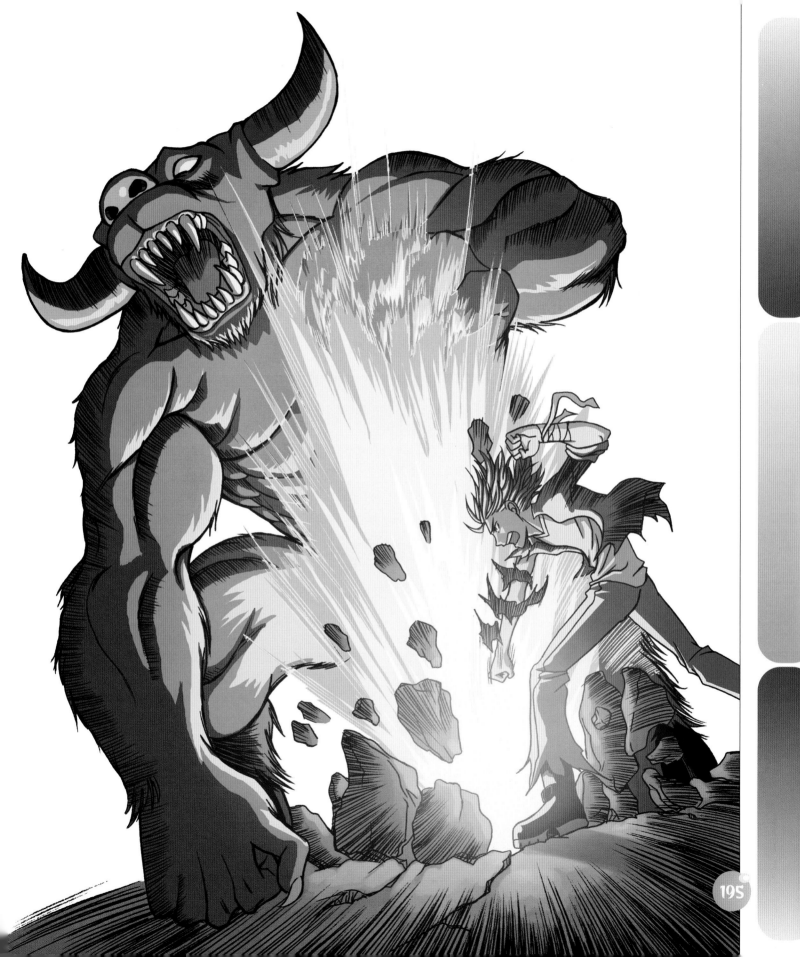

Animal-Based Spirits and Demons

In many graphic novels and anime shows, the hero has been cursed. The curse can take many forms, but often an animal demon latches onto the hero, and he or she is doomed to carry the burden of evil forever. The accursed person can often transform back and forth from magical animal to human, such as when super strength and powers are needed. Here are some of the most popular types of creatures that are used for animal legends.

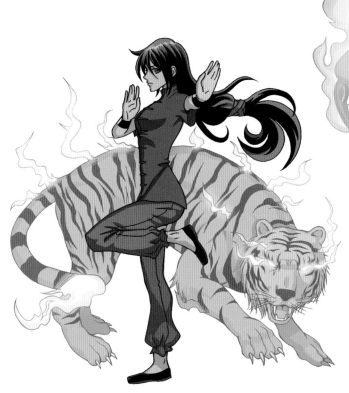

Tiger Girl

Notice how flames arise from the tiger's stripes. In addition, the tiger represents a style of Shaolin Kung-Fu, so it's a perfect match for this skilled fighter.

Scorpion Boy

How do we know this boy is evil? Because the scorpion is a creature we always associate with the forces of darkness. The flames shooting from the scorpion's pincers are mirrored in the boy's hand. In fight scenes, the boy would likely have in reserve an ultimate weapon: a piercing fist that plunges deep into the body, just like the scorpion's stinger.

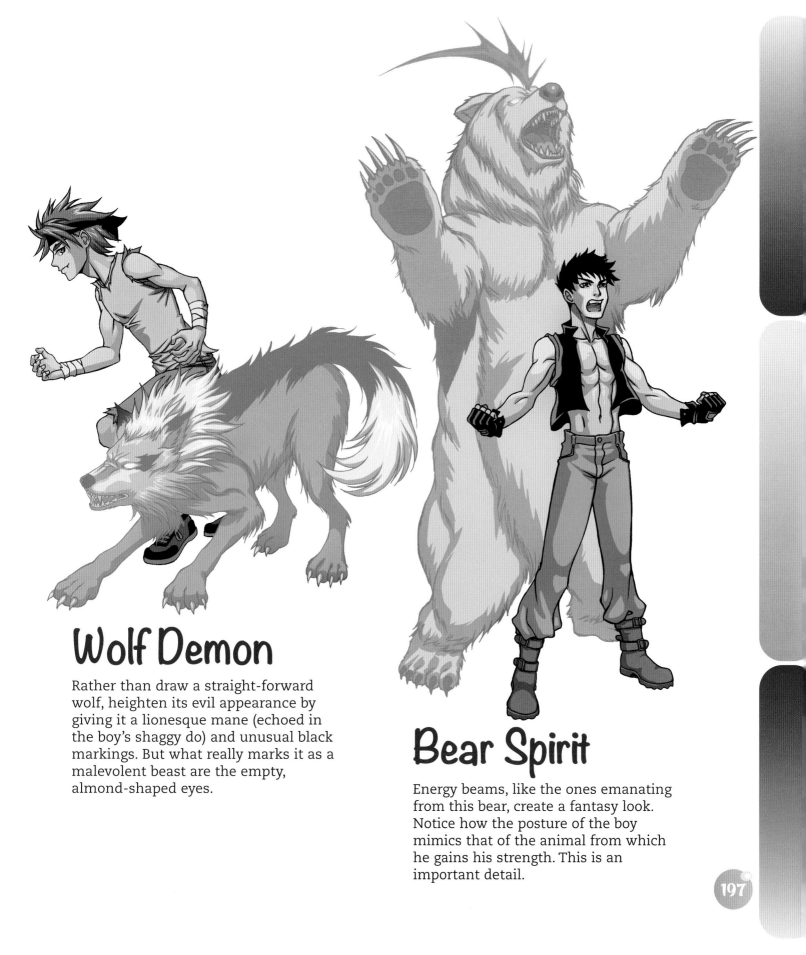

Wolf Demon

Rather than draw a straight-forward wolf, heighten its evil appearance by giving it a lionesque mane (echoed in the boy's shaggy do) and unusual black markings. But what really marks it as a malevolent beast are the empty, almond-shaped eyes.

Bear Spirit

Energy beams, like the ones emanating from this bear, create a fantasy look. Notice how the posture of the boy mimics that of the animal from which he gains his strength. This is an important detail.

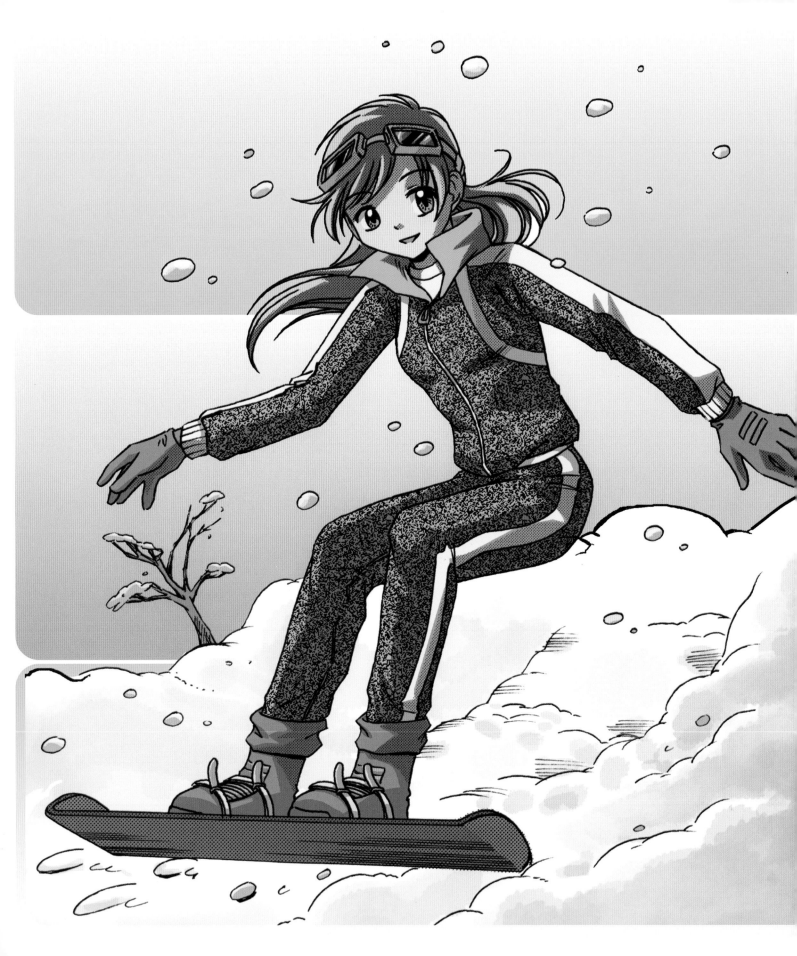

Girl Athletes

Just like America, Japan is crazy for girls' sports. And an entire manga genre has sprung up around the subject. It's good gal versus bad gal, with our hero gal facing the opposing team's bigger, meaner star in a cruel face-off. The girls on the enemy team usually get the upper hand early on, but our hero fights back with guts and courage to win in the end! There's a lot of off-court drama, too, to keep things interesting.

Field Hockey Champ

What used to be an obscure sport has grown by leaps and bounds into one of the most popular outdoor events. In drawing poses for field hockey, it's important to keep the stick and arms away from the body. You don't want them to overlap the torso, which would make the drawing look cramped and hard to read. Be sure to space the hands apart on the stick for more stability. Remember, it's not a baseball bat.

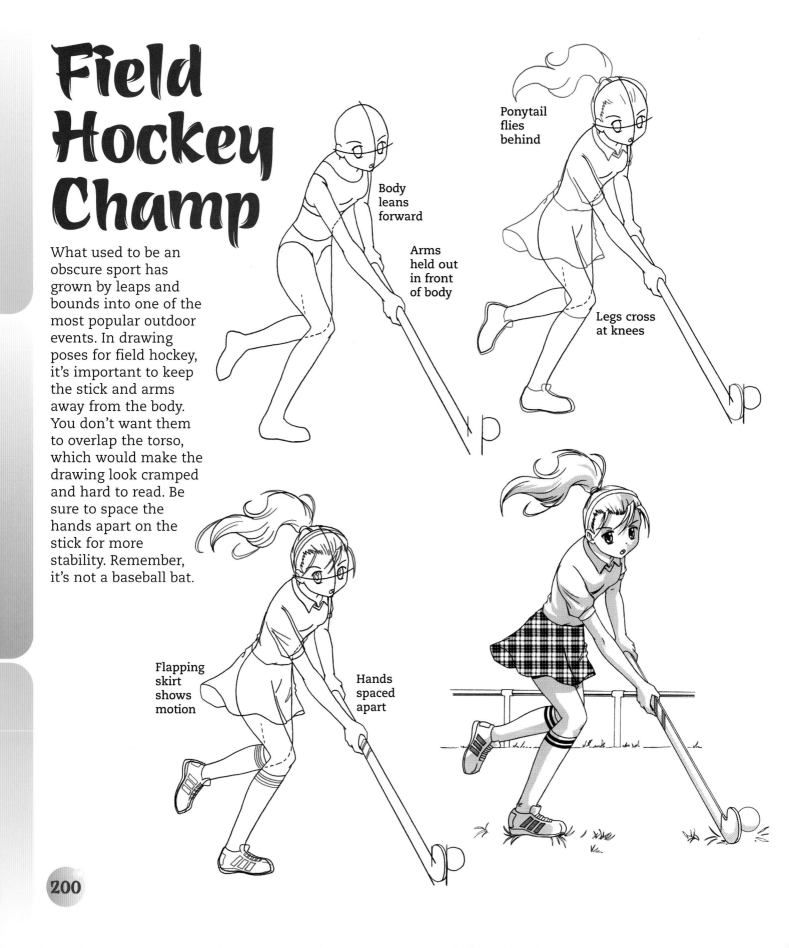

Body leans forward

Arms held out in front of body

Ponytail flies behind

Legs cross at knees

Flapping skirt shows motion

Hands spaced apart

200

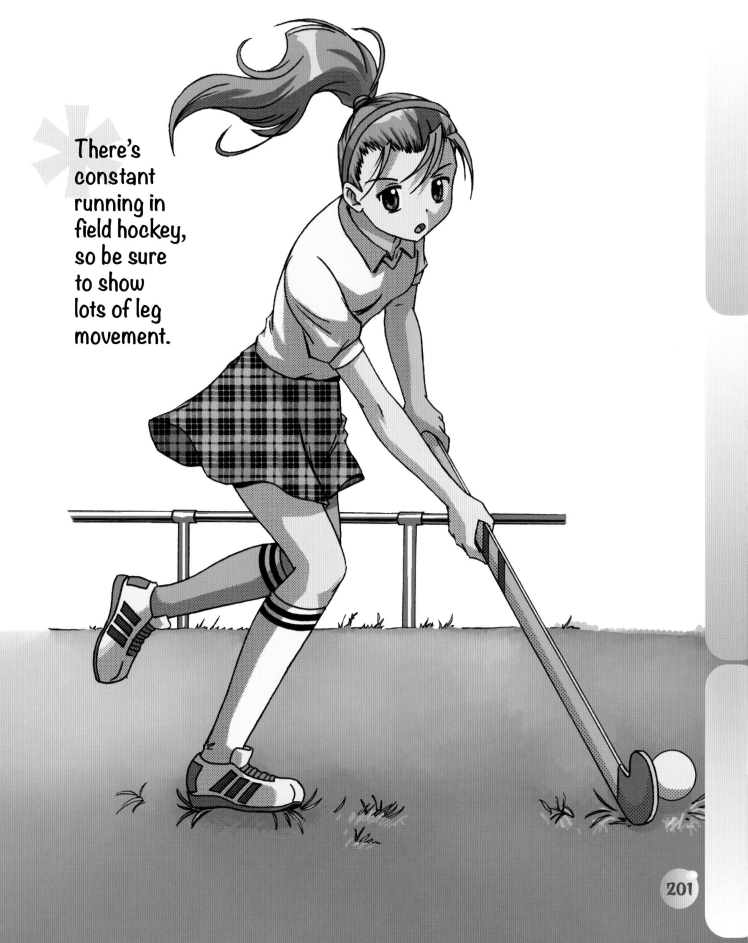

There's constant running in field hockey, so be sure to show lots of leg movement.

Tennis Ace

Tennis has always been popular, but it is especially popular in the manga world. Short skirts and short-sleeve shirts with headbands, and often wristbands, are the standard tennis costume. Sometimes, a character will wear a visor. But no pro tennis player competes wearing sunglasses.

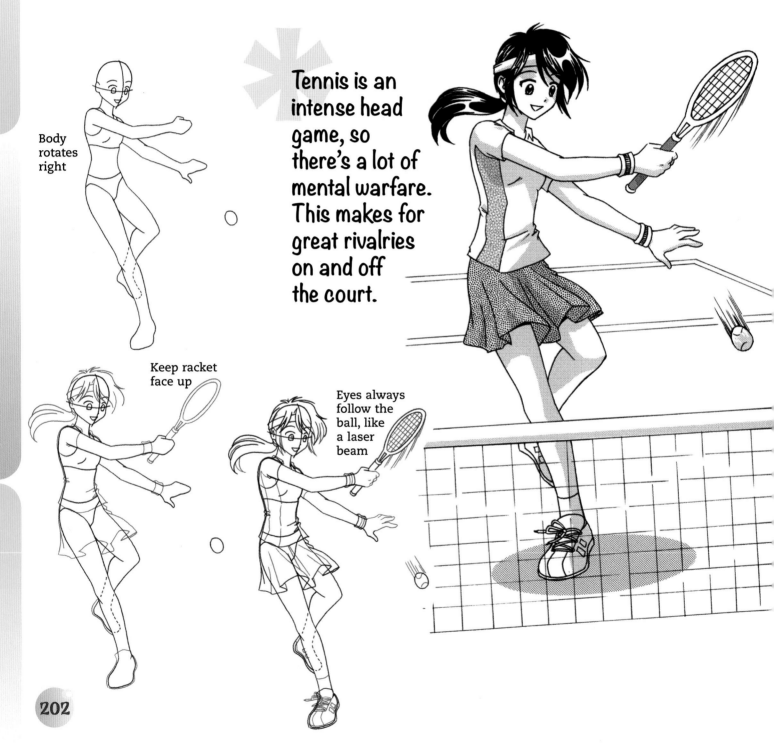

Body rotates right

Tennis is an intense head game, so there's a lot of mental warfare. This makes for great rivalries on and off the court.

Keep racket face up

Eyes always follow the ball, like a laser beam

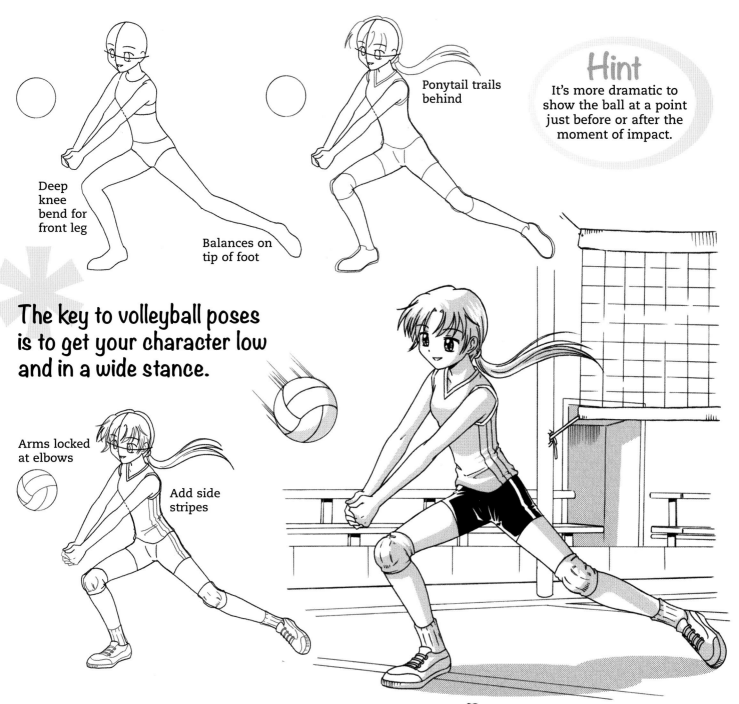

Ponytail trails behind

Hint
It's more dramatic to show the ball at a point just before or after the moment of impact.

Deep knee bend for front leg

Balances on tip of foot

The key to volleyball poses is to get your character low and in a wide stance.

Arms locked at elbows

Add side stripes

Volleyball Star

The underhand return, shown here, is the quintessential volleyball move—something you don't see in any other sport. It's always good to use a signature play when representing a particular sport. That way, the reader "gets it" at a glance. Notice how she's moving forward to meet the ball. All good athletes, in any sport, do this—they anticipate the ball.

203

Teen Equestrian

There are two types of riding: Western style—the way cowboys ride—and English. English riding, shown here, is more traditional and requires that fancy riding uniform. English riding horses, like their riders, are the epitome of class and good breeding. The horse and rider form a special bond. They read each other's thoughts, become jealous of other's affections, and can come to each other's rescue when one of them is in trouble.

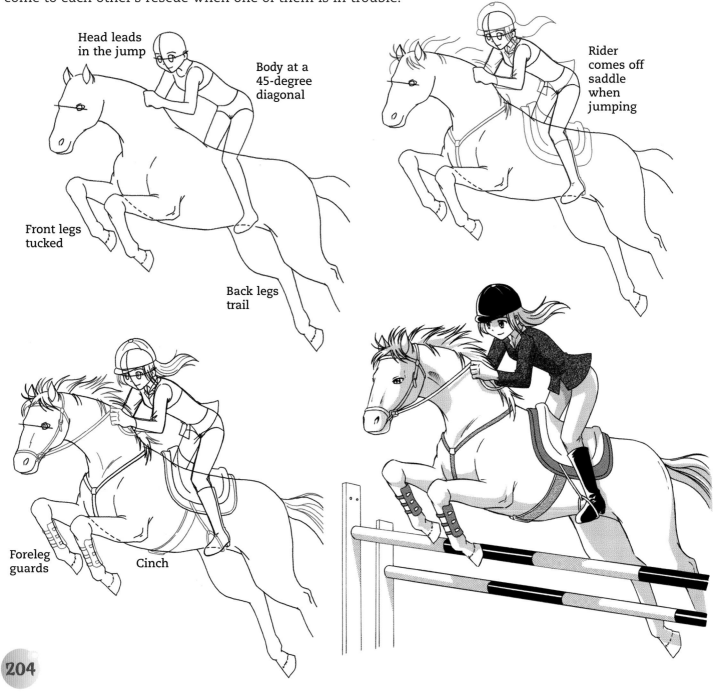

Head leads in the jump

Body at a 45-degree diagonal

Front legs tucked

Back legs trail

Rider comes off saddle when jumping

Foreleg guards

Cinch

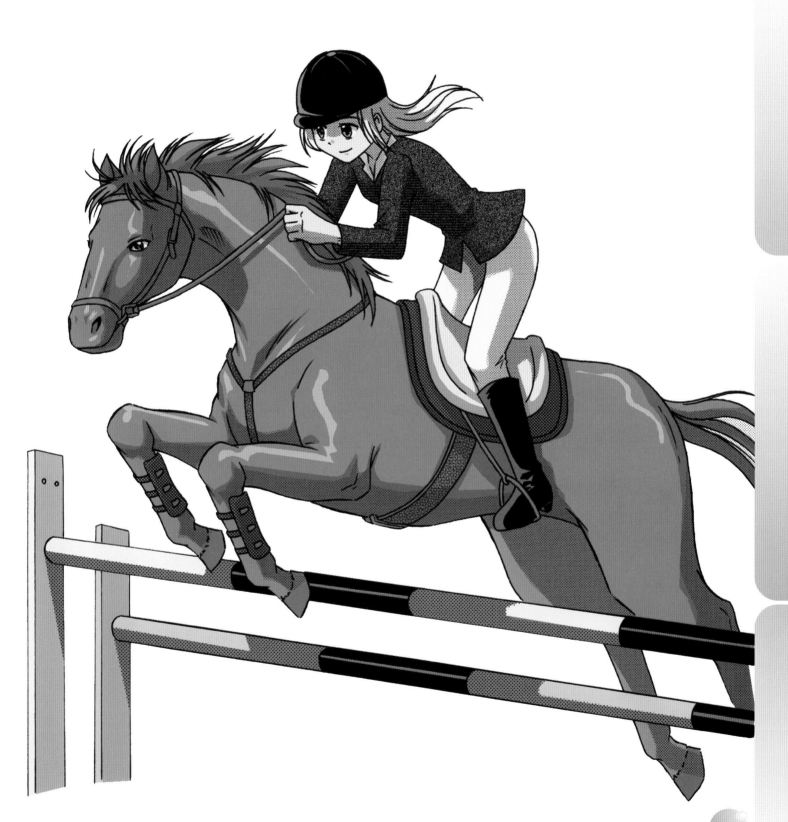

Karate Girl

There are two general types of martial arts: striking and grappling. Striking arts include karate, tae kwon do, and kung fu. Grappling arts include judo, jujitsu, and aikido. In the striking arts, there are drills, sparring, and board (or brick) breaking. Each is exciting. Here, we see a typical karate exercise—breaking boards on top of cinderblocks. The gym where she practices is called a dojo.

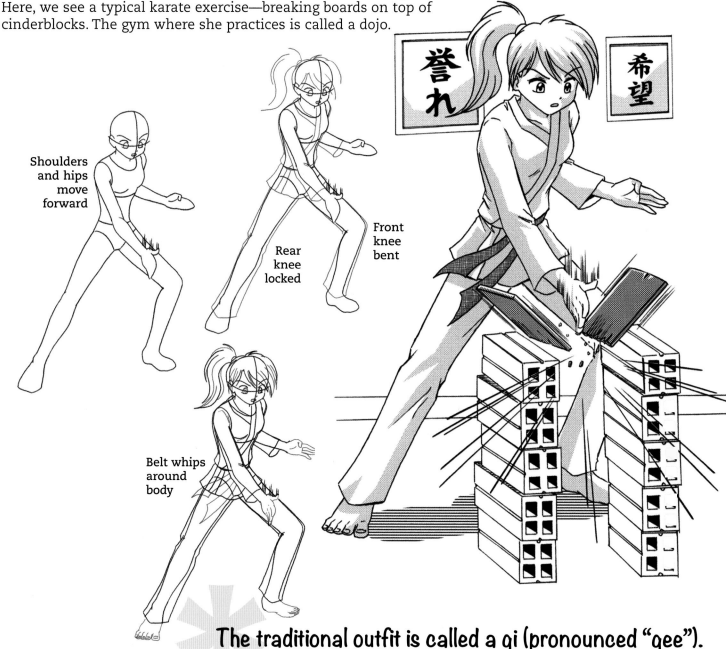

Shoulders and hips move forward

Rear knee locked

Front knee bent

Belt whips around body

The traditional outfit is called a gi (pronounced "gee"). The most common gi is white, but some are black. Red ones, my friends, are only for the movies!

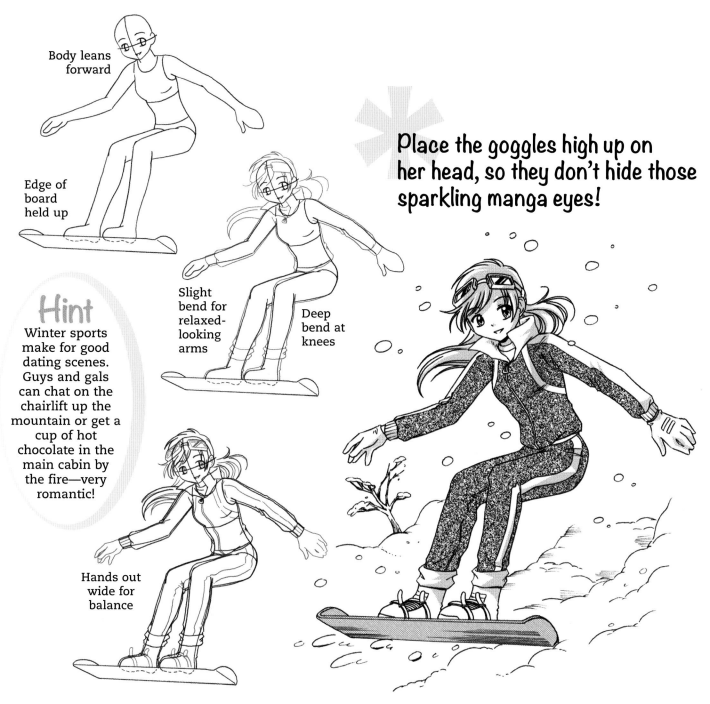

Body leans forward

Edge of board held up

Slight bend for relaxed-looking arms

Deep bend at knees

Place the goggles high up on her head, so they don't hide those sparkling manga eyes!

Hint
Winter sports make for good dating scenes. Guys and gals can chat on the chairlift up the mountain or get a cup of hot chocolate in the main cabin by the fire—very romantic!

Hands out wide for balance

Snowboarder

Let's not forget the ever-popular winter sports! If you look out at the ski slopes from atop a chair lift, one thing is plainly obvious: The younger set is on snowboards, and the old folks are on skis. On skis, you keep the tips up, but on snowboards, it's the side edge that must be kept raised. It sprays the snow forward and allows you to steer. The feet are locked into the snowboard, parallel to each other.

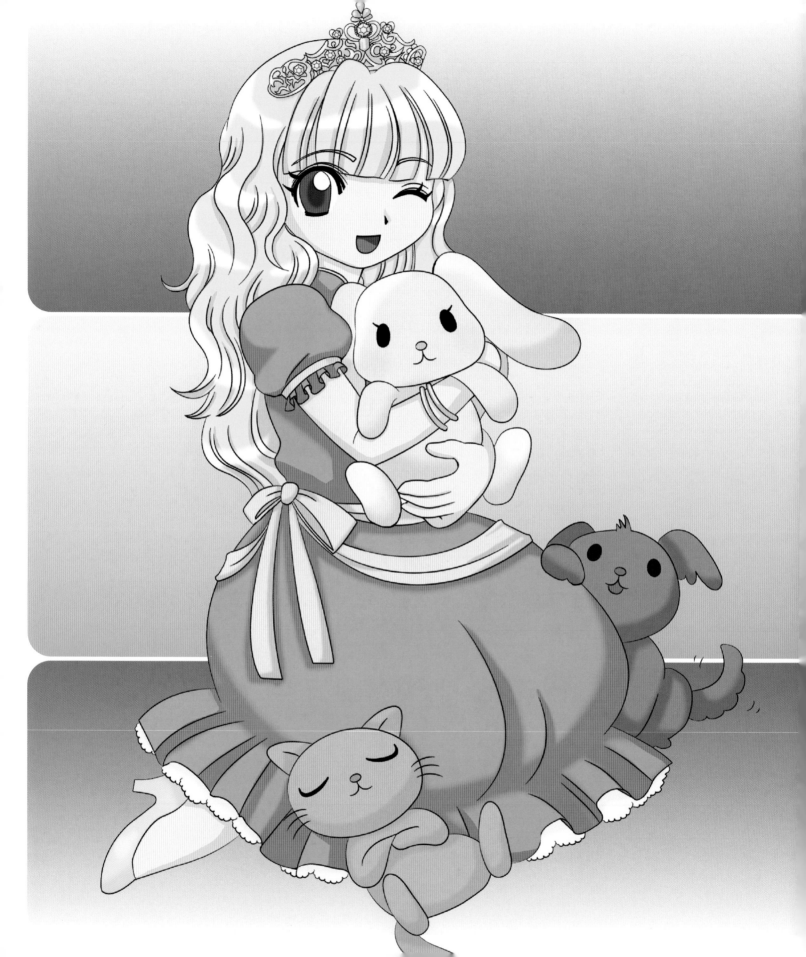

Princess Power

Princesses in manga run the gamut from the earthbound to the intergalactic. There are good ones, bad ones, ones who sit around looking pretty, and ones who fight alien invaders. But they're all attractive and youthful. Although many wear tiaras, it's not essential, especially for warrior types. They mostly live in fantasy castles, which can be located in valleys, on mountaintops, in the middle of lakes, high up in the clouds, or floating in the sky.

Spoiled Princess

This rich girl lives in her daddy's castle. She's given everything she wants. But what if she falls in love with a pauper who comes from the wrong side of the moat? What if Daddy threatens to cut her off from all of her worldly possessions and creature comforts? Which would she choose, true love or a life of luxury and splendor?

This type of princess, who comes from a long line of nobility, almost always has long hair and wears a small tiara.

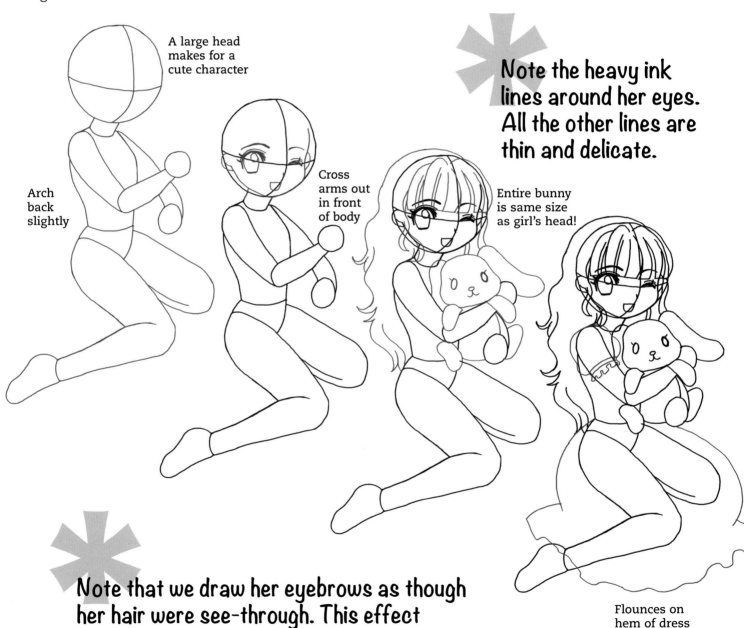

A large head makes for a cute character

Arch back slightly

Cross arms out in front of body

Note the heavy ink lines around her eyes. All the other lines are thin and delicate.

Entire bunny is same size as girl's head!

Note that we draw her eyebrows as though her hair were see-through. This effect works well with dainty characters.

Flounces on hem of dress

Princess Pets

Animals like these are "chibi" types—small, miniature characters. They are built on simple shapes, instead of drawn realistically. They're always plump and cute, with button eyes and tiny mouths and noses. They are favorites of manga lovers of all ages!

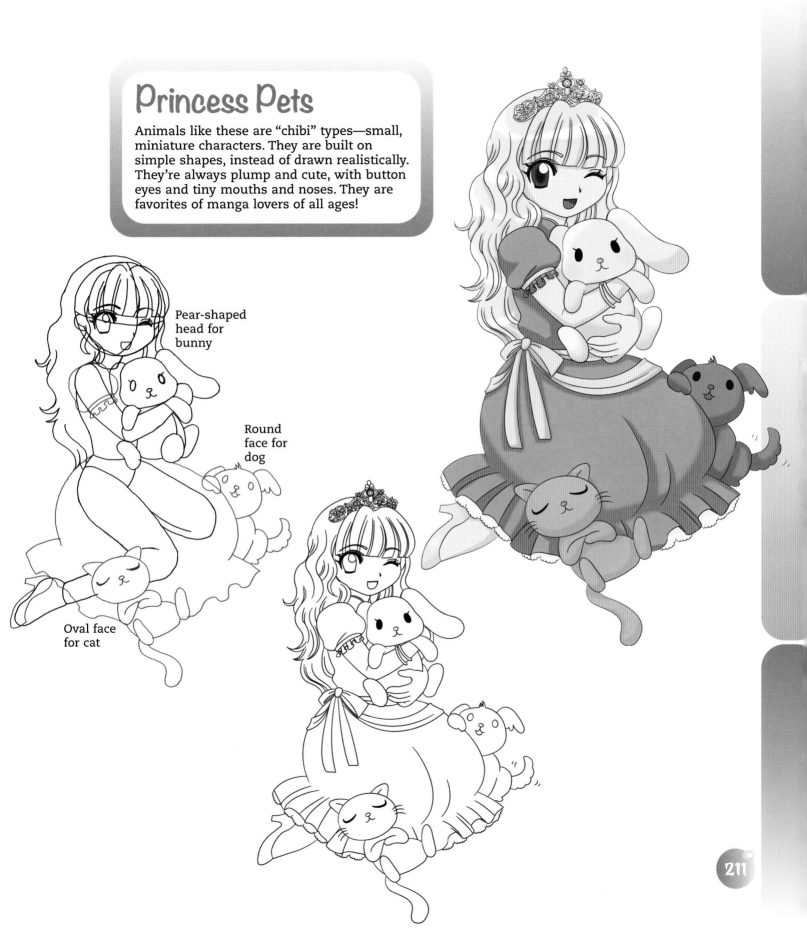

Pear-shaped head for bunny

Round face for dog

Oval face for cat

211

Princess From Another Galaxy

Space fantasies often feature idealized views of the future, such as advanced kingdoms threatened by interplanetary barbarians seeking to take them over. How better to negotiate for total surrender than to take the planet's princess hostage? All of her subjects love her and would give anything to get her back safe and sound!

Because she's a fantasy character, you can give her a fanciful hair color.

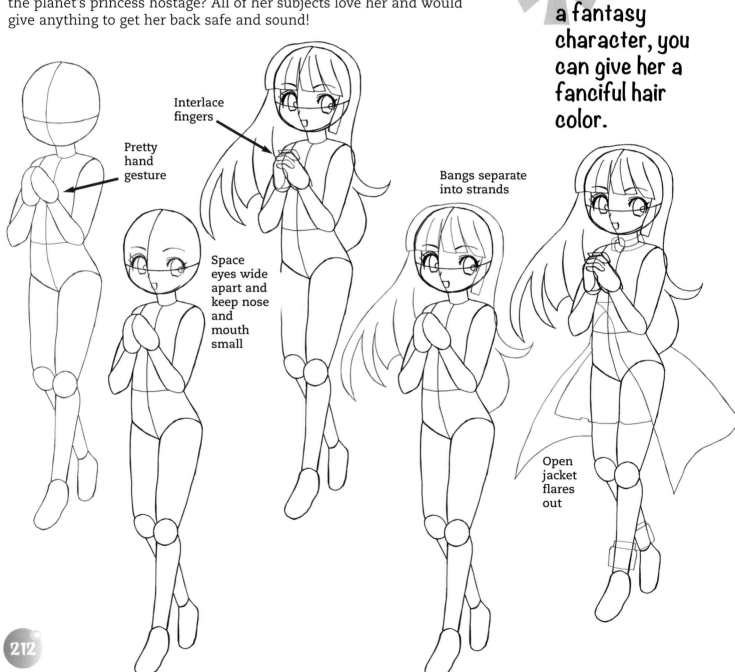

Pretty hand gesture

Interlace fingers

Space eyes wide apart and keep nose and mouth small

Bangs separate into strands

Open jacket flares out

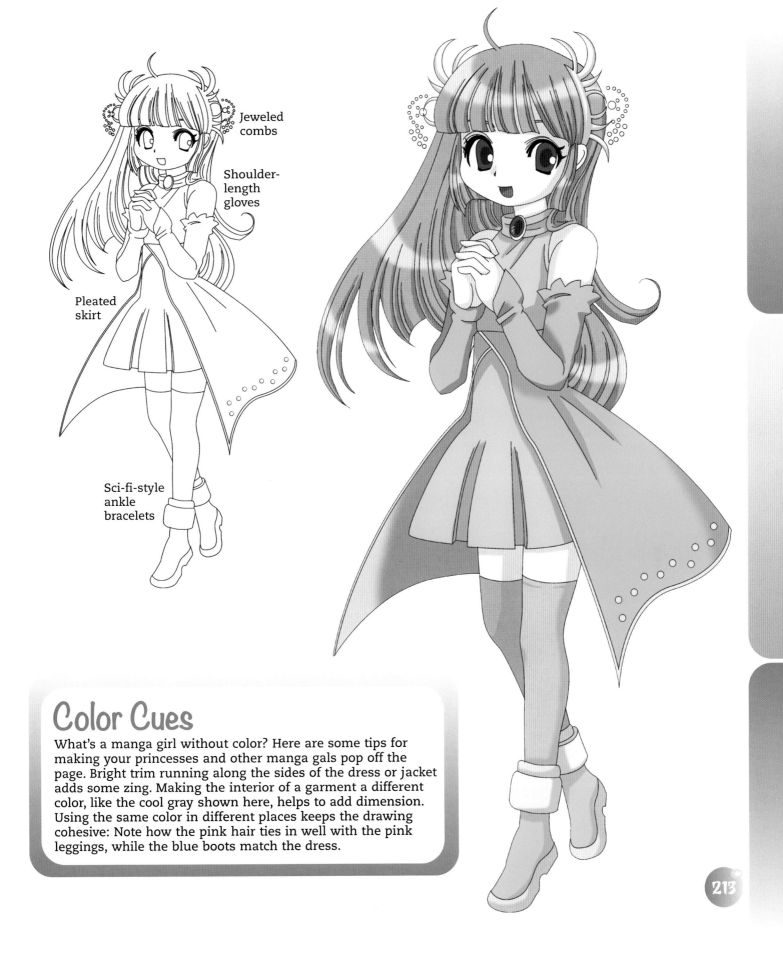

Jeweled combs

Shoulder-length gloves

Pleated skirt

Sci-fi-style ankle bracelets

Color Cues

What's a manga girl without color? Here are some tips for making your princesses and other manga gals pop off the page. Bright trim running along the sides of the dress or jacket adds some zing. Making the interior of a garment a different color, like the cool gray shown here, helps to add dimension. Using the same color in different places keeps the drawing cohesive: Note how the pink hair ties in well with the pink leggings, while the blue boots match the dress.

Fighter Princess

The typical fighter princess is a cross between a knight and a magical girl. The long gloves, short pleated skirt and leggings are pure magical girl genre. She should wear only as much body armor as necessary. You don't want to cover her up too much, or the reader will lose sight of the character underneath and see only a suit of armor. Give her flowing, waist-length fantasy hair for a glamorous look. She doesn't need a tiara—it's too prissy for a warrior.

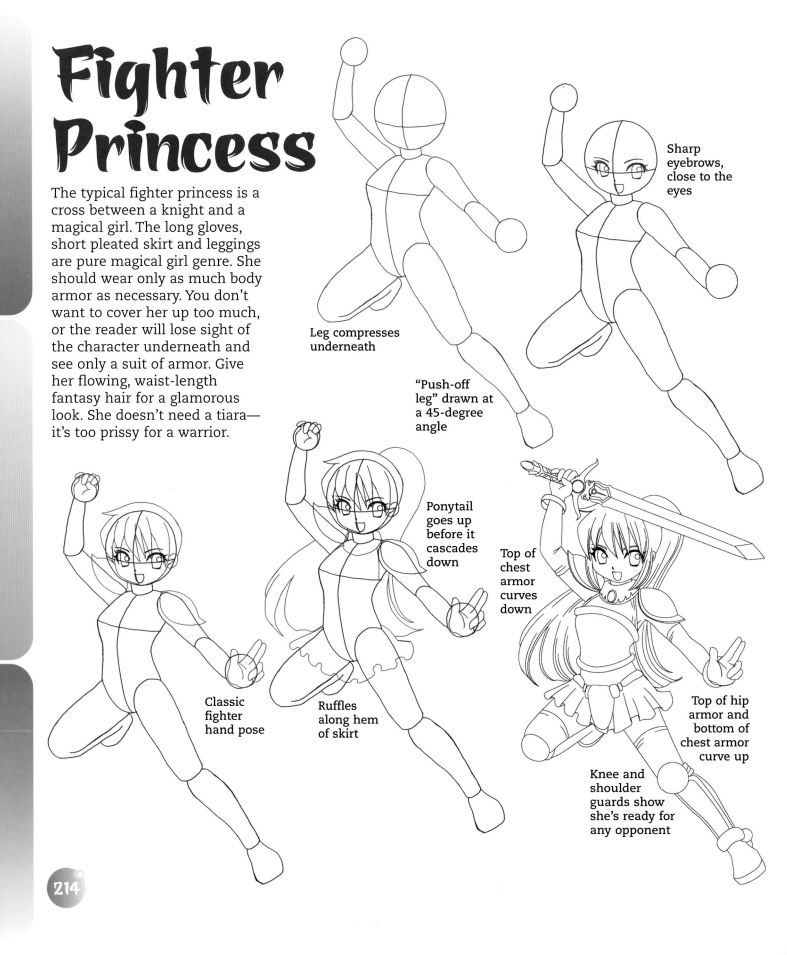

Leg compresses underneath

Sharp eyebrows, close to the eyes

"Push-off leg" drawn at a 45-degree angle

Ponytail goes up before it cascades down

Top of chest armor curves down

Classic fighter hand pose

Ruffles along hem of skirt

Top of hip armor and bottom of chest armor curve up

Knee and shoulder guards show she's ready for any opponent

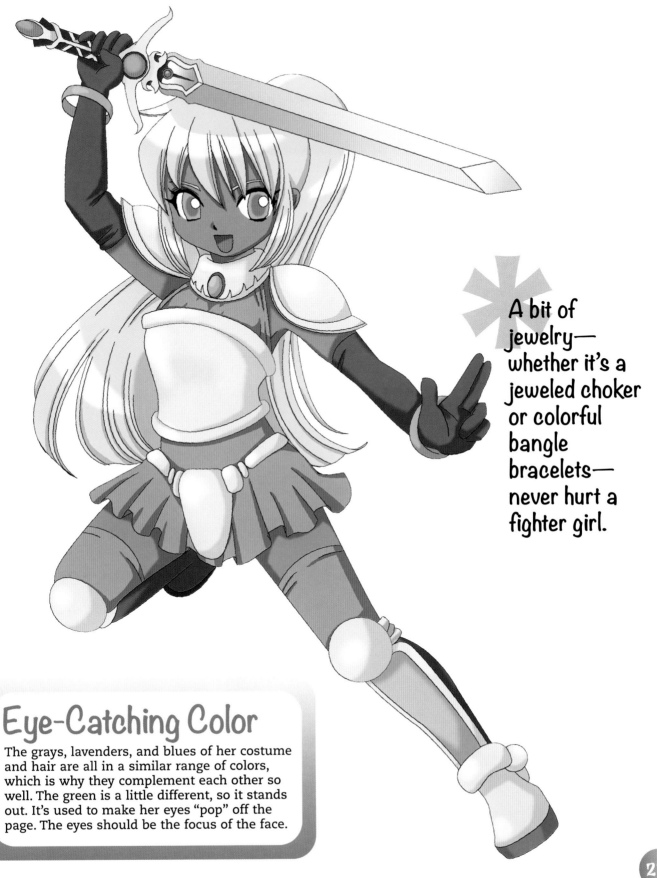

A bit of jewelry—whether it's a jeweled choker or colorful bangle bracelets—never hurt a fighter girl.

Eye-Catching Color

The grays, lavenders, and blues of her costume and hair are all in a similar range of colors, which is why they complement each other so well. The green is a little different, so it stands out. It's used to make her eyes "pop" off the page. The eyes should be the focus of the face.

Evil Princess

If ever there were a character who loved to plot and scheme, it would be the evil princess. She's beautiful, but also cruel. Never satisfied with the amount of power she has, she's always plotting to acquire more. She is often portrayed as part of an evil team—with her as its leader. Evil characters like her often wear tight-fitting body suits. High heels complete the severe look.

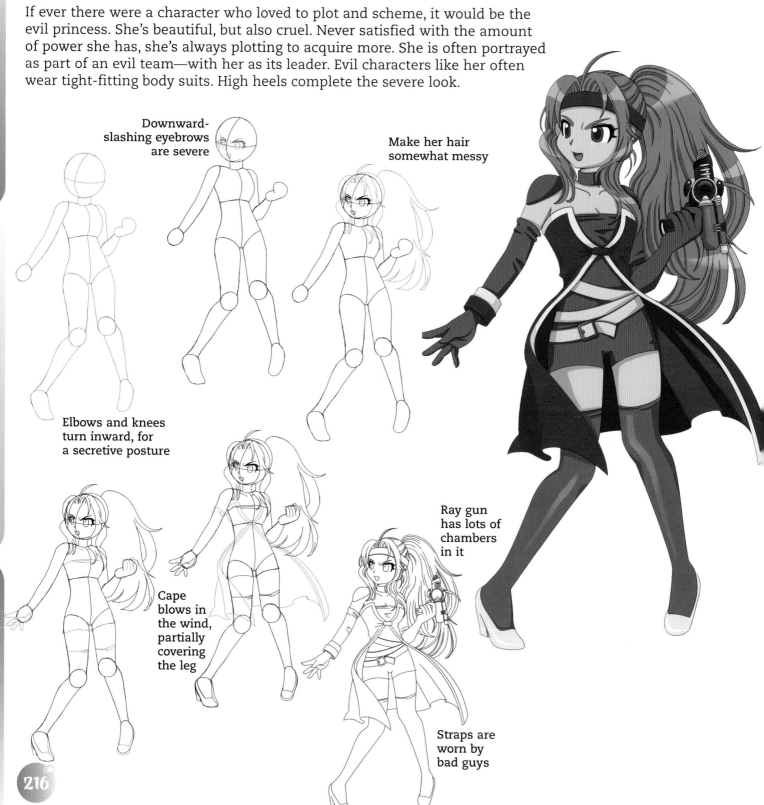

Downward-slashing eyebrows are severe

Make her hair somewhat messy

Elbows and knees turn inward, for a secretive posture

Cape blows in the wind, partially covering the leg

Ray gun has lots of chambers in it

Straps are worn by bad guys

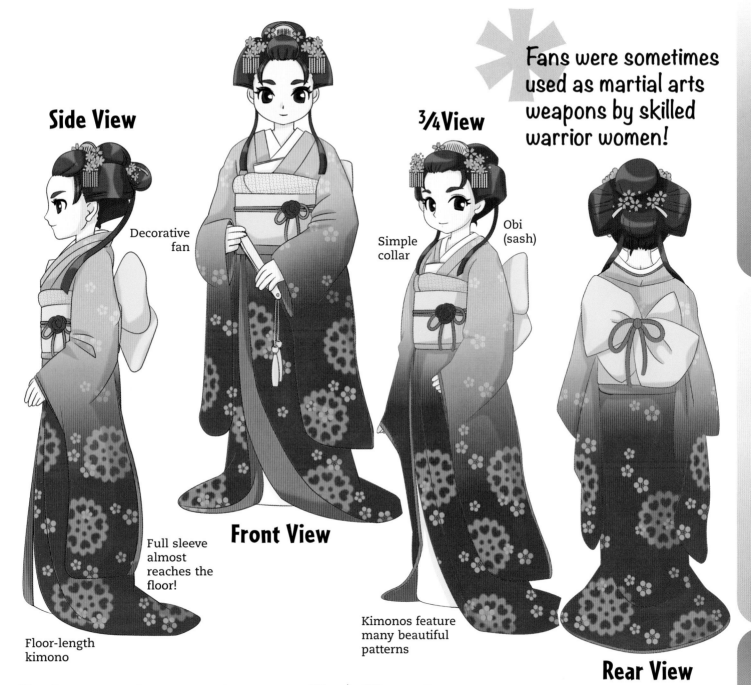

Side View

Decorative fan

Full sleeve almost reaches the floor!

Floor-length kimono

Front View

3/4 View

Simple collar

Obi (sash)

Kimonos feature many beautiful patterns

Fans were sometimes used as martial arts weapons by skilled warrior women!

Rear View

Historical Princess

Historical dramas are very popular in manga. The word history might conjure up thoughts of homework assignments, but these historical stories are not boring, because they're fictionalized period pieces—stories that take place at some cool time in the past with original characters who wear authentic, eye-catching costumes. They often feature princesses, princes, samurai, ninjas, noblemen, and warriors. Here is a beautiful, historical princess of feudal Japan, wearing the famous kimono.

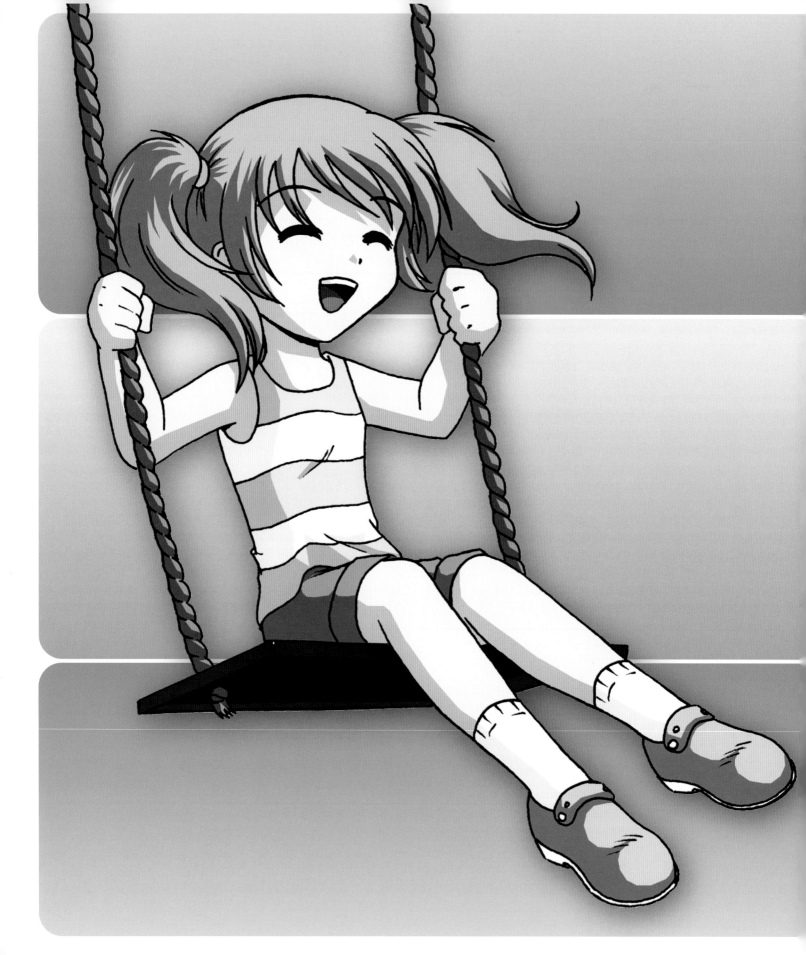

Kodomo!

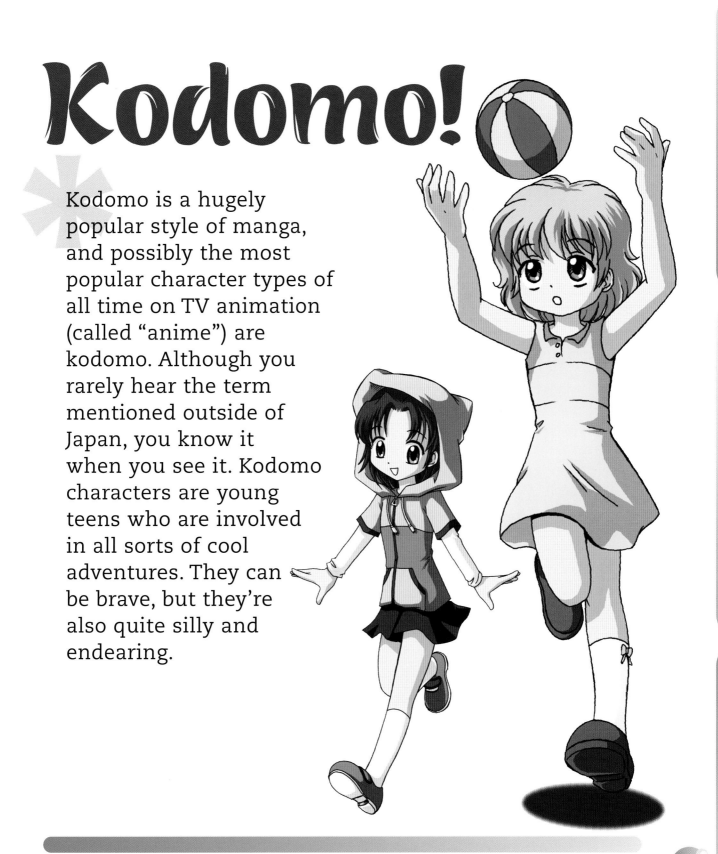

Kodomo is a hugely popular style of manga, and possibly the most popular character types of all time on TV animation (called "anime") are kodomo. Although you rarely hear the term mentioned outside of Japan, you know it when you see it. Kodomo characters are young teens who are involved in all sorts of cool adventures. They can be brave, but they're also quite silly and endearing.

Kodomo Style: Keep It Round!

Just making a character look young doesn't automatically turn her into a kodomo-style character. You have to make sure that everything about her is soft and round.

Note that the nose and mouth are minimized, which makes the eyes look bigger by contrast.

Large, round eyes are spaced wide apart

Short ponytails look youthful

Vary the hand gestures

Knee bent inward suggests a friendly, yet modest personality

Kodomo Body

Note the kodomo girl's large, round head, big round eyes, and relaxed, appealing pose. It doesn't get any cuter than this!

Angular Body

Sure she's the kodomo age range, but notice that the outline of her face, her eyes, and her pose are more angular than the kodomo girl's. As a result, she's not as cute.

Kodomo Eyes

The overall shape of the eye is based on a rounded square, or a circle.

Angular Eyes

Angular eyes, which are drawn more often by American artists who are trying to imitate Japanese manga, are based on a geometrical shape with sides, like this pentagon.

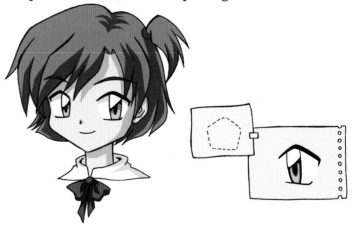

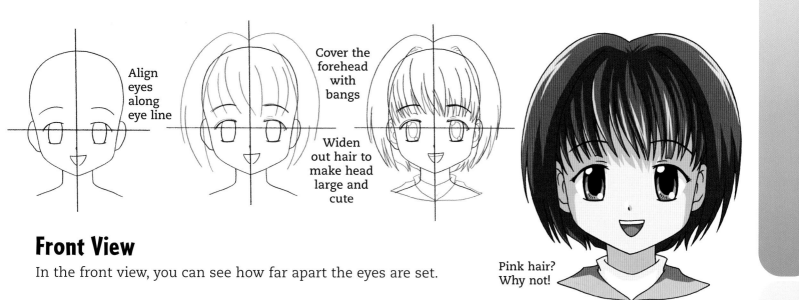

Align eyes along eye line

Cover the forehead with bangs

Widen out hair to make head large and cute

Front View

In the front view, you can see how far apart the eyes are set.

Pink hair? Why not!

Profile

Notice that in the side view the ears are close to the middle of the head. Some beginners think that the back of the head stops just behind the ears, but there is almost as much head behind the ears as there is in front.

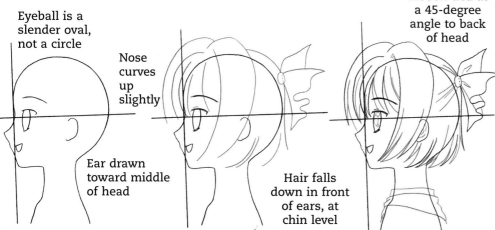

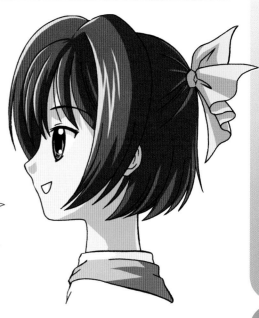

Eyeball is a slender oval, not a circle

Nose curves up slightly

Ear drawn toward middle of head

Hair falls down in front of ears, at chin level

Ribbon tied at a 45-degree angle to back of head

The Kodomo Head

The kodomo face is wide with big cheeks and a little chin. The eyes are large and set wide apart, and the nose is extra tiny. All of the features are set low on the face, which means that there is a lot of forehead to cover with a bunch of brushy hair.

Kodomo Expressions

Here's something I really enjoyed when I was learning to draw—copying expressions. When you copy expressions, you learn much more than just how to draw different faces. You also learn to reproduce characters at many different angles and to make them recognizable in every pose. That's the essence of character design.

Caring

Bottom eyelids push up on the eyes, making them narrower. Eyebrows push upward. A small smile punctuates the expression.

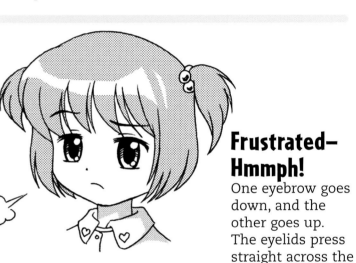

Glad

Heavy upper eyelids curve down. Big shines in the eyes make this expression really sparkle.

Frustrated—Hmmph!

One eyebrow goes down, and the other goes up. The eyelids press straight across the eyes. Note the puff of steam!

Delighted

Head tilts, eyes close (note thick eyelashes), and eyebrows arch up. Mouth opens wide.

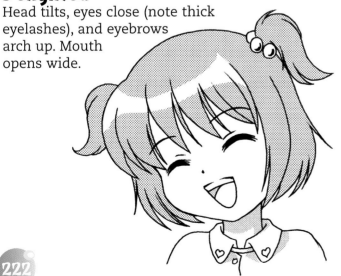

Angry

Eyebrows crush down on eyeballs. Draw a tense, little O for the mouth. And note those emotion lines drawn diagonally across her cheek.

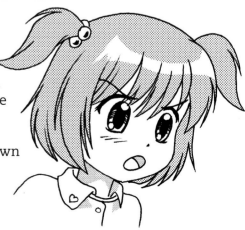

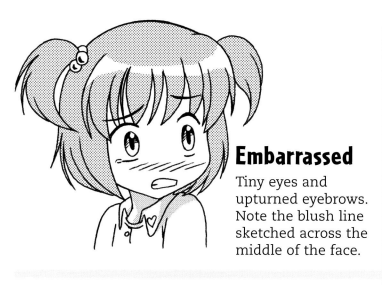

Embarrassed

Tiny eyes and upturned eyebrows. Note the blush line sketched across the middle of the face.

Crying

The head tilts forward when crying (unless the character is wailing uncontrollably, in a humorous manner).

Surprised

Mouth opened slightly, with the tongue tucked inside. Very high, arching eyebrows.

Tired

Squint one eye as her fist rubs against it. The other eye remains half open. Note bubbles of grogginess.

Curious

Focused eyes and a tiny mouth. Eyebrows come together and sweep up in the middle.

223

The Kodomo Body

Younger characters have rounder heads than older characters. And string bean bodies work best for kids age 10 to 12. We're looking for a round head on a sliver of a body, which translates into an eager, energetic look.

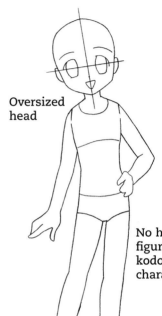

Oversized head

No hourglass figure on kodomo characters!

Front View

Older teens and adults have wider shoulders and hips, but the torso on kodomo characters is mostly straight up and down. Don't make the arms and legs too long and graceful—that's for older characters. And that big head resting on a delicate, little neck will guarantee her a sweet and charming look.

Hair usually at least shoulder length, if not longer

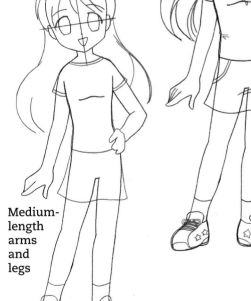

Medium-length arms and legs

Leaning her slightly to the side adds a bit of energy to an otherwise static pose.

224

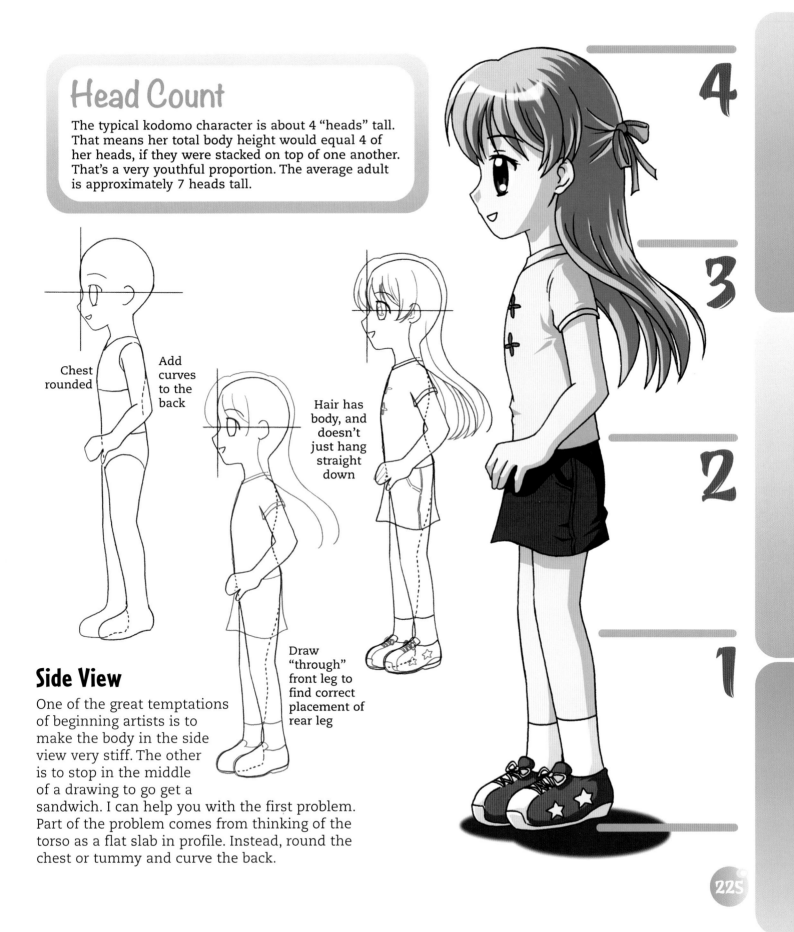

Head Count

The typical kodomo character is about 4 "heads" tall. That means her total body height would equal 4 of her heads, if they were stacked on top of one another. That's a very youthful proportion. The average adult is approximately 7 heads tall.

Chest rounded

Add curves to the back

Hair has body, and doesn't just hang straight down

Draw "through" front leg to find correct placement of rear leg

Side View

One of the great temptations of beginning artists is to make the body in the side view very stiff. The other is to stop in the middle of a drawing to go get a sandwich. I can help you with the first problem. Part of the problem comes from thinking of the torso as a flat slab in profile. Instead, round the chest or tummy and curve the back.

4

3

2

1

Action Poses

One thing's for sure, if a kodomo character is standing still, it won't be for long. These high-energy girls are always on the move, whether it's goofing off with friends, or competing in sports.

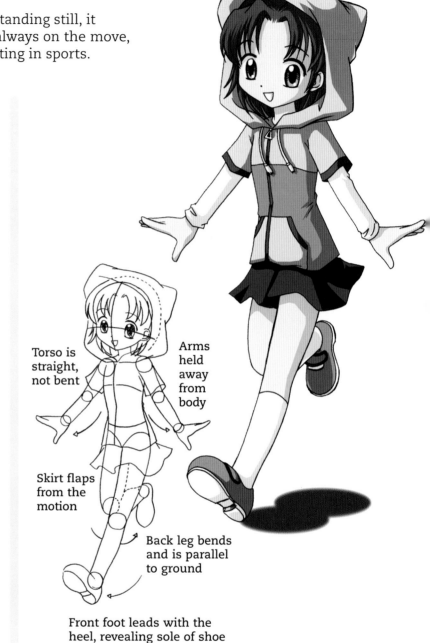

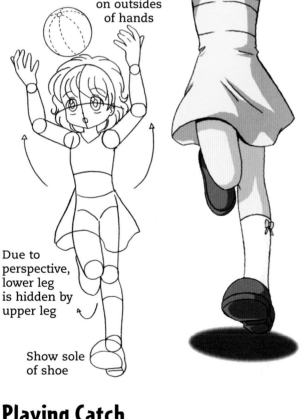

Thumbs go on outsides of hands

Due to perspective, lower leg is hidden by upper leg

Show sole of shoe

Torso is straight, not bent

Arms held away from body

Skirt flaps from the motion

Back leg bends and is parallel to ground

Front foot leads with the heel, revealing sole of shoe

Playing Catch

This pose gets the arms in on the action. They are held above the head, slightly bent.

Running

Because young characters typically have shorter torsos that won't bend or twist a lot, much of the action comes from how you position the arms and legs.

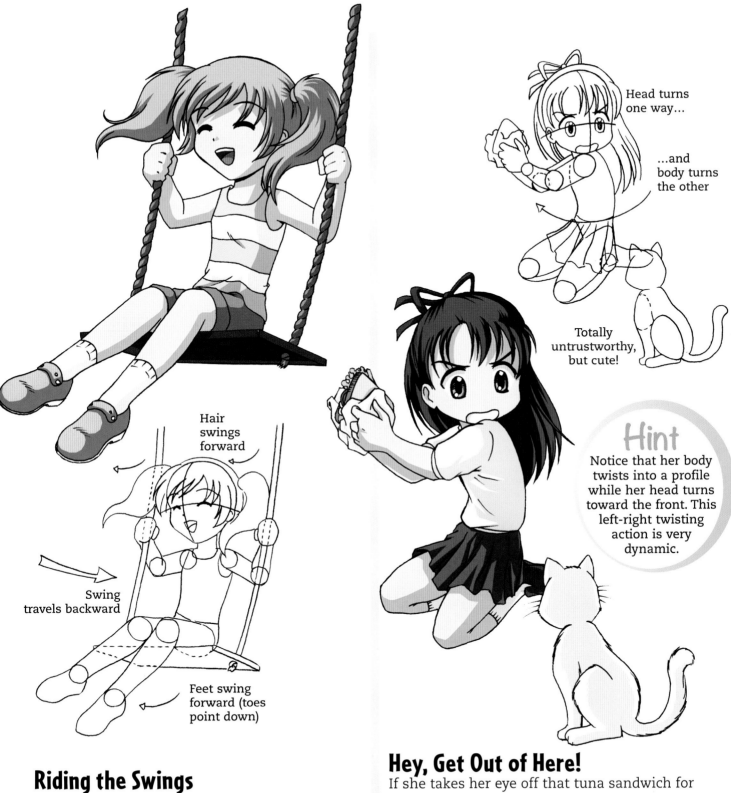

Head turns one way...

...and body turns the other

Totally untrustworthy, but cute!

Hair swings forward

Swing travels backward

Feet swing forward (toes point down)

Hint

Notice that her body twists into a profile while her head turns toward the front. This left-right twisting action is very dynamic.

Riding the Swings

As she swings backward, her legs and hair swing forward. This combination of forces really gives a sense of movement through space.

Hey, Get Out of Here!

If she takes her eye off that tuna sandwich for one second, it'll be history. See how the shoulder rises up so the chin tucks under it? Without it, the pose would lose it's charm.

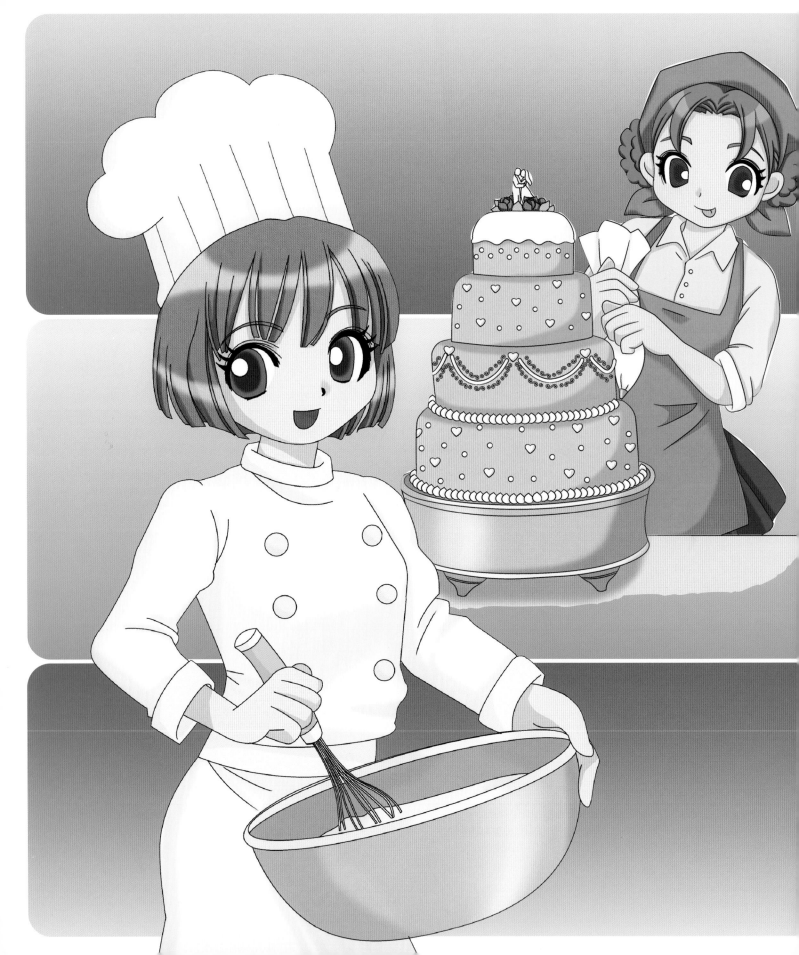

Fantasy Chefs!

Occupational genres are all the rage in manga these days—and none is more popular than cooking. Japanese youth are obsessed with manga stories that feature young gourmets! Choose an ethnic style of food and dress the cook in an outfit that best represents that country's cuisine. Half the fun is in creating the chefs' costumes, but there is also a lot of humor that goes on in these comics—especially among the apprentice chefs—where anything can, and will, go wrong!

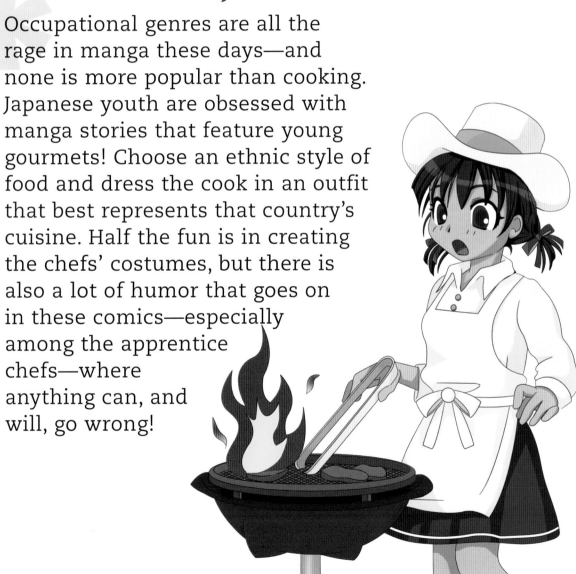

Hibachi Chef

Famous for their work in Japanese steak houses, hibachi chefs grill all sorts of interesting dishes right before your eyes. They are experts with knives and can slice and dice food in a blur. But the most spectacular aspect of their work are the huge flames that erupt into the air as they grill—it's quite an eyeful.

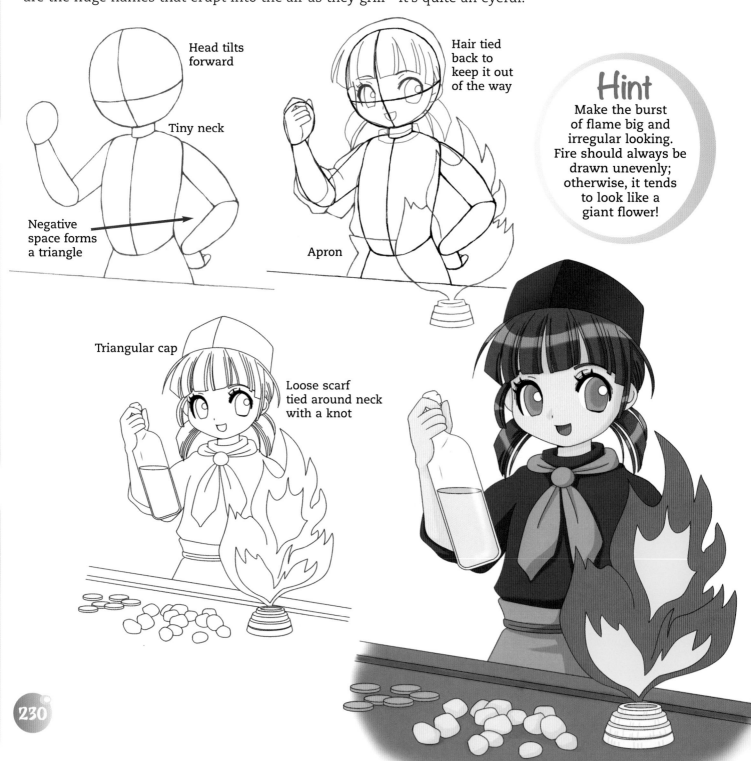

Head tilts forward

Tiny neck

Negative space forms a triangle

Hair tied back to keep it out of the way

Apron

Hint
Make the burst of flame big and irregular looking. Fire should always be drawn unevenly; otherwise, it tends to look like a giant flower!

Triangular cap

Loose scarf tied around neck with a knot

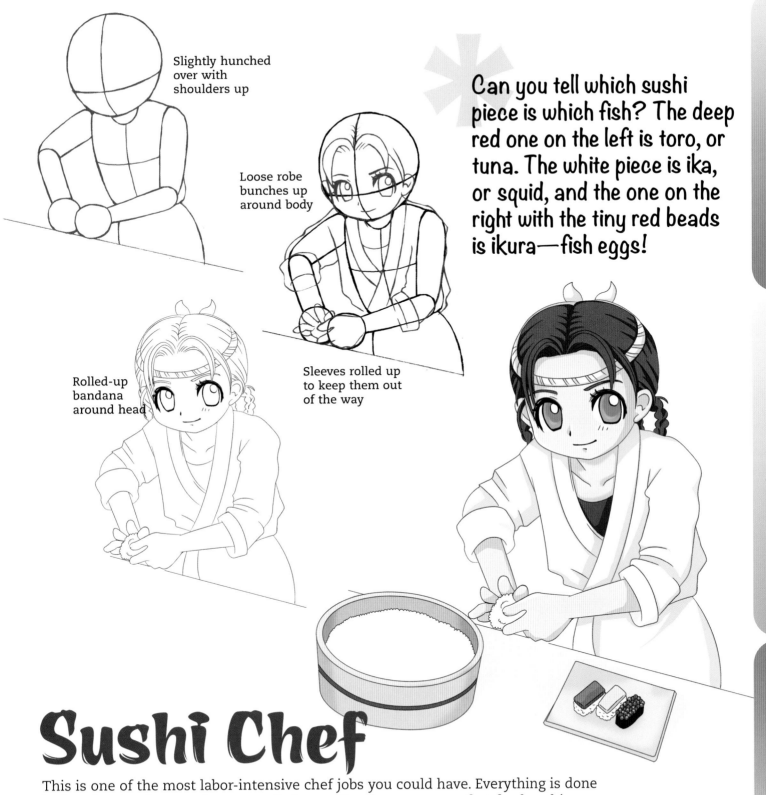

Slightly hunched over with shoulders up

Loose robe bunches up around body

Can you tell which sushi piece is which fish? The deep red one on the left is toro, or tuna. The white piece is ika, or squid, and the one on the right with the tiny red beads is ikura—fish eggs!

Sleeves rolled up to keep them out of the way

Rolled-up bandana around head

Sushi Chef

This is one of the most labor-intensive chef jobs you could have. Everything is done by hand, using force and pressure. In Japan, they have as many fast food sushi restaurants as we have hamburger places. Everyone eats sushi. But not just anyone can be a sushi chef. The visual appeal of a well-formed piece of sushi is seen as equally important as its taste, and the sushi chef is a well-respected artisan.

French Chef

The quintessential French chef wears a tall, oversized hat that poufs at the top, along with a buttondown jacket. This formal attire shows that she works in a high-end establishment. She's busy mixing up a large bowl of batter to make a fluffy soufflé—très français!

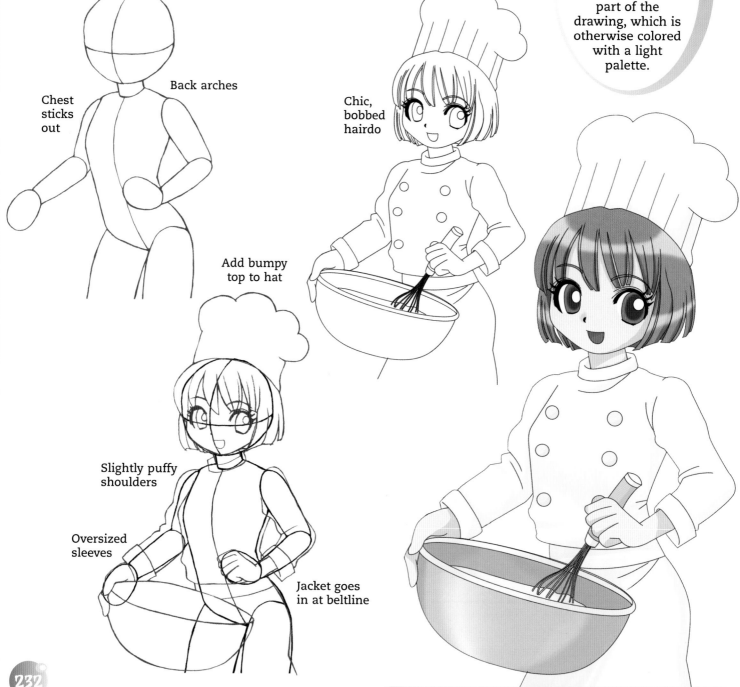

Chest sticks out

Back arches

Chic, bobbed hairdo

Add bumpy top to hat

Slightly puffy shoulders

Oversized sleeves

Jacket goes in at beltline

Hint
Notice how her eyes really stand out? That's because they are the darkest part of the drawing, which is otherwise colored with a light palette.

232

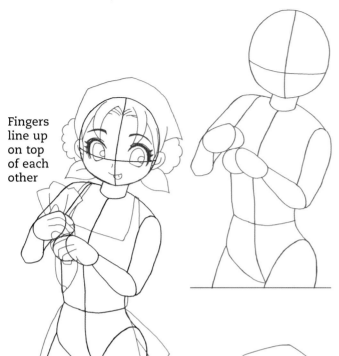

Fingers line up on top of each other

Drawing Dynamic Scenes

This scene could have been drawn with the cake off to the side of the character, instead of in front of her, but that would have flattened the image. Some begining artists don't want to block part of a figure, which they have spent time and energy drawing. But the amount of the figure cut off is minimal, and the result brings the cake closer to the viewer, and to the figure, which energizes the scene.

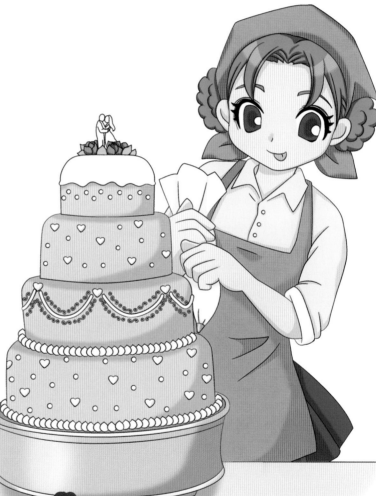

Bride and groom figurines

Four layers and a platform

Pastry Chef

I don't know about you, but it always looks like so much fun when I see a pastry chef adding squiggles of icing along the edges of a cake. I'd never try it, though—I'd probably misspell a word and try to fix it with a pencil eraser, and I hear that doesn't work too well on icing!

Pizza Maker

This chef's outfit is all white, with a chef's hat that leans to one side. If it was any other color, all that white dough and flour would make huge white marks all over it. A raw pizza should be drawn as if it were a gigantic pancake, twirling unevenly in the air. Her hands are up, about shoulder height, as she releases the pie. She must follow the pie with her eyes, or she might end up wearing it!

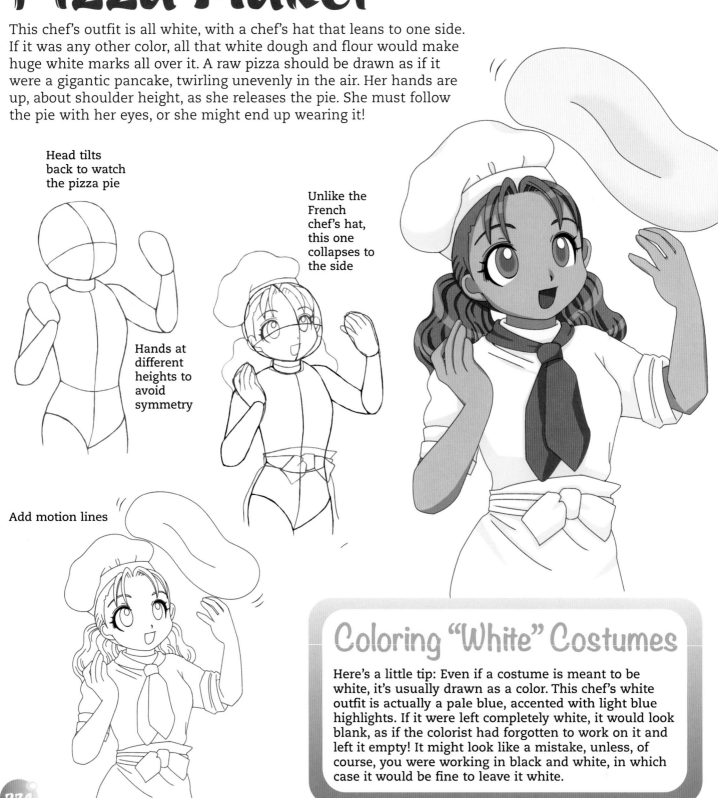

Head tilts back to watch the pizza pie

Unlike the French chef's hat, this one collapses to the side

Hands at different heights to avoid symmetry

Add motion lines

Coloring "White" Costumes

Here's a little tip: Even if a costume is meant to be white, it's usually drawn as a color. This chef's white outfit is actually a pale blue, accented with light blue highlights. If it were left completely white, it would look blank, as if the colorist had forgotten to work on it and left it empty! It might look like a mistake, unless, of course, you were working in black and white, in which case it would be fine to leave it white.

234

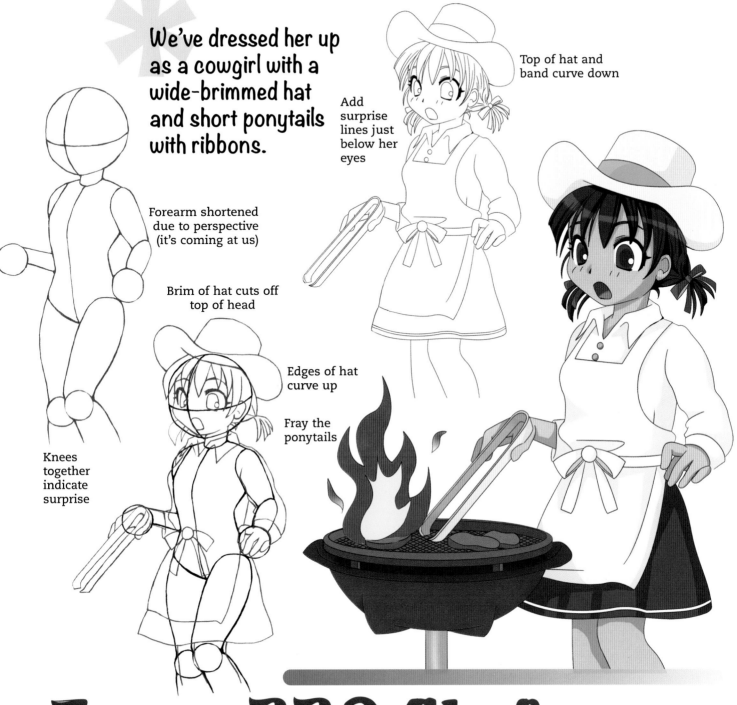

We've dressed her up as a cowgirl with a wide-brimmed hat and short ponytails with ribbons.

Top of hat and band curve down

Add surprise lines just below her eyes

Forearm shortened due to perspective (it's coming at us)

Brim of hat cuts off top of head

Edges of hat curve up

Fray the ponytails

Knees together indicate surprise

Texas BBQ Chef

This novice chef needs a few lessons in the fine art of grilling. Looks like she cheated and used some quick starter fluid, and a bit too much of it at that. One thing's for sure: No one's going to have a tough time recognizing that those burgers were charbroiled. Show the whites of her eyes and give her a tiny mouth, for a surprised expression!

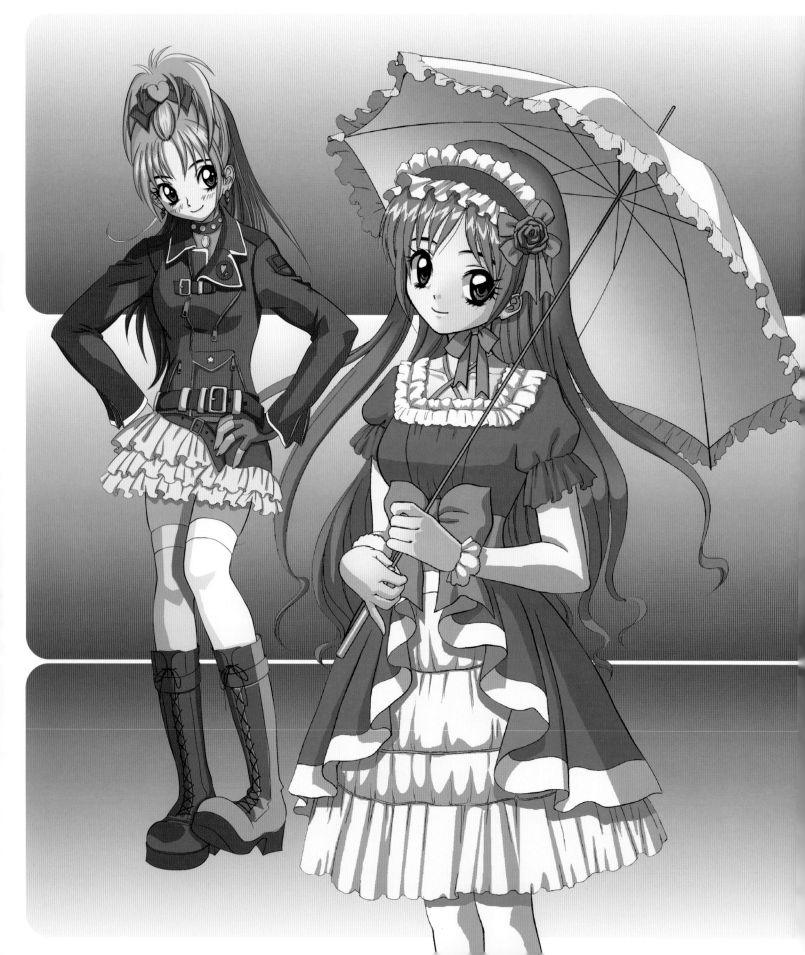

Gothic and Frilly Girls

There is a very popular movement in Japanese fashion that is spreading to the U.S. and around the world. Inspired by Victorian and Edwardian fashions, girls and young women dress in outfits that range from gothic to elegant to sweet and feature tons of ruffles, bows, and frills. These ladies are at the very cutting edge of fashion, and characters based on them are popping up in manga and anime. And, boy, do they like to dress up—the more "stuff" you can add to these characters, the better!

Dress-Up Doll

Is she expecting sun or rain? Neither, but she saw this really cool umbrella at a thrift shop and it went so well with her outfit that she just had to have it! If you enjoy drawing frilly ruffles and flounces, you're going to love this style. This girl sports a distinctive "doll" look that is created by the lacy dress she wears and the prim and proper pose she assumes.

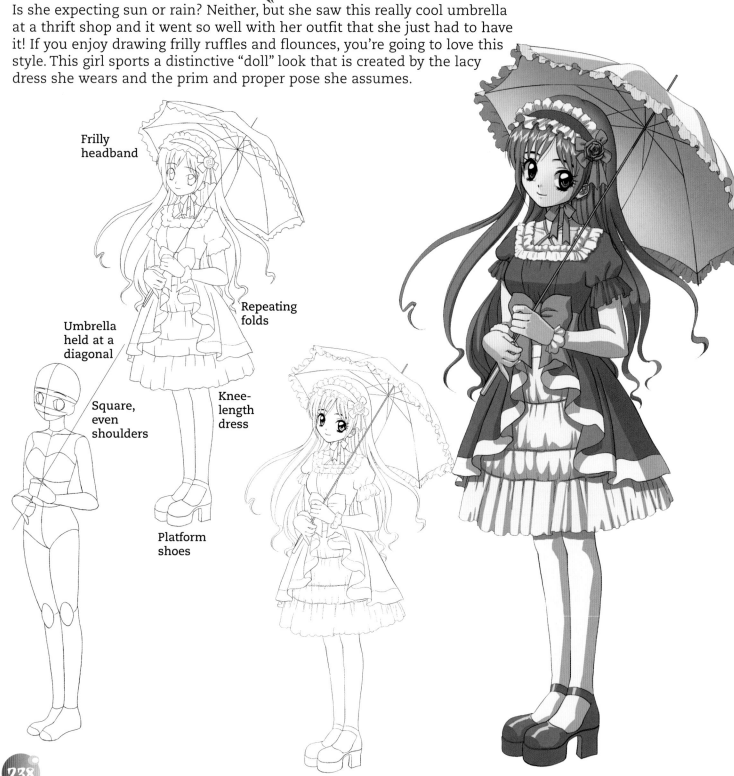

Frilly headband

Repeating folds

Umbrella held at a diagonal

Square, even shoulders

Knee-length dress

Platform shoes

238

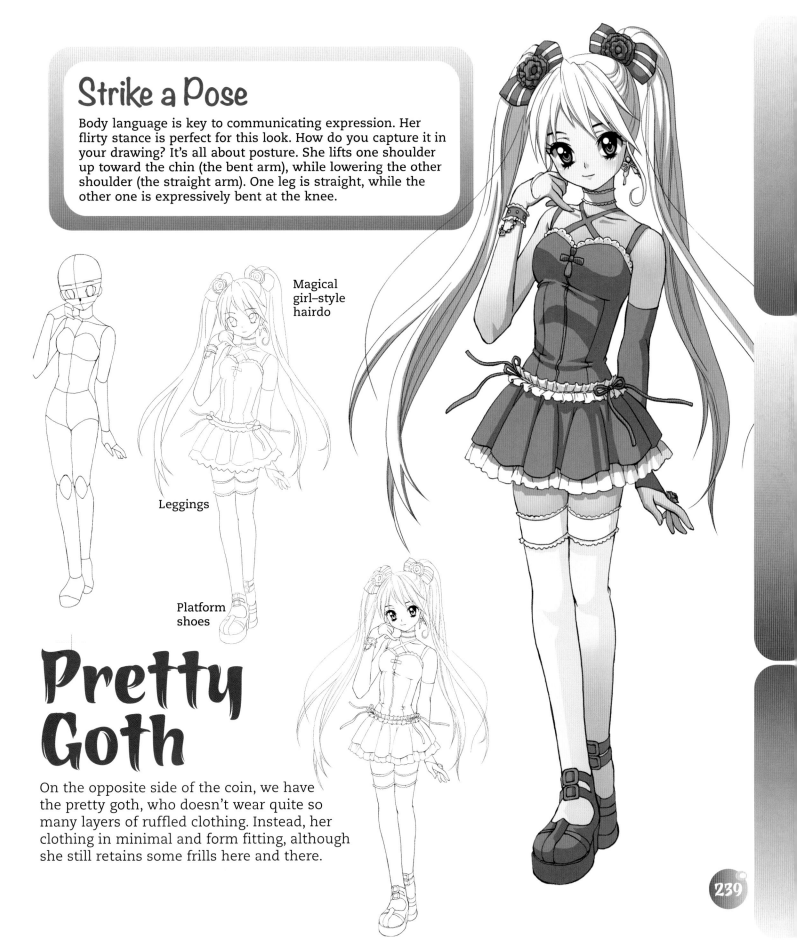

Strike a Pose

Body language is key to communicating expression. Her flirty stance is perfect for this look. How do you capture it in your drawing? It's all about posture. She lifts one shoulder up toward the chin (the bent arm), while lowering the other shoulder (the straight arm). One leg is straight, while the other one is expressively bent at the knee.

Magical girl–style hairdo

Leggings

Platform shoes

Pretty Goth

On the opposite side of the coin, we have the pretty goth, who doesn't wear quite so many layers of ruffled clothing. Instead, her clothing in minimal and form fitting, although she still retains some frills here and there.

Urban Goth

The leather jacket says downtown Tokyo. Make it heavy leather, like a biker jacket. How do you indicate that? By giving it a big leather belt and buckle, and by showing the thickness (dimension) of the collar. And add a pouch and zippers. Yep, it's got the whole nine yards. But you can tell she's an urban goth, not a biker gal, because she's wearing a lacy dress under the jacket.

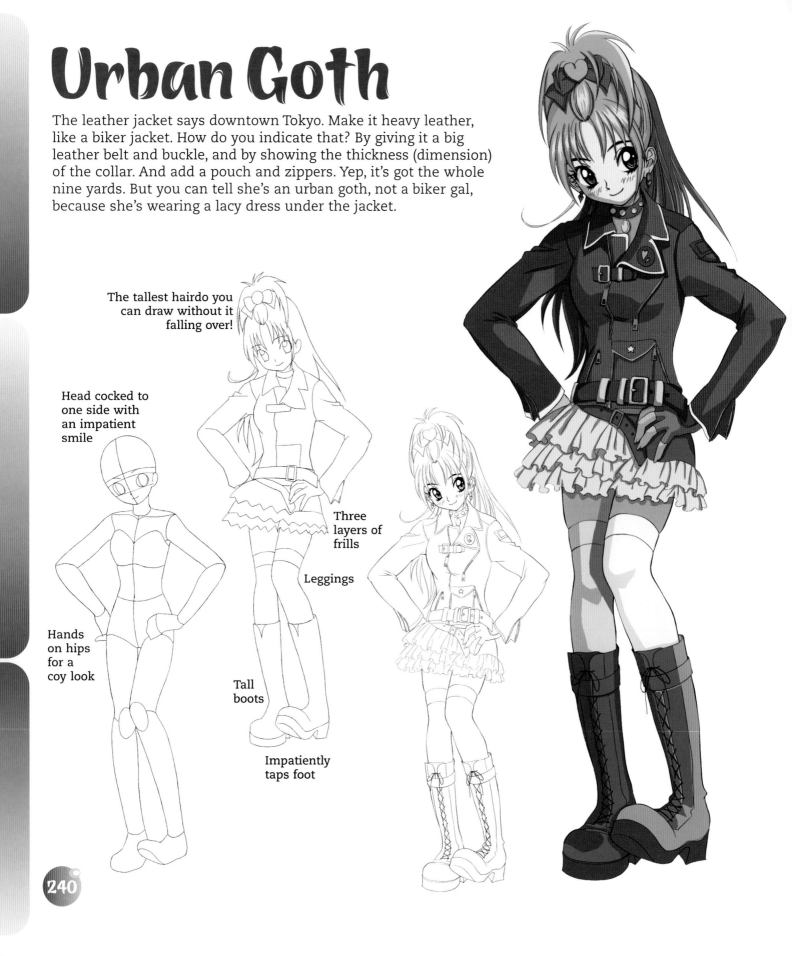

The tallest hairdo you can draw without it falling over!

Head cocked to one side with an impatient smile

Hands on hips for a coy look

Three layers of frills

Leggings

Tall boots

Impatiently taps foot

Face in 3/4 view, as she turns back to look at us

Note the line of the spine

She balances on her heels, for a fun look

Short ponytails

Silly pompoms

Rabbit-ear hood

Oversize pant covers

A silly stance always looks youthful.

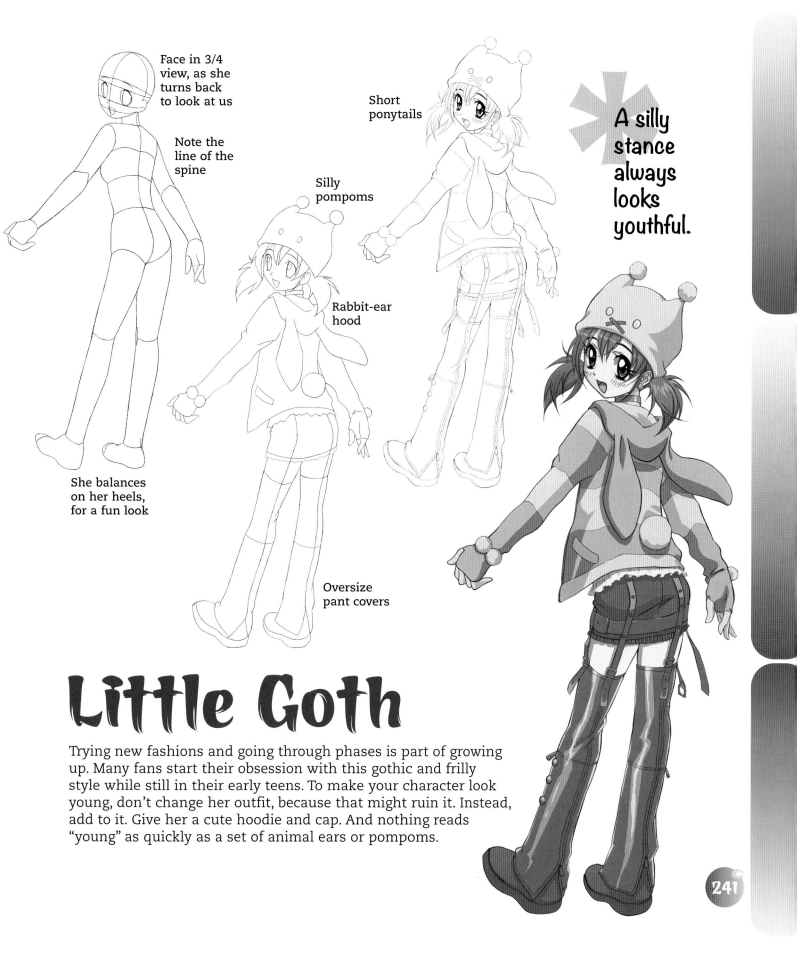

Little Goth

Trying new fashions and going through phases is part of growing up. Many fans start their obsession with this gothic and frilly style while still in their early teens. To make your character look young, don't change her outfit, because that might ruin it. Instead, add to it. Give her a cute hoodie and cap. And nothing reads "young" as quickly as a set of animal ears or pompoms.

Dress It Up!

Now let's go in for some close-ups to get a good look at different hairstyles and accessories, collars, straps and all the things that make the gothic and frilly style so appealing. Remember, these outfits are the ultimate in over-the-top dressing up, which is part of the reason girls like them so much!

Frilly Headband

Note the rosette detail on the side and how the headband ties under the chin. This look is oh so demure and feminine.

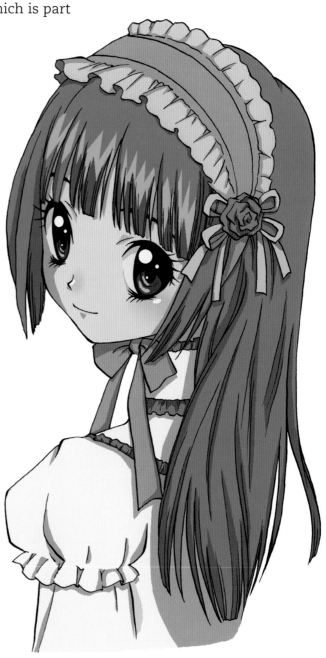

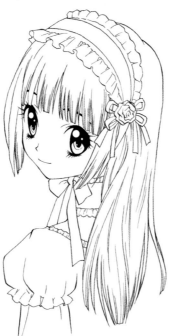

242

Tiara

The tiara coordinates with the necklace and ties the look together. It can be a gothic touch, or work as an accessory for a sweet and frilly look.

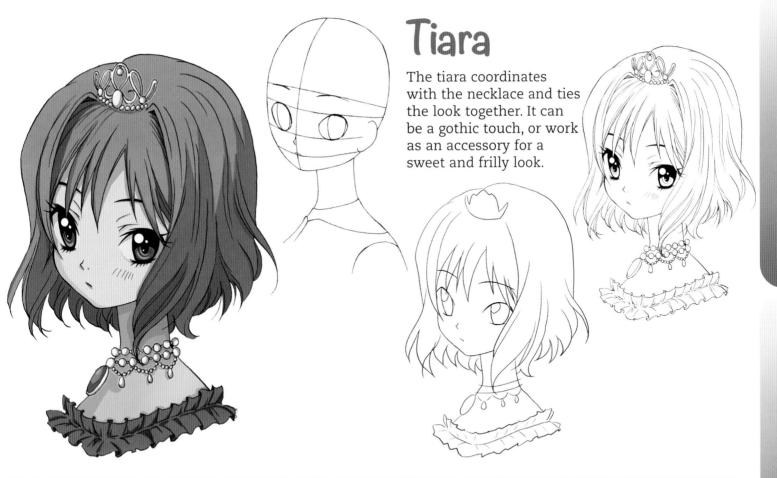

Baby Doll Ringlets

Large double bow spreads out on top of the head.

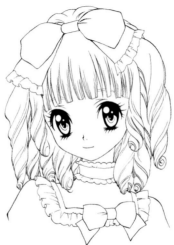

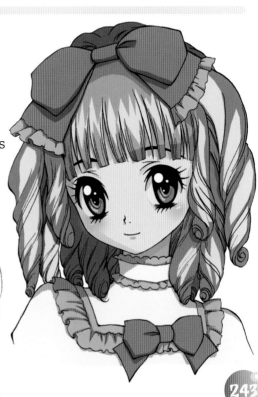

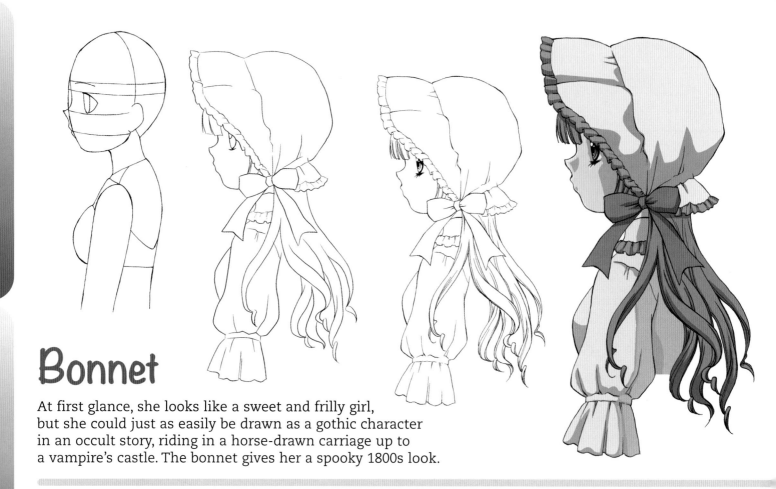

Bonnet

At first glance, she looks like a sweet and frilly girl,
but she could just as easily be drawn as a gothic character
in an occult story, riding in a horse-drawn carriage up to
a vampire's castle. The bonnet gives her a spooky 1800s look.

Beret and Cape

This look is super-cute. Again, you could easily cast
her in a vampire story as the innocent bystander who
is suddenly approached by the Prince of Darkness.

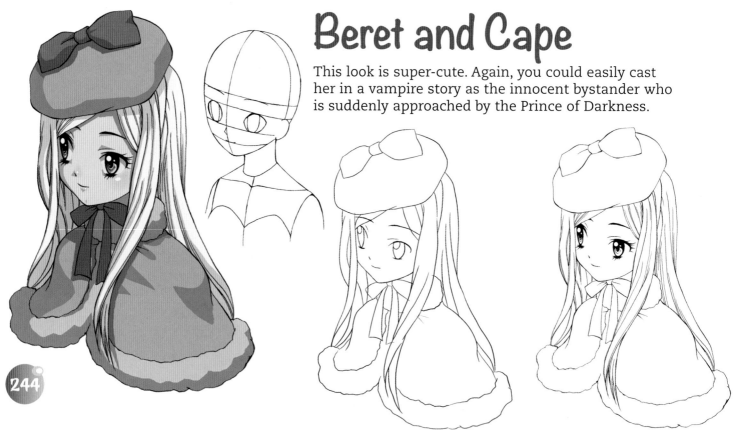

All Gothic, All the Time

No doubt about this one. She's completely goth. The bare shoulders and all those straps scream "gothic." But she's not a goth in the sense of being a dark and troubled character. In this genre, the characters are bubbly and appealing, and don't have to spend Thursday afternoons at their therapist's office.

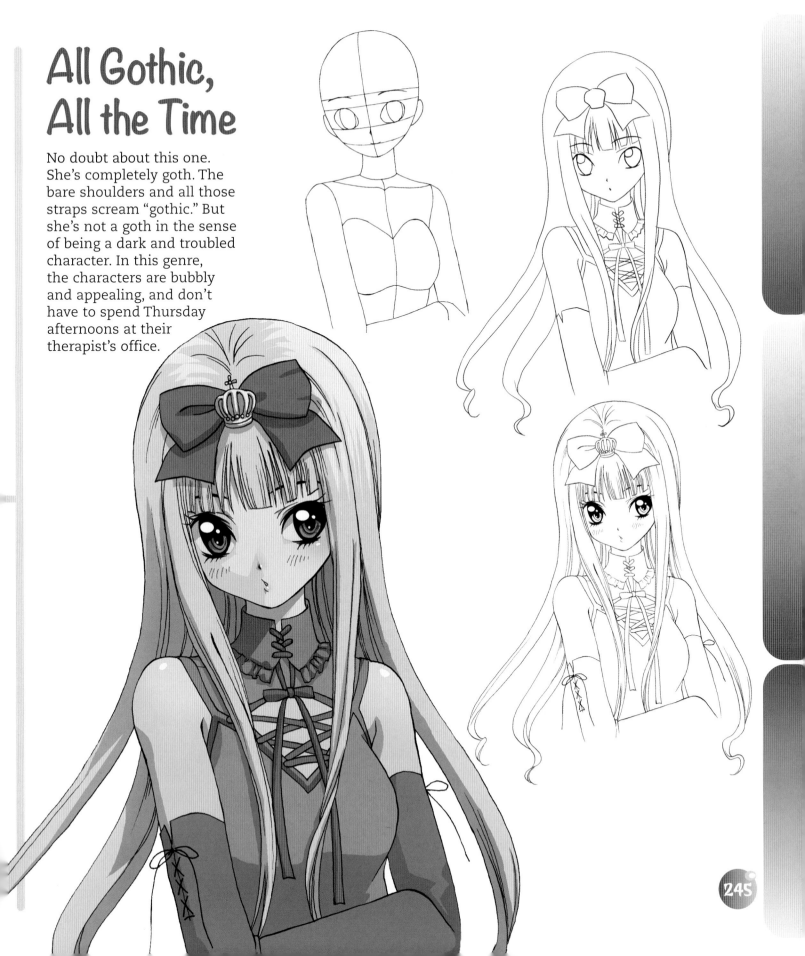

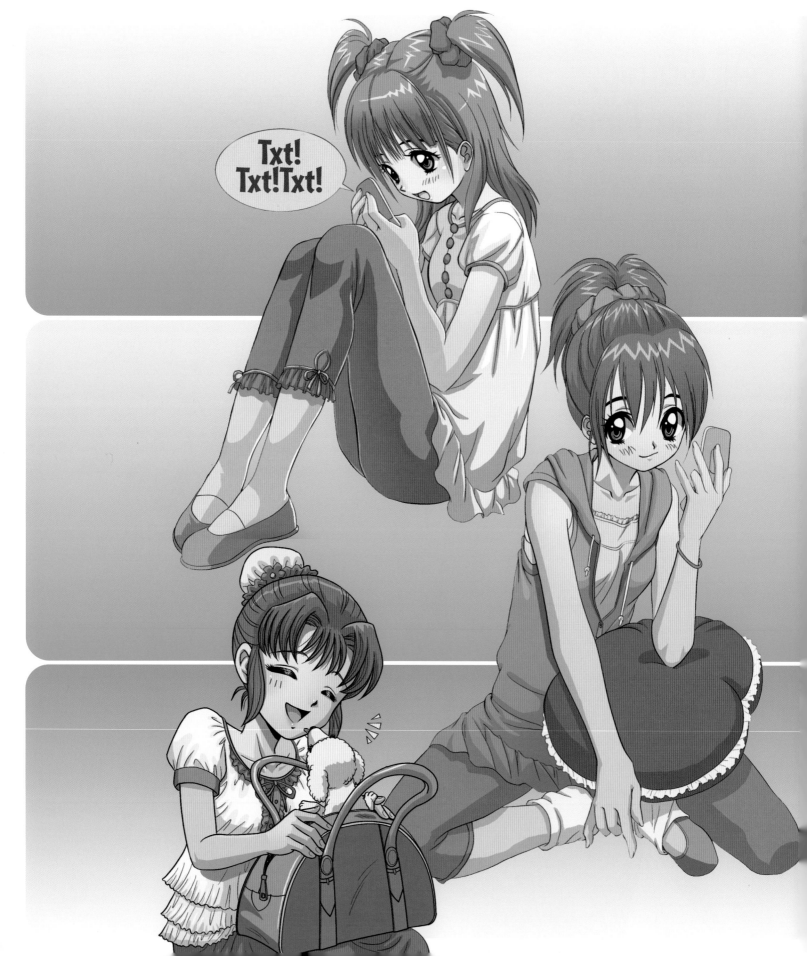

Slice of Life!

Many popular manga graphic novel series fall into the "slice of life" category. Stories in this genre include characters in everyday situations dealing with the ups and downs of friendships and relationships. These stories are touched with humor. And like life itself, there are often surprising twists and turns in the plot lines. The characters who star in these stories are just like you and your friends. They're real people, which makes it easy for readers to identify with them.

Everyday Stuff

The slice-of-life genre is made up of little scenes from daily life. Since the characters wear everyday clothing, we concentrate more on body language than on wardrobe to evoke emotions. So let's focus on working those poses. We'll cover the special tricks you'll need to make sure they come out right.

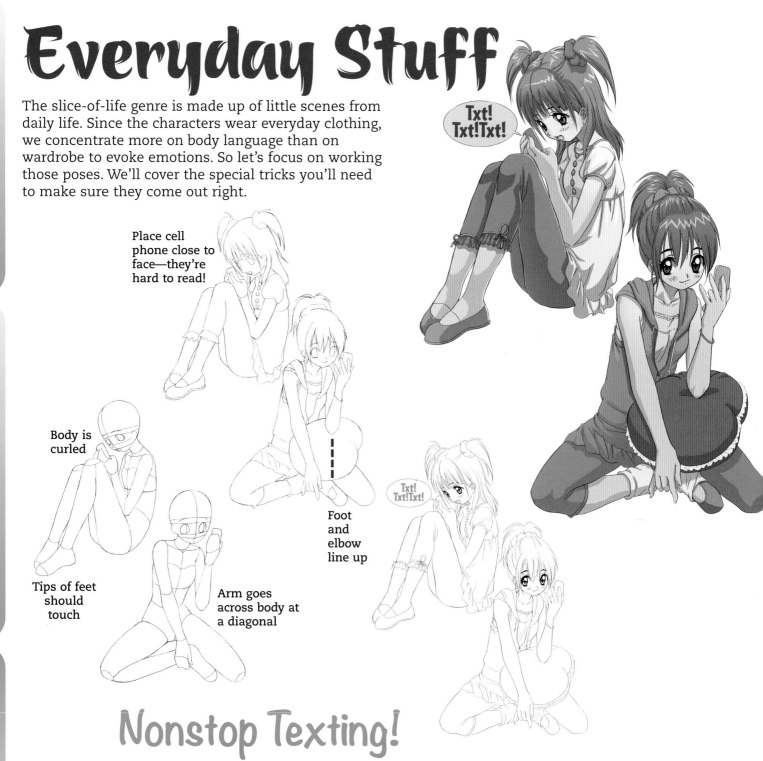

Place cell phone close to face—they're hard to read!

Body is curled

Tips of feet should touch

Arm goes across body at a diagonal

Foot and elbow line up

Txt! Txt!Txt!

Nonstop Texting!

Don't try to get in between a teenage girl and her cell phone—that's a dangerous place to be! When she's texting, she curls up with her phone, almost as it were a good cup of coffee. It's fun, but sort of a private thing, too. So she's protective of it, and her body language shows it. She pulls away into her own world—just her and her 85,000 best friends.

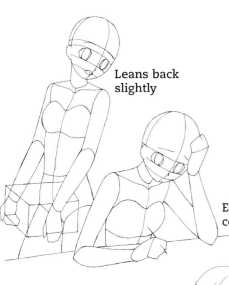

Leans back slightly

Elbow makes contact with table

Scratching her head is a clear sign of frustration.

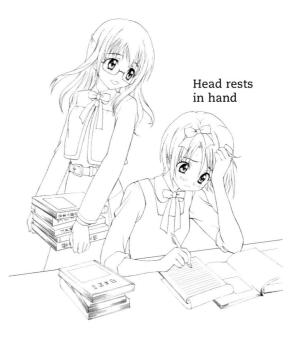

Head rests in hand

Eyes on her friend

Eyes on her homework

Cramming for Exams

How many problems and equations can you cram into one schoolgirl's brain before it explodes? Teachers don't seem to know the limit. And each teacher thinks her class is the most important one, so she piles on as much homework as she can! Study partners are essential, especially in upper grades. And they're perfect devices for manga stories, because your character has a built-in buddy to talk to. They can be confidantes.

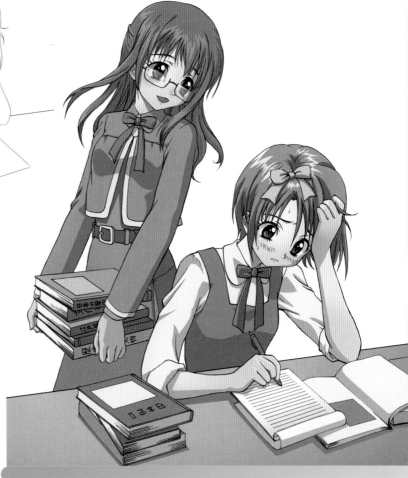

Primping

When a girl gets ready for a date in the slice-of-life genre, she pulls out all the stops. Nerves heighten. Hair becomes as important as world peace. And her little brother waiting desperately to use the bathroom? Well, he'll just have to wait.

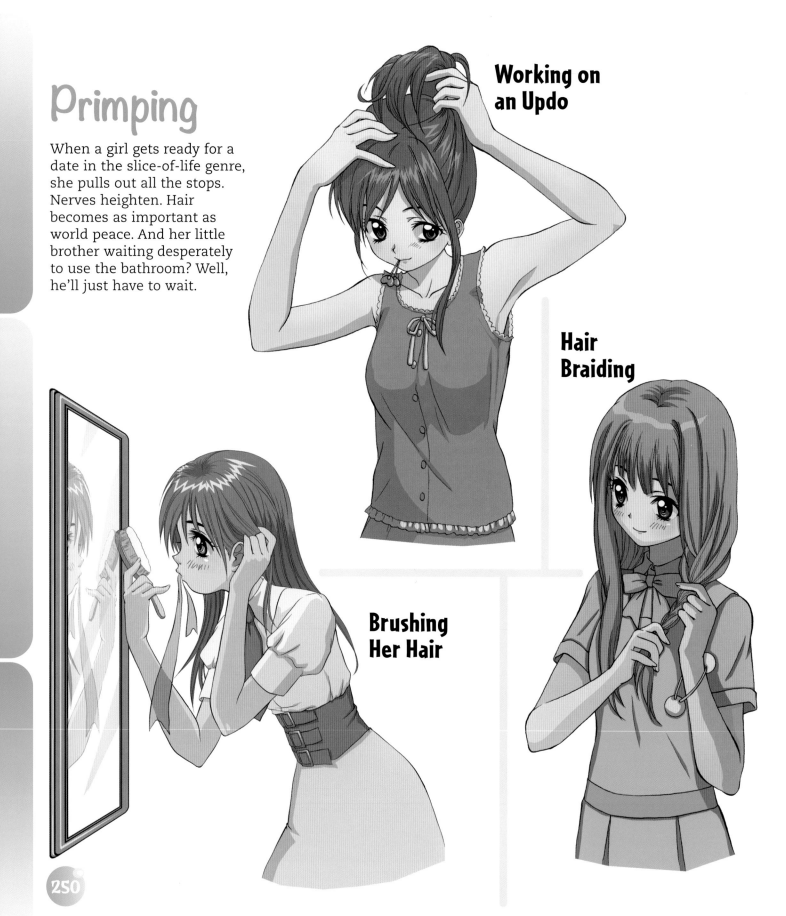

Working on an Updo

Hair Braiding

Brushing Her Hair

250

Girls and Their Pets

Pets, especially dogs and cats, are featured in many manga stories. Just like people, dogs and pups come in all shapes and sizes. Some of the small ones travel in purses. The big ones drag their owners by the leash. And of course, there are the cats, which believe that any surface—including their owners—is okay to climb on. These adorable sidekicks add some zing to the cast of human characters.

Shoulders up

Big bangs

Floppy handles

Little, rounded head

Small snout and nose

Bag lies straight across her lap

Have Puppy, Will Travel

Girls are very protective of their puppies and don't like to leave them alone, so they try to sneak them along wherever they go—to school, into the movies, etc. That works for only so long. Sooner or later, a puppy wants to bark, chew, or pee on something. The younger the pup or kitten, the rounder its head is drawn.

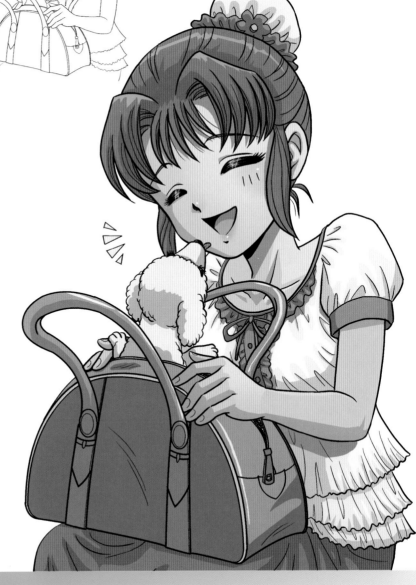

Big Dog!

Ever walk a dog like this? He will enjoy it, but you won't. Forced perspective is at work in this drawing. This means that part of the image is enlarged to exaggerate its size. In this case, the dog appears unusually large relative to the girl in order to emphasize his size and strength. See how forced perspective increases the size of his front paws? And the dog's head, which is, in reality, no bigger than a human's, is drawn much larger than hers.

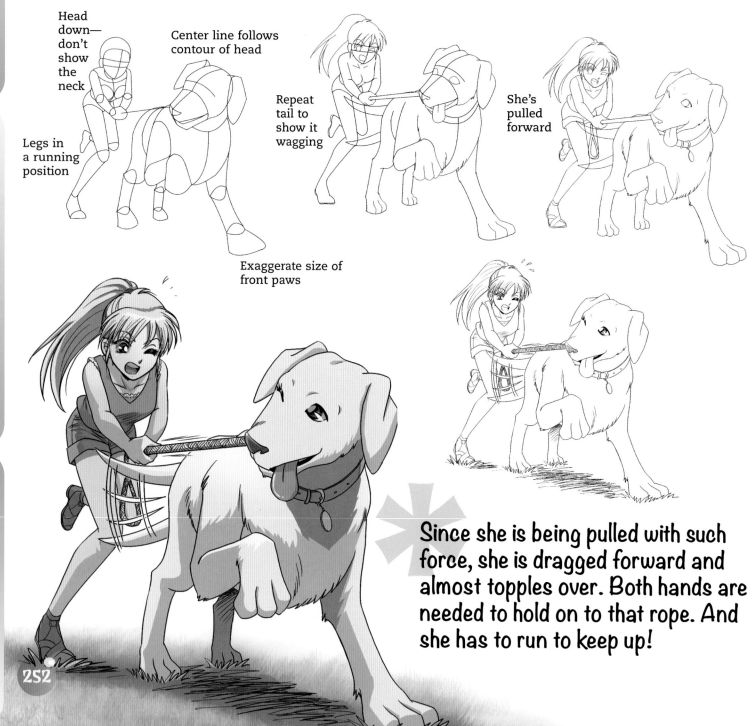

Head down—don't show the neck

Center line follows contour of head

Legs in a running position

Repeat tail to show it wagging

She's pulled forward

Exaggerate size of front paws

Since she is being pulled with such force, she is dragged forward and almost topples over. Both hands are needed to hold on to that rope. And she has to run to keep up!

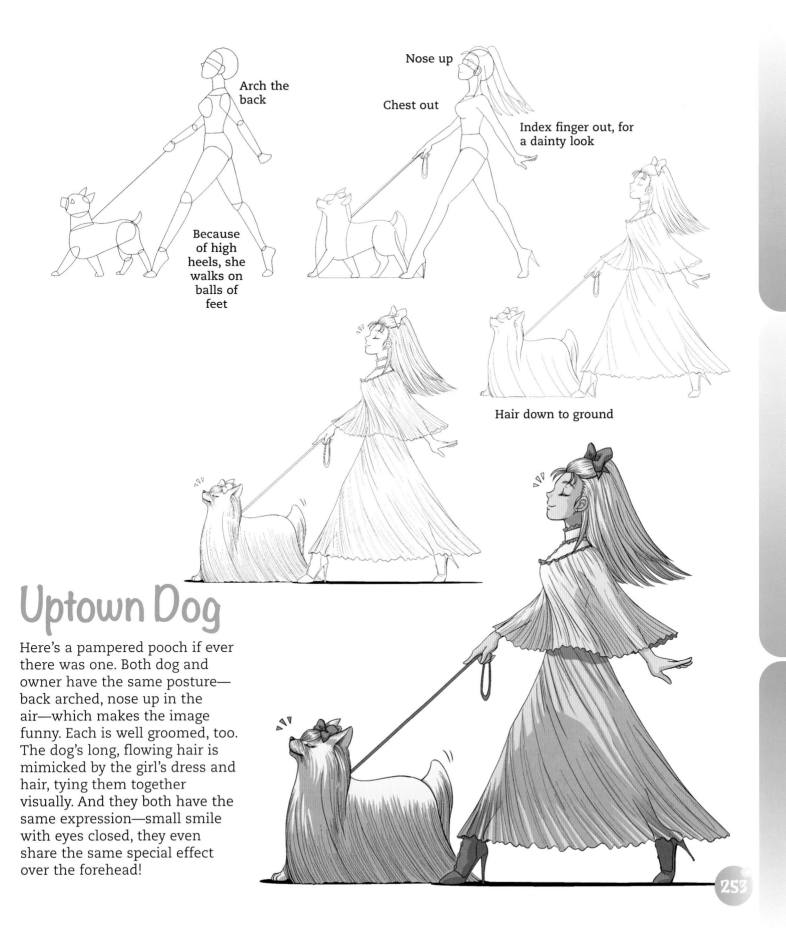

Arch the back

Nose up

Chest out

Index finger out, for a dainty look

Because of high heels, she walks on balls of feet

Hair down to ground

Uptown Dog

Here's a pampered pooch if ever there was one. Both dog and owner have the same posture—back arched, nose up in the air—which makes the image funny. Each is well groomed, too. The dog's long, flowing hair is mimicked by the girl's dress and hair, tying them together visually. And they both have the same expression—small smile with eyes closed, they even share the same special effect over the forehead!

Kittens! Kittens! Kittens!

Well, these kitties are a bit confused. They think this girl is a scratching post with ears. But they're so cute, she'll let them do anything they want! Kittens get into all sorts of trouble, and there's just no way to keep them out of any "restricted" area of the house. Better just wave the white flag now. The kittens have taken over. While grown cats are often depicted as solitary pets, kittens work well in groups that play together. It just magnifies the adorable factor.

Her expression is a combination of surprise and delight: It's fun to have kittens climb all over you, but how the heck do you get them off?!?

Vary the kitten's expressions—this one has a big, bright smile with open eyes and mouth

This one is a bit concerned he's falling off!

And this one's eyes are closed in a wide smile

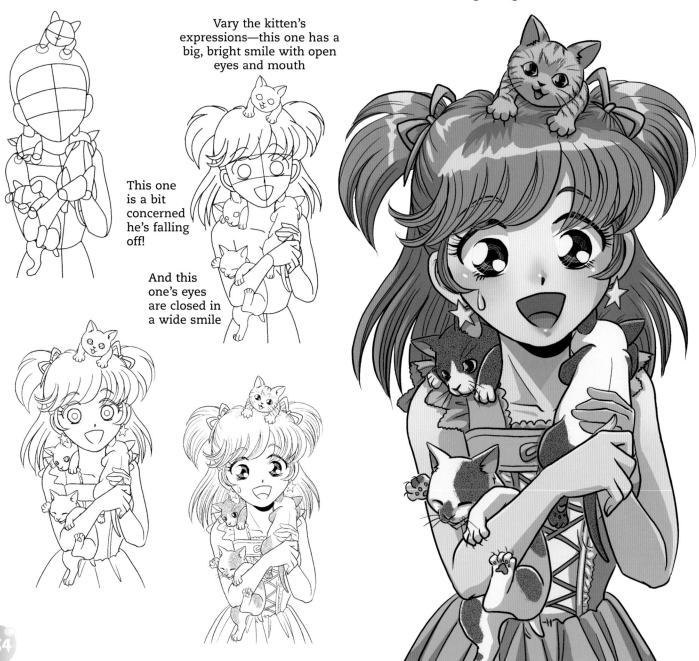

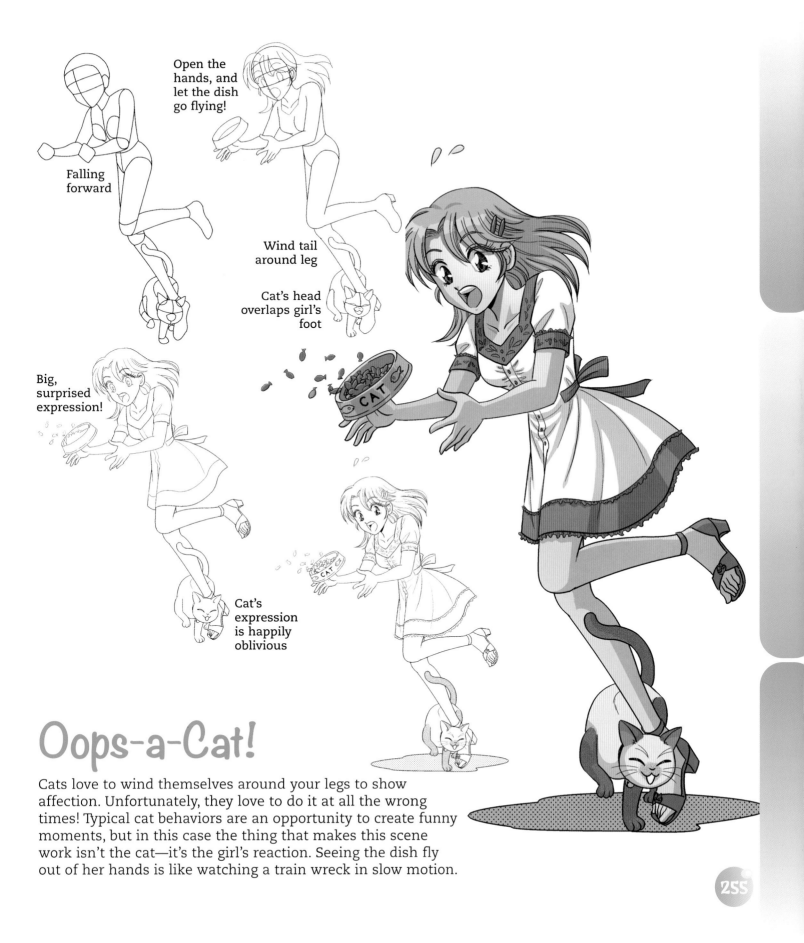

Open the hands, and let the dish go flying!

Falling forward

Wind tail around leg

Cat's head overlaps girl's foot

Big, surprised expression!

Cat's expression is happily oblivious

CAT

Oops-a-Cat!

Cats love to wind themselves around your legs to show affection. Unfortunately, they love to do it at all the wrong times! Typical cat behaviors are an opportunity to create funny moments, but in this case the thing that makes this scene work isn't the cat—it's the girl's reaction. Seeing the dish fly out of her hands is like watching a train wreck in slow motion.

Beach Party!

There are plenty of popular manga series that take place in school, but even manga characters like to take a break from school once in a while. So naturally, there are manga stories that take place at the beach, where teens gather for fun in the sun. Let's take a brief detour and draw some characters playing beach volleyball and splashing around.

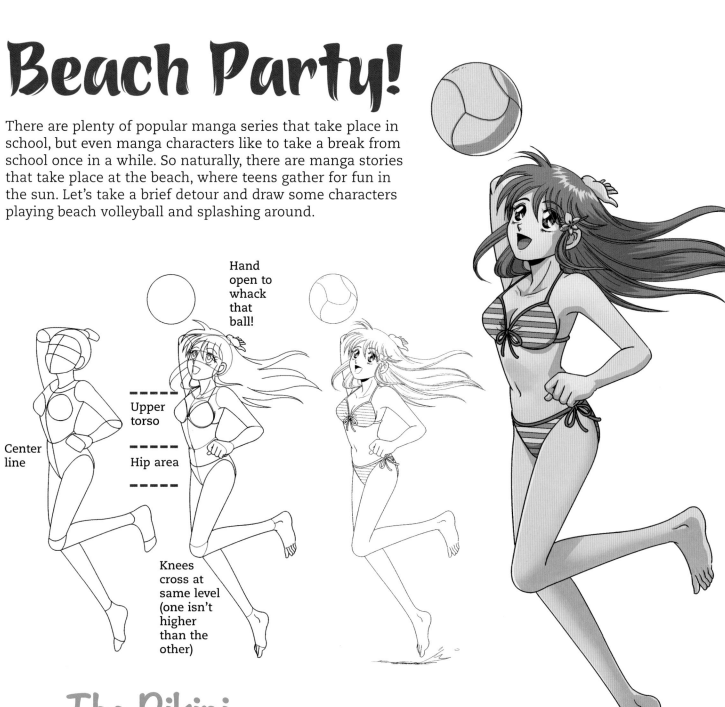

Hand open to whack that ball!

Center line

Upper torso

Hip area

Knees cross at same level (one isn't higher than the other)

The Bikini

When drawing people in bathing suits, you've got to pay special attention to the construction of the figures, because you've got nowhere to hide your mistakes. Drawing the center line down the body helps to anchor the torso in the right direction—in this case a 3/4 view. Notice how the body is drawn in two distinct sections: 1) the upper torso, and 2) the hips, just as you would see in a department store mannequin. This is the easiest way to draw the female figure.

One-Piece Bathing Suit

It may not look like it at first, but this is actually an easy pose to draw, because the head and upper body are facing us in a simple front view. As she runs toward the water (brave soul that she is!) draw one foot out in front, and one lagging behind. The calf of the far leg should get smaller, due to perspective. That far leg partially hides behind the front leg. This overlapping action gives the pose some depth—and, happily, makes it easier to draw, as well.

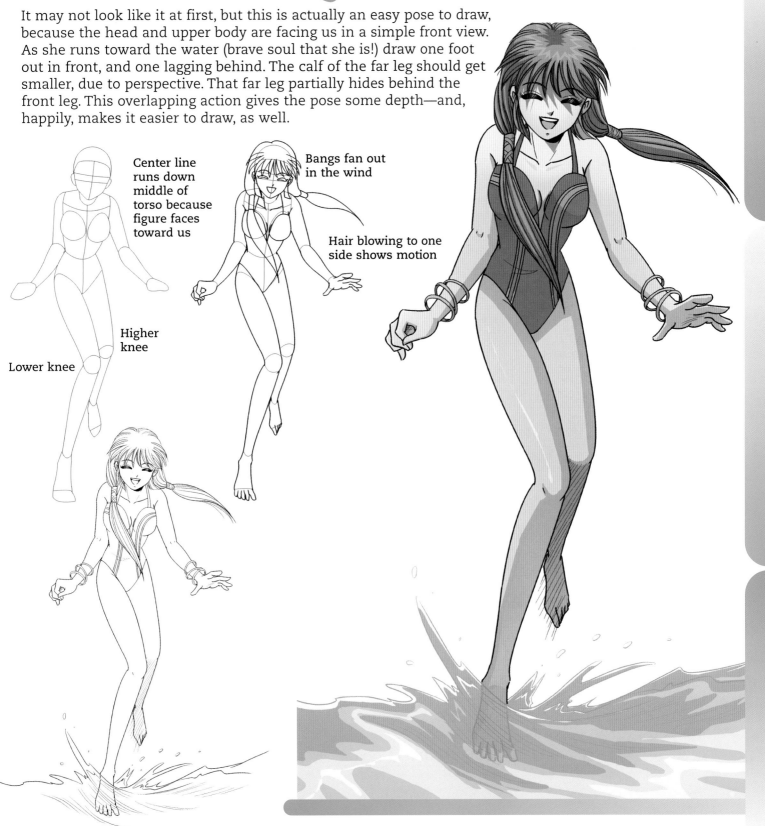

Center line runs down middle of torso because figure faces toward us

Higher knee

Lower knee

Bangs fan out in the wind

Hair blowing to one side shows motion

Summer Picnic on the Sand

A good composition is one that leads the eye from one person to the next, in an uninterrupted row, like dominoes. Either way your eyes scan this picture, left to right (American style), or right to left (Japanese style), the action flows smoothly.

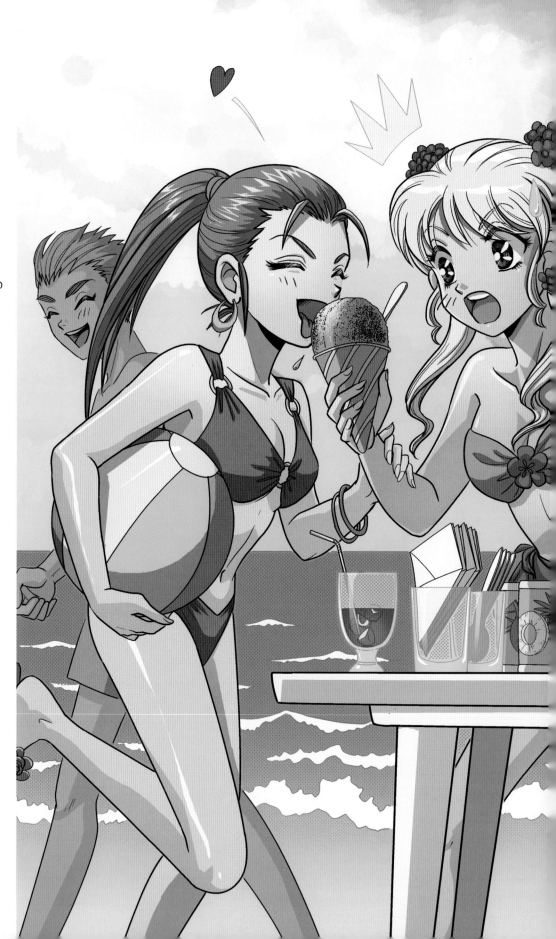

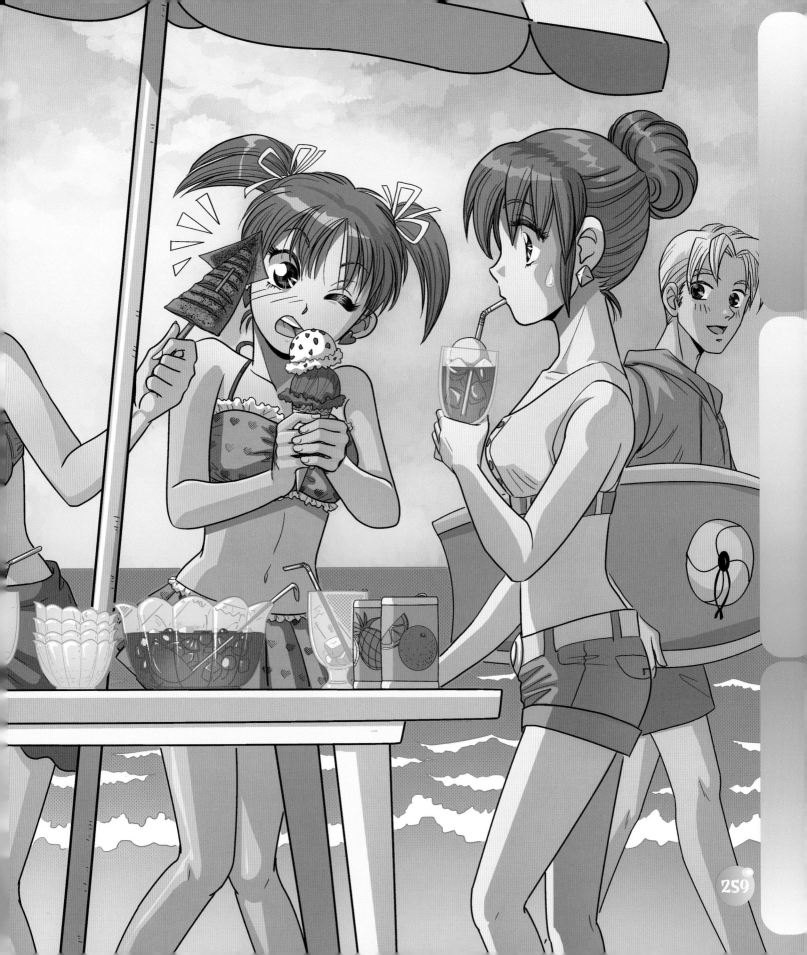

Boy Crazy!

Crushes bring out quirky traits in otherwise sane girls—some get silly and embarrassed, while others are jealous and possessive. At this awkward age, attempts to capture the boy's attention don't usually work on the first try. They're either too forward, or too subtle. But that's what makes for funny stories.

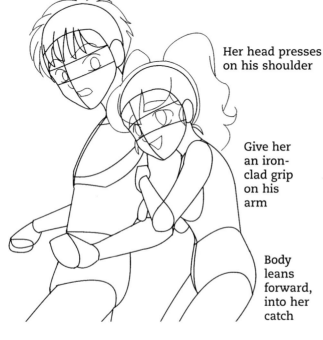

Her head presses on his shoulder

Give her an iron-clad grip on his arm

Body leans forward, into her catch

Possessive Type

Um, do you think she's a little too forward, maybe? Nah. She just likes to be with him all the time. And I do mean ALL the time. Day and night, wherever he goes. And you know just how much 15-year-old boys like to have their girlfriends tag along when they hang out with their pals. Pretty soon, he's going to resort to hiding in the school stairwells!

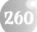

Shy Girl

If he were to actually speak to her, she'd probably have to run away. Many teen romances start off with false starts, miscommunications, and other complications. For example, the popular girl might have just broken up with this guy. But seeing our star character (the girl in this picture) giving him homemade (albeit slightly burnt) cookies makes her so jealous that she now wants him back! Whom will he choose? Ah yes, love is never easy.

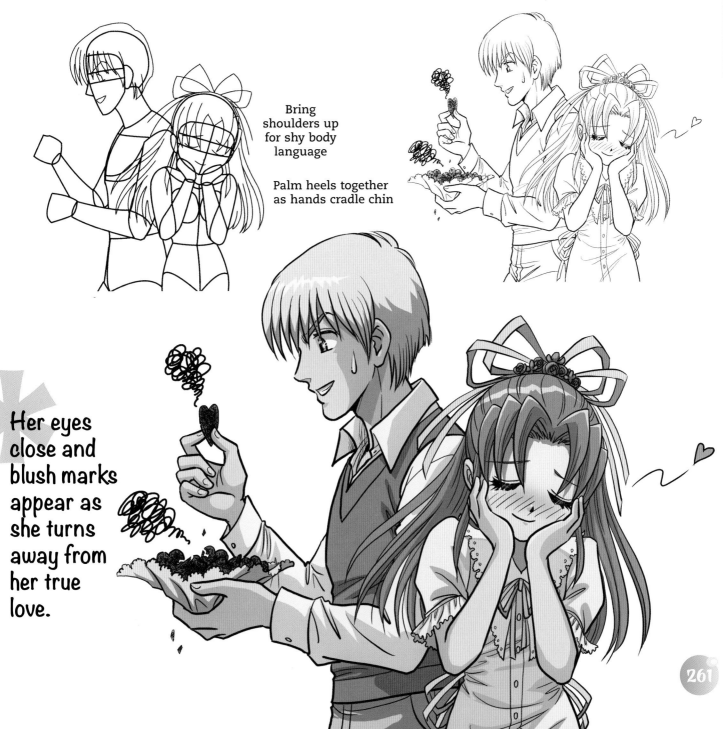

Bring shoulders up for shy body language

Palm heels together as hands cradle chin

Her eyes close and blush marks appear as she turns away from her true love.

So Embarrassing!

She likes him, but he'll never know it, because she's too embarrassed to send any signals to that effect. She's just too self-conscious. In fact, he misreads her reactions to him as disliking him. "Why does she hate me?" he wonders, when, in fact, it's exactly the opposite.

Urgent expression

Hand keeps him at a distance

Other hand held close to body, protectively

The Plot Thickens

To make your stories interesting for your readers, you have to add some plot twists. For example, in this story, the shy girl might ask a friend of hers to talk to the boy. This friend is supposed to tell the boy that the shy girl likes him to break the ice for her. But before the friend can get to the point, the boy asks her out. She goes on the date, to try to talk to him about the shy girl. But meanwhile, the boy is falling for the friend.

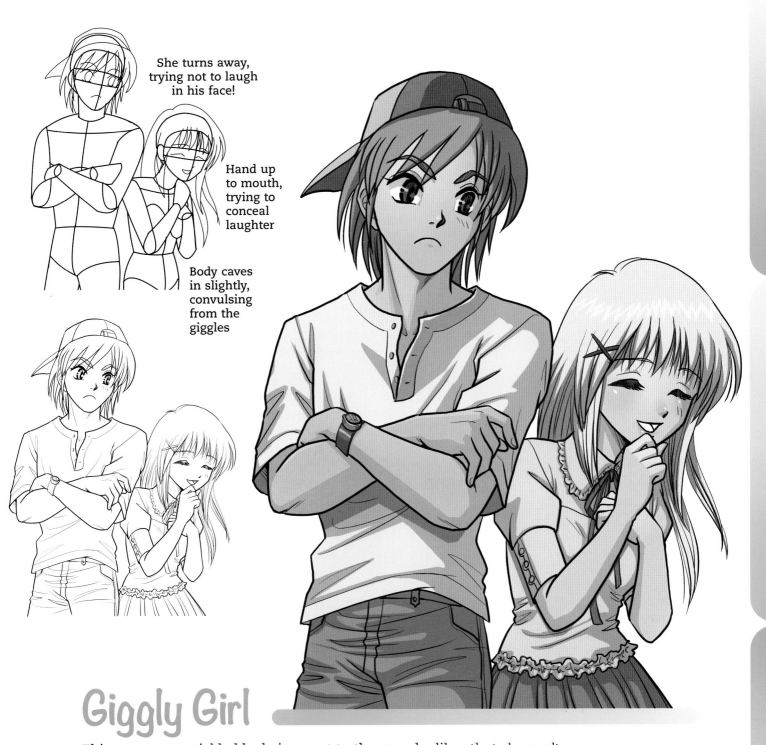

She turns away, trying not to laugh in his face!

Hand up to mouth, trying to conceal laughter

Body caves in slightly, convulsing from the giggles

Giggly Girl

This one gets so tickled by being next to the guy she likes that she can't stop giggling. He likes her too, but how can you talk to a girl who won't stop tittering? He knows he's not that funny. But boys are insecure too. Maybe she's laughing at him, he wonders. Actually, she's just nervous. When people giggle, their heads go down. When they laugh uproariously, their heads go back. Giggly eyes are always drawn shut and curving downward.

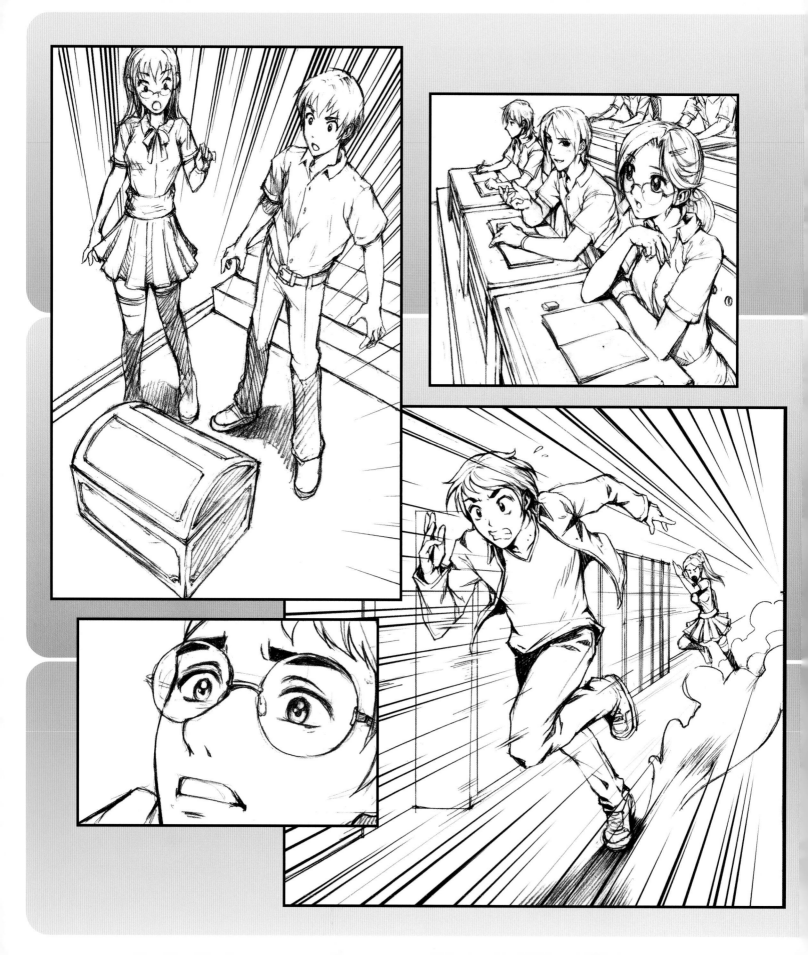

The ABCs of Scene Staging

This chapter offers one of those rare instances in which you don't have to draw in order to learn to draw! This is a conceptual chapter. Of course, I encourage you to practice drawing any of the illustrations in this chapter that you like, but it's not mandatory. This chapter is designed specifically to give you new ideas. It will change your approach to staging scenes, AND it will help you understand the "how" and "why" of effective scene staging.

Drawing Two People in a Scene

An important element of drawing comics is learning how to draw people interacting. You can read through most other how-to-draw books and never find any information about drawing more than one character at a time. But can you imagine reading a graphic novel with only one character in it? I can't either, so I thought you'd like this section.

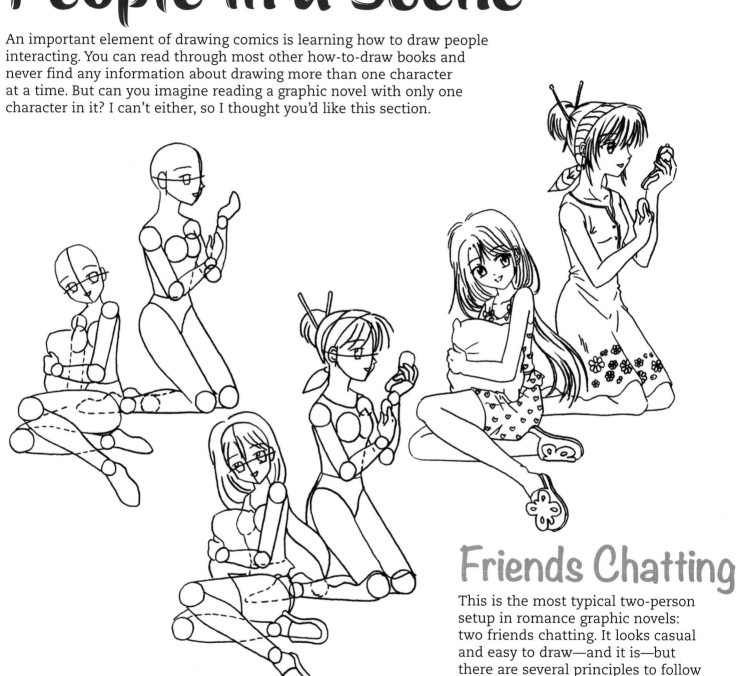

Friends Chatting

This is the most typical two-person setup in romance graphic novels: two friends chatting. It looks casual and easy to draw—and it is—but there are several principles to follow in order to make it look that way.

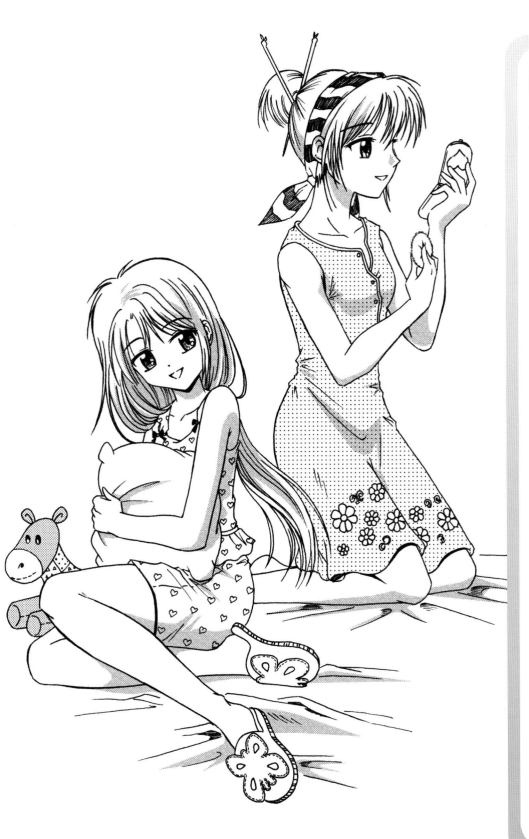

Do's & Don'ts of Drawing Multiple Characters

Here are some tips for drawing scenes with two or more characters in them.

Do

● Draw them at different angles, like closeups, medium shots and full shots.

● Vary the characters' expressions

● Vary the characters' heights

● Vary the characters' arm gestures.

● Draw them at ages that would normally relate to each other.

Don't

● Draw them too close together or too far apart.

● Give them clothing that indicates different temperatures (in other words, one character shouldn't wear a sweater while the other wears a sleeveless outfit).

● Have both characters talking at the same time.

● Always pose them in the side view—it's flat. Instead, vary it.

● Always pose them looking directly at each other. They can look at other things and still be a couple, even while talking to each other

When Boy Meets Girl

Keeping a little distance between characters shows shyness, which can be appropriate for first-time encounters. Note how the boy's gesture leads to the girl's, like dominoes. First, he tips his hat, then she raises her hand playfully to her face, smiles and points her toe. This is a couple who will most likely hit it off. That is, until his girlfriend strolls by!

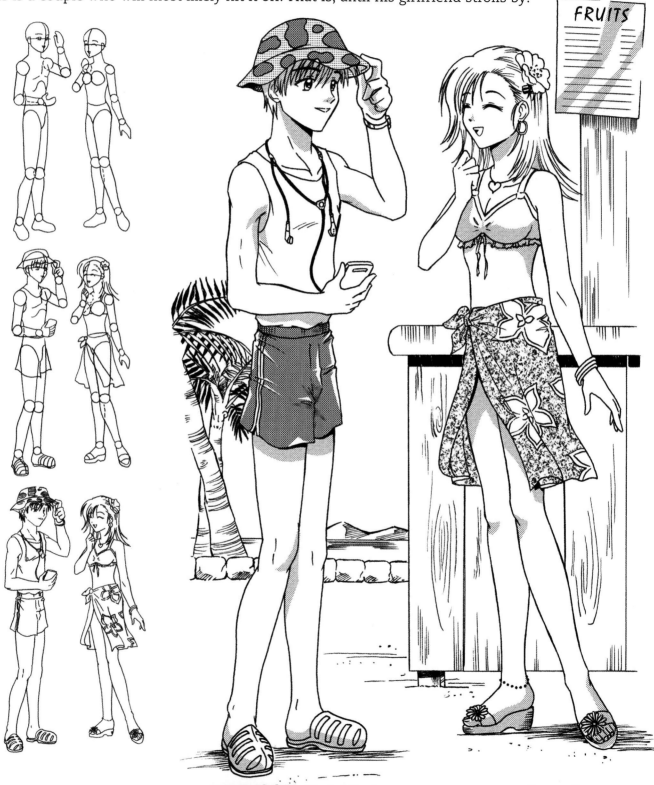

Cosplay!

When two manga fans meet at a Comicon, and both are wearing costumes from the same anime show, the sparks can really fly! The beginner would pose these two sitting on the bench talking to each other. It's functional, but not a whole lot more. The intermediate would pose one character on the bench and the other standing. It varies the look, but it's still not energetic.

But a pro will draw the pose so that one character sits on the bench while the other character is walking past and suddenly notices the seated character's costume. Sure, it's a small difference, but notice how much energy this setup has.

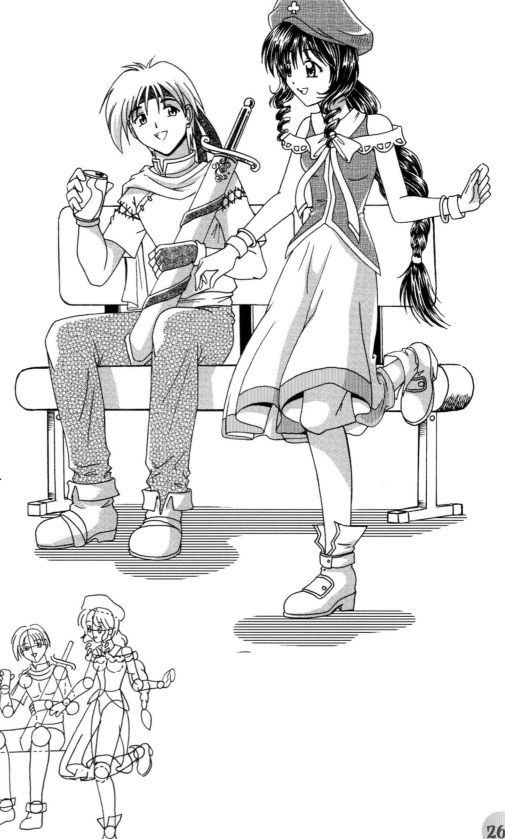

Both characters avoid the center.

I wonder if he likes me...

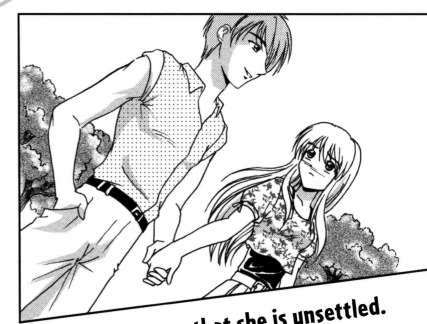

The tilted frame shows that she is unsettled.

Drawing Couples: Scene by Scene

Here are a variety of ways to stage couples who are dating. They walk apart when they're insecure. They hold hands when they're secure. And they hold each other close when they're in love.

We can also view this two-page spread as a story progression in pantomime. She's walking along with him, not sure if he likes her. Then, tired of being ignored, she has an argument with him, only to find out that he really does like her. She is surprised and happy. They'll probably be arguing again by the end of the story.

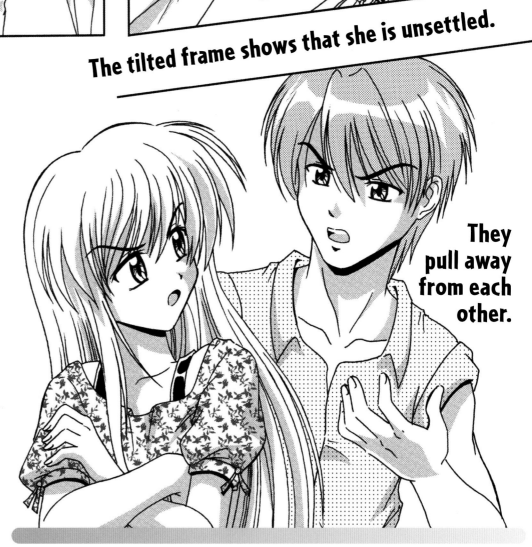

They pull away from each other.

They look deeply into each other's eyes.

He gently touches her face. Note the over-the-shoulder angle.

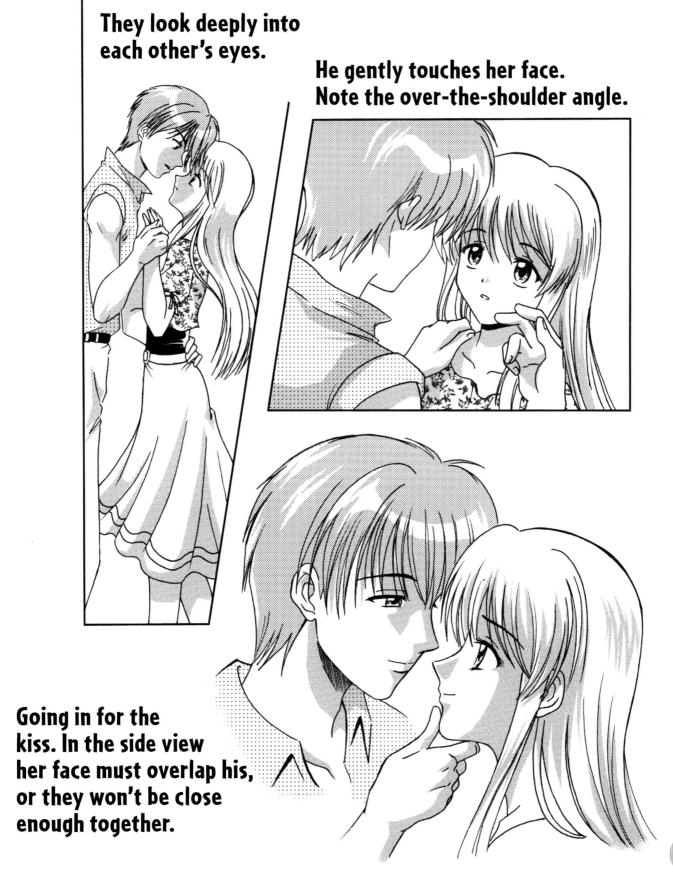

Going in for the kiss. In the side view her face must overlap his, or they won't be close enough together.

Action Scenes

Action should be exciting, not static. That's just common sense. Flat and side angles are usually not good first choices for action scenes. They have the unfortunate effect of making the figures appear frozen in suspended animation, like two statues, even if the figures themselves are well drawn. The eye wants to see action drawn with these things going for it:

- A steep diagonal
- A foreground/background dynamic to create depth
- Characters of varied sizes due to perspective
- Special-effect streak lines

Flat Angle

This side view shows no urgency. It's too flat and is two-dimensional. The reader can't get into the picture and doesn't become emotionally involved.

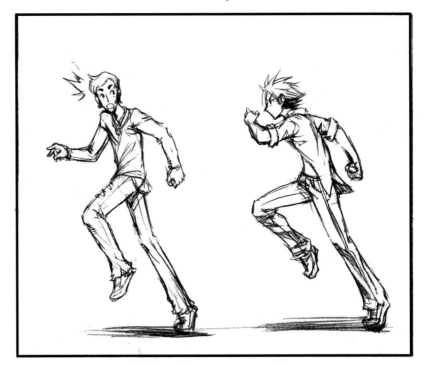

Deep Angle

Drawn at an angle, the characters appear to run deeper into the picture itself, and the reader's eye follows, becoming more involved in the unfolding drama.

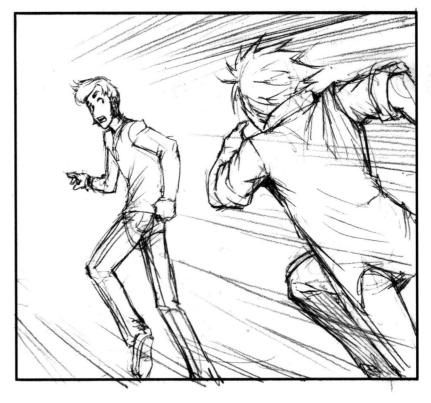

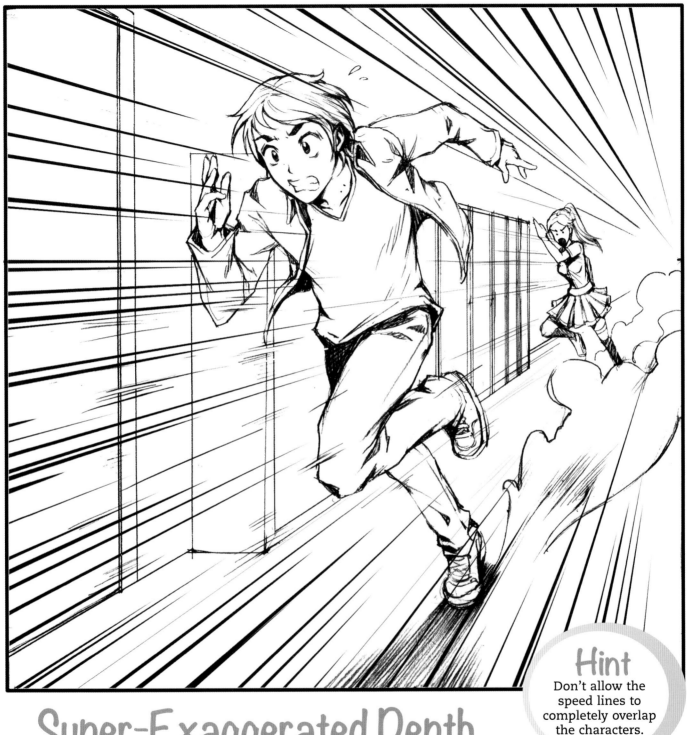

Hint
Don't allow the speed lines to completely overlap the characters.

Super-Exaggerated Depth

With the aid of diminishing speed lines that travel into the distance, this type of scene creates super-depth. It is excellent for showing characters moving across large distances. Be sure to greatly enlarge the size of the characters as they come closer to the reader, due to perspective.

Group Shots Vs. "Two-Shots"

Here, we start off the scene by establishing a group of students in a classroom situation. We haven't narrowed down the focus yet.

We want to then follow it up by cutting to a closer shot of the two main characters–our stars. So we change the angle to a flat, front view. This has the effect of cutting out the rest of the world and giving the two characters a more intimate feeling, as if the panel creates their own little room. Can you see that? And since there's no action, a flat front view works well.

Group Shot on a Diagonal

This is a good angle for establishing a larger group of characters. Staging them all in a front view would look like a police lineup!

Two-Shot: Flat Front View

The flat front view may not be good for action scenes, but it is useful for focusing the reader's attention on a limited number of characters.

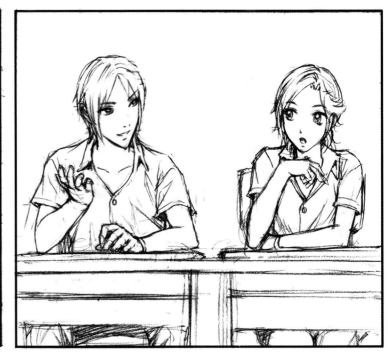

Filling the Panel

You can't—and shouldn't try to—squeeze complete figures of both characters into each panel at all times. It isn't necessary, and in this example, it would make the panel so wide that it would end up losing focus and looking empty. But which character do you allow the panel wall to chop in half? (Please pardon the gruesome metaphor!)

As a rule, it's preferable to show all of the far character and cut off the character in the foreground.

Far character shown in full

RIGHT!

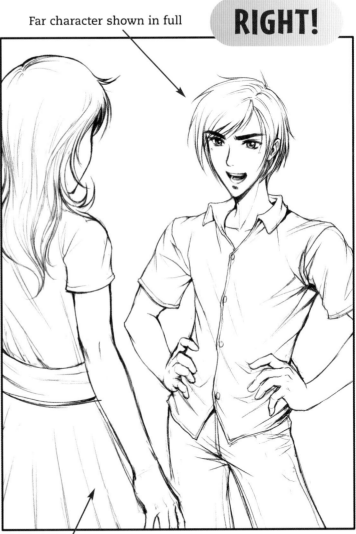

WRONG!

Far character is cut off

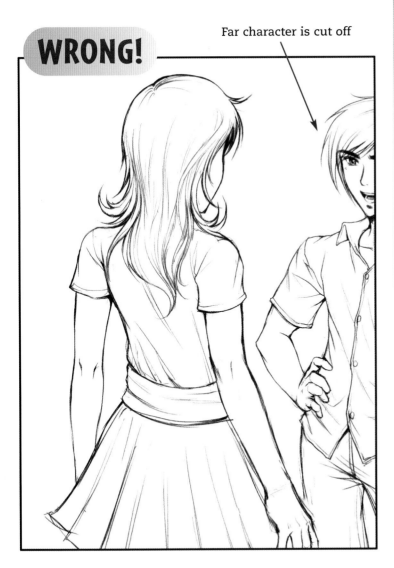

Foreground character is cut off

Extreme Drama Takes Extreme Angles

The Mysterious Boy walks down the hall, but the school athletes block his way. What's he gonna do? This could spell trouble. No one messes with these jocks!

The side view is a good, clear choice. But it's nothing new. In order to heighten the drama, there is not much we can do to the actual drawing itself, which is already very good. For the answer, we'll have to look to the "camera" angle. For extreme drama, we either go below or above the character. But going below (looking up at a character) makes a character appear huge, awesome, and creepy in the eye of the reader. None of those descriptions seem to fit the Mysterious Boy or this scene. On the other hand, changing the angle to look down at the characters gives a sense of the surroundings and a feeling that we are observing the situation—perfect!

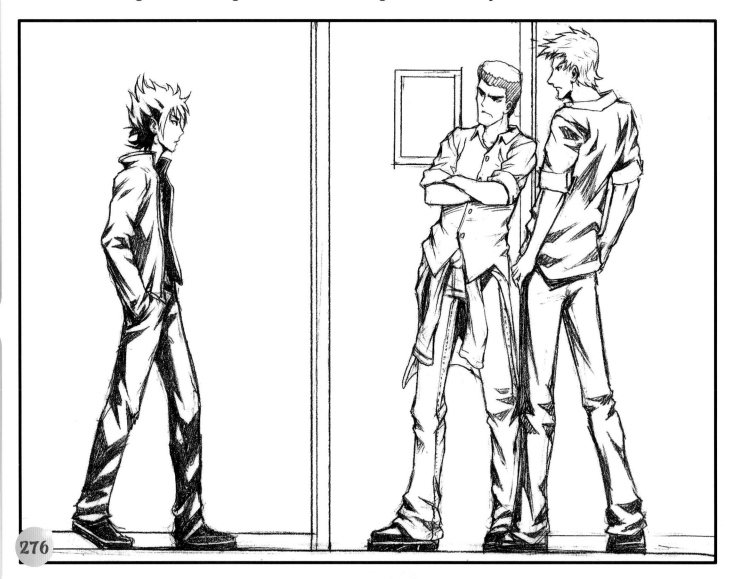

Now we really feel the impending conflict! The tension awesome. I believe you're now starting to understand the value of choosing the correct angle for the correct moment. You can't get this type of drama from a drawing alone without the correct angle to match it. This is called a "down" shot or a "bird's-eye view."

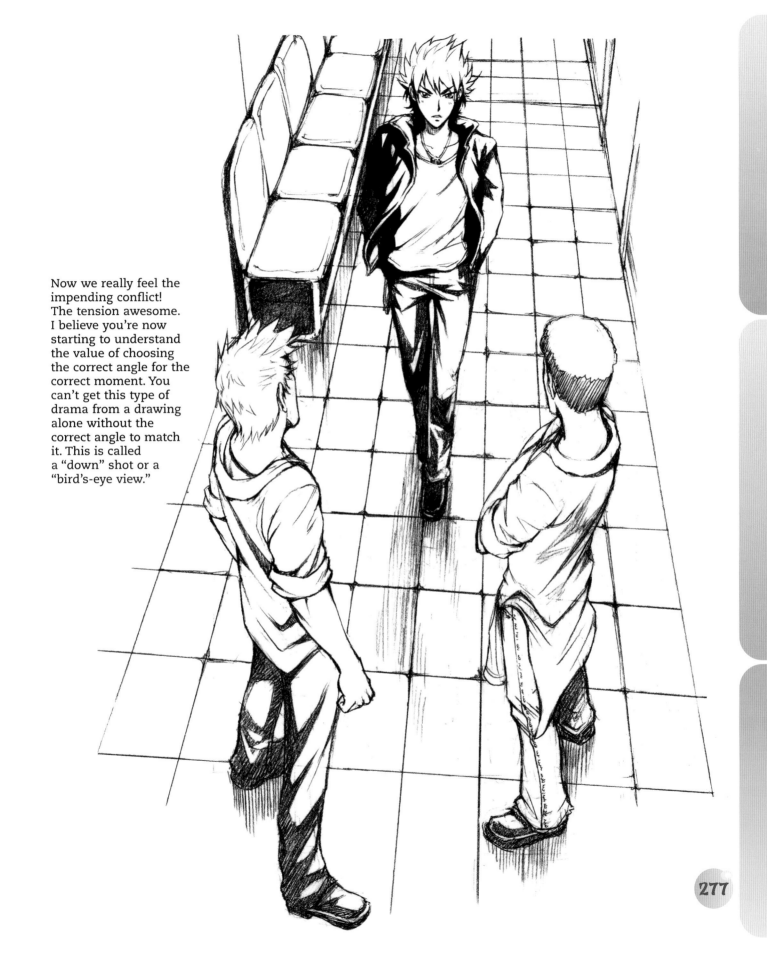

Good Cuts & Bad Cuts

When you cut from one panel to another, you don't want to jar the reader, unless that's the point, as in some fast and furious action scenes. For the most part, the "cuts" should flow smoothly from one to the other. There are two ways to do this: Move in toward the character, or move around the character. (Moving up or down is reserved for more dramatic shots.) If your move from one angle to the next is too big, with no baby steps in between, it can also be jarring. So let's take a look at some what-to-do's and what-not-to-do's.

Full Shot to Medium Closeup: Front View

This is a very safe, standard cut. Not too close, not too far. We have simply moved closer in to a comfortable distance.

YES!

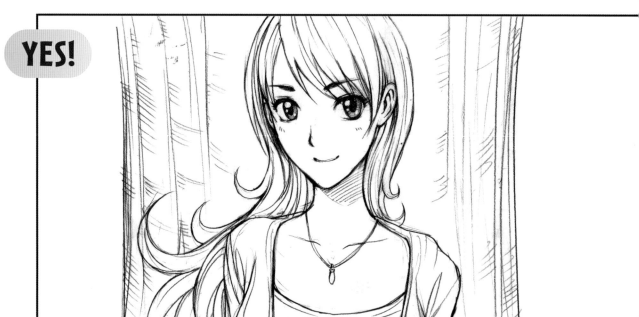

Full Shot to Medium Closeup: 3/4 Angle

Now we not only move in, but we also move around the character into a 3/4 angle. This angle involves the reader a little more because it brings us into an entirely new angle, and therefore, we're expecting something new to happen. Perhaps someone is arriving to talk to her.

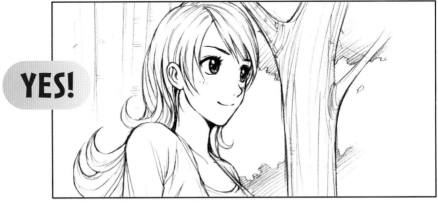

YES!

Full Shot to Rear Closeup

This time, we've moved too far around the character without enough steps in between the full shot and the closeup to prevent the cut from appearing abrupt. This shot sequence, as shown, doesn't work at all.

NO!

Extreme Closeups

The extreme closeup is a fantastic tool to use in highly dramatic situations. It's the exception to the rule that you need gradual steps when cutting from one angle to the next. The extreme closeup should be an abrupt cut. Just go for it, without the in-between steps. It's essential to crop most of the face off at the borders of the panels for this shot, but leave all of the eyes in—AND—just as importantly, leave empty space in front of the face.

Tilted & Odd-Shaped Panels

We can also tilt the angle and alter the shape of the panel itself. But don't overuse this technique. You don't want a page full of weird-shaped panels. One is enough for an accent. If they're all weird-looking, none will stand out. Use the strange-shaped panel in conjunction with major moments in your story.

You can also use odd-shaped panels for times when you just want to break the monotony of a spread (a "spread" is two pages that face each other when a book is opened). No matter how pretty the pictures are, if the left page has six square panels and the right page has six square panels, then the first impression the reader will get is: B-O-R-I-N-G-! But by tossing in a couple of odd-shaped panels, you spice things up and hold the reader's interest.

Normal Panel

Tilted, Odd-Shaped Panel

The Reveal

The "reveal" is a popular, often humorous device in the romance genre, which is filled with comedic moments. It occurs when something funny and unexpected has just happened, and it's shown to the audience. What's more, the characters must show a big reaction to it—because that's what cues the audience in to the fact that something out of the ordinary has just taken place. Not all reveals are funny. Some can be surprising. But the principles are the same. Here are some examples of subjects ripe for revealing.

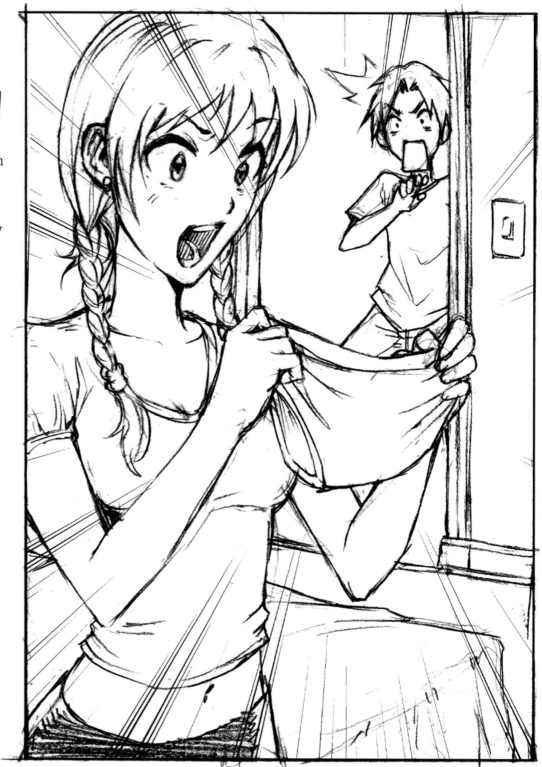

Embarrassing Moment Reveal

His mom accidentally placed his clothes in his sister's drawer. How embarrassing!

Treasure Chest Reveal

Revealed objects often radiate special-effects lines that give the drawing a magical, powerful quality.

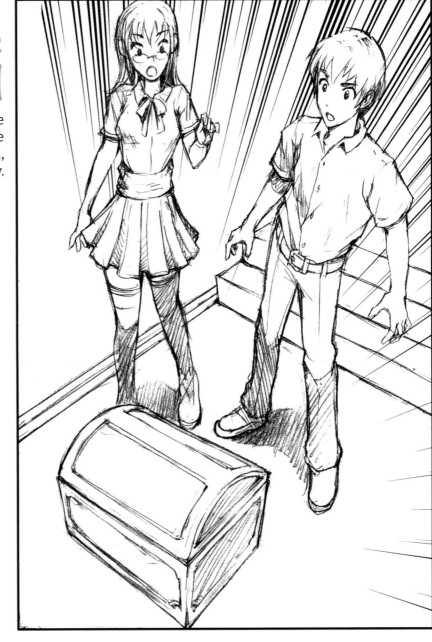

The Double Reveal

Split into two panels, the double reveal features a setup and a payoff.

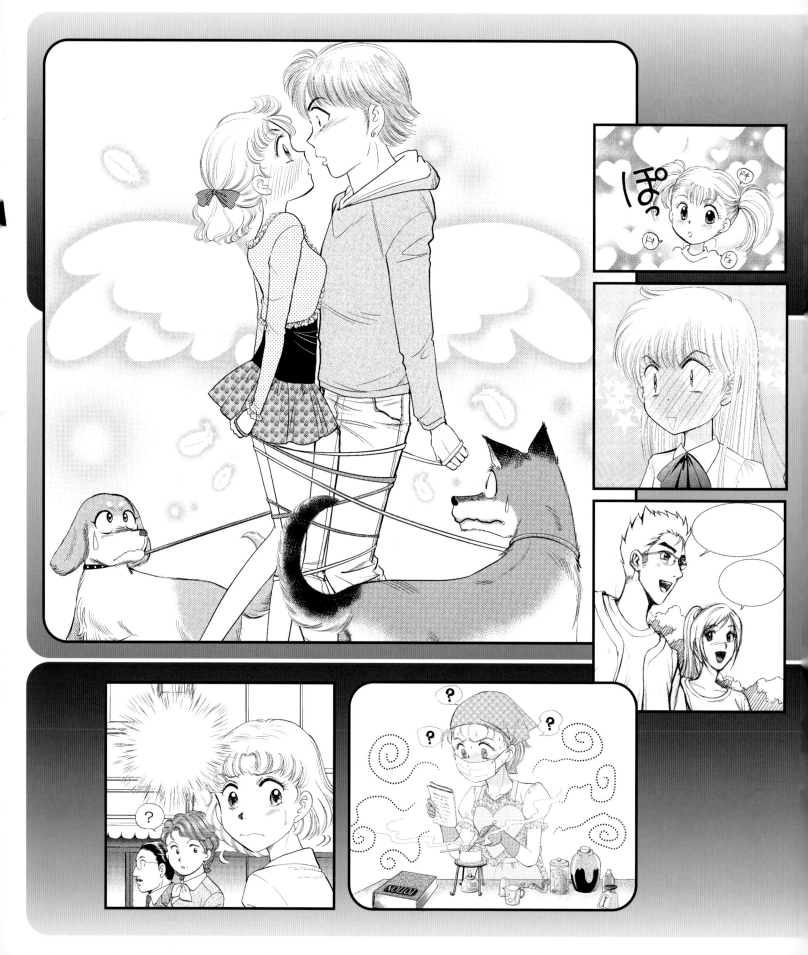

Finishing Touches

Once you've designed your characters, clothed them and placed them in exciting scenes, you have to give them something to say! This chapter covers all the aspects of using speech balloons AND shows you how to add special effects and other touches to give your drawings that extra pizazz that will put them over the top!

Special Effects

Special effects are very important in the romance genre. They enhance the mood, embellish the art, and amplify the state of mind of the characters. And there's one more reason to include special effects: They just plain look pretty! The last reason may be the most important of all.

Full-Moon Effect

Any circle behind two characters creates a romantic mood. It doesn't even have to be a literal moon. It can just be a sphere that sets the scene. Notice the edges that create the outline of the circle, and how they gradate from black to gray to white—it's not a hard line. Frame your characters' heads in the middle of the circle. If you're going to draw a literal moon, then the full moon is the best. The cresent moon is used exclusively for occult comics. And half moons are avoided altogether in comics, because they look like strange, incomplete shapes in the sky.

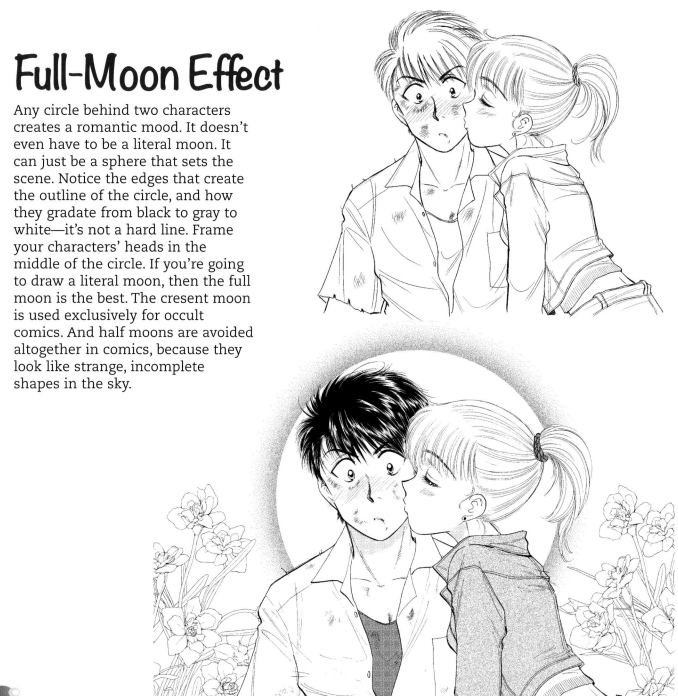

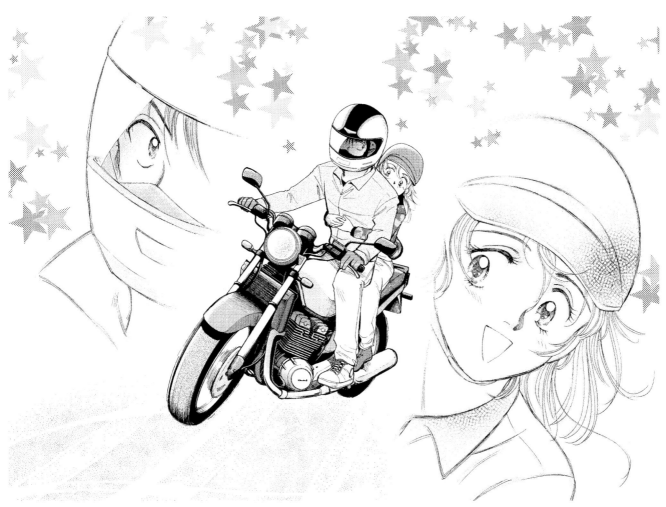

Stars

This is a fanciful effect that gives a carefree, cheerful feeling. It also adds a bit of glamour to a scene. The stars should be gathered in random bunches and trail off, almost like leaves in the breeze. You can often buy these effects online or purchase them from an art store. But it looks just as good to draw them freehand. If you do decide to draw them freehand, I recommend drawing them with a light gray marker without outlining them in black. This will give them a cool effect, making them look sort of translucent.

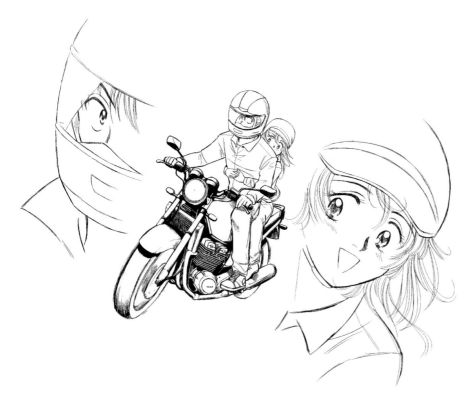

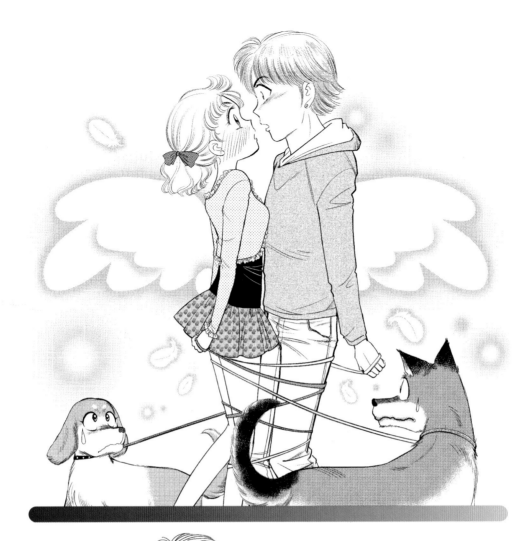

Blush Clouds

Special effects sometimes visually externalize what is going on with a character internally. Here we have a character who is extremely embarrassed because her dog has tied her up to a boy she has a crush on but has been too shy to talk to. The moment is so big for her that it warrants more than a few streaks on her face. A cloud of emotion bursts onto the scene behind the two of them. And because the special-effect cloud is placed evenly behind the two characters, it has the effect of bringing them together as a single unit instead of as individuals, which also underscores the intention of the scene.

Repeated Dots

Repeated dots like these are a humorous, abstract design that conveys jealousy. Make sure that the dots radiate from the head as if it were a vanishing point. And enlarge the dots as they travel outward. Note, too, that the dots get darker as they get large. All of this combines to give the effect of an actual stream of dots—or a stream of heated emotions radiating out across the room.

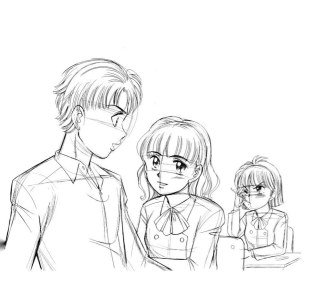

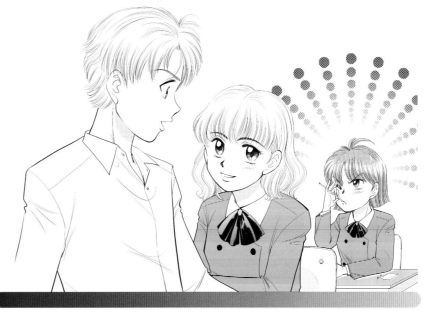

Clouds of Doubt

A patchy, sponge-like effect across the page creates the impression of emotional upset and worry. The mottled look should be uneven and dark. Will he leave her? Will he stay? The look on her face would not be nearly as grave were it not for the intensity of the background effect.

Daydream Effect

When a character is daydreaming, his or her head should partially overlap the dream sequence, which should be large and appear to be floating. The reader should be able to tell at an instant what is going on in the daydream. How do you show that? By keeping the character big in the daydream frame, for example, in a medium or closeup shot. You can make the daydream cloud any shape you like: round, bumpy, square, rectangular. But don't give it too many characters or a detailed background inside of it, because a cluttered daydream is tough to read. And then it begins to look real, not airy.

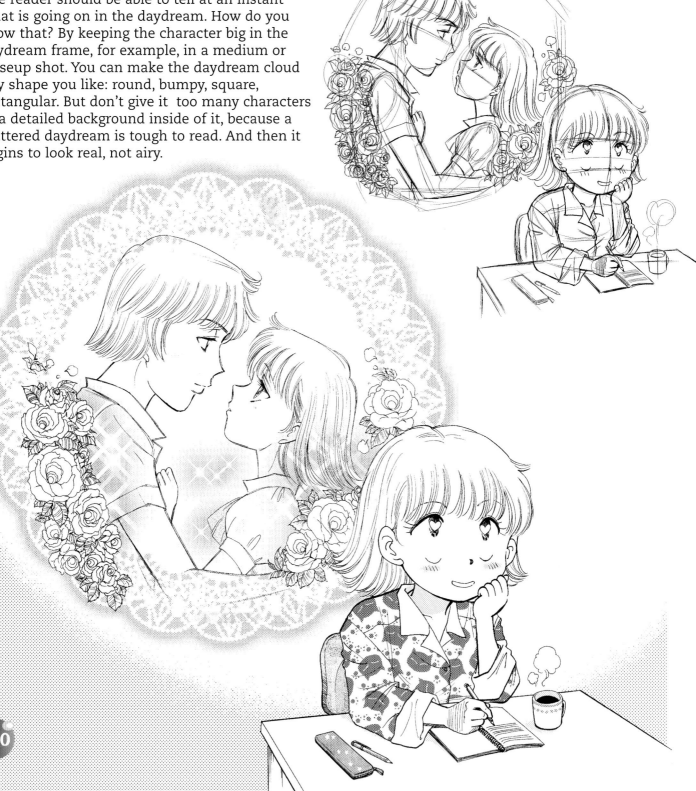

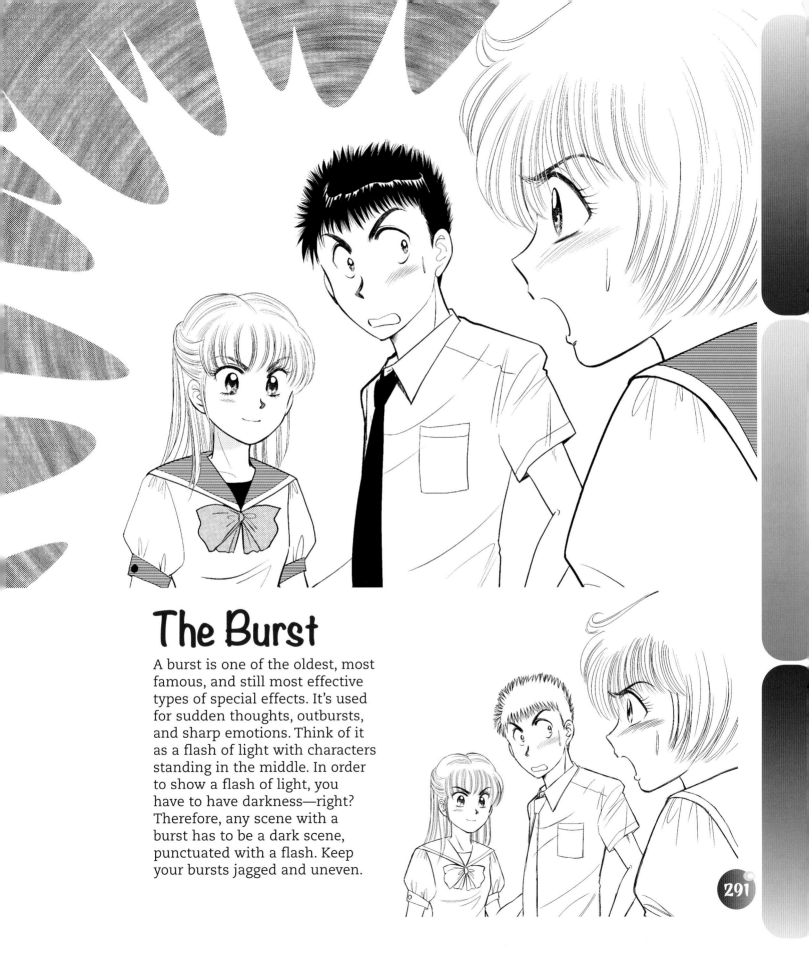

The Burst

A burst is one of the oldest, most famous, and still most effective types of special effects. It's used for sudden thoughts, outbursts, and sharp emotions. Think of it as a flash of light with characters standing in the middle. In order to show a flash of light, you have to have darkness—right? Therefore, any scene with a burst has to be a dark scene, punctuated with a flash. Keep your bursts jagged and uneven.

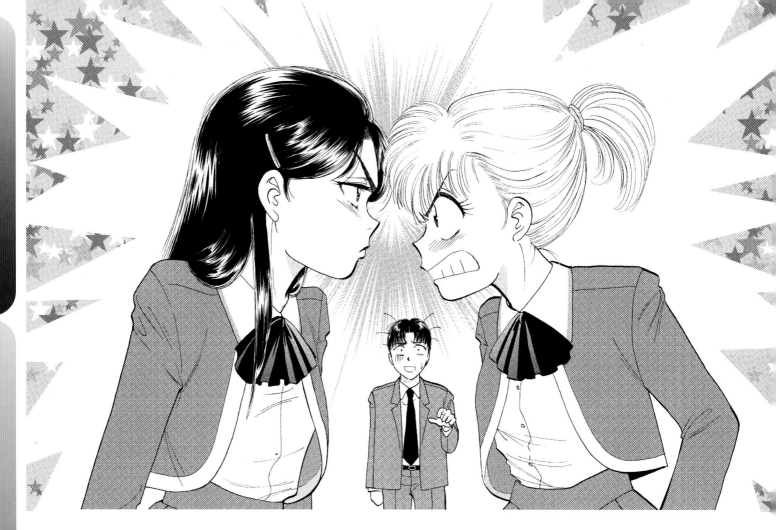

Broken Shards

Talk about a shattered relationship! Look at those sharp points invading the panel from all sides. Yee-ouch! Looks painful! In addition, there's a mini-burst where their two foreheads are about to collide. Whatever set off the fuse between them, it's about to turn into one heck of an explosion. I think it may—just may—have to do with that boy in the background.

Hint

Note the composition: A boy is standing between their friendship, figuratively as well as literally! Often, you can translate the emotional into the visual with basic placement.

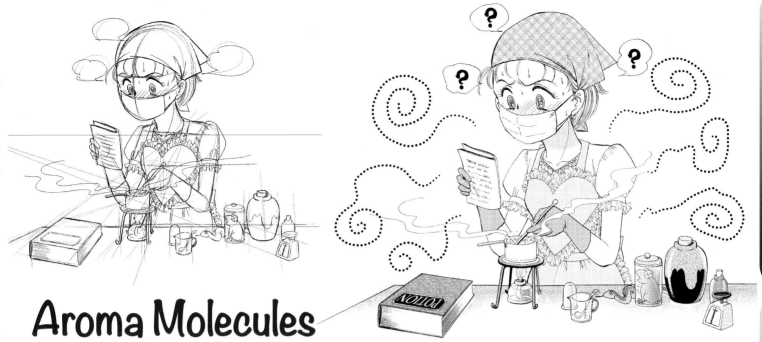

Aroma Molecules

When a fragrance—or odor—wafts up from a bubbling brew, we know that a love potion is in the works. The witchy nature of this concoction is shown by the serpentine, curling lines. Dots work best, as solid lines tend to read as smoke or steam, not smells.

Red in the Face!

In comics, you can show a character getting red in the face without using any color! Simply add sketch marks—usually diagonally—across the cheeks and darken the face with gray tones. In this scene, her crush has just walked past her—but she can't think of a single thing to say to him!

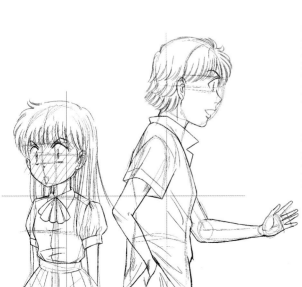

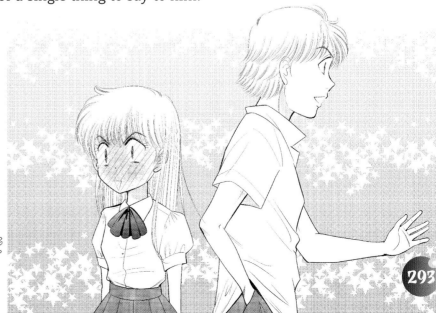

Dramatic Streaks

Streaks equal urgency, which heightens the drama of any situation. But don't let the special effects do all the work. The scene itself has to be exciting, or it's like adding an exclamation point to a boring sentence—the audience won't be moved by it. Notice how the streaks start off darker toward the bottom of the cliff and lighten as they travel upward toward the boy—and safety.

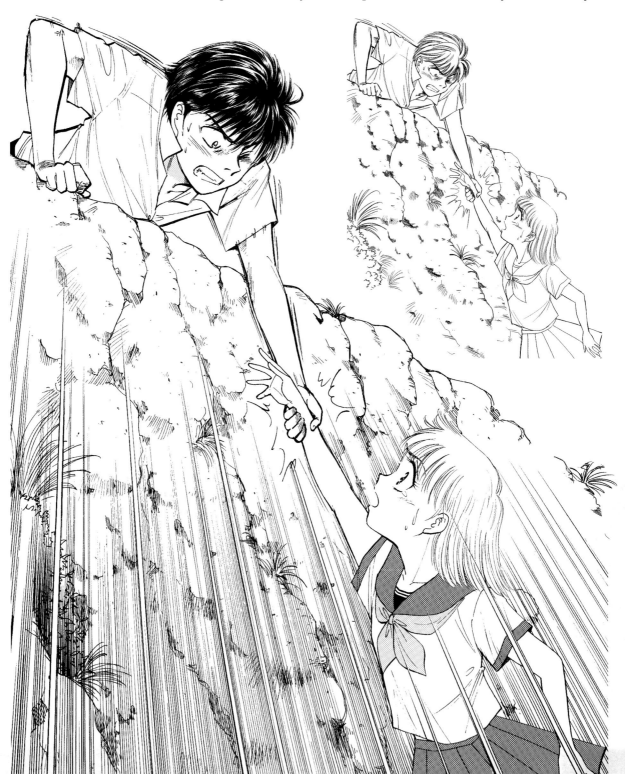

Flash of Light

This is a highly dramatic effect—a burst of ethereal light behind a character. It's laying on the drama pretty thick, but when the entire story leads up to one particular crescendo, you owe it to your readers to pull out all the stops. Notice how all the streaks point to the center of the action. Now you're really directing the reader's eye. As the artist, you're in charge, like a movie director.

His girlfriend has been hurt by an evil warlord! This is the worst news anyone could ever get—especially since the prom is only two days away!

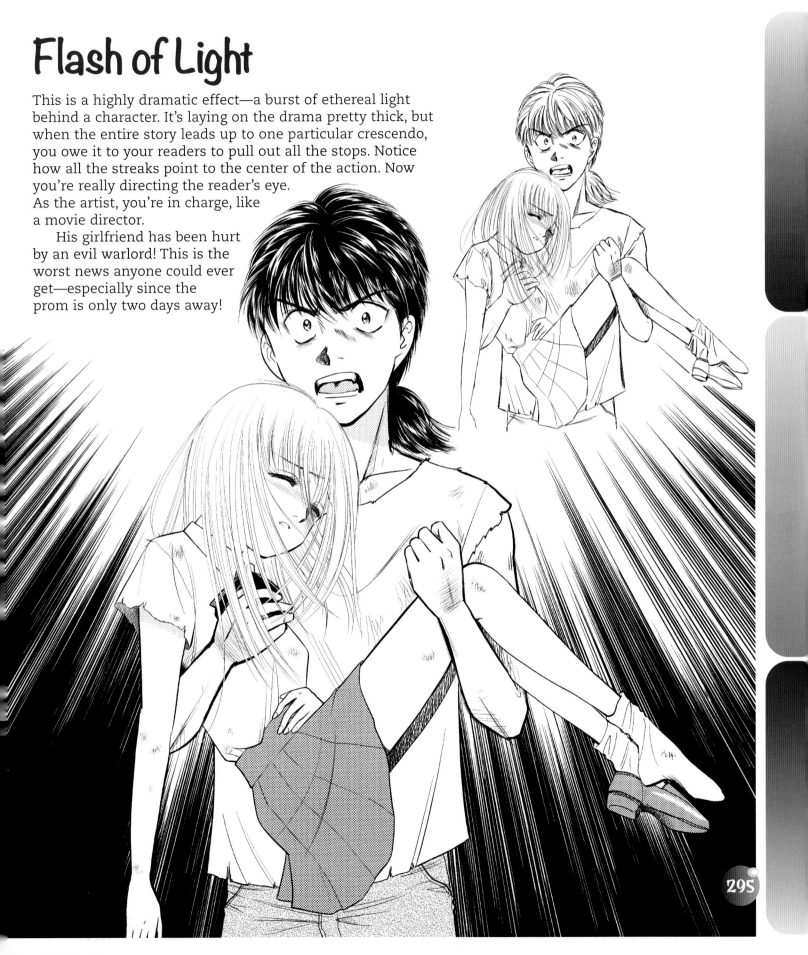

Speech Balloons

The placement of speech balloons is fairly informal in manga, unlike in American comics, where formal principles of layout and composition dictate the approach. However, there are some basic conventions and attractive options for using speech balloons that I'd like to share with you, so you can use them in your stories.

Positioning Speech Balloons

There are three basic heights that work best for speech balloons.

Off to the Side

Below the Head

Above the Head

When One Balloon Is Not Enough

Have you ever seen a speech balloon containing just tons of writing? Even if you could fit it all into one balloon—don't! It looks awful when it's so crowded—like a reading assignment for school. Remember, teens buy manga to escape reading assignments, not to get more of them! The best way to handle a long speech is to break it up into two balloons. Here are the three most popular methods for doing so.

Two Separate Panels

Two Balloons Within the Same Panel

Two Balloons That Break Out of the Panel Borders

Special-Effects Speech Balloons

Now that we've learned about the effective placement of speech balloons, let's have some fun with them! Special-effects speech balloons are like speech balloons with expressions on them. They really bring out the attitude of the speech within the balloon. You'll find a much wider variety of these in manga than in Western comics.

These light–hearted special-effects balloons are a great addition to the romance genre. The designs are mainly based on jagged balloons or uneven streaks in the shape of bursts of light.

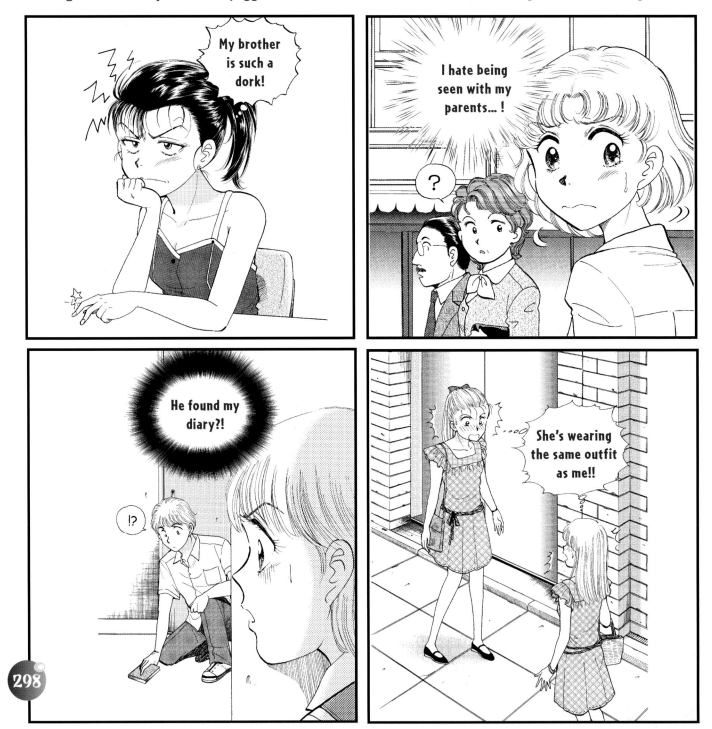

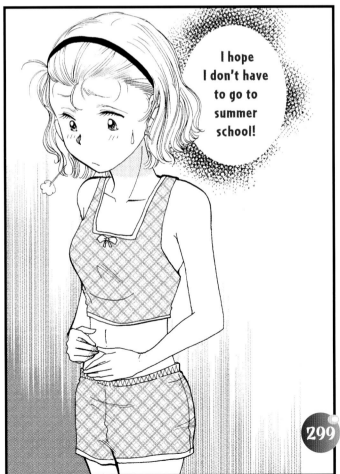

Japanese Sound Effects

Most manga graphic novels we read in the U.S. are translations from Japan. The words are written on a separate layer that can be removed so the text can be translated. However, the sound effects splashed over the art are part of the artwork itself, which is why they are still in Japanese, and why you never see words like "WHAM!" or "BLAM!" Japanese sound effects have no inherent meaning but are onomatopoeic, which means they sound like the meanings and emotions associated with them. Here are some common ones.

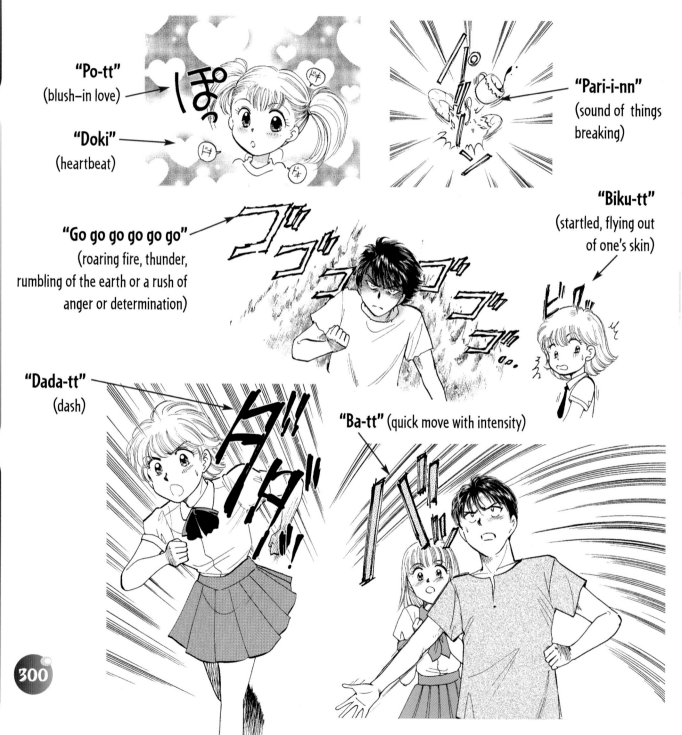

"Po-tt" (blush–in love)

"Doki" (heartbeat)

"Pari-i-nn" (sound of things breaking)

"Go go go go go go" (roaring fire, thunder, rumbling of the earth or a rush of anger or determination)

"Biku-tt" (startled, flying out of one's skin)

"Dada-tt" (dash)

"Ba-tt" (quick move with intensity)

Index

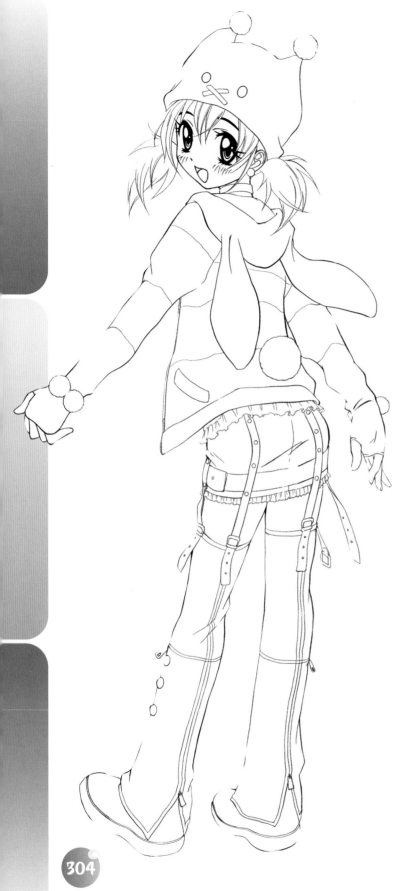